becoming undone

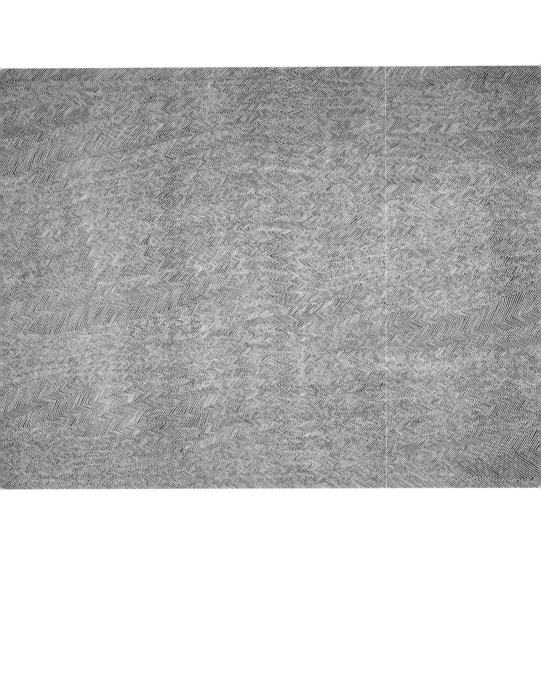

becoming undone

DARWINIAN REFLECTIONS ON LIFE,

POLITICS, AND ART

ELIZABETH GROSZ

DUKE UNIVERSITY PRESS *Durham & London* 2011

© 2011 Duke University Press

All rights reserved

Printed in the United States of America on acid-free paper ∞

Designed by Amy Ruth Buchanan

Typeset in Carter + Cone Galliard by Keystone Typesetting, Inc.

Library of Congress Cataloging-in-Publication Data appear on
the last printed page of this book.

Frontispiece: *Untitled*, Doreen Reid Nakamarru. Copyright
estate of the artist, 2010, licensed by Aboriginal Artists Agency.

contents

acknowledgments

This book would not have been possible without the efforts of many others. I would like to thank my colleagues in the women's and gender studies department at Rutgers University for the support they have given me in my far-flung researches. I have had a most conducive environment to think about feminist questions and feminist texts. This has been enhanced by a semester in the women's studies program at Duke University, where I completed this book. And through my ongoing engagements with the Centre for Women and Gender Research at the University of Bergen, Norway. My special thanks to colleagues at all three institutions for their interest and provocations. I would like to single out Rey Chow, Ed Cohen, Joanne Givand, Tone Lund-Olsen, Ellen Mortensen, Lillian Spiller, and Robyn Wiegman for their friendship and support during the writing of the various chapters that make up this book; and particularly Luce Irigaray and Doreen Reid Nakamarra, whose works not only absorbed me during this project but who were generous enough to speak with me about their very different but also surprisingly connected work. These discussions proved indispensable for this project. I have learned from the advice of Claire Colebrook and Nicole Fermon in writing this book. My heartfelt thanks for their detailed readings of the text. I would also like to thank Courtney Berger, my editor, who has worked generously and enthusiastically with me over a number of different texts. Nicole Fermon not only helped review the manuscript but also to inspire the hope for the future that this book exam-

ines. My deep gratitude to her for her optimism and positive spirit. This book is dedicated, with love, to my mother, Eva Gross.

Chapter 1 was originally presented at the Australasian Universities Language and Literature Association Thirty-fifth Congress, "The Human and Humanities in Literature, Language and Culture," held at the University of Sydney in February 2009. Chapter 2 originally appeared as "Deleuze, Bergson and the Concept of Life," *Revue Internationale de Philosophie* 3 (2007): 287–300. Chapter 3 was originally published as "Bergson, Deleuze and the Becoming of Unbecoming," *Parallax* 11, no. 2 (2005): 1–10. Chapter 4 appears in *New Materialisms: Ontology, Agency, and Politics*, edited by Diana Coole and Samantha Frost (Durham, N.C.: Duke University Press, 2010). Chapter 5 is forthcoming in *New Feminisms: Mapping out Feminisms-to-Come*, edited by Henriette Gunkel, Chrysanthi Nigianni, and Fanny Söderbäck (Basingstoke, U.K.: Palgrave Macmillan, 2012). A version of Chapter 6 was originally published in *Working with Affect in Feminist Readings: Disturbing Differences*, edited by Marianne Liljeström and Susanna Paasonen (London: Routledge, 2010). Chapter 7 was presented at the third Annual Irigaray Circle Conference, held at Hofstra University in October 2008. Chapter 8 was originally presented at Darwin Day at Dusquesne University in March 2009; Chapter 9 was originally presented at the Sexual Difference Seminar held at the University of Minnesota in November 2009. Chapter 10 was originally presented at the conference "Part Animal, Part Two: A Conference on Architecture," held at Columbia University in March 2008. Chapter 11 was originally published in *Before and After Science: 2010 Adelaide Biennial of Australian Art* (Adelaide: Art Gallery of South Australia, 2010).

becoming undone

introduction

This book is an attempt to address a series of imperceptible movements, modes of becoming, forms of change, and evolutionary transformations that make up natural, cultural, and political life. I have called these movements "becomings," but what it is that becomes, and what it becomes, are less clear and less interesting than the movement itself. Movement does not attach to a stable thing, putting it in motion; rather, movement preexists the thing and is the process of differentiation that distinguishes one object from another. I am interested in the processes that make and unmake objects, whether these are natural objects, manufactured objects or those objects that live and experience.

These various forms of movement, forms of accomplishment or actualization, constitute material and living things. This book explores the conditions under which material and living things overcome themselves and become something other than what they were. It elaborates the *difference* that constitutes things, including subjects, and that structures the relations between things. Things undergo becomings, which transform them in ways which are unpredictable and irreversible. These becomings are the testament to the differences that constitute whatever identity things — including subjects, living beings — might have. Becomings complexify, transform, overcome in ways that are measurable but also imperceptible. I will look at how change occurs, that is, how difference elaborates itself, whether it is at the level of material and natural objects and forces, or at the level of

organic beings and their forms of growth and decay, or at the level of social organizations and the forces of change they attempt to contain, slow down, and control.

Every thing, every process, every event or encounter is itself a mode of becoming that has its own time, its own movements, its own force. These multiple becomings both make and unmake, they do (up) and they undo. These becomings enable life to erupt from certain mixtures of chemicals, to complicate and enable materiality to undergo becomings, and to generate living beings of all kinds, within which both individuals and species (if these terms make sense) also become more and other than their histories through their engagement with dynamic environments. They also enable orders of social organization (both animal and human) to emerge from certain forms of life that transform those forms and that are themselves the sites of further becomings, becomings that function through the generation of a kind of politics, a complex interaction of populations, collectives, groups. Each of these becomings is a mode of transformation of the actual and the present according to virtual forces, forces that emerge from within, meeting forces that surround and enmesh things, events, and processes. These becomings are individuations, processes of the production of things, processes that transform states of matter, processes that enable and complicate life.

This book explores the complex relation between living beings, species, and individuals, and the forces of materiality. It does so through analyzing the implications of Charles Darwin's understanding of the evolution of life within environments that provide the criteria and the various forces that constitute natural selection. The evolution of life, in Darwin's own writings, is complicated, transformed, reoriented through the advent of the operations of sexual selection. Following Darwin (Darwin as he speaks in his own writings, a Darwin not commonly addressed in some of the fields that have emerged because of his work — evolutionary biology, genetics, ethology), I attempt to develop a concept of life that does not privilege the human as the aim or end of evolution, but sees the human as one among many species. If the human is simply one among many of the trajectories that life on earth has elaborated, then many of the most cherished beliefs about how humans will and should behave in the light of the manifest and lived differences that divide the human will be thrown open to new lines of development, new kinds of practice, and new modes of thought. I explore the ways in which the Darwinian revolution in thought disrupts and opens

up life to other forms of development beyond, outside, and after the human (while still following a trajectory of sexual difference). This disruption or upheaval of the order of being, the ways in which the future is an active and open dimension of life, subjected to its own orders of becoming, and how an open-ended but relentless force to futurity undoes all stability and identity while also retaining a fidelity to historical forces are the objects of analysis in this text. It explores how the philosophy of becoming, which emerged with full force in the nineteenth century and early twentieth, through the writings of Darwin, Friedrich Nietzsche, and Henri Bergson, have enabled thinkers in the late twentieth century and early twenty-first, such as Michel Foucault, Gilles Deleuze, Félix Guattari, Jacques Derrida, and Luce Irigaray, to use the concept of becoming to analyze a variety of social, political, economic, and conceptual relations. It explores how becomings undo the stabilities of identity, knowledge, location, and being, and how they elaborate new directions and new forces that emerge from these processes of destabilization.

The book is divided into three sections. Part 1, "Life: Human and Inhuman Becomings," analyzes the question of life and how it is reframed through the revolution in thought Darwin opened up and Bergson and Deleuze elaborated. In these three chapters, I examine the ways in which the concept of life has emerged with reinvigorated force through the writings of Darwin, who considers life as an emergence from earlier forms, increasing in complexity and organization, elaborating itself both from the forces of difference that come from within species and the forces of natural selection that come from the environment of the living being. Life is the creative utilization and elaboration of natural resources, and that which brings unexpected transformations to the environment that intensify its own forces. But life is also the elaboration of at least two lines of development, two morphologies, two types of body: a divergent development that brings with it endless variation and endless difference. Darwin brings to his understanding of life as emergence the profound idea that it is sexual difference, through sexual selection, that enhances, intensifies, and varies life, elaborating more variation and more difference in the world. He has developed an entirely new understanding of life based on the entwining of natural with sexual selection, enveloping the forces that make up the environment of a living being with the forces of attraction and appeal to create individuals and species that differ as much as possible in their forms and capacities; life as the ever more complex elaboration of difference.

Darwin has produced many heirs to his work, those who follow his work in the natural sciences, those who are now attempting to elaborate it in relation to the social sciences, and those who look at the implications of his work in the humanities. This book will focus on his philosophical heirs, the implications that his work has bequeathed to nineteenth- and twentieth-century philosophy and beyond, especially through the work of his major French interpreter, Henri Bergson, whose works were so significant to the writings of Deleuze, both alone and in his collaborations with Guattari. Darwin, Bergson, and Deleuze represent a new kind of philosophy of life, a trajectory in which life is always intimately attuned to and engaged with material forces, both organic and inorganic, which produce, over large periods of time, further differentiations and divergences, both within life and within matter as well as between them. Darwin has, in effect, produced a new ontology, an ontology of the relentless operations of difference, whose implications we are still unraveling.

In what ways does a Darwinian understanding of the place of man in the order of being problematize those knowledges — the "humanities" — devoted to the understanding of the human in separation from the animal? This is the question that occupies chapter 1, "The Inhuman in the Humanities: Darwin and the Ends of Man." In what ways do Darwin and his followers elaborate a concept of life that has philosophical implications for how we understand the profusion of life on earth, life understood without teleology, without purpose, without a final accomplishment, without the human as its end or goal? In what ways might Darwin's decentering of the human affect how we understand the humanities, those disciplinary knowledges directed to man? How to understand life as no longer bound by and defined through a hierarchy in which man is the pinnacle of all living forms? This is the question that also occupies the second chapter, "Deleuze, Bergson, and the Concept of Life." Here I explore the ways in which Bergson and Deleuze elaborate and develop, each in his own ways, Darwin's concept of life, so that it comes to include the material universe in its undivided complexity (for Bergson), or so that it can be extended into inorganic forms, into the life of events (for Deleuze). How does the concept of emergent life transform how we understand materiality? Is life a continuation of the forces of matter or their transformation? In chapter 3, "Bergson, Deleuze, and Difference," I explore how Darwin's most unrecognized concept — difference, or variation — may contribute to the contemporary fascination with the question of lived and structural differences between hu-

mans, differences lived as raced, sexed, or class-based. That is, I attempt to address how we may rethink subjectivity and the human using the Darwinian concept, developed through the philosophies of Bergson and Deleuze, of constitutive or internal difference. While exploring the interrelations between Darwin, Bergson, and Deleuze, the first part of this book is nevertheless a philosophical homage to the profound and transformative implications of Darwin's conception of life, in which the human is one species among many, one destined itself to be overcome, as are all the forms of life on earth.

In part 2, "Disturbing Differences: A New Kind of Feminism," the implications of this tradition or counter-tradition of life, of Darwin's, Bergson's, and Deleuze's entwined conceptions of life, are explored from a feminist perspective, and some of the most central concepts of contemporary feminism — questions of agency and identity, questions of diversity and intersectionality, questions about feminism's relations to epistemology and ontology — are addressed and in some ways shifted using their insights. I don't want to suggest for a moment that Darwin, Bergson, and Deleuze are feminist theorists, only that their work provides an alternative to the traditions of liberal political thought, phenomenology from its Hegelian to its contemporary forms, and structuralism and poststructuralism, which have so far provided inspiration for much of contemporary feminist theory. Instead, I want to explore how a new framework in which the human man and woman are contextualized not only by human constructs, that is, by linguistic and cultural environments, but also by natural and animal geographies and temporalities might help us to rethink some of the key concepts in feminist thought. Such a move may be described as a "new materialism," but I would prefer to understand life and matter in terms of their temporal and durational entwinements. Matter and life become, and become undone. They transform and are transformed. This is less a new kind of materialism than it is a new understanding of the forces, both material and immaterial, that direct us to the future.

Part 2 explores some of the implications of this new understanding of the becoming of all beings for feminist and other forms of radical political thought. It explores new directions and new questions in feminist theory, questions no longer oriented only to the subject but to the world, aimed at expanding how we understand the forces of animal and human becoming in the case of human political life. In chapter 4, "Feminism, Materialism, and Freedom," I explore how Bergson's understanding of freedom, funda-

mentally linked to but emergent from our habitual relations to the material world, may serve feminist and other radical political thought better than the phenomenological, liberal, and Marxist frameworks feminist theory has previously used to develop its understanding of subjectivity and freedom. In chapter 5, "The Future of Feminist Theory: Dreams for New Knowledges," I explore how new forms of feminist, antiracist, and class theory might be created, and what epistemological forms—what philosophical concepts—may be more appropriate to an ontology of becoming, a philosophy of difference, such as that developed by Deleuze and Guattari. The next chapter, "Differences Disturbing Identity: Deleuze and Feminism," further explores the relevance of Deleuze's understanding of difference for challenging some of the dominant forms of feminist thought and for developing a new, more nuanced and subtle understanding of the forces of power than that represented by the models of intersectionality or multiple overlapping forms of oppression that are so powerful within much of contemporary feminist theory. In these chapters I attempt to articulate new questions for feminist theory to consider: questions that reach beyond those of the subject and its identity, about forms of knowledge and how we know, or about the human as the only form of culture to new kinds of questions about what is beyond us, what is different from us, what is inhuman (within and around us); questions about the real. Chapter 7, "Irigaray and the Ontology of Sexual Difference," elaborates Irigaray's concept of sexual difference, developing it not only in terms of its psychical and political significance but primarily as a corporeal and ontological concept that links the human to the natural world as much as to the social world. Along with Deleuze, Irigaray is among the few contemporary theorists committed to the creation of a new ontology, one which addresses the forces of becoming, which, in Irigaray's case, must be understood in terms of at least two sets of forces, two kinds of processes, two relations to the world that cannot be generically combined into one. Irigaray provides a more dynamic and powerful understanding of philosophy as the elaboration or unfolding of ontological forces, forces of the real, the forces of sexual difference which mark both the natural world and the worlds of human culture. Irigaray's work on sexual difference, arguably the greatest concept within feminist thought, opens up unexpected connections between her concept of sexual difference and Darwin's understanding of sexual selection, which I explore in the third part of the book.

In this final part, "Animals, Sex, and Art," Darwin's understanding of the

tensions between survival and excess, that is, between natural and sexual selection, are explored primarily because they are the center of a nonreductive Darwinian analysis of the creative, productive enmeshment of sexuality and sexual difference with the excesses of attraction that may be the raw materials of art practices. A new understanding of the creativity of art may be elaborated using Darwin's understanding of sexual selection. His work may turn out to be surprisingly contemporary, surprisingly postmodern.

In chapter 8, "Darwin and the Split between Natural and Sexual Selection," I address Darwin's relevance to contemporary feminism. His work on sexual selection is remarkably astute and original, yet it has largely been ignored by the biologists who follow him. Sexual selection is primarily understood by Darwin's followers as a version of his understanding of natural selection. Yet this interpretation reduces the excess and creativity of sexual selection to a struggle for fitness. It may be that this work on sexual selection requires something like a feminism of difference in order to be adequately understood. I develop this concept in further detail in the following chapter, "Sexual Difference as Sexual Selection: Irigarayan Reflections on Darwin." There I explore the ways in which Irigaray's and Darwin's works may be strengthened through a kind of cross-fertilization, and the concepts of sexual selection and sexual difference rendered more radical, paradoxically, by including biological as well as cultural forces.

The final two chapters are devoted to developing a Darwinian-Deleuzian understanding of art. In "Art and the Animal," I examine how the concept of sexual selection influences the production of art and how art has a genealogy that links it to the sexual forces of animals. Here instead of relying on Darwin directly, I use the work of Jakob von Uexküll, which has been so influential in ethological studies. His work establishes new questions regarding the world of animals that Darwin made relevant but did not explore. His work is directed to the intimate involvement of living beings with the partial worlds they inhabit, worlds that may include other living beings. Through the work of Uexküll, Konrad Lorenz, Karl von Frisch, and other founders of ethology, we can see the direct links between sexual attraction and artistic excess. The bee and the flower exist in a relation of attraction and mutual address across species, in an elaboration of sexual selection that spreads it from within a species to between two or more species. Art and territory become directly linked. Art becomes connected to the processes of becoming-inhuman, to the production of an animal excess, within and before the human. In chapter 11, "Living Art and the Art of

Life: Women's Painting from the Western Desert," I address some of the most captivating and stirring forms of contemporary art, produced by indigenous women artists of the Western Desert in central Australia. This is an art that while fully cultural nevertheless affirms its fundamental connections with both the animals with which humans share territory and the specific nature and forces of territory or geography itself. While exploring the art of both a remarkable individual, Doreen Reid Nakamarra, and a women's painting collective, the Martu women painters, I attempt to bring together my interests in Darwin and the question of genealogies of the animal his work raises; Deleuze and the questions of becoming, becoming-more, and becoming-other that he elaborates; and Irigaray, with her focus on sexual difference and sexual specificity, without explicitly referring to their work. This is an art that speaks for itself, which works as art completely in its own terms; but it is also an art that generates concepts and that develops its own philosophies and its own modes of immersion in life.

This book is devoted to an exploration of the various excesses that forms of life engender: excesses of creativity, intensity, sexuality, and force that produce life as more than itself, a form of self-overcoming that incorporates matter and its capacities for self-overcoming within its own becomings. This capacity for self-overcoming is the condition for the emergence of art, for the eruption of collective life, and for the creation of new forms of politics, new modes of living.

life

HUMAN AND INHUMAN

BECOMINGS

The Inhuman in the Humanities

DARWIN AND THE ENDS OF MAN

In truth, there are only inhumanities, humans are made exclusively of inhumanities, but very different ones, of very different natures and speeds.
— GILLES DELEUZE AND FÉLIX GUATTARI, *A Thousand Plateaus*

Writing is a question of becoming, always incomplete, always in the midst of being formed, and goes beyond the matter of any livable or lived experience. It is a process that is, a passage of Life that traverses both the livable and the lived.
— GILLES DELEUZE, "Literature and Life," *Essays Critical and Clinical*

The place of the animal and the inhuman in our conceptions of the human, and their possible role in the humanities, those disciplines and interdisciplines devoted to the study of humans and their cultural and expressive relations, will be my object of exploration here. I want to discuss what is before, beyond, and after the human: the inhuman, uncontainable condition of the human, the origin of and trajectory immanent within the human. In asking about the inhuman — the animal, plant, and material forces that surround and overtake the human — I am not asking a new question but merely continuing a tradition that resurfaced in the final decade of the twentieth century as an echo of the Nietzschean lament for the all-too-human. Not only do Gilles Deleuze and Félix Guattari address the question of becoming-animal by examining the writings of Baruch Spinoza, Friedrich Nietzsche, and Henri Bergson; Jacques Derrida makes the animal,

animals, and the relations of animality to the human, the object of interrogation in his final book, *The Animal That Therefore I Am*, and Giorgio Agamben places the animal at the center of his reflections on man as political being.

The animal has returned to haunt the conceptual aura of the humanities, those disciplines that have affirmed and even constituted themselves as beyond the animal. The animal is a necessary reminder of the limits of the human, its historical and ontological contingency; of the precariousness of the human as a state of being, a condition of sovereignty, or an ideal of self-regulation. The animal is that from which the human tentatively and precariously emerges; the animal is that inhuman destination to which the human always tends. The animal surrounds the human at both ends: it is the origin and the end of humanity.

There is an intangible and elusive line that has divided the animal from the human since ancient Greece, if not long before, by creating a boundary, an oppositional structure, that denies to the animal what it grants to the human as a power or ability: whether it is reason, language, thought, consciousness, or the ability to dress, to bury, to mourn, to invent, to control fire, or one of the many other qualities that has divided man from animal. This division — constitutive of the humanities as they developed from the nineteenth century onward — has cast man on the other side of the animals.[1] Philosophy has attributed to man a power that animals lack (and often that women, children, slaves, foreigners, and others also lack: the alignment of the most abjected others with animals is ubiquitous). What makes man human is the power of reason, of speech, of response, of shame, and so on that animals lack. Man must be understood as fundamentally different from and thus as other to the animal; an animal perhaps, but one with at least one added category — a rational animal, an upright animal, an embarrassed animal — that lifts it out of the categories of all other living beings and marks man's separateness, his distance, his movement beyond the animal. As traditionally conceived, philosophy, from the time of Plato to that of René Descartes, affirmed man's place as a rational animal, a speaking animal, a conscious animal, an animal perhaps in body but a being other and separated from animals through mind. These Greek and Cartesian roots have largely structured the ways in which contemporary philosophy functions through the relegation of the animal to man's utter other, an other bereft of humanity. (Derrida affirms the continuity that links the Greeks and Descartes to the work of phenomenological and psychoanalytic

theory running through the texts of Immanuel Kant, G. W. F. Hegel, Martin Heidegger, Emmanuel Levinas, and Jacques Lacan.) This more or less continuous tradition is sorely challenged and deeply compromised by the eruption of Darwinism in the second half of the nineteenth century. Philosophy has yet to recover from this eruption, has yet to recompose its concepts of man, reason, and consciousness to accommodate the Darwinian explosion that, according to Sigmund Freud, produced one of the three major assaults that science provided as antidote to man's narcissism. The first, the Copernican revolution, demonstrated that the earth circulates the sun, and the third, the Freudian revolution, demonstrated that consciousness is not master of itself. But the second of these assaults, the Darwinian revolution, demonstrated that man descended from animals and remains still animal, and was perhaps a more profound insult to mankind's sense of self than the other two. Derrida understands that Darwin's is perhaps the greatest affront, the one that has been least accommodated in contemporary thought.[2]

Darwin in the Humanities

I want to explore Darwin's place in the humanities and the implications his work has for the ways in which the human is conceived. It is his conception of animals and plants, the world of the living — which equally incorporates the animal, the vegetal, and the human alongside protozoa, bacteria, and viruses — that has yet to fully impact the humanities, though it has, highly selectively and often problematically, dominated the biological sciences.[3] It is perhaps more than appropriate today to reevaluate Darwin's conception of the descent of man and to explore what it means for philosophies of man and of life that might develop in Darwin's wake. What would a humanities, a knowledge of and for the human, look like if it placed the animal in its rightful place, not only before the human but also within and after the human? What is the trajectory of a newly considered humanities, one that seeks to know itself not in opposition to its others, the "others" of the human, but in continuity with them? What would a humanities look like that does not rely on an opposition between self and other, in which the other is always in some way associated with animality or the nonhuman? What kind of intellectual revolution would be required to make man, and the various forms of man, one among many living things, and one force among many, rather than the aim and destination of all knowledges, not

only the traditional disciplines within the humanities, but also the newer forms of interdisciplinarity?

What would the study of, for example, literature and language which did not privilege the human as its paradigm look like? Is it possible for us to understand, say, language differently, beyond and outside the limits of the human? Could there be an ethology of language? Or of expression? Ironically, in view of the common misinterpretation of Derrida as someone who focuses primarily on discourse, this is one of the central questions that Derrida asks of the tradition of modern philosophy since Descartes: what would a theory of language, signification, or the trace look like that did not, through logocentric techniques, privilege not only the human but a particular kind of (European, masculine, upright, and erect carnivorous — a carnophallologocentric) subject and discourse? What would a theory of language be like that understood language in its full resonance as trace, as the material and incorporeal incision that marks and hides its own movement, a trace that in no way privileges the voice or speech? Isn't such an ethology precisely what Derrida has searched for as a language beyond logocentrism, a language that is trace in all its complexity? And isn't language that erupts from the animal already a language beyond the signifier, such as Deleuze seeks, a language linked not only to the signification of what is absent, but a language that acts and transforms, more amenable to a pragmatism than a linguistics?[4] We see the glimmer of a possibility of a new humanities in which languages of all kinds, languages in all the stages of their elaboration, from the glorious rhythmic dancing of bees to the pheromonal impulses of ants (as I will discuss in chapter 10), do not culminate in human languages but include them as one means among many for the linguistic elaboration of life.

How open-endedly must we understand language, representation, and art — those qualities that we have up to now relegated to the human only to the extent that they are denied to the animal — if we are to problematize the opposition between animal and human, and fully immerse the human in the worlds of the animal? What is distinctively human in the humanities if man is again, in the light of Darwin's rearrangement of the universe, placed in the context of animals and animal-becomings? These questions resonate with our perilous identity and ask us to address the future destinations of man, man after mankind, man in the wake of the Overman, the human at the moment of its dissipation and beyond. What would the humanities, a knowledge of the posthuman, be like far in the future, after mankind has

evolved beyond man? What are the limits of knowing, the limits of relevance, of the humanities? This is not simply the question of how we might include the animal, incorporate it into the human, as some contemporary animal rights philosophies imply. It is more to ask the question: what is the limit of the humanities? Beyond which points must it be forced to transform itself into new forms of knowledge, given its inability to accommodate the full range of humanity let alone the inhuman forms of life that surround and enable the human?

Perhaps this is another way of asking: at what point do the humanities find themselves inevitably connected to the natural sciences? And at what point is it that the sciences find that they need another framework or perspective from which to understand their various objects of investigation, not from outside, as they tend to do, but from within, as the humanities attempt? In other words, if man is understood, following Darwin, as one among many animals, not as a rational animal who has what other animals lack, but an animal who has perhaps in different degrees of development what may also be viewed in undeveloped form in other animals, degrees of tendency, then perhaps we may understand that the natural sciences, even as they may be augmented by the social sciences, nevertheless remain unable to grasp the *qualitative* nuances that only the humanities — each in their different ways — address. The humanities each address, without clear-cut borders, the human as a literary, linguistic, artistic, philosophical, historical, and culturally variable being. They remain irreplaceable to the extent that these questions have not been and perhaps cannot be addressed through other knowledges. However, they are not invariable, and each discipline is subjected to more or less frequent upheavals, transformations, and reassessments that are themselves historically and culturally regulated.

Darwin understood the extent to which man has ordered the natural world according to his own various interests: "If man had not been his own classifier, he would never have thought of founding a separate order for his own reception."[5] This seems remarkably close to Derrida's claim: "*Animal* is a word that men have given themselves the right to give. These humans are found giving it to themselves, this word, but as if they had received it as an inheritance."[6] The sciences as much as the humanities require other perspectives than those which have dictated what counts as human, what categories of human are classified as borderline, less than human, or already on the animal-side of the human.

This question of what constitutes the human is one of the most intense

and fraught questions of the modern era. It constitutes the center of feminist, antiracist, and class-based struggles. These struggles have been elaborated around precisely the question of who to include or exclude when characterizing the human. What Darwin's legacy may make explicit, in ways that his own, humanities-based writings attest, is that there cannot be scientific accounts of the world which are not also embedded in, surrounded by, and associatively connected with other kinds of ("humanist") knowledge, framing the world in terms of its lived possibilities, in terms of its possibilities of becoming-other, that the natural sciences alone cannot address. What Derrida makes clear is that this very act of naming "the animal" is already relegation of the animal to mute inarticulateness, the granting of the power of political and cultural representation, of representationality itself, to the human alone.[7] We need a humanities in which the human is no longer the norm, rule, or object, but instead life itself, in its open multiplicity, comes to provide the object of analysis and poses its questions about man's — and woman's — specificity as a species, as a social collective, as a political order or economic structure.

Darwin and the Distinctively Human

Darwin published *The Descent of Man* (1871) in part as an attempt to demonstrate that the principles he outlined for explaining the origin and evolution of species in *On the Origin of Species* (1859) were as relevant for an analysis of man, mankind in all its sexual and racial variations, as they are for the analysis of the descent of animal species from preexisting species. While he famously also delayed the publication of his book on man after the long-delayed publication of *On the Origin of Species*, fearing a wide-scale backlash, this was a book that he wisely understood was needed to address why in "man" there are two sexes, and why among all the forms of man, there are different races with different qualities even if there is no measure that could hierarchically order the races of man. He needed to show both that the principles broadly regulating the modification or genealogy of species applied also to man and that nevertheless these principles are able to address very wide variations in behavior and appearance that distinguish the different types of "man" from each other.

Darwin's argument, in brief, is that the differences between man and other animal species are differences of degree, not differences in kind, and that the differences between the races and cultures of mankind are likewise

differences of degree and not kind: "We must . . . admit that there is a much wider interval in mental power between one of the lowest fishes, as a lamprey or lancelet, and one of the higher apes, than between an ape and man; yet this immense interval is filled up by numberless gradations. . . . [Differences,] between the highest men of the highest races and the lowest savages, are connected by the finest gradations. Therefore it is possible that they might pass and develop into each other" (*The Descent of Man*, 1:35).

The idea of "numberless gradations," of the "finest gradations," of "no fundamental difference" (ibid.), anticipates one of the most profound and motivating of concepts in twentieth-century thought and beyond: the idea of difference, of differences without the central organizing principle of identity — not a difference between given things, a comparison, but a difference which differentiates itself without having clear-cut or separable terms. Darwin affirms that the differences between the lowliest fish and mankind is not a difference in kind but a difference of degree, a difference that can be obtained by insensible gradations, the slowest movements of transformation that link the existence of one species to the emergence of another. To affirm as he does that "there is no fundamental difference between man and the higher mammals in their mental faculties" (*The Descent of* Man, 1:35) is to affirm both that man and mammals, and mammals and all other living things, are linked through "numberless gradations." It also affirms that there may not be only two different kinds of knowledge about these two kinds of living beings (one human, the other animal) but also a new kind of hybrid knowledge, somewhere perhaps between the natural sciences (which encompasses man's knowledge of other animals and objects, man's knowledge from outside) and the humanities (which include man's knowledge of man and his various social institutions and products) that can more adequately address the implications of this fundamental continuity, indeed genealogy, between man and all other now or once living species, and indeed between man and the materiality of the nonliving universe.

This is indeed precisely the affront to the privilege of consciousness, language, and reason that Freud understood as one of science's insults to human narcissism: what we consider most special about our status as a species — that we speak, we reason and comprehend, we produce knowledges, we hide ourselves or cover our tracks, we know ourselves, we deceive — while uncontested by Darwin is not accorded any special privilege by him either. The conditions for the emergence of all these qualities, and every other distinctively human capacity are already there in animal existence. It is

Darwin who most adequately addresses Derrida's questioning of why we must assume that all language, all reason, all knowledge must accord with the model of its European history. Why is language conceived as a uniquely human attribute (along with the face, with shame, and the lie) when it must have come from somewhere, have elaborated itself in its prehistorical forms, connecting itself to some animal origin?[8] In Darwin's understanding, all the qualities that have been variously used to characterize man's specific uniqueness are already developed in some perhaps more elementary or less elaborated form in animal species.[9] This is his broad argument regarding not only reason, moral feelings, and even an aesthetic sense (this occupies chapter 2 of *The Descent of Man*), but perhaps most unusually, in the light of the structuralist and poststructural privileging of language, it is also his argument regarding language and instrumental thought.

Language, which for him functions primarily and in the first instance as a mode of sexual attraction or appeal, is that which man shares with many species, each of which may have the capacity to elaborate and develop simpler signs systems into languages, fully blown. In a most intriguing way, language finds its origins neither in communication nor in defense: its function is not to enhance natural selection, to provide techniques for survival. Rather, as I will elaborate in considerably more detail, it begins as a form of sexual allure, a mode of enhancement and intensification, as a musical form that only gradually develops itself into a language which in turn may help facilitate the qualities of reasoning, communication, and information transmission that enable the enhanced survival of social groups. While it may serve to secure higher rates of survival, Darwin insists on the primarily erotic and attractive nature of vocalization, its rhythmic and melodic force in explaining the origins of language. Languages, like species themselves, while they may not have a clear-cut or singular origin, nevertheless proliferate, compete with each other, and submit to the exigencies of their own forms of "natural selection" in the competition between individual words within a single language as well as between different languages and language speakers.[10] Once they exist — and their origin and existence is contingent upon their (random) erotic appeal — they are submitted to precisely the same criteria of natural and cultural (or artificial) selection that assess and evaluate all other biological and cultural forms.

This is the most provocative and unusual element in Darwin's understanding of language: that the supposedly most uniquely human characteristic, language, along with all of the arts and all moral and intellectual

accomplishments, is animal in its origins, sources, and forces to the extent that it resides within and operates according to the logic of sexual selection:

> With respect to the origin of articulate language . . . I cannot doubt that language owes its origin to the imitation and modification, aided by signs and gestures, of various natural sounds, the voices of other animals, and man's own instinctive cries. When we treat of sexual selection we shall see that primeval man, or rather some early progenitor of man, probably used his voice largely as does one of the gibbon-apes at the present day, in producing true musical cadences, that is in singing; we may conclude from a wide-spread analogy that this power would have been especially exerted during the courtship of the sexes, serving to express various emotions, as love, jealousy, triumph, and serving as a challenge to their rivals. The imitation by articulate sounds of musical cries might have given rise to words expressive of various complex emotions. (*The Descent of Man*, 1:56)

Language is not the uniquely human accomplishment that post-Enlightenment thought has assumed, but, for Darwin, is already a tendency, residing within the voice and in other organs capable of resonating sound, to articulate, to express, to vibrate, and thus in some way to affect bodies. Articulation, vocalization, and resonance are possibilities inherent in a wide variety of organs, ranging from body parts that have no specific connection to the creation of sound to organs specifically devoted to or capable of emitting sounds.[11] Language is not a unique and singular accomplishment, but, like Darwin's account of convergent development (such as the simultaneous elaboration of vision in various species that are not directly linked through descent), it relies on the notion that there are tendencies that many forms of life share, whether these tendencies are actualized or not. Such tendencies may be the heritable results of variations, random acquisitions. This notion of a tendency, an orientation to elaborate or exploit a particular natural resource (like light) signals to Henri Bergson, perhaps Darwin's first philosophical heir, an inner force that life shares with the forms of life that come before it, linking it to a vast chain of life that no living being, including man, may be conscious of, yet which produces life interconnected in its every detail to all other living forms.[12] Such tendencies regulate the evolutionary development of various organs, such as eyes, but also such complex behaviors as articulation and vocalization. Although Darwin does not say so, it is clear in the writings of Nietzsche and Bergson and, through

them, Deleuze, who elaborate a new kind of philosophy in his wake, that life must be understood as the ongoing tendency to actualize the virtual, to make tendencies and potentialities real, to explore organs and activities so as to facilitate and maximize the actions they make possible. The living body is itself the ongoing provocation for inventive practice, for inventing and elaborating widely varying practices, for using organs and activities in unexpected and potentially expansive ways, for making art out of the body's capacities and actions.[13]

If language begins as song, as cadence or musical resonance, a force which excites, intensifies, and marks both the bodies that emit song and those that hear it, then there are clearly strong affiliations between human language and the sometimes remarkably complex songs of birds (remarked on and fully elaborated musically in the work of Olivier Messiaen[14]), whales, dolphins, and other song-forming species. Human vocalization is, for Darwin, as for Bergson and Deleuze and the lineage of their works that this book addresses, only one form of articulation, one form of language-becoming, and by no means the only path to language. The human represents one branch of an anthropoid line of language, birds an altogether different line, and bees and other insects another line again. Each develops languages, communication systems, forms of articulated becoming, sign-systems, according to its own morphological capacities, its own sexual interests, and its own species-specific affects. Each "speaks" as it can, elaborating a line of movement that brings sound, movement, resonance into being, that composes songs, sound-lines, statements, expressions as complex and rich as each species can bear.

Are there not a hundred thousand potential languages, romantic themes, urges, impulses to be transmitted and acted on? Are not language and music, as Darwin suggests, connected to stirring, enhancing, and elaborating emotions, affections, passions? Is not the language of bees as open to elaboration, to musicality, to poetry, that is, to dissemination or the trace, as any human language? Karl von Frisch's observations of the remarkable dancing language of bees demonstrate so much more: they attest not just to the indexical or demonstrative nature of signs, but to the contaminating effects of musicality.[15] As Frisch describes it, bees do not transmit a message that precisely locates a source of food in the so-called round dance: they transmit something less specific but equally motivating. They impart information that there is nutrition, but not unambiguously, and not without the bees themselves fanning out and seeking food in a wide area without precise

information about its source. Above all, dancing bees generate a wave of excitement, a wave of activity to the bees in the vicinity of the dance. Other bees do not observe the round dance (or its companion in communication, the waggle dance), which is commonly performed in a darkened hive; they feel it, with their bodies, their antennae, in the contagious movements they themselves come to enact.[16] And if there are a hundred thousand potential languages, expressive impulses, and modes of bodily communication, from human language to the dancing of bees and the song performances of birds, to the chemical language of cells themselves within every living body, then new notions of collectivity, new notions of social production, new modes of linguistic analysis are waiting to be born, waiting to be commensurate with and adequate to the multiplicity of life-forms to which they apply. A new humanities becomes possible once the human is placed in its properly inhuman context. And a humanities that remains connected not only to the open varieties of human life (open in terms of gender, sex, class, race, ethnicity, nationality, religion, and so on) but also to the open varieties of life (its animal and plant forms) is needed, one that opens itself to ethologies and generates critical ecologies.

Animal Ethics, Aesthetics, and Rationality

Darwin has suggested in a most surprising and provocative fashion that if we place man in his rightful place as one among many animal species, it is no longer clear whether the qualities that man defines as uniquely his own — the forms of reason that enable abstraction, logic, arguments, deductions, inferences, and so on, or the forms of moral, religious, ethic, or aesthetic discernment and commitments and practices that others have specified as uniquely human — do in fact serve to distinguish man from other animals. If man is not the sole life-form that produces and judges reason, morality, art, or religion, this not only problematizes all of the humanities that have made the human the mark and measure of creativity, it also obscures the animal conditions for the emergence of so-called human qualities. It obscures the fundamental relativity of knowledges, aims, goals, and practices (a relativity not according to given values, but a perspectivalism that is always relative to the perceiving, moving, acting body and its particular morphology) and the ways in which each species, from the humblest to the most complex, orients its world according to its interests, capacities, knowledges, and uses.

Darwin makes it clear that he does not believe that it is possible to understand a single, (God-given) morality, reason, or logic as regulating all of life on earth. Rather, each species, each bodily form, orients the world, and its actions in it, according to its ability to maximize action in the world, the kinds of action that its particular evolved bodily form enables. Life must be understood as the ongoing exploration of and experimentation with the forms of bodily activity that living things are capable of undertaking. This is perhaps the only ethics internal to life itself: to maximize action, to enable the proliferation of actions, movements. He speculates that we cannot assume that the kinds of morality that we as humans find "natural" or conducive to our well-being (as widely conflicting as these are among different categories of the human) are of the same kind that would regulate other species. He argues that if other social animals — and he refers here primarily to bees, a favorite among philosophers, as we will see! — were rightfully attributed a sense of beauty, morality, or well-being, a very different type of ethics, aesthetics, and technics would come into existence, just as a language of a very different kind than the human's has now been elaborated as the masterful and complex language of bees:

> I do not wish to maintain that any strictly social animal, if its intellectual faculties were to become as active and as highly developed as in man, would acquire exactly the same moral sense as ours. In the same manner as various animals have some sense of beauty, though they admire widely different objects, so they might have a sense of right and wrong, though led by it to follow widely different lines of conduct. If, for instance, to take an extreme case, men were reared under precisely the conditions of hive-bees, there can hardly be a doubt that our unmarried females would, like the worker-bees, think it a sacred duty to kill their brothers, and mothers would strive to kill their fertile daughters; and no one would think of interfering. Nevertheless the bee, or any other social animal, would in supposed case gain, as it appears to me, some feeling of right and wrong, or a conscience. (*The Descent of Man*, 1:73)

We have here an insect ethics, a morality that accords with the morphologies and life-cycle of bees, in which the self-interest of various categories of bees drives what might be understood as a way of living, a mode of morality which maximizes what bees privilege. Were men to be brought up as bees, Darwin suggests, they too would elaborate a bee-morality. Our sense of right and wrong, of beauty and attractiveness, of fellow-feeling and

antagonism to enemies and outsiders, is not derived from a uniquely human sensibility or from a social organization that is purely man-made, for ethics, he suggests, is an effect of how we live and change. Thus it is as open to the forces of confrontation that constitute natural selection as every other evolving phenomenon. An insect ethics is as elaborate and developed as forms of insect taste and insect discernment; to accompany any insect ethics there is also an, or indeed many, insect aesthetics, as well as insect pleasures, insect desires, insect forms of life, and insect modes of intensification.

Darwin implies that the different morphological and social structures that regulate species life, that privilege certain organs and activities, suggest a certain kind of ethics, aesthetics, and technics, or at least the rudimentary materials for such forms of organization. The different needs and tastes of different species imply a wide variety of forms of intelligence, sociality, and creativity, which are themselves submitted to the forces of natural selection. These various forms of ethics, aesthetics, and technics are the primitive or elementary resources for group and individual survival. They are pragmatic resources in the struggle for existence that either provide advantages or disadvantages for their participants in so far as they aid or hinder life's elaborate explorations. In Darwin's own words:

> The difference in mind between man and the higher animals, great as it is, is certainly one of degree and not of kind. We have seen that the senses and intuitions, the various emotions and faculties such as love, memory, attention, curiousity, imitation, reason, etc., of which man boasts, may be found in an incipient, or even sometimes in a well-developed condition, in the lower animals. They are also capable of some inherited improvement, as we see in the domestic dog compared with the wolf or jackal. If it be maintained that certain powers, such as self-consciousness, abstraction etc, are peculiar to man, it may well be that these are the incidental results of other highly-advanced intellectual faculties; and these again are mainly the result of the continued use of a highly developed language. (*The Descent of Man*, 1:105)

There are, in short, a multiplicity of forms of reason, love, curiosity, conscience, tool-making, art-making, science, and invention if we focus not only on the vast range of human cultures but also at the open tendencies of various animal species, each on its own path of evolutionary elaboration. There are as many forms of beauty and attraction, and thus of artfulness, as there are forms of sexual appeal (as vast and unimaginable as these may be,

taking into account the incredible variation of sexual morphologies that characterize the animal world), and as many forms of sexual attraction as there are different body ideals and pleasing forms. There are as many forms of reason, and thus modes of knowing, and forms of scientific apprehension, as there are organs of perception and modes of efficient action. There are as many modes of ethics or morality as there are bonds that bind together individuals and groups through relations of affection, convenience, safety, or comfort and separate them from their enemies or competitors. There are as many forms of political and social organization as there are collections of large numbers, populations. If these inventions are forms of self-transformation and part of the evolutionary becoming in which all of life partakes (this is the object of analysis in the next chapter), then reason, language, culture, tools, and other distinctively human accomplishments must now take their place, not as the overcoming or surpassing of an animal ancestry but as its most recent elaboration, as one of the many possible lines of elaboration that life has enabled. The human, when situated as one among many, is no longer in the position of speaking for and authorizing the analysis of the animal as other, and no longer takes on the right to name, to categorize, the rest of the world but is now forced, or at least enticed, to listen, to respond, to observe, to become attuned to a nature it was always part of but had only aimed to master and control — not nature as a unified whole, but nature as ever-striving, as natural selection, as violence and conflict.

Darwin has effected a new kind of humanity, a new kind of "enlightenment," neither modeled on man's resemblance to the sovereignty of God nor on man's presumed right to the mastery of nature, but a fleeting humanity whose destiny is self-overcoming, a humanity that no longer knows or masters itself, a humanity doomed to undo itself, that does not regulate or order materiality but that becomes other in spite of itself, that returns to those animal forces that enables all of life to ceaselessly become.

Darwin has helped multiply, pluralize, proliferate all kinds of becomings, becomings in directions that cannot be known in advance, becomings which sweep up man in their forces along with all other living things. In the process, he has engendered a concept of man as a being as much at the mercy of the random forces of becoming and self-overcoming, of natural selection, as any other form of life. Man is not the center of animal life, just as the earth is not the center of the universe. The human is but a momentary blip in a history and cosmology that remains fundamentally indifferent to

this temporary eruption. What kind of new understanding of the humanities would it take to adequately map this decentering that places man back within the animal, within nature, and within a space and time that man does not regulate, understand, or control? What new kinds of science does this entail? And what new kinds of art?

TWO	Deleuze, Bergson, and the Concept of Life

Darwin helped associate the problem of difference with life, even though Darwin himself had a false conception of vital difference.
— GILLES DELEUZE, *Desert Islands and Other Texts, 1953–1974*

Darwin's decentering of man from his right to dominion over the world of nature elaborated a new genealogy of the human: the human is created, not in the image of God but from some unknown but lowly primordial creature. This fracturing of man's singular place in the order of being created a philosophical question that Bergson (along with a few others) explicitly elaborated. How to conceptualize life without privileging man as its pinnacle? How to understand evolutionary emergence as a relation between life and matter? If Bergson extracts a truly philosophical concept of life from the scientific endeavors of Darwin, then ultimately Deleuze draws his understanding of life from Bergson. There is an indirect filiation between Deleuze and Darwin, even if, for Deleuze, Darwin misunderstands vital difference. Nevertheless, Darwin elaborates a vital difference as the motor of all forms of life, what life shares in spite of its lines of divergence.

Alain Badiou is correct to insist that, of all the figures in the history of philosophy to which Deleuze loyally adhered, Bergson is Deleuze's "real master."[1] This may be because, like Darwin, Bergson makes difference the proliferative engine of life itself, but unlike Darwin — at least as far as Deleuze is concerned, as we see in the epigraph opening this chapter — Bergson

did *not* misunderstand this vital difference: vital difference is the machinery of the real, it is the heart of life, but also the very core of the material world. Vital difference, life, characterizes not only all that is alive, what life shares in common, what distinguishes life from the "merely" material, but also what life derives from nonlife, what life and nonlife participate in together. If Darwin demonstrates man's immersion in and emergence from animal (and ultimately plant) life (or even life before plants and animals separated), it is Bergson, and through him Deleuze, who demonstrates man's immersion in and emergence from the inhuman, the inorganic, or the nonliving.

Bergson develops a new concept of life that he has remade as his own. Bergson is the most Darwinian of the philosophers, as Deleuze himself is the most Bergsonian. (This is itself a fundamentally mutational, evolutionary relation, a relation of "descent with modification," or "descent through difference.") Which is to say that each reforms, transforms, and realigns the components that compose life as a concept. For Darwin life is the consequence of actions and passions, the actions of individual variation and sexual selection, and the passions, the passivity, of natural selection. These are the peristaltic forces of cohesion and disintegration, the forces that make a living being a cohesive whole and the forces outside the living being that test its capacity to survive and thrive. For Bergson, life is that which dynamizes, within and beyond itself, the forces of matter by suffusing the material present, the actual, with the virtuality of memory: it is the accumulation of the past simultaneous with the movement of the present that brings with it the necessity of invention, newness, a future not contained in the present. And for Deleuze, life is that which does not spread from the organic to the inorganic but runs between them, an impersonal force of contraction and dilation that characterizes events, even nonliving events, as much as it does life. Each distinguishes life as a kind of *contained dynamism*, a dynamism within a porous boundary, that feeds from and returns to the chaos which surrounds it something immanent within the chaotic whole: life as a complex fold of the chemical and the physical that reveals something not given within them, something new, an emergence, the ordered force of invention.

For Bergson life must be understood as that which both exceeds itself and also enables matter to unleash its endless virtualities. Life is a double orientation: *out* to matter, as that which responds to, resolves, or addresses the problems and provocations matter imposes through the evolutionary dispersion and proliferation of bodily forms, through morphology, specia-

tion, individual variation; and *in*, to its own past, through the cohesion and continuity of consciousness in its immersion in the richness of memory, virtuality, the past. This double direction — out, to space, the world of matter, objects, things, states, quantities, and in, to an immersion in consciousness, duration, quality, and continuity — marks the living in its debt both to the (relatively) inert materiality of the inorganic, which the living carries within the chemistry of every organ and process of its body, and to the creativity and inventiveness of consciousness that correlates quite precisely with the range of possible actions posed by a living body. Life, that excess within matter that seeks to extend matter beyond itself and its present forms, is not the "origin" of the virtual but rather one of its modes of actualization, the potentiality of matter itself, insofar as matter is the material of life as well as nonlife.

I propose here to explore Deleuze's rather scattered and enigmatic understanding of the concept of life by linking it to the thick strand of Bergsonism that runs through his writings. It is his Bergsonism, and Bergson's basic Darwinism, that opens Deleuze's writings up to the ethological and the geological, to the machinic phylum, and to the biosemiological; that is, to an understanding of individuality as a kind of dynamic integrative absorption of an outside that is always too much, too large, to be ordered and contained within life alone, but which extends life beyond itself into the very reaches of the inorganic.[2] In short, in Deleuze's writings it is his Bergsonism that holds together these otherwise disparate interests and orientations, which could perhaps be compressed together under the label of "inorganic life."

Matter

Deleuze concentrates his discussion of Bergson on a series of concepts — among them, duration, intuition, difference, multiplicity — that skirt around the notion of life without directly addressing it.[3] It is as if this notion has already been too overworked; it is either too mired in a biologism that reduces it to a unique type or organization, to organs and their cohesive functioning in organisms, or it is a concept that has been absorbed by phenomenology, which separates the human from the animal and from its given objects even as it tries to reconcile them within experience. Neither organicism nor phenomenology is adequate. Each assumes the functional or experiencing body as a given rather than as the effect of processes of

continual creation, movement, or individuation. Instead, through Bergson, Deleuze indirectly explores the concept of life, tracing its outer edges without plunging into its psychical or biological depths directly. He provides only a kind of darkened illumination of this concept that is so central, so haunting to his work yet so obscured and indirectly developed within it.

The central tenets of Bergson's philosophy have been well rehearsed elsewhere.[4] Here I want to focus only on the curious entwinement of matter and life that Bergson formulates in *Creative Evolution* and *The Creative Mind*. Bergson's primary question concerns what constitutes organic life. What is it that all forms of life share? What differentiates the living from the nonliving? What constitutes the *élan vital*? How can it be distinguished from the order that structures relations within material systems? In other words, how can life be differentiated from matter, opposed to matter, specified as different in kind from matter? What is the relation between life and matter, perhaps the central concern of contemporary philosophies of life? This is a Darwinian question, a question possible only after Darwin's revolution, which assumes the emergence of life from some kind of perhaps peculiar or perhaps common chemical and material arrangements.

Bergson elaborates some of the differences between life and matter: the inorganic world, *at first glance*, is fundamentally spatial, linked to the arrangements of objects, and in principle capable of mathematical calculation in terms of laws or universals. It remains intact whatever principles we apply to divide it, for it is infinitely divisible. In dividing it, we can constitute closed systems with rigorously controllable variables which enable us to both manipulate various material elements according to our interests and make the operations of such closed systems in principle predictable. Materiality, under these contained conditions, is primarily characterized by repetitions or near-repetitions, where separated elements are rendered capable of returning to previous states or directly anticipating states to come. These repetitions, past and future, are already contained within the present: observing their current configurations in enough detail provides us with the capacity to understand their future arrangements. These states or configurations are the very material rhythms and regularities that mark life and serve as the only measure of its duration.[5] The material world is that which is capable of unrolling or unfolding what has been already rolled or folded, that is, caused: it is the inevitable unwinding or unfurling, the relaxation, of what has been cocked and set, dilated, in a pregiven trajectory. The relatively orderly structure of the material world — for order is that which we

impose on the world more than what we find in it (which makes it amenable to scientific and mathematical calculation, but only to calculations that are potentially infinite in number and that may be incommensurable relative to each other) — is engendered by the tendency of its elements to repeat, to form orderly and predictable relations, to contain in the present all possible connections in the future. It is this relative stability and orderliness, predictability, that is the very foundation or condition for a life of invention and novelty, a life in which pure repetition is never possible. It is only because life perceives that which is regular and orderly in the material world that it has the resources necessary to innovate and invent.[6]

For Bergson, it is a misunderstanding to assume, as both our perception and its formalization as science tend to,[7] that matter is somehow to be located in a broad, neutral medium, a plane or receptacle that is spatial, though this is a ready, perhaps inevitable, assumption we make. Matter is not located in or on such a plane: rather, for Bergson, it is space that deposits itself within and through material objects, through the movement of matter.[8] Space is in itself an aggregate of the multiplicity of movements, a map not of locations, points, but of trajectories. To assume that matter is spatial is to reduce the material to the geometric, to the mechanical, one of the "natural" habits of perception and intelligence which most easily facilitate actions but which also merely schematize space and objects rather than understanding the dynamic connections of matter and movement. Our abstract conception of space is one reduced to being the bearer of the self-identity of objects, a transparent, invisible, forceless ethereal soup which merely maps the relations and relative locations of objects; it is the very model or ideal of stillness, immobility, and thus indeed the very model of a model! The relation between material objects, at least those to which intellect is most directed, involves juxtaposition, reciprocal exteriority, and extension. While the mutual outsideness of objects facilitates concerted action, it also involves a kind of abstract schematization that misses the most direct and intimate connections and relations of dependence within the material world as a whole, as well as between matter and life.

Organic Life

Life is, for Bergson, an extension and elaboration of matter through attenuating divergence or difference. Matter functions through the capacity of objects to be placed side by side, to be compared, contrasted, aligned,

and returned to their previous states. Relations between objects are external, a reflection of their relative positions in space. Following Darwin, Bergson understands that life emerges from matter through the creation of an ever-broader gulf or discontinuity between cause and effect or stimulus and response. In its emergence, life brings new conditions to the material world, unexpected forces, forms of actualization that matter in itself, without its living attenuations, may not be able to engender. But with the emergence of life and its ever-divergent forms of elaboration, life comes to possess a difference in kind from matter.

In life, Bergson suggests, states are never external to each other, readily separable through a kind of discontinuity or connected only by juxtaposition. They are never directly divisible or separable. They do not admit degrees of magnitude. They interpenetrate without clear distinction. Bergson suggests that within consciousness — to which all forms of life tend in varying degrees — there can be no prolongation of a state which is not at the same time a change in state.[9] No state is disconnected from the tenor of all the others, for they are inseparable, interleaved or mutually fringing, never ceasing, and always changing qualities, magnitudeless intensities.

Life is not some mysterious alternative force, an other to matter, but the elaboration and expansion of matter, the force of concentration, winding, or folding up that matter unwinds or unfolds. Organic life is different in kind from matter, but this difference utilizes the same resources, the same forces, the same mobilities characterizing the material order. Life is an elaboration out of matter, part of which remains fundamentally attuned to inert materiality and part of which resists all forms of stasis and fixity, to which our understanding of matter tends. Bergson does not believe matter itself is inert. Rather, his claim is that our mental and intellectual habits, particularly those regulating scientific intelligence, tend to the reduction of movement and change to identity and stasis. Our mental habits are unable to see in materiality the same potential for dynamism and unpredictability that they are likewise unable to discern in life! Life comes to elaborate a difference in kind from matter only through matter's ability to provoke and support life, to lean life in the direction of matter's laws and forces. Life is a divergence from matter that is itself material, that delays and discontinues various material effects through the deviations of life's forms of framing.

Life is temporal, durational, which means that within it, there can never be any real repetition but only continual invention insofar as the living carry the past along with the present. This situation implies that even a formally

identical state can be differentiated from its earlier instantiations because of the persistence of memory, the inherence and accumulation of "repetitions" in the present. I am not the same subject in each repetition, for I carry all earlier repetitions within me as memory. Memory is not so much added to each perception as each perception inheres in an order of the virtual that expands and elaborates it through its difference from, and thus in its addition to, each earlier repetition. If matter compresses and thus reduces the past to its present forms, to the actual contained in the present, the living are distinguished from the nonliving through the continuous growth and accumulation of the past, through their inherent immersion in virtuality.[10]

While matter presents itself as the other or opposite of duration for intelligence, for the principles that regulate the natural sciences, it also attempts to colonize and contain duration in its spatializing impulses, to make duration over into a form of spatialization; yet, in spite of its scientific reduction to closed systems operating according to predictable laws, matter also carries, as it were in secret, duration, flux, nonidentity, becoming. Bergson affirms that, as a whole, as undivided, as open, the material universe is also duration, although when divided and rendered analyzable, it presents itself as the other, the spatial counterpart, the opposite of duration. Mind and matter, rather than binary terms, are different degrees of duration, different tensions, modes of relaxation or contraction, neither opposed nor continuous, but different nuances, different actualizations of one and the same, ever-differing duration that equally touches and transforms the material and the living world.[11] Matter and life are thus not opposites, binary pairs (plus or minus vital force), as many of Bergson's readers have assumed in labeling him a dualist, but intimately implicated in each other, different degrees of one and the same force. Life is matter extended into the virtual; matter is life compressed into dormancy. Matter thus contains the dynamic forces that engender and enrich life in its various forms: life erupts from (and transforms) the material conditions that enable matter to "remember" (the simplest organic cell). In turn, if life is the evolutionary elaboration of these material forces now directed through the virtuality of memory, it still carries within itself, in all its forms, not only the entire evolutionary history that preceded and made it possible, but also the elements of the material whole from which it is cut. Life is always on the verge of returning to the inorganic from which its elements, its very body and energies, are drawn. Life and matter cannot, in this tradition, be understood as binary opposites; rather they are divergent tendencies, two different directions or trajectories

inherent in a single whole, matter as undivided, matter as it includes its "others" — life, ideality, connectivity, temporality.

The Unity of Life

If life can be understood as parasitic on matter, if it draws from matter the forces it requires to enable it to persist, to grow, and to make, it can also be understood as a fundamental unity. This unity of life is not a unity in the sense that all living beings are affiliated (genetically, morphologically, eco-systemically) but in the sense that all of life is equally pushed — in its originary emergence from the "prebiotic soup" of chemical elements through to the vastly variable forms of life that have existed and exist today — by a temporal, or evolutionary, impetus to vary itself, to capitalize on its material conditions, to differ. The unity of life is not an end, a final harmony or cohesion, but the beginning, the impetus all of life shares with the chemical order from which it differentiates itself, and which it carries within it as its inherited resource: "Something of the whole . . . must abide in the parts."[12]

Bergson is careful to distinguish his position from vitalism, the claim that there is a special substance, force, or form that distinguishes life from non-life, although his concept of the *élan vital* is commonly regarded as a form of vitalism. Vitalism itself, of course, takes many forms. But in his sense, in the sense of a special force distinguishable from other natural or material forces, Bergson cannot be regarded as a vitalist. He is interested in the vitality of life rather than in some supervening quality that all forms of life share. For Bergson, life is not unified because it has its own special impetus but because it cleaves to materiality, because all of life has a common interest both in mimicking and harnessing materiality, and in seeking those sites of material indetermination which it can exploit in order to "invent" new forms and new practices, to evolve and become other.[13] The common impetus life carries within it is that of *materiality itself*, the capacity to make materiality extend itself into the new and the unforeseeable. Bergson explicitly denies his position is vitalist to the extent that vitalism assumes a finished and distinct living individual whereas in his view life assumes a continuous, never ceasing relation of change. There can only be a vital force to the extent that there is a distinct principle of individuation.[14] But if the individual is never distinct from or stands over and above the ongoing processes of its development and aging, then any postulate of a vital force will extend well beyond the living, into the intimate connections the living have with the

nonliving and, paradoxically, into the very heart of materiality itself. In Bergson's own words, "The position of vitalism is rendered very difficult by the fact that, in nature, there is neither purely internal finality nor absolute distinct individuality. The organized elements composing the individual have themselves a certain individuality, and each will claim its vital principle if the individual pretends to have its own. But, on the other hand, the individual itself is not sufficiently independent, not sufficiently cut off from things, for us to allow it a 'vital principle' of its own."[15]

It is the configuration of nonliving forces that induces life in all its dynamic unpredictability. If there is a vital force in life, it is only life's capacity to harness the indeterminacy of matter for its own purposes. Life is not suffused of a special substance, soul, mind, or consciousness that separates it from materiality. It is the vital indeterminacy of the material world that enables life and that life exploits for its own self-elaboration. For Bergson, as for Stuart Kauffman and some contemporary evolutionary cosmologists, life is not at all improbable, a rare and unlikely occurrence, the miracle of a unique combination of matter.[16] Rather, wherever matter unwinds itself with the tiniest measure of indeterminacy, life has the chance to emerge, to undergo processes of self-organization, and, given a long enough period of time, to differentiate itself into innumerable living individuals and species.[17] All individuals and species are thus connected, not only through a common genealogy or filiation, but above all through a common struggle, a common power of the conversion of the smallest fragment of the indeterminacy of matter into the contingency, or freedom, of life: they are connected by the transformation of matter, through incorporation into the behavior, movement, or action of forms of life.

The *élan vital* is nothing other than the forces of self-organization functioning within those "systems" that carry along the traces of their past in their present; in other words, that have memory. All forms of life share this protraction of the past into present, and the retroaction of the present onto the past, through the capacity to reorient chemical and physical processes. Life inserts itself into materiality and follows its paths, its modes of canalization of energy, in order to reinsert into it that "explosive force" of action, of indetermination, of the future, that life returns to the material. Life "unfolds" that which is folded in matter; it runs in the inverse direction, dilation rather than contraction, unrolling rather than rolling, ascent rather than descent, creation rather than entropy: "In vital activity we see, then, that which subsists of the direct movement in the inverted movement, a

reality which is making itself in a reality which is unmaking itself.[18] Life re-makes, recoils, matter which is in the process of unmaking, uncoiling. Life is thus intimately bound up, but in a different direction, with the sinuosities of matter, for not only is it linked to and emergent from matter, bestriding it, but it also inverts, delays, and redirects its force.

Life brings the virtual, the past, memory (but also the future, the new, intentionality) to bear on the actual, the present, the material: it brings out the latencies already there but unactualized, providing new modes of actualization, indeed new actuals and new directions for actualization, while also generating ever-new virtuals. This means that life does not add a vital spark to the inertia of the inorganic; rather, it extracts that (dynamic, virtual) excess within the inorganic to extend itself. It is the tendency to extend, to prolong, to differ from itself that it both borrows from and returns to matter. Life is that tendency, *in matter itself*, to prolong, delay, detour, which means that matter, "an undivided flux," is as alive, as dynamic, as invested in becoming as life itself.[19]

Inorganic Life

Why is it that Deleuze obsessively returns, as if the idea can't let him go, to those concepts (consciousness, duration, quality, intensity) that constitute life and its intimate entwinement with matter (objects, space, quantity, extensity); that is, to Bergsonism and particularly to Bergson's reworking of Darwin's conceptions of life? Deleuze seems to be seeking a new understanding of life that does not tie it to recognizable forms and contours but to its own outside. He is concerned with the "life" of events, and the continuities and connections that run between what is conventionally divided into the living and the nonliving. He is less interested in life as lived, experienced, than he is in that part of life which cannot be lived by a subject — thus his abiding fascination with the life of animals and plants, the life of inhuman forces, the life of concepts, the life of sensations which impinge on and entwine, co-actualize, with human life.

Deleuze seeks to understand life without recourse to a self, subject, or personal identity, or in opposition to matter and objects. He seeks something impersonal, singular, that links a living being, internally, through differentiation or repetition, to elements and forces that are nonliving. This is what links the concept of life, for him, to becoming-animal, to the Body without Organs, and to immanence rather than to transcendence, the hu-

man, or the organism. He is interested in the nonliving tentacles that extend themselves into the living, the provisional linkages the nonliving and the living form to enable the living to draw out the virtualities of the nonliving; that is, to enable the nonliving to have a life of their own. If the material is the secret heart of the living which unifies and affiliates life in all its forms, then equally life is what returns to materiality a virtuality, a life of its own, nonorganic life.

At the very end of his life, Deleuze returns to this question regarding the concept of a life that evades or exceeds a particular life or identity, a life either at the moment of its earliest emergence[20] or at that point of its fading between life and death, a life lived in excess of a subject, beyond consciousness. He seeks a concept of life that elaborates a pure impersonality, a singularity without identity. This is the kind of singularity a life shares, not with the material world as a whole, but with nonliving *events*, self-actualized and unpredictable emergences, which are also absolutely singular without individuality, without identity or given form. This is the life the living share with the weather, the ocean, gravitational forces, even the chemical transformations out of which they are formed and to which they return; and it is this shared life, aligning life with nonliving forces, that provides the condition under which life creates, makes, invents, that is, adds to the nonliving a new force of virtuality, new singularities.

It is his Bergsonism that directs Deleuze to a concept of inorganic life, and to the very elaborations and emergences Gilbert Simondon charts in his understanding of a pre-individual individuation. Simondon elaborates this process of emergence that precedes and prepares for the possibility of an individual. It requires that there is something in pre-living material forces, some tensions, some forces, that enable living individuals, distinct objects, collectives, and technical objects. Coming between Bergson's understanding of the cleavage of life to materiality and Deleuze's elaboration of a life beyond living beings, Simondon provides a series of models and processes by which to understand how the material, or at least materiality before it has been separated from ideality, gives rise to and enables the existence of living forms which transform and reorient these material forces. Preindividual processes include what Bergson understands as materiality, the chaotic cohesion of the material universe, as well as the individuals, alive or not, produced through the relative isolation and cohesion of elements or systems, components, of the material, which form entities — organisms, states,

and objects—that Bergson understands as fundamentally extricated. For Simondon, individuation is a concept of being in which becoming is the most fundamental force. If Bergson's work is the elaboration of an ontology of Darwinism, then Simondon's work on individuation extends this Bergsonian ontology of life back into nonliving inhuman forces that life continues and transforms. Simondon writes, "The opposition holding between the being and its becoming can only be valid when it is seen in the context of a certain doctrine according to which substance is the very model of being; but it is equally possible to maintain that becoming exists as one of the dimensions of the being, that it corresponds to a capacity beings possess of falling out of step with themselves, of resolving themselves by the very act of falling out of step. *The preindividual being is the being in which there are no steps* [phases]."21

Individuation is that movement preceding, including, and post-dating the genesis and elaboration of any individual, whether material or organic. The individual is only one stage, a provisional product, within a larger movement of elaboration which gathers forces of disparate and incompatible, sometimes incommensurable, dimensions that can only be resolved, if at all, in the creation of an individual which narrows down and provisionally harmonizes these disparities through a kind of unification, a "metastable equilibrium," a systematization or cohesion of some of these forces. The individual is a solution or response to the problem posed by intense yet incompatible forces struggling with each other. Preindividual forces, larger, less organized, and more chaotic than the individuals that form through them, constitute a multiplicity of blocks of becoming, which are the resources and potentials the individual requires to come into existence as such.

For Simondon, life is distinguished from the merely physical, not through a difference in kind, a different kind of organization, a different type of energy, but through a difference of degree: the living never attain the cohesion and unity of the material individual that "crystallizes" all that it needs of its preindividual forces at once. There is no moment of attaining an individual, self-identical, or stable status which dramatically transforms preindividual forces—the disparities in potential energy between incommensurable and noncommunicating forces—into fixed individuals, as occurs chemically in quantum-type leaps of molecular reorganization. In life, the processes of individuation never cease, instead they coexist with the duration of the living organism itself. The organism never fully coincides

with itself, or attains an identity in which it is what it is. The living organism is more a singularity than an individual; and ironically, it is material individuals which attain the self-identity for which we assume a subject strives.

For Simondon, life is differentiated from the nonliving by three primary differences: first, the living being's individuality is coextensive with a permanent process of individuation, whereas in the case of a physical object, individuation may be effected through a single encounter, and through the reiteration of an initial singularity. Second, the living being produces individuations from an internal resonance, and not simply through the disparity between internal and external forces, a disparity between its internal qualities and its external milieu. It thus grows not only at its extremities, the points of surface contact with its outside, but from within, through an internal organization. And third, the living individual engenders continuous individuations from within itself. It directs itself to problems, provocations, not only through adaptation but through the potential to reconsider its own internal organization, through its own individuating interiority.[22]

Life becomes self-organizing through the prolongation and resonance of an internal disparity, an out-of-phase-ness with itself that it shares with matter. Life remains indebted to the preindividual to the extent that the resources for all its becomings, all its future individuations and self-actualizations, must be drawn from these singularities which it must incorporate. Life elaborates an interior, one that is never finalized or secure but which must itself develop metastable forms capable of further elaboration. It is this process of elaboration that differentiates a cell from a chemical, or the simplest form of life from a stone. The living produce a barrier, a cell, an outline, a minimal space or interval that divides it from its world, at least provisionally, but through which it nevertheless accesses those parts of the preindividual, the real, or matter that it requires to continue and develop itself.

Deleuze is interested in this moment of impersonal consciousness, when the subject diverts momentarily into singularity, when the personal gives way to the impersonal and the living connects with and is driven by events beyond it. This is not when a lucid consciousness knows its objects, but that moment when a consciousness follows and joins matter, when matter and life align to form art. Deleuze refers to this as "a life" rather than his or my life; a life no longer personal but always absolutely singular, a life that is individuated but no longer individual.

Life brings art to matter and art brings matter to life. Art here is not to be

understood as fabrication or *techné*, the subordination of matter to conscious purpose or taste, but as intensification. Life magnifies and extends matter and matter in turn intensifies and transforms life. Art is engendered through the excess of matter that life utilizes for its own sake, and through that excess of life that directs it beyond itself and into the elaboration of materiality. This art cannot be identified with the creation of artworks, but rather it is a temporary, unstable, perhaps unsustainable union of the living and the nonliving, a co-becoming, like wave-surfing or gymnastics, in which unliving forces (an event) and living forces coalesce, impart to each other their impacts and resources, and create for a moment a hybrid, something nonliving which nonetheless lives a life of its own. It is this union that Deleuze understands as becoming-other. In the moment at which the surfer joins the wave, the wave and the board produce something new: a movement, a force, larger than a living being and no longer able to be controlled by an agent. The living being becomes a force in a nonhuman becoming, along with gravitational forces and fluid mechanics. Nonorganic life contains a double virtuality — a virtuality, excess, or indetermination that matter contains within itself as its potential to be more and other; and a virtuality, potential, or becoming in which life becomes impersonal and asubjective the closer it approaches and co-mingles with matter. Life can be understood as the becoming-artistic of the material world, and art can be understood as the mode of making matter live through rolling or winding-up that coincides and crosses with unrolling or unwinding. This intense moment of becoming-artistic, this moment that cannot be sustained indefinitely in a living being alone, can only be generated, prolonged, made to live through the nonorganic life of matter. It is this concept of life that Deleuze himself invents, but invents only through the lineage of intellectual becomings that made his writings possible, even if unexpected — only through the lineage that has wrested life from the privilege of the human and placed it in the living and nonliving world.

Bergson, Deleuze, and Difference

Intuition is the joy of difference.
— GILLES DELEUZE, *Desert Islands and Other Texts, 1953–1974*

I have placed Darwin, Bergson, and Deleuze in a context where each is seen as the interlocutor of the theorist that preceded him, and where each develops in a direction that is pointed to by the preceding theorist but which remains largely unelaborated in that earlier work. Bergson develops Darwin's idea that species are separated by degrees of difference; they are forms of variation that contain a common beginning and a common elaborative force but that diverge, fan out, and differ from each other more and more as time passes. Deleuze develops from Bergson the idea that these differences, differences of degree that enable species to differ from each other and differences in kind that create lines of cleavage between the material and the living, are constitutive differences — not differences between already existing entities, but those differential forces that internally differentiate things, including living beings.[1] The concept of difference, difference as force, is elaborated and developed within this intellectual genealogy that runs alongside of, and at times undermines, the emphasis on identity that also emerged in the nineteenth century. It is Bergson's and Deleuze's understanding of this concept that I address here.

Deleuze and Difference

Unlike many of his contemporaries, for whom ethical and political questions govern epistemology and ontology (for example, Emmanuel Levinas, Jacques Derrida, and Jean-François Lyotard), Deleuze is concerned primarily, though not solely, with the creation of a concept of being, the real, or ontology that serves as a ground for reconceiving ethics and politics, and for generating new kinds of knowledges and new forms of epistemology. This real is no longer defined, as it was for Plato, by an unchanging essence, nor as it was for G. W. F. Hegel, through its negation of all that it is not. Instead, it is understood as dynamic, forceful, excessive. Deleuze seeks to construct a philosophy adequate to the complexity, positivity, and force of the real. He seeks the outlines, contours, and methods of a new way of conceiving ontology, new ways of thinking and conceptualizing the real as dynamic, temporally sensitive forms of becoming.

It was this fascination with the ontological that directed Deleuze, particularly in his earlier writings, to Baruch Spinoza, Friedrich Nietzsche, and Bergson (among others), who form, through an uneasy amalgam, the three loci by which he structures this plane of consistency from his earliest to his final texts. While there have already been a number of studies on his relations to these key philosophical figures,[2] my goal in this chapter is to focus on his reading of Bergson's texts, to explore his Bergsonism, to see what role it plays in his understanding of ontology. Deleuze is perhaps the most ontological of thinkers, the one whose writings are all directed to how to understand the unity of being even while affirming its fundamentally differentiating forces.

There are only a few texts Deleuze authored or co-authored that do *not* contain at least one reference to Bergson and in some way testify to his continuing fascination with Bergsonian concepts, and most particularly, with the concept of concepts, the concept that makes clear the conceptual slipperiness of all concepts, duration. Deleuze never leaves Bergson: from his earliest writings to his last works, from his reflections on the nature of philosophy itself to his understanding of cinema and the arts and his conception of science, there remains an unfailing pleasure in and commitment to Bergson's conversion of the stasis of being into the becoming of difference.[3] Bergson's work functions as a haunting melody of life's entwinement with matter, which underlies Deleuze's search for a new ontology, a new way to understand the real as dynamical open-endedness.

Deleuze understands Bergson as perhaps the greatest theorist of difference, the theorist whose insistence brought difference into philosophy and showed that philosophy was irresistibly drawn, insofar as it is directed by real questions and problems, those that impinge on us without relief, to its central concern: that which differs from itself, that which exists only as becoming.[4] The function of philosophy, in Bergson's understanding, is to bring to knowledge that which the sciences must necessarily leave out, the continuities and connections that the sciences cannot see in their focus on closed systems and definable and isolatable terms.[5] He seeks to articulate in systematic terms that which the arts express more directly than the sciences but can articulate only through an absolute and ungeneralizable singularity: the continuity of the real, the immersion of life and matter in the real, the real function and effect of duration. Neither science nor art can grasp simultaneously both the relentless universal force of difference, and its absolute specificity. As each touches on one, it elides the other. Philosophy, as ontology, as metaphysics, functions somewhere between these approaches, seeking the two-faced movement of universalization and particularity through that which unites them: the force of duration, which is also the movement of difference.

Deleuze affirms from the beginning to the end of his writings the open-ended parallelism between the living being, itself an open-ended series of integrated becomings and unbecomings, forms of doing and undoing, and the material universe as a whole, an open-ended cohesion of integrated natural forces, objects, and relations.[6] The tension between the open-endedness of living systems, and of the material universe as a whole, and their integration as living wholes or totalities, as cohesive qualitative syntheses — a tension that science attempts to resolve through causal linkages that at best explain only actual relations rather than relations of emergence or eruption — can only be explained through recourse to the reality of duration and its forces of (self-)differentiation.

Deleuze found in Bergson the most direct articulation of the force of difference, as he found in Spinoza the most inventive and affirmative concept of nature, and in Nietzsche the most provocative and profound concept of power or force. Each contributes irreducibly to Deleuzianism; they are the rafts on which Deleuze's own asystematic system floats. Bergson, though, is the one who provides a nonreductive means of linking the sciences and the arts to philosophy, and his work functions as the conduit

between Spinozan proliferation and Nietzschean repetition. Arguably the least well known in the present of the major figures Deleuze draws on from the history of Western philosophy, Bergson functions as a kind of glue or adhesive, enabling the mosaic of concepts he brings together to spring to life, to (provisionally) form a plane.

There are four key and closely interrelated concepts in Bergson's writings — difference, duration, intuition, and becoming — that are particularly powerful in orienting Deleuze's understanding of the relations between life and matter. These concepts are crucial in Deleuze's understanding of the real. They enable Deleuze to produce a philosophy of the real, not a materialism, but a theory that addresses the real without distinguishing its material from its ideal components, a kind of supersaturated materialism, a materialism that incorporates that which is commonly opposed to it — the ideal, the conceptual, the mind, or consciousness. This theory implies a new kind of philosophy, a new kind of understanding of the real that avoids both an empiricist reduction of the real to what is observable and the idealist understanding of the real as that which coincides with our representations of it. Darwin, Bergson, and Deleuze between them produce an account of the real as impinging force, the real as difference in itself. Duration is difference, the inevitable force of differentiation and elaboration, which is also another name for becoming. Becoming is the operation of self-differentiation, the elaboration of a difference within a thing, a quality, or a system that emerges or actualizes only in duration. Duration is the "field" in which difference lives and plays itself out, the "domain" of becoming; duration is that which undoes as well as makes. To the extent that duration entails an open future, it involves the fracturing and opening up of the past and the present to what is virtual in them, to what in them differs from the actual, to what in them can bring forth the new. This unbecoming is the very motor of becoming, thus making the past and present not given but fundamentally ever-altering.[7]

Bergsonian Difference

Deleuze has three texts specifically devoted to Bergson's philosophy.[8] While difference is the concept that seems to preoccupy many of his writings, it is the specific focus of these three texts. Deleuzian difference *is* Bergsonian. Although his position has been commonly confused with Derrida's and

Lyotard's, there are a number of crucial differences between Deleuze's understanding and that of his contemporaries, the so-called "philosophers of difference" of the late twentieth century.[9]

Difference has tended to be conceived of in one of two ways over the last century or so. Either it has been construed as comparative, an external difference between complete entities or things, which can be measured or represented according to a third or extrinsic term, a metric which determines relations of more or less. Or it has been understood as constitutive, an internal relation to terms or entities which structures them according to their negative relations to other entities. For example, within feminist theory, egalitarian feminism, which seeks to provide women with positions equal to and directly comparable with those of men, represents women in terms of their sameness or equivalence to men. There are two given entities —men and women—which can be compared and evaluated in terms of some ideal of the human, and the project for equalization of rights and responsibilities between the two sexes requires and calls on a third term, some conception of "human dignity," "human rights," by which equality can be measured or charted.

Positions now described in terms of a "feminism of difference," usually associated with the writings of French feminists, can serve as examples of the second understanding of difference, in which men and women are no longer understood as given, separate entities but as terms which require each other, terms which function diacritically. Woman is not-man, and lacks the characteristics that define or signify man. For feminists of difference, though, the political problem with such an understanding of difference is that the terms are not reversible and their relation is not reciprocal. Man is *not* the negation of woman; for only woman is defined negatively in patriarchal cultures. Difference, the potential for a reciprocal and mutually defining relation between terms, is reduced to opposition; though it remains virtual, it retains a potential existence.

What both conceptions of difference share is an understanding of difference as a relation of *two terms* — whether construed as external to each other or as a relation of terms internal to an entity — which entail an implicit *third* term. In the case of external difference, the third term functions as the measure, the metric, the universal form of the two terms being compared; in the case of internal difference, the third term is the specific, non-universalizable entity within which internal difference, the two contrasting terms, is lodged. In other words, the debate on the status and nature of difference

has tended to see it as a struggle of two entities, two terms, a pair; a struggle to equalize two terms in the one case, and a struggle to render the two terms reciprocal in the second.

Deleuze's project is different. For him, difference is not a concept bound up with units, entities, or terms but is that which characterizes *fields*, and indeed reality itself. Difference is an ontological rather than a logical, semiological, political, sociological, or historical category. It is a relation between fields, strata, and chaos. It is a movement beyond dualism, beyond pairs, entities, or terms at all.[10] Difference is the methodology of life and, indeed, of the universe itself. Entities, all entities, *things* in their specificity and generality, and not just *terms*, are the effects of difference, though difference is not reducible to things insofar as it is the process that produces things and the reservoir from which they are produced.[11] If Derrida takes Saussurian "pure difference" as far as it will go, and Irigaray takes (psychoanalytically conceived) sexual difference as far as it will go, each directed to that which, in semiology and in psychoanalysis, lies outside semiology and psychoanalysis, to a movement of formation that makes these disciplines possible, Deleuze moves in a different direction, away from signification and subjectification toward ontology, taking Bergsonian difference to its absolute limit.

Bergson provides the possibility of somehow resolving these two conceptions of difference by developing a model that includes them both while filling in their intermediary or transitional links. He is concerned both with that external difference that constitutes different things and renders them amenable to comparison, which he construes as differences of nature, and also with constitutive or internal differences that explain and produce these differences of nature without themselves having a nature other than their own differing. We find differences of nature in the world, through empirical investigation, but we find internal differences directly only within ourselves and our immersion in duration.[12] However, these differences, the differences between external and internal difference, between differences in kind and differences of degree, cannot be understood as differences in nature, as external to each other, for, as Bergson makes clear, different things, differences in nature, turn out in the end to be merely the modes of expansion or actualization of internal difference: they turn out to be the lowest degree, the slowing down, of differences of degree. And in turn, differences of degree can be seen as the acceleration and expansion of differences in nature or kind. Each becomes the slower or faster, the compression or dilation, of

one and the same pulsating unbecoming. It is this understanding of a compressible, dilatable difference that saves Bergson from oppositional or dualist thinking. The differences between differences in kind and differences of degree themselves constitute a difference of degree!

It is thus no longer a question of "undoing" binary terms, of freeing up the subordinated term in an oppositional or dualistic structure (this has been, for many, the intellectual task of feminism itself, the undoing of the binary opposition between masculine and feminine). Dualisms cannot be resolved either through monism, which involves the reduction of the two terms to one, or through the addition of extra terms—as if three or four terms would somehow overcome the constraint of the two (or the one, for the two binary terms are translatable into a single term and its negation). It is only the proliferation of dualisms, as well as their capacity for infinite reversal that reveals the stratum, the field, on which they are grounded, which is the real object of both Deleuze's and Bergson's explorations. Underlying the dualistic structure by which difference has come to be represented is a fundamental continuum, a movement of degrees, a movement of differentiation that elaborates a multiplicity of things according to a unity of impulse or force.

What Deleuze understands through Bergson's conception of difference is that dualisms, relations of binary opposition, do not involve two terms at all but two *tendencies* or *impulses*, only one of which is the ground, the very form, of the other. One of the terms is the ground of the other, the force which, in differentiating itself, generates a term (or many) that maps, solidifies, and orders this ground. In Bergson, the ground, duration, thus generates those impulses that reveal themselves as things, objects, matter, that which is opposed to duration or functions as its other. While matter presents itself as the other or opposite of duration, it also attempts to colonize and contain duration in its spatializing impulses, to make duration over into a form of spatialization, which is to say, stabilization. Yet matter, in spite of its scientific reduction to closed systems operating according to predictable laws, also carries, as it were in secret, duration, flux, becoming, at its very core. As a whole, as undivided, as open, the material universe is also duration, although when divided and rendered analyzable, it presents itself as the other, the opposite, of duration.[13] Matter is duration at its most dilated, as life, to which matter is commonly opposed; it is duration as it is experienced, in its varying degrees or qualities of expansion or contraction. Mind and matter, life and matter, rather than binary terms, are different

degrees of duration, different *tensions*, modes of relaxation, or contraction, neither opposed nor continuous, but different nuances, different actualizations of one and the same thing that is ever differing duration.[14]

In Bergson, difference has four facets which other more semiological and deconstructively oriented conceptions of difference do not address. In one facet, difference presents itself as differences of nature. As such it is the object of empirical intuition, the investigation of specific and irreducible differences, natural articulations of the real, the ways in which the real divides itself in its elaboration. Second, difference functions through a force of internal difference. As such it is the internal dynamic of open-endedness, ensuring that not only does it differ from itself, or become, it also differs from everything "like" it, everything with which it shares a species or category, a resemblance. Thus species, or categories, modes of resemblance, have their own inner dynamic, or "tendency," a difference in nature.[15] Third, difference operates or acts through degrees, which entails that not only are terms differentiated, but they are also linked through their different degrees of actualization of tendencies and processes that are present everywhere but expressed or actualized only in particular degrees (of contraction or dilation). And finally, the fourth facet of difference is that its movement must always be understood as a process of differentiation, division, or bifurcation.[16]

Difference is not the union of the two sexes, the overcoming of race and other differences through the creation or production of a universal term by which they can be equalized or neutralized, but the generation of ever-more variation, differentiation, and difference. Difference generates further difference because difference makes inherent the force of duration (becoming and unbecoming) in all things, in all acts of differentiation, and in all things thus differentiated.

Intuition

Bergson's philosophical method, which he calls "intuition," has very little in common with the generally understood meaning of this term: a vague empathy or feeling. There is nothing impulsive, emotive, or vague about Bergson's intuition, which is a rigorous philosophical method for an attunement with the concrete specificities of the real. Intuition is the method by which unique and original concepts are created and developed for objects, qualities, and durations that are themselves unique and specific. Intuition is, for Bergson, a relatively rare but ever-productive force in the his-

tory of philosophy. It occurs only when old and familiar methods by which intelligence seeks to address the present and the new exhaust themselves and provide only generalizations rather than a concept uniquely suited to their object. An intuition is a remarkably simple concept whose economy and unity is belied by the (philosophical) language which expresses it. It is a "shadow," a "swirling of dust,"[17] more than a concrete and well-formed concept. It is an emergent and imprecise movement of simplicity that erupts by negating the old, resisting the temptations of intellect to understand the new in terms of the language and concepts of the old (and the durational in terms of the spatial), rejecting old systems and methods in order to bring about a new thought, a new way of seeing, a new possibility for understanding the real differently. It is this eruption of intuition, as rare as it is, that marks the history of philosophy, much as, according to Thomas Kuhn, the paradigm shift continually marks and remakes the history of science.[18] Bergson understands analysis, that which science most commonly utilizes as its method, as that which decomposes an object into what is already known, that which an object shares with others, a categorical rather than an individuating mode of knowledge. Intuition, by contrast, is that mode of (internal) transport into the heart of a thing such that it suits that thing alone, its particularity in all its details. Intuition is a mode of "sympathy" by which every characteristic of an object (process, quality, etc.) is brought together, none is left out, in a simple and immediate resonance of life's inner duration and the absolute specificity of its objects. It is an attuned, noncategorical empiricism, an empiricism that does not reduce its components and parts but expands them to connect this object to the very universe itself.[19]

Intuition has a double aspect, or rather, is composed of two tendencies which blur into each other, which exhibit the same fusional continuum that marks differences in kind or in nature and differences of degree. The first is a tendency downward, inside, into a depth beyond practical utility, available to us at those moments of reflection when we can perceive our own inner continuity above and beyond action and definable results. The second is a reverse movement, in which this downward tendency sees in itself, in the depth of its own self-immersion, the durational flow that also characterizes the very surface of objects in their real relations with each other. Bergson claims that if one reaches deep enough, one finds a continuity with the surface, one rebounds directly to things in their immediacy: "Let us then go down into our own inner selves: the deeper the point we touch, the stronger

will be the thrust which sends us back to the surface. Philosophical intuition is this contact, philosophy this impetus. Brought back to the surface by an impulsion from the depth, we shall regain contact with science as our thought opens out and disperses."[20]

This return movement is the direct contact of the living with the material, of duration with space, the movement whereby the one compresses itself as the other. The object touches the subject, the mind partakes of and as matter, and matter is made conceptual, rendered virtual, but only at those moments when intuition, as difficult as it is to muster, erupts.[21] It can only occur, Bergson suggests, because our own inner life, the continuity of consciousness, reveals to us varieties of quality (that is, qualitative differences), a continuous forward movement and a unity and simplicity of direction, which can only be discerned retrospectively. This inner continuity, to which all living beings have direct access in varying degrees, is that through which they can access the continuity with matter and the world of objects, through which a different kind of knowledge is possible.

Bergson is the first to admit, along with Deleuze, that philosophers are not the only "professionals" of intuition: this quality philosophy shares with those moments of rupture and emergence that also characterize the sciences and the arts. Yet scientists, with some exceptions,[22] are loathe to admit an extra-rational sympathetic intuition guiding their methodologies. And so Bergson commonly refers to art, and to the activities of artists as giving a clearer expression to this intuitive impulse:

> Suppose that instead of trying to rise above our perception of things we were to plunge into it for the purpose of deepening and widening it. Suppose that we were to insert our will into it, and that this will, expanding, were to expand our vision of things. We should obtain . . . a philosophy where nothing in the data of the senses of the consciousness would be sacrificed: no quality, no aspect of the real would be substituted for the real ostensibly to explain it. . . . It would have taken every thing that is given, and even more, for the senses and consciousness, urged on by this philosophy to an exceptional effort, would have given it more than they furnish it naturally. . . . For hundreds of years, in fact, there have been men whose function has been precisely to see and to make us see what we do not naturally perceive. They are the artists.[23]

Adding to science and its intuitive intimations, philosophy provides the continuities and connections between things and systems that science must

ignore in order to focus on measurable and utilizable data. Philosophy also adds to the nonfunctional perceptual immersion in things and qualities that art generates, a language, a set of concepts that makes art communicable and able to link with and augment the ultimately pragmatic focus of the sciences. While lying in some senses "between" art and science, philosophical intuition is nevertheless its own unique discipline, the activity or tendency directed to the discernment of duration and its movements of continuity and discontinuity, becoming and unbecoming. Intuition is the method for the discernment of differences. It is difference's most attuned and direct expression.

Intuition is not simply the discernment of natural differences, qualitative differences, or differences in kind. It is the inner orientation to tendency, to the differences between tendencies. It is the capacity to understand natural differences beyond a monistic or dualistic model, not as a relation of two terms, but as the convergence of two or more tendencies or dispositions, not connected through Hegelian negation but brought together through contraction and dilation.[24] Intuition is not the division of terms, or even the differences between terms, but the discernment of the (differing) tendencies that compose terms in their specificity, not through opposition or dialectical sublation but through contraction and dilation. The either-or is transformed into the both-and.[25]

Following Bergson, Deleuze proliferates dualisms, not because the world or the real is readily divisible into binary pairs but because each of these pairs — mind and matter, space and duration, differences in nature and differences of degree, intelligence and intuition, territorialization and deterritorialization, and so on — is the expression of a single force (not, as Alain Badiou suggests in *Deleuze: The Clamour of Being*, the univocity of being, but its diversity and plurality as becoming) that is best expressed by one of these terms, the one most commonly suppressed by rational thought, the one that nevertheless conceptually underpins the other. The proliferation of dualisms enables us to see that one term — mind (or memory), duration, differences of degree, deterritorialization — is not that to which the other is reducible, but the underlying principle of the other, its secret depth or complication. It is that which rationality or consciousness has abandoned only to the extent that the rational and the conscious are linked, not to the abstract but to the pragmatic, the perceptual, to a mastery of the material world, which can be understood only by being simplified, reduced, divided.

Intuition is an attempt within philosophy to restore to philosophy those

manifold links and connections that this simplification brings to its understanding of the real, to restore the complexity of undecidability to the real. It is the attempt to make explicit the fine threads within and between objects (including living beings) that always make them more than themselves, always propel them in a mode of becoming. What intuition gives back to the real is precisely that virtuality which complicates the actual. What it acknowledges is the real's capacity to be otherwise, its ability to become more and other.[26]

Becoming/Unbecoming

In a certain sense, Bergson's project can be understood as the transformation of the concept of being through the generation of an ontology of becoming, the transformation of the actual in terms of the elaboration of the virtual, and the transformation of intelligence through the intervention of intuition. These are three expressions of one and the same program — the replacement of static conceptions of things through the creation of dynamic conceptions of relations. Deleuze's attraction to Bergsonism lies in precisely his undermining of the stability of fixed objects and states and his affirmation of the vibratory continuity of the material universe as a whole; that is, in his developing a philosophy of movement and change rather than one seeking things and their states.

Becomings are the open-ended elaboration of tendencies, virtualities, that are not fully or equally actualized, and the movement of these tendencies in directions that are to some extent delimited but are fundamentally unpredictable. It is not things, either subjects or objects, which become, but rather the virtualities latent in them, whose (future) actualizations cannot be contained in the present. Thus it is not an object or subject that becomes — indeed there is no subject of becoming or a thing that is the result of becoming — but only something in objects and subjects that transforms them and makes them other than what they used to be.

Becoming is a (perpetual) change in substance, but it cannot be identified with a substance — or subject — that changes. Change does not need an underlying static object, a vehicle somehow carrying change along with it. Change preexists objects and is their condition of possibility. Which is to say that becoming, changing, is the force that duration, the inherence of the past in the present, brings to matter, to objects. Becoming is not the playing out of an already established path of development, like the dialectical un-

folding of what is already given if unelaborated. The later "stages" or movements of becoming are not already contained in its earlier "stages," for surprise and the unexpected always mark this movement: "There are changes, but there are underneath the change no things which change: change has no need of a support. There are movements, but there is no inert or invariable object which moves: movement does not imply a mobile."[27]

It is this sense of durational force, the force of temporality as complication, dispersion, or difference that makes any becoming possible and the world a site of endless becomings: "This indivisible continuity of change is precisely what constitutes true duration."[28] Life expresses becoming through the dual processes of species evolution (at the level of the group or category) and aging (at the level of the individual) at the most simple level; but equally matter itself, the world of objects, must become other than itself in order for it to be capable of engendering and sustaining life. Life (mind, memory, consciousness in varying degrees) is inserted into the world of material objects only to the extent that it partakes of them and can utilize them for its own purposes. Both at its surface, through perception, and in its depth, through intuition, life brushes up against matter as its inner core. But matter must also be capable of housing the aspirations that life imposes on it. It must be capable of becoming more and other than what it is (at any one time) in order for life to emerge or evolve in the first place, and for life to be able to induce the expression of matter's virtuality, which is to say, its capacity for being otherwise, its capacity or potential for becoming. If the tendency of matter is to remain closed to its virtuality, to remain self-identical, that is because it contains in itself an inherent openness, which links it to the rest of the universe.

Each object or thing can become otherwise, even if its present being can be calculated and measured quite precisely. By virtue of its inherence in the whole of matter, each object is more than itself, contains within itself the material potential to be otherwise and to link with and create a continuity with the durational whole that marks each living being. Becoming is thus not a capacity inherited by life, an evolutionary outcome or consequence, but the very principle of matter itself, with its possibilities of linkage with the living, with its possibilities of mutual transformation.

This attracts Deleuze (both in his own work and in his collaborations with Guattari) to Bergsonian becoming and to the durational whole Bergson posits to explain the endless multiplicity of becomings that constitute all material things. Bergson intuits a becoming that is ontological, that is con-

cerned with the ways in which the virtualities of objects transform and are transformed by the activity of living beings that is in some sense "evolutionary," insofar as it derives from a Darwinian understanding of life as temporal elaboration, but is also beyond Darwin in its understanding of the coevolution of life with things. According to Deleuze and Guattari,

> "Becoming is not an evolution, at least not an evolution by descent and filiation. Becoming produces nothing by filiation: all filiation is imaginary. Becoming is always of a different order than filiation. It concerns alliance. If evolution includes any veritable becomings, it is in the domain of *symbioses* that bring into play beings of totally different scales and kingdoms, with no possible filiation. There is a block of becoming that snaps up the wasp and the orchid, but from which no wasp-orchid can ever descend. . . . Accordingly, the term we would prefer for this form of evolution between heterogeneous terms is 'involution,' on the condition that involution is in no way confused with regression. Becoming is involutionary, involution is creation."[29]

For Bergson, life overcomes itself through the activities it performs on objects and itself: it becomes, both over the long-term time scale of evolutionary transformation and adaptation and the short-term time scale of an individual life, something other than its (species or individual) past while retaining a certain continuity with it. Its becomings are contingent only on its capacity to link with, utilize, and transform the apparent givenness and inertia of material objects and to give to these objects new virtualities, new impulses and potentials. As Deleuze and Guattari affirm, this is a coevolution, not simply in the Darwinian sense of mutual or symbiotic development of species that share the same or related environments, but in the sense of a symbiosis between the living and the nonliving. It is because the nonliving contains in itself the virtualities required to undertake the becomings entailed by its external transformation (by the living) that life carries becoming as its core. It is because life is parasitic on matter that life carries within itself the whole that matter also expresses.[30] It is because life is contingent on harnessing materiality that it is forced to encounter what resists or opposes it, undoing what it has been to become more and other.

Bergson understands life not as a repetition of matter so much as a reply to it, a self-transformation in response to it. For him, the varieties of species are an acknowledgement of the virtualities life had within itself from the

first, qualities of becoming and transformation that govern life from the "beginning": each species (and each individual) is a corporeal response to a problem the environment poses of how to extract from it the resources needed for life to sustain and transform itself.[31] The becoming of life is the undoing of matter, which is not its transformation into (inert) being but its placement in a different trajectory of becoming. Life intervenes into (parts or elements of) matter to give them a different virtuality than that through which matter initially generated the possibilities of life. Life recapitulates matter's durational dynamism by becoming in all directions available to it; that is, in differing as much as possible in its coevolution with matter. Life brings *new* virtuality to matter, which already harbored in itself the impetus of becoming.

The Real

Deleuze seeks an understanding of the real that is based on two principles he shares with Bergson: first, the real is positive, full, has no lack or negation, except through its own positive capacity for self-enfolding; second, the real is dynamic, open-ended, ever-changing, giving the impression of stasis and fixity only through the artificial isolation of systems, entities, or states. His abiding concern remains with the real, with defining and refining being or reality so that its difference from itself, its fundamental structure of becoming or self-divergence, is impossible to ignore. He is searching for a real that lacks nothing, that is fully positive, that functions as a whole, as well as for a real that changes, that generates the new, that continues becoming, even as it undoes earlier becomings. In short, Deleuze seeks a real that is intimately linked to the dynamism of temporality itself, on which duration exerts its forces of becoming and unbecoming, of making and unmaking, which is open-ended, impossible to predict in detail but always complexifying and elaborating. This is a real in which difference is the key characteristic, a real which differs from itself and uses difference as its engine for becoming.

Bergson and Deleuze remain committed to developing an ontology adequate to the ever-changing continuity that marks a temporally structured and sensitive universe. Bergson attributes to the universe as a whole a durational power that enables all objects, things, to be synchronized; that is, temporally mapped relative to each other, divisible into different fluxes,

while nevertheless capable of participating in a single, englobing current forward. The real here is understood as durational: it is composed of millions, even billions, of specific durations, each with its own measure, its own span, yet each duration can be linked to the others only because each partakes in the whole of duration and carries in it durational flow, that is, an irresistible orientation forward and an impulse to complexify in this movement. As Deleuze tells us, "In Bergson, thanks to the notion of the virtual, the thing differs from itself *first, immediately*."[32] It is because the real is construed as fundamentally dynamic, complex, open-ended, because becoming, which is to say, difference, must be attributed to it in every element, that it cannot begin to become; it does not acquire virtuality but is and always was in flux. There never was the self-identity and stasis necessary for a fixed identity, a given boundary and clear-cut states — that is, for objects as they are conceptually understood, except that which is discerned through bodily and perceptual needs.

Although Deleuze has been understood as a political and cultural theorist, he is primarily an ontologist, whose interest is in redynamizing our conceptions of the real. Philosophy, for Deleuze, is not the contemplation of or reflection on this timeless structure of never-ceasing change, it is the letting loose, freeing up, and putting into play of those conceptual and pragmatic constraints that rigidify scientific forms of knowing, and that are harnessed yet contained in the frame, the boundary, required for the work of art. Philosophy is the mobilization of the force of difference in which immobility and the static dominate thought; it is the freeing up of becoming from any determinate direction. It is the becoming-artistic of scientific knowledge and the becoming-scientific of artistic creation, the creation of something new, not through sensation or affect, but through concepts that draw on the same source — durational self-differing (which Deleuze understands as the whole) — that makes the sciences and the arts possible but limits each to its proper place. Philosophy is an undoing of this proper place, the unhinging of place and space itself, a return to the fluxes of becoming that constitute the real. This is decidedly not a new conception of philosophy (it underlies the work of many of the pre-Socratics, as well as Spinoza and Nietzsche, and of course Bergson — the very counter-history of philosophy that Deleuze has revivified through his entire body of work). It is a return to an understanding of philosophy that has never dominated the discipline, that has only appeared as its most extreme and often most

neglected forms, to be taken up elsewhere, outside the discipline. Philosophy is restored, not as conceptual master of the real, but as that labor of undoing and redoing, unbecoming and becoming, that approaches the real with increasing complexity, that demarcates for it concepts that more and more adequately fit the real, including the dynamic forms of life and the dynamic patterns of matter that the real contains.

disturbing differences

A NEW KIND OF FEMINISM

Feminism, Materialism, and Freedom

Concepts of autonomy, agency, and freedom — the central terms by which subjectivity has been understood in the twentieth century and early twenty-first — have been central to feminist politics for over half a century. While these concepts are continually evoked in feminist theory, however, they have been rarely defined, explained, or analyzed. Instead they have functioned as a kind of mantra of liberation, a given ideal, not only for a politics directed purely to feminist questions, but to any politics directed to class, race, national, and ethnic struggles. Here I would like to open up these terms that are so commonly used to define subjectivity or identity, and to problematize their common usage in feminist and other political discourses. I will attempt to recast the concepts by which subjectivity has been understood in the terms of a philosophical tradition which is rarely used by feminists but which may dynamize such concepts and make them ontological conditions rather than moral ideals.

I will not turn to the philosophical tradition in which questions of freedom and autonomy are irremediably tied to the functioning of a de-privatory power of the (oppressive or dominant) other — that is, the tradition of phenomenology that dates from Hegel and extends through Marxism, and which influences and inflects existentialism, structuralism, and poststructuralism, which in turn have so heavily influenced most contemporary forms of feminist thought regarding the subject. Instead, I look to a more archaic tradition but also a more modernist one that feminists have

tended to avoid, the one I have tried to follow throughout this book — the philosophy of life, the philosophy of biology, the philosophy of nature, initiated to some extent by the pre-Socratics and developed in the writings of Spinoza but fully elaborated primarily in the nineteenth century through the texts of Darwin, Nietzsche, and Bergson. This tradition flourished well into the earliest decades of the twentieth century and then entered a long dormancy, only to be restored as a research program at the end of the twentieth century.

I will attempt to rethink concepts like freedom, autonomy, and subjectivity in ontological, even metaphysical, terms rather than, as has been more common over the last century, through the discourses of political philosophy and the debates between liberalism, historical materialism, and postmodernism regarding the sovereignty and rights of subjects and social groups. In doing so, I hope to provide new resources, new concepts, and new questions in reconsidering subjectivity beyond the constraints of the paradigm of recognition that have marked feminist thought for more than half a century. In elaborating the centrality of matter to any understanding of subjectivity or consciousness as free or autonomous, one needs to look outside the traditions of thought that have considered subjectivity as the realm of agency and freedom only through the attainment of reason, rights, and recognition — social, cultural, and identificatory forces outside the subject enacting its social constitution.

Thus, instead of linking the question of freedom to the concept of emancipation, or to some understanding of liberation from or removal of an oppressive or unfair form of constraint or limitation, as is most common in feminist and other anti-oppressive struggles and discourses, I want to explore concepts of life where freedom is conceived not only or primarily as the elimination of constraint or coercion, but more positively as the condition of or capacity for action. In doing so, I hope to elaborate a new understanding of freedom, agency, and autonomy, not in terms of a concept of "freedom from," where freedom is conceived negatively, as the elimination of constraint, but in terms of a "freedom to," a positive understanding of freedom as the capacity for action, reframing the concept of freedom by providing it with a different context that may provide it with other, different political affiliations and associations and a different understanding of subjectivity.

The difference between "freedom from" and "freedom to" has, of course,

a long and illustrious history. It perhaps finds its most recent expression in the genealogical writings of Michel Foucault, who, in distinguishing the negative or repressive hypothesis of power from the positive understanding of power as that which produces or enables, relies heavily on Nietzsche's distinction between the other-directedness of a reactive herd morality and the self-affirmation of an active or noble morality unconcerned with the other and its constraints, directed only to its own powers and to the fullest affirmation of its own forces. The distinction between freedom-from and freedom-to is to a large extent correlated with a conception of freedom that is bound up with, on the one hand, a shared existence with the other and the other's power over the subject, and, on the other, a freedom directed only to one's actions and their conditions and consequences. The kind of Darwinian-Bergsonian-Deleuzian reading I am proposing throughout this book offers not only a new ontology and a new way of conceiving life; it also offers possibilities for new concepts of politics, and, as we shall see, a new understanding of aesthetics. In particular, it has implications for how feminist theory and politics may also be reconceived.

Is feminist theory best served through its traditional focus on women's attainment of a freedom from patriarchal, racist, colonialist, heteronormative constraint? Or by exploring what the female — or feminist — subject is and is capable of making and doing? It is this broad and overarching question — one of the imponderable dilemmas facing contemporary politics well beyond feminism — that is at stake in exploring the subject's freedom through its immersion in materiality.

I have no intention of presenting a critique of the notion of "freedom from," for it clearly has a certain political relevance,[1] but its relevance should not be overstated, and if freedom remains tied to only this negative concept of liberty, it remains tied to the options or alternatives provided by the present and its prevailing and admittedly limiting forces, instead of accessing and opening up the present to the invention of the new. In other words, a "freedom from," while arguably necessary for understanding concepts like subjectivity, agency, and autonomy, is not sufficient, for it at best addresses and attempts to redress wrongs of the past without providing any positive direction for action in the future. It entails that once the subject has had the negative force of restraints and inhibitions limiting freedom removed, a natural or given autonomy is somehow preserved. If external interference can be minimized, the subject can be (or rather become) itself, can be left to

itself and as itself, and can enact its given freedom. Freedom is attained through rights, laws, rules that minimize negative interference rather than affirm positive actions.

The tradition of "freedom to" has tended to be neglected in feminist and other radical political struggles, though it may make more explicit and clear what is at stake in feminist notions of subjectivity, agency, and autonomy. But rather than turning to Nietzsche and Foucault to articulate this network of connections (as I have done elsewhere[2]) — for they are the most obvious and explicit proponents of a positive conception of freedom, freedom as the ability to act and in acting to make oneself even as one is made by external forces — I will look at the work of someone more or less entirely neglected in feminist and much of postmodern literature: Henri Bergson. His understanding of freedom is remarkably subtle and complex and may provide new ways of understanding both the openness of subjectivity and of politics as well as their integration and cohesion with their respective pasts or histories.[3] Bergson's work may help us to articulate an understanding of subjectivity, agency, and freedom that is more consonant with a feminism of difference than with an egalitarian feminism, which more clearly finds its support in various projects centered around the struggles for rights and recognition. In this sense, although there may be no direct connection between the writings of Irigaray and those of Bergson, nevertheless, some Bergsonian conceptions may serve to explain Irigaray's understanding of what autonomy might be for a subject only in the process of coming into existence, a subject-to-be (a female subject).[4] Bergson might help to rethink how subjectivity and freedom are always and only enacted within and through the materiality that life and the nonliving share, a materiality not adequately addressed in alternative traditions that have until now remained so influential in feminist thought.

Bergson and Freedom

Bergson's understanding of freedom and its links to subjectivity is articulated in his first major publication, *Time and Free Will* (1959), which not only outlines his conceptions of duration and space (which become the centerpiece of his analyses in *Matter and Memory* [1988] and *Creative Evolution* [1998]), but also embeds his work in the traditional metaphysical opposition between free will and determinism, an ancient debate still articulating itself with great insistence, ironically, even within contemporary

feminism. His understanding of freedom, as with his notions of perception, life, and intuition, lies outside and beyond the traditional binary distinctions that characterize so much of Western thought.

Bergson argues that in traditional debates regarding free will and determinism, both sides share a number of problematic commitments. Both presume the separation or discontinuity of the subject from the range of available options or alternatives; the subject's stable, ongoing self-identity; a fundamental continuity between present causes and future effects (whether causes are regarded as internal or as external to the subject are what tend to define the positions of the determinist and the libertarian, respectively); and an atomistic separation or logical division between cause and effect. In other words, as in all oppositional or dichotomized divisions, both sides of the free will–determinism debate are problematic, and share assumptions that enable them to regard the other as their opposite.[5] As with all oppositional structures, we need to find something that articulates what both views, in spite of their contradictions, share in common, and what exceeds their terms and functions outside their constraints.

For the hard-core determinist, if one had an adequately detailed knowledge of antecedent events — that is, causes — one could predict with absolute certainty what their effects would be, whether these causes are material and external, or psychical and internal. In its most recent incarnations, determinism has affirmed that causes may lodge themselves within the living organism, as effects of an en masse conditioning of the body and its behavior, or as a consequence of the more microscopic molecular movements and structure of the brain, or the even more miniscule chromosomal structure of each cell. (Recent discourses on "the gay brain" [e.g., LeVay's *Queer Science*], the "gay gene," or the construction of queer through too close a "contamination" by queer lifestyles are merely contemporary versions of this ancient debate.) What lies behind each variation of this position is the belief that if one could know the brain's structure or genetic or behavioral patterns intimately enough, one could predict future behavior, whether criminal, sexual, or cultural.

On the other side is the libertarian or free will position, which asserts that even if determinism regulates the material order, in the realm of the human subject there is an inherent unpredictability of effects from given causes. Given a variety of options or alternatives, it is unpredictable which one will be chosen: it is an open or free act. Freedom is understood, on the antideterminist position, as the performance of an act by someone who

could have done otherwise, even under the same conditions. Both libertarians and determinists share the belief that the subject is the same subject, the same entity, before and after the alternatives have been posed and one chosen. Even after choosing a particular course, the subject could review that course and either make the same choice again in precisely the same way (the determinist position) or make a different choice, even in the same circumstances (the libertarian position). For both, the choice of one of the options does not annihilate the existence of the others but leaves them intact, capable of being chosen (or not) again.

Bergson's position on the question of freedom is more complex than either the determinist or the libertarian view. For him, it is not so much subjects that are free or not free; rather, it is *acts* that, in expressing a consonance (or not) with their agent, are free (or automatized) and have (or lack) the qualitative character of free acts. An act is free to the extent that "the self alone will have been the author of it, and . . . it will express the whole of the self" (*Time and Free Will*, 165–66). Bergson's position is both alluringly and nostalgically metaphysical and strikingly simple: free acts are those that spring from the subject alone (and not from any psychical state of the subject or any manipulated behavior around the subject); they not only originate in or through a subject, they express *all* of that subject — in other words, they are integral to who or what the subject is.

In this understanding, there is no question that the subject would or would not make the same choice again. Such a situation is impossible. The precise circumstances cannot be repeated, at the very least because the subject is not the same. The subject has inevitably changed, grown older, been affected by earlier decisions, become aware of the previous choice, and so on. If the subject were absolutely identical in the replaying of a particular choice, neither the determinist's nor the libertarian's position would be affirmed. All one could say is that the subject is the self-same subject. Yet even in the case of an example favored by the determinist — the subject under hypnosis — there is a measure of freedom insofar as the act performed through suggestion must still be rationalized, integrated in the agent's life history, given a history, and qualitatively inserted into all the agent's other acts in order to be performed.[6]

With even this most constrained and manipulated of circumstances, when one person's will is imposed on another's without their conscious awareness, Bergson argues that there must nevertheless be a retrospective cohesion between the subject's current act and the previous chain of con-

nections that prepared for it and made it possible. Even in this case, it is only retroactively, after the act is completed, that we can discern or mark the distinction between a cause and an effect, for in psychical life there cannot be the logical separation of cause from effect that characterizes material objects in their external relations to each other. What characterizes psychical life, Bergson insists, is not the capacity to lay parts (in this case, psychical states) side by side, for this only accomplishes a certain spatial ordering not possible for or lived by the living being, who requires the immersion and coherence of a being in time. Psychical states are not like objects for they have no parts, they cannot be directly compared, they admit of no magnitude or degree.

Psychical states have three relevant characteristics: first, they are always qualitative, and thus incapable of measurement without the imposition of an external grid. (This characteristic alone makes psychical determinism an incoherent position — if causes cannot be measured and precisely calculated, even if determinism is in principle correct, ironically it remains unable to attain its most explicit goal, prediction.[7]) Second, psychical states function, not through distinction, opposition, categories, identities, but through "fusion or interpenetration" (Bergson, *Time and Free Will*, 163), through an immersion or permeation that generates a continuity between states or processes and makes their juxtaposition impossible (this is the basis of Bergson's critique of associationism, the empirical principle that explains the connection between one term and another through their common or frequent association).[8] And third, they emerge or can only be understood in duration rather than through the conventional modes of spatialization that generally regulate thought, especially scientific or instrumental thought — that is to say, any mode of analysis or division into parts. Parts, elements, states, are only discernible as spatial categories or terms. While these attributes or divisions may be imposed on the continuity of life and consciousness, they do not arise from them, for life is as much becoming as it is being. It is durational as much as it is spatial, though we are less able to see or comprehend the durational flux than the mappable geometries of spatial organization.

Free acts erupt from the subject insofar as they express the whole of that subject even when they are unexpected and unprepared for: "We are free when our acts spring from our whole personality, when they express it, when they have that indefinable resemblance to it which one sometimes finds between the artist and his work" (Bergson, *Time and Free Will*, 172).

Acts are free insofar as they express and resemble the subject, not insofar as the subject is always the same, an essence or an identity, but insofar as the subject is transformed by and engaged through its acts, becomes through its acts. As Bergson describes, "Those who ask whether we are free to alter our character lay themselves open to [this] objection. Certainly our character is altering imperceptibly every day, and our freedom would suffer if these new acquisitions were grafted on to our self and not blended with it. But, as soon as this blending takes place, it must be admitted that the change which has supervened in our character belongs to us, that we have appropriated it" (ibid.).

Bergson's point is that free acts come from, or even through, us. (It is not clear if it matters where the impetus of the act originates — what matters is how it is retroactively integrated into the subject's history and continuity.) This subject from which acts spring is never the same, never self-identical, always and imperceptibly becoming other than what it once was and is now. Having been undertaken, free acts are those which transform us, which we can incorporate into our becomings in the very process of their changing us. Free acts are those which both express us and which transform us, which express our transforming.

What both the determinists and the libertarians misunderstand is the very notion of *possibility*: the determinist assumes that there is only one possible act that can occur from given conditions or antecedents for any given subject. The libertarian assumes that there could be several different acts that could ensue from given conditions or antecedents. Both assume, given two possible outcomes, x or y, either that one was never in fact possible (the determinist) or that both are equally possible (the libertarian). Neither understands that the two options were never of equal value because neither exists in itself as an abstract possibility. If we follow Bergson's famous distinction between the possible and the virtual,[9] the possible is at best the retrospective projection of a real that wishes to conceive itself as eternally possible but which becomes actual only through an unpredictable labor and effort of differentiation, an epigenesis that exceeds its preconditions. It is only after a work of art, concept, formula, or act exists, is real, has had an actuality, that we can say that it must have been possible, that it was one of the available options. Its possibility can only be gleaned from its actuality, for the possible never prefigures the real, it simply accompanies it as its post facto shadow. So although we can posit that x and y are equally possible (or not equally possible), it is only after one of them has been actualized,

chosen, that we can see the path of reasons, causes, or explanations which made it desirable.[10] Only after one of the options has been chosen can we see that the unchosen option is not preserved in its possibility but entirely dissolves, becoming simply a reminiscence or projection.

Bergson has provided an understanding of freedom that is not fundamentally linked to the question of choice, to the operations of alternatives, to the selection of options outside the subject and independently available to it. It is not a freedom of selection, of consumption, a freedom linked to the acquisition of objects, but a freedom of action. A freedom, while he ascribes it to a self, is above all connected to an active self, an embodied being, a being who acts in a world of other beings and objects. Acts, having been undertaken, transform their agent so that the paths that the agent took to the act are no longer available to it except abstractly or in reconstruction. Indeed, there are no paths to any possible action (that is why an action remains possible but not real) until the action is acted, and then the path only exists in reconstruction, not in actuality. The path can only be drawn after the movement is completed. Once the act is performed, we can divide, analyze, assess, and treat as necessary what in the process of its performance remains undivided, unanalyzable, surprising, and utterly contingent. The act, once performed, once actualized, is different from the indeterminacy of its performance.

Moreover, Bergson's understanding of freedom dissolves the intimate connection between freedom and the subject's internal constitution or pre-given right. Freedom is not a quality or property of the human subject, as implied within the phenomenological tradition, but can only characterize a process, an action, a movement that has no particular qualities. Freedom has no given content; it cannot be defined. In Bergson's words, "Any positive definition of freedom will ensure the victory of determinism" (*Time and Free Will*, 220). This is in part because it is not an attribute, quality, or capacity that exists independent of its exercise. It is not that subjects are or are not free; rather, *actions*, those undertaken by living beings, may sometimes express such freedom. Freedom is a matter of degree, and characterizes only those acts in which one acts with all of one's being and in the process becomes capable of transforming that being. It is rare that our actions express with such intimate intensity the uniqueness of our situation and our own position within it.[11] But it is at these moments that freedom at its most intense is expressed.

Freedom is thus the exception rather than the rule, in the sense that it can

only function through the "autonomy" of the living being against a background of routinized or habituated activity. It is only insofar as most of everyday life is accommodated through automatism, by a kind of reflex or habit, that free acts have their energetic and aesthetic-moral force and their recoil impact on their author or agent. Associationism or determinism have their relevance in conscious life. They provide an explanation of the automatized substrate of daily behavior that provides a probabilistic guarantee of accomplished action. It is only against this assumed or taken-for-granted background economy of details that free acts may erupt.[12] In place of either a rigid determinism or the pointless and undirected openness of libertarianism, Bergson poses indeterminacy as the defining characteristic of life and the condition for freedom: "It is at the great and solemn crisis, decisive in our reputation with others, and yet more with ourself, that we choose in defiance of what is conventionally called a motive, and this absence of any tangible reason is the more striking the deeper our freedom goes" (*Time and Free Will*, 170).

Freedom and Materiality

In his later works,[13] Bergson focuses less on freedom as the exclusive attribute of a self, concentrated only on the one, conscious side of the distinction between the organic and the inorganic, as he did in his earlier *Time and Free Will*, and more on the relations between the organic and the inorganic, the internal constitution of freedom through its encounters with the resistance of matter. If freedom is located in acts rather than in subjects, then the capacity to act and the effectiveness of action is to a large extent structured by the ability to harness and utilize matter for one's own purposes and interests. Freedom is not a transcendent quality inherent in subjects but is immanent in the relations that the living has with the material world, including other forms of life.

As the correlate of life itself, whose accompaniment is consciousness in a more or less dormant or active state, freedom is not the transcendent property of the human, but the immanent and sometimes latent capacity of life in all its complexity. Life is consciousness, though not always an active consciousness. Consciousness is the projection onto materiality of the possibility of a choice, a decision whose outcome is not given in advance; that is to say, it is a mode of simplifying or skeletalizing matter so that it affords us

materials on and with which to act.[14] It is linked to the capacity for choice, for freedom. It is not tied to the emergence of reason, to the capacity for reflection, or to some inherent quality of the human. Life in its evolutionary forms expresses various degrees of freedom, correlated with the extent and range of consciousness, which is itself correlated with the various possibilities of action. The torpor or unconsciousness that characterizes most plant life makes the concept of freedom for it largely irrelevant or operational only at its most minimal level, insofar as "choice" or action are not generally available to vegetal existence.[15]

Yet the most elementary forms of mobile life, animal existence from the protozoa upward, exhibit an incipient freedom in some of their most significant actions. This capacity for "choice"—even if reduced to the choice of when and where to contract or expand, when and what to eat—expresses both the particularity of each species and the specificity of individuals within them.[16] Each species, Bergson suggests, has the consciousness precisely appropriate to the range of actions available to it: each species, and here Bergson anticipates the work of some theoretical biologists,[17] has a world open up to it within which its organs have, through natural selection, the capacity to extract for it what it needs for its ongoing existence. Each animal species, whether regulated by instinct, as are the social insects, or by intelligence, as occurs in gradations through the vertebrates, has a world in which it can act, in which it requires a certain consciousness, in which there is for it a "fringe" of freedom, a zone of indetermination that elevates it above mere automated response to given stimuli.

It is this zone of indetermination that for Bergson characterizes both the freedom representative of life, and the capacity for being otherwise that life can bestow on (elements, factors of) material organization. Indetermination is the "true principle" of life, the condition for the open-ended action of living beings, the ways in which living bodies are mobilized for action that cannot be specified in advance.[18] The degrees of indetermination are the degrees of freedom. Living bodies can act, not simply or mainly through deliberation or conscious decision, but through indetermination, through the capacity they bring to the material world, to objects, to make them useful for life in ways that cannot be specified in advance.[19]

Indetermination spreads from the living to the nonliving through the virtuality that the living bring to the inorganic, the potential for the inorganic to be otherwise, to lend itself to incorporation, transformation, and

energetic protraction in the life and activities of species and individuals. As Bergson writes, "At the root of life there is an effort to engraft on to the necessity of physical forces the largest possible amount of *indetermination*."[20] Life opens the universe to becoming more than it is.

But equally, Bergson argues, matter as a whole, the material universe, must contain within itself the very conditions for the indeterminacy of life which it generated, those mixtures or compounds which may yield memory, history, the past, and make them linger, press on, and remain relevant to the present and future. Matter must contain as its most latent principle, its most virtual recess, the same indeterminacy that life returns to it. This is the common point of binary terms (matter and memory, extension and consciousness, space and duration) and that which exceeds them — the fundamental interimplications of mind and matter, of life and the inorganic, their origins in the indeterminacy of the universe itself, the point of their endosmosis — where matter expands into life and life contracts into matter in pure duration. Life, and its growing complications through the evolutionary elaboration, generates a "reservoir of indetermination"[21] that it returns to the inorganic universe to expand it and make it amenable to and the resource for life in its multiple becomings. In turn, matter, while providing the resources and objects of living activity, is also the internal condition of freedom as well as its external limit or constraint. Bergson affirms life's enmeshment in a materiality that tends to habit and to determination: "[The evolution of life] is at the mercy of the materiality which it has had to assume. It is what each of us may experience in himself. Our freedom, in the very movements by which it is affirmed, creates the growing habits that will stifle it if it fails to renew itself by a constant effort: it is dogged by automatism."[22]

Materiality tends to determination; it gives itself up to calculation, precision, spatialization. At the same time, it is also the field in and through which free acts are generated through the encounter of life with matter and the capacity of each to yield to the other its forms and forces, both its inertia and its dynamism. Matter, inorganic matter, is both the contractile condition of determination and the dilating expression of indetermination, and these two possibilities characterize both matter in its inorganic forms and those organized material bodies that are living. Immersed in matter and an eruption from it, life is the continuous negotiation with matter to create the conditions for its own expansion and the opening up of matter to its own virtualities: "[Life] was to create with matter, which is necessity itself, an instrument of freedom, to make a machine which should triumph over

mechanism, and to use the determinism of nature to pass through the meshes of the net which this very determinism had spread."[23]

Composed of isolatable systems, fixed entities, and objects with extrinsic relations to each other, the material universe is the very source of regularity, predictability, and determination that enables a perceiving being to perform habitual actions with a measure of efficacy. Yet as an interconnected whole, the universe exhibits hesitation, uncertainty, the openness to evolutionary emergence, the very indetermination that characterizes life. At its most contracted, the material universe is regular, reborn at each moment, fully actual and in the present; but at its most expansive, it is part of the flow of pure duration, carrying along the past with the present, the virtual with the actual, and enabling them to give way to a future they do not contain. The universe has this expansive possibility, the possibility of being otherwise not because life recognizes it as such but because life could only exist because of the simultaneity of the past with the present that matter affords it.[24]

Feminism and Freedom

Feminists have long assumed that patriarchy and patriarchal power relations, as a coercive form of constraint, have limited women's freedom by not making available to women the full range of options for action afforded men. And it is certainly true that the range of "choices" available to women as a group is smaller and more restricted than that available to men as a group. But the question of freedom for women, or for any oppressed social group, is never simply a question of expanding the range of available options so much as it is about transforming the quality and activity, the character, of the subjects who choose and make themselves through how and what they do. Freedom is not linked to choice (a selection from pre-given options or commodities) but rather to autonomy, and autonomy in turn is linked to the ability to make (or refuse to make) activity (including language, that is, systems of representation and value) one's own, to integrate the activities one undertakes into one's history, one's becoming. It is my claim that something like a Bergsonian understanding of freedom coheres more readily with Irigaray's and other feminists' conception of sexual autonomy than with a feminist egalitarianism that is necessarily rooted in sexual indifference. Although Bergson was not interested in and predates the paradigm of sexual difference posed by Irigaray, his conception of freedom links actions to a process of self-making that closely anticipates

Irigaray's understanding of sexual difference, the autonomy and dual symmetry of the two sexes, as that which is virtual, that which is in the process of becoming.[25]

Bergson has elucidated a concept of freedom that links it not to choice but to innovation and invention. Freedom is the realm of actions, processes, events that are not contained within or predictable from the present. It is that which emerges, surprises, and cannot be entirely anticipated in advance. It is not a state one is in or a quality that one has, for it resides in the activities one undertakes that transform oneself and (a part of) the world. It is not a property or right bestowed on or removed from individuals by others but a capacity, a potentiality, to act both in accordance with one's past, as well as "out of character," in a manner that surprises.

Freedom is thus not an activity of mind but one primarily of the body: it is linked to the body's capacity for movement and thus its multiple possibilities of action. Freedom is not an accomplishment granted by the grace or good will of the other, but is attained only through the struggle with matter, the struggle of bodies to become more than they are, a struggle that occurs not only on the level of the individual but also of the species.

Freedom is the consequence of indetermination, the very indetermination that characterizes both consciousness and perception. It is this indetermination — the discriminations of the real based on perception, the discriminations of interest that consciousness performs on material objects, including other bodies — that liberates life from the immediacy and givenness of objects, but also from the immediacy and givenness of the past. Life is not the coincidence of the present with its past, its history, it is also the forward thrust of a direction whose path is only clear in retrospect. Indetermination liberates life from the constraints of the present. Life is the protraction of the past into the present, the suffusing of matter with memory, which is the capacity to contract matter into what is useful for future action, to make matter function differently in the future than in the past. The spark of indetermination that made life possible spreads through matter in the activities that life performs on matter, and the world itself comes to vibrate with its possibilities for being otherwise.

So what does Bergsonism, or the philosophy of life, offer to feminist theory over and above liberal, Marxist, empiricist, or phenomenological conceptions of freedom? If we rely on a conception of freedom that is linked to the controlling power of socially dominant others, a class, a sex, a race — a view which all these conceptions in some way share — we abandon in ad-

vance the concept of autonomy. If freedom is that which is bestowed on us by others, it cannot be lodged in autonomy, in the individual's inner cohesion and historical continuity. It comes from outside, from rights granted to us, rather than capacities inherent in us. Freedom becomes transcendent rather than immanent, other-oriented rather than autonomous, linked to being rather than to doing. Such an understanding of freedom, at least from the point of view of a philosophy of life, is reactive, secondary, peripheral, seen as outside of life instead of the very condition of life. Freedom is a question of degree rather than an absolute right; it is attained rather than bestowed, and it functions through activity rather than waiting passively for its moment.

Being gay or straight, for example, is not a question of choice (of options already given in their independent neutrality — e.g., the choice of men or women as sexual objects, or masculine or feminine as modes of identification) but an expression of who one is and what one enjoys doing, of one's being. It is the expression of freedom without necessarily constraining itself to options already laid out. Gayness (or straightness) is not produced from causes, whether physiological, genetic, neurological, or sociological; nor is it the consequence of a free choice among equally appealing given alternatives. It is the enactment of a freedom that can refuse to constrain sexuality and sexual partners to any given function, purpose, or activity, that makes sexuality an open invention, even as it carries the burden of biological, cultural, and individual construction.

The problem of feminism is not the problem of women's lack of freedom, or simply the constraints that patriarchal power relations impose on women and their identities. If women are not, in some sense, free, feminism could not be possible. The problem, rather, is how to expand the variety of activities, including the activities of knowledge production,[26] so that women and men may be able to act differently, to open up activities to new interests, perspectives, and frameworks hitherto not adequately explored or invented. The problem is not how to give women more adequate recognition (who is it that women require recognition from?), more rights, or more of a voice, but how to enable more action, more making and doing, more difference. That is, the challenge facing feminism today is no longer only to give women a more equal place within existing social networks and relations but to enable women to partake in the creation of a future unlike the present.

The Future of Feminist Theory

DREAMS FOR NEW KNOWLEDGES

> If we give up the effective subject, we also give up the object upon which the effects
> are produced. Duration, identity with itself, being are inherent neither in that
> which is called subject nor in that which is called object: they are complexes of
> events, apparently durable in comparison with other complexes — e.g., through the
> differences in tempo of the event.
> — FRIEDRICH NIETZSCHE, *The Will to Power*

Much has changed in the last twenty years regarding feminist theory and
practice, although there are of course continuities and the elaboration of
ongoing questions that remains pressingly the same. Although women re-
main secondary and subordinated to men in economic and political terms
— indeed, the economic disparity between the average wages of men and
women is greater now than it was two decade ago, and the number of
women who function as political leaders is lower now than two decades ago
— it is also true that many new questions, issues, problems have emerged
that were unrecognized or even nonexistent twenty years ago. Religious
fundamentalisms and terrorism existed but not as globally linked phenom-
ena; globalization itself was a dream more than an economic reality; queer
theory had yet to emerge as such from its origins in lesbian and gay strug-
gles; Marxism and psychoanalytic theory represented ideal radical intellec-
tual positions by which culturally variable relations could be analyzed and
understood in universally relevant terms; and class analysis, through its

extension and reorientation, provided a model by which the position of women, colonized subjects, and indeed all social minorities, could be recognized and analyzed and their oppression understood and integrated into a single model. And perhaps most striking in terms of the generation of feminist theory, women's and gender studies programs and departments have proliferated throughout universities and institutions of higher learning, and have become relatively professionalized and institutionally incorporated. In many contexts this means that feminist theory — the unique contribution of feminist programs and departments that needed to be added to their interdisciplinary focus — has become in many situations normalized, rendered into an entity, a knowable thing, surrounded by and aligned with history and methodology courses, even as it remains highly contested and without any agreed upon content, canonical texts, or named authors.

It must be acknowledged that feminism has not succeeded in either of its competing and contradictory aims: either the creation of a genuine and thorough-going equality, which reveals the fundamental sameness of humanity underneath or beyond all its morphological and representational variations; or the constitution of a genuine and practical autonomy, in which women choose for themselves how to define both themselves and their world, this second goal being the ideal represented in philosophies of sexual difference. Given this reality, it may now be time once again to raise the question, not of what feminist theory *will* be, but of the much less depressing subject of what it *could* be, perhaps even what it *ought* to be.

My concern is not with extrapolating the future from the feminist theory we know today (such projections, while rarely accurate as predictions beyond the short term, are usually more reliable indices of contemporary anxieties and desires). Rather, I want to address what feminist theory could be, and what my dream of a future feminist thought should be. What is feminist theory at its best? What is its continuing radical promise? How is it to be located relative to the other disciplinary forms, other fields of knowledges? Or relative to the range and variety of interests of women, understood in all their differences? Or relative to what remains unsaid, unspoken, unrepresented in other knowledges? To what can feminist theory aspire? What might it name, and produce? How can we produce knowledges, techniques, methods, practices that bring out the best in ourselves, that enable us to overcome ourselves, that open us up to the embrace of an unknown and open-ended future, that bring into existence new kinds of beings, new kinds of subjects, and new relations to objects?

Concepts

One of the things that has changed quite dramatically in the last two decades is how we understand power, and what relations discourses, texts, knowledges, and truths may have to the operations of power. Although Foucault's works were largely translated and published in English well over twenty years ago, his writings were contestatory, challenging the intellectual dominance of Marxism, and of Marxist feminism. Today, it seems, Foucault's conception of power as a series of relations of force that utilize whatever tactics they can — including the production of truth — is a much more accepted understanding of power than the once pervasive concept of power as a form of falsehood or ideology, which seemed to fascinate the previous generation of feminist theorists and other radical scholars of race, class, and ethnicity. Knowledges are weapons, tools, in the struggles of power over what counts as truth, over what functions as useful, over what can be used to create new systems, forces, regimes, and techniques, none of which are indifferent to power. This is not to say that those discourses aspiring to the status of truth and to be included in the canon of knowledge(s) are not really true, only that truth itself, which requires quite onerous conditions for statements to be included as true, is always already an effect of power, and a condition of power's ever more effective operation.

If Foucault concentrates on truth, particularly of the kind that is produced in what he calls the "sciences of man" — the human sciences, within disciplinary discourses and practices like psychology, sociology, criminology, economics, biology, and so on — he never really addresses the field within which his own work is usually classified, that of theory, or perhaps, if we understand the term in its broadest and least academic sense, philosophy (dare we call theory by its real name?), a field that, if it relies on truth at all, requires a very different understanding of what truth is and how it functions. One suspects that theory has become theory, has renamed itself as theory, only in reaction to the hijacking of philosophy by the most narrow and conservative of intellectual forces, which make the discipline as devoid of social effects and social criticism as it can possibly be. How different would radical theory be if the discipline which initially spawned theoretical exploration remained committed to such explorations without constraint, without limit? How strong could feminist theory become if it

flourished where knowledge comes to understand itself and its relations to the real most directly?

Foucault does not address those discourses that do not directly aspire to truth but nonetheless aim to generate certain political, social, or cultural effects, what in English is called "theory." This is much more the concern of his contemporaries, Deleuze and Guattari, who ask: What is it to think? What is philosophy? What is a concept? In addressing the questions of what is feminist theory and what could it become, we need to understand first what theory is and might become. For this, it seems to me that Deleuze's and Guattari's work is, if not indispensable, then at least extremely useful: they enable us to understand, in keeping with something like Foucault's understanding of power and its investments in "games of truth," that concepts, theories, are strategies, struggling among themselves, with forces and effects that make a difference and that are significant beyond themselves insofar as they become techniques by which we address the real, the forces that surround and suffuse texts, that occupy the outside of texts. In addressing the question, "What is feminist theory?," we are primarily addressing the question of what it is to think differently, innovatively, in terms that have never been developed before, about the most forceful and impressive impacts that impinge upon us and that thinking, concepts, and theories address if not resolve or answer.

Feminist theory, at its best, in its ideal form, is about the generation of new thought, new concepts, as much as if not more than it is about the critique of existing knowledges. It is not, however, so much about the generation of new truths, which must meet complex and normalizing conditions to be part of the true, but new thinking. We must ask, as do Deleuze and Guattari in their final collaborative work, *What Is Philosophy?* (1994), what is a concept? How is philosophy, theory (especially feminist philosophy, feminist theory), a practice involved in the production of concepts? To simplify Deleuze's and Guattari's position, we can say that "in the beginning" — a beginning understood in evolutionary terms — there is chaos, the whirling forces of materiality without limit, without boundary. Life emerges from the chaos of materiality through chance, through the protraction of the past into the present; that is, through the production of virtuality, latency, or potential which adds to the materiality of chaos the possibility of finding some order, of extracting enough consistency to enable life to elaborate itself, to bifurcate and experiment with difference, with

the constitution of individual and collective variability, from which natural selection is made possible. Only when the evolutionary elaboration of life reaches a certain complexity do concepts come to function as forms for the generation of order. Ideas, mind, mentality are evolutionary effects, orders of emergence, as Gilbert Simondon recognized, that are conditional on preceding orders of biological complexity.[1] Concepts are one of the ways in which the living address and attempt to deal with the chaos which surrounds them (other ways include the functive, which orders science, and percepts and affects, which organize the arts).

Concepts emerge, have value, and function only through the impact of problems generated from outside. (Deleuze and Guattari claim: "All concepts are connected to problems without which they would have no meaning and which can themselves only be isolated or understood as their solution emerges."[2]) Concepts are not solutions to problems, for most problems — the problem of gravity, of living with others, of mortality, of the weather — have no solutions, only ways of living with problems. They are the production of immaterial forces that line materiality with *incorporeals*, potentials, latencies: concepts are the virtualities of matter, the ways in which matter can come to be otherwise, the promise of a future different from the present. ("The concept is an incorporeal, even though it is incarnated or effectuated in bodies" [Deleuze and Guattari, *What is Philosophy?*, 21].) So concepts are ways in which the living add ideality to the world, transforming the givenness of chaos, the pressing problem, into various forms of order, into possibilities for being otherwise. Concepts are practices we perform, not on things, but on events ("The concept speaks the event, not the essence or the thing" [ibid.]), to give them consistency, coherence, boundaries, purpose, use. Concepts do not solve the problems that events generate for us: they enable us to surround ourselves with possibilities for being otherwise that the direct impact of events on us does not. So concepts are not answers, solutions — though we tend to think that solutions eliminate problems, in fact a problem always coexists with its solutions. Instead they are modes of address, modes of connection, what Deleuze and Guattari sometimes call "movable bridges" (ibid., 23), between those forces which relentlessly impinge on us from the outside to form a problem and those forces we can muster within ourselves, harnessed and transformed from outside, by which to address problems. This is why concepts are created. They have a date, often also a name; they have a history that seizes hold of them in inconsistent ways, making of them new concepts with each

seizure and transformation insofar as each concept has borders and edges that link it up and evolve it with other concepts.

Perhaps most interestingly, concepts cannot be identified with discourses or statements, which means that concepts can never be true. Truth is a relation between statements or propositions and states of affairs in the world. Concepts are never propositional because they address, not states of affairs, but only events, problems. Events are, by definition, problems insofar as they are unique, unrepeatable conjunctions of forces that require some kind of response under peril of danger. For Deleuze and Guattari, one of the mistakes of institutional philosophy is to collapse the concept into the proposition, to assert questions of truth in place of questions of force.[3] They write, "Concepts are centers of vibrations, each in itself and every one in relation to the others. This is why they all resonate rather than cohere or correspond with each other" (*What is Philosophy?*, 23).

Deleuze and Guattari argue that the nature of the concept, that is, their own concept of the concept, has six complex characteristics (*What is Philosophy?*, 19–22). First, every concept, as a complex heterogeneity, has components which themselves are concepts. This links every concept, in each incarnation or particularity, to a chain of potentially infinite other concepts and to a historically contingent number of other concepts. These other concepts are the history, the forms of contiguity and contingency that constitute each concept and its conceptual landscape. Second, each concept produces out of its diverse components a provisional but tightly contained consistency that is both an endoconsistency and an exoconsistency, which regulates its relations with its neighboring, competing, and aligned concepts.[4] This means that even a slight shift in the relations of these components or these neighboring concepts begins a process of producing a new concept. Third, not only does a concept have an internal consistency and a relatively stable external positioning among other concepts, it is a form of absolute self-proximity, of self-survey without distance or perspective. In other words, the concept grasps and contains its diverse components intensively; the concept is emergent from its features, not once and for all, but continuously. It is the immediate consciousness of its changing components, without any outside position from which to reflect on its consistency or heterogeneity.[5] The concept's fourth characteristic is that it is incorporeal or virtual even though it is "effectuated" through bodies and events. Concepts address events, not as their answer or solution, but as a form of framing that connects an event or its features to others in some broad

pattern. The concept is the potential of the event to connect in ways other than those that are given. Fifth, the concept cannot be identified with discourse or representation, or with propositions or statements, which are some of the common modes of analyzing concepts, modes of submitting them to truth or to intension. Concepts themselves, while representable, are not reducible to discourse or representation, for they are modes of resonance or vibration, modes of connection or disconnection between other concepts and, above all, to events.[6] And sixth, concepts are not isolated though they are cohesive. They link with other concepts, both the concepts that they compete with and those that they help generate, on a desert plane, a plane of immanence or consistency, the plane on which all concepts affect each other or overcome one another. This is an abstract plane that links concepts to each other, even without direct historical connections, through what Derrida understands as dissemination, or the endless possibility of a new context revivifying an old term, or that Deleuze understands as an unlimited horizon or indivisible milieu of events, the concept's possibilities for being reconfigured through new components, or through new fragments linking components in new ways.

We need concepts in order to think our way in a world of forces that we do not control. Concepts are not means of control but forms of address that carve out for us a space and time in which we may become what can respond to the indeterminate particularity of events. Concepts are thus ways of addressing the future, and in this sense are the conditions under which a future different from the present — the goal of every radical politics — becomes possible. Concepts are not premonitions, ways of predicting what will be; on the contrary, they are modes enacting of new forces. They are themselves the making of the new.[7] The concept is what we produce when we need to address the forces of the present and to transform them into new and different forces that act in the future.

Thus the concept is central, indispensable, to addressing the new, not through anticipation or forecasting but through the task that it performs of opening up the real, the outside. The concept is thus the *friend* of all those seeking radical social change, who seek new events and new alignments of forces. The concept does not accompany revolutionary or radical change (change has to be accomplished in its own terms, in the field or territory in which it functions) but renders it possible by adding the incorporeals to the force or weight of materiality.

The concept is how living bodies, human bodies — that is, male and

female bodies of all types — protract themselves into materiality and enable materiality to affect and transform life. The concept adds to the world, or the events which comprise the world, a layer of incorporeality, an excess that makes it more than it presently is, that imbues it with the possibility of being otherwise, the possibility of dispersal and transformation.[8] The concept is what bathes the object or the real, matter, in potential, making it available in the future in ways unrecognized in the past, opening it up to a new order. The concept is what opens up the thing, object, process, or event — the real — to becoming other, to indeterminate becomings. The concept is one way, not the only way but a highly significant way, in which life attaches itself to forces immanent in but undirected by the present. Along with the percept and the affect, the concept is how we welcome a people to come, a world to come, a movement beyond ourselves, rather than simply affirming what we are.

Unlike identity politics, which affirms what we are and what we know, the concept, theory, is never about us, about who we are. It affirms only what we can become, extracted as it is from the events which move us beyond ourselves. If theory is conceptual in this Deleuzian sense, it is freed from representation — from representing the silent minorities that ideology inhibited (subjects), and from representing the real through the truths it affirms (objects) — and is opened up to the virtual, to the future which does not yet exist. Feminist theory is essential, not as a plan or anticipation of action to come, but as the addition of ideality, incorporeality, to the horrifying materiality, the weighty reality, of the present as patriarchal, as racist, as ethnocentric, a ballast to enable it to be transformed.

The Force of Concepts

What was clear over the last two decades, as much as today, is that we need conceptions of knowledge, techniques of knowing, that are forms of contestation rather than merely a more equitable distribution of the dominant forms of order, reason, and truth. Feminist theory, as the production of concepts relevant to understanding women, femininity, and social subordination more generally, and to welcoming their transformation, is the production of new concepts, concepts outside, beyond, or at the very limits of those concepts that have defined men, women, and their relations up to now. Both patriarchal and feminist theory address, each in their very different ways, an intractable and irreducible problem: the problem of sexual

difference, the problem of morphological bifurcation, the production of two different types of bodily form and consequently two different types of subjectivity that cannot without loss be understood through or reduced to a singular, universal, or purely human model. This is a problem — that is, a question, a provocation, that requires techniques or procedures to deal with it — that every society (human and animal) however small or simple must face, an ongoing *event* that cannot be evaded, but for which there is no solution. How the two sexes are to coexist is a question that life itself, in its unpredictable variability, addresses in an ongoing way without clear-cut or agreed-upon solutions, for it is one of the pressing frameworks (along with birth, illness, and mortality, among many other material contingencies) that every society must manage if it is to continue.

Sexual difference is managed in two contrary ways through patriarchal and feminist conceptualizations. For patriarchy, the task is to ensure a certain or guaranteed precedence of masculinity and male privilege even as sexual difference remains open-ended and to be resolved or lived through various strategies. For feminism, by contrast, the task is to seek either a more equitable distribution of resources between men and women (for liberal and Marxist feminism) or the possibility of sexual symmetry entailed through an acknowledgement of sexual difference (as argued by those described as radical feminist and sexual difference theorists). Each is a contestatory relation, a struggle, that attempts to bind or unbind certain forces through the elaboration of concepts that highlight and singularize, specify, and surround these forces. Each struggles to generate concepts that bring into existence a future that serves its interests. I do not want to suggest here that there is any parallelism between these two sets of concepts, that they directly engage with each other, or that they are mutually defining — patriarchy and feminism are not two protagonists in an evenly matched struggle, for feminism is the very excess and site of transformation of patriarchy. Instead, their relations are discontinuous, open-ended, each calling into existence its own constituencies, its own future peoples, its own landscape of events without direct reference to the other.

Theory, whether patriarchal, racist, colonialist (usually all of these!), or otherwise, is one means, and certainly not the only one, by which we invent radical or unforeseen futures. It is one intense practice of production, like art, like economic production, like many other kinds of labor that makes things — in this case, concepts — that did not exist before, that opens up new worlds to come. The production of concepts is by no means a priv-

ileged production (indeed, within capitalism its value is quite minimal), but it is nevertheless a necessary condition for the creation of new horizons of invention, just as theory is by no means the only path to social change but remains a necessary condition for the creation of new frameworks, new questions, new concepts by which social change can move beyond the horizon of the present. (Here "theory" cannot be understood in opposition to its dichotomous other, "practice," but must be seen as its own, rather dull, form of practice, the practice of research, writing, teaching, and learning, a practice that has become socially marginalized at an increasing rate over the last three millennia.) Although struggles at the level of "practice" are obviously crucial, indispensable, for the accomplishment of relevant social change, it is also true that without concepts, which both face chaos and extract from it some of its uncontained force while providing us with a minimal order with which to address and frame it for our purposes, we have no horizon for the new, no possibility of overcoming the weight of the present, no view of what might be, only the weighty inertia of what is. Without concepts, without theory, practice has no *hope*, its goal is only reversal and redistribution, not transformation.

The New

At its best, feminist theory is about the invention of the new: new practices, new positions, new projects, new techniques, new values. It is clear that it must understand and address the old, what is and has been, and the force of the past and present in attempting to pre-apprehend and control the new, and to that extent feminist theory is committed to "critique," the process of demonstrating the contingency and transformability of what is given. It is also clear that there needs to be not only the production of alternatives to patriarchal (racist, colonialist, ethnocentric) knowledges but, more urgently and less recognized, a freedom to address concepts, to make concepts, to transform existing concepts by exploring their limits of toleration, so that we may invent new ways of addressing and opening up the real, new types of subjectivity, and new relations between subjects and objects.

To be more explicit, it seems to me that the emphasis feminist theory places on certain questions needs to be reoriented and directed to other concerns. I do not want to suggest that these issues are useless, for each has had and will continue to have its historical significance for feminist thought; rather, I would like to see their dominance of the field end, and new ques-

tions asked. There are, in particular, three areas of feminist concern that I would displace in favor of other issues, other questions. The first of these is the overwhelming dominance, even among those who lament its existence, of identity politics, by which I mean the concern with questions of the sub-ject — the subject's identity, experiences, feelings, affects, agency, and ener-gies. The proliferation of subject positions, the opening up of the subject to all the vagaries of a hyphenated existence as class, race, gender, and sexually specific being, the concept of intersectionality as a way of addressing these hyphenations (which simply multiplies without transforming the terms that intersect with each other), the proliferation of memoirs, the over-whelming emphasis on the personal, the anecdotal, the narrational, while important for a long period of feminism's existence, have now shown us the limit of feminist theory. To the extent that feminist theory focuses on ques-tions of the subject or identity, it leaves questions about the rest of existence — outside of and beyond or bigger than the subject, or what is beyond the subject's control — untouched. Feminism abdicates the right to speak about the real, about the world, about matter, about nature, and in exchange, cages itself in the reign of the "I": who am I, who recognizes me, what can I become? Ironically, this is a realm that is increasingly globally defined through the right to consumption, what the subject can have and own.

This focus on the primacy of the subject (whether the subject is under-stood as a desiring subject, a speaking subject, or as a decentered subject) has obscured two sorts of issues. The first relates to what constitutes the subject that the subject cannot know about itself (the limits of the subject's subjectivity, the content and nature of the agency or agencies that we can attribute to a subject). The second relates to what is beyond the subject, bigger than the subject, outside the subject's control or possibly even com-prehension. The subject does not make itself; the subject does not know itself. The subject seeks to be known and to be recognized, but only through its reliance on others, including the very others who function to collectively subjugate the subject. We need to ask with more urgency now than in the past: if the subject strives to be recognized as a subject of value in a culture which does not value that subject in the terms it seeks, what is such recogni-tion worth? And once the subject is recognized as such, what is created through this recognition? To focus on the subject at the cost of focusing on the forces that make up the world is to lose the capacity to see beyond the subject, to engage with the world, to make the real. We wait to be recog-nized instead of making something, inventing something, which will enable

us to recognize ourselves, or more interestingly, to eschew recognition altogether. I am *not* what others see in me, but what I do, what I make.[9] I become according to what I do, not who I am. This is not to ignore the very real differences between subjects and their various social positions, only to suggest that these differences, and not the subjectivity between which these differences are distributed, are the vehicles for the invention of the new.

Linked to the preeminence of the subject and of concepts of subjectivity is the privileging of the epistemological (questions of discourse, knowledge, truth, and scientificity) over the ontological (questions of the real, of matter, of force, or energy). This is the second area of feminist concern that should be displaced. Epistemology is the field of what we, as suitably qualified knowing subjects, are able to know of the objects we investigate, including those objects which are themselves subjects (whenever the object is living, we cross the boundary between objects and subjects). Thus it makes sense that in a politics of intellectual struggle, epistemological questions have prevailed, and, as in the disciplines beyond women's studies, have come to displace or cover over ontological questions. Twentieth-century thought has followed this trajectory — the translation of metaphysical questions about the real into epistemic questions of the true — which is also a translation of the categories relevant for the object into those now concerned with the subject. Feminist theory needs to turn, or perhaps return, to questions of the real — not empirical questions regarding states of affairs (for these remain epistemological), but questions of the nature and forces of the real, the nature and forces of the world, cosmological forces as well as historical ones. In short, it needs to welcome again what epistemologies have left out: the relentless force of the real, a new metaphysics.

This means that, instead of further submersion in the politics of representation, in which the real can only ever be addressed through the lens imposed on it by representation in general and language or discourse in particular, where ontology is always mediated by epistemology, we need to reconsider both representation and representational forces in their impact on the mediation of the real. This image of the real enshrouded by the order of representations, an order which veils us from direct access to the real, is perhaps the most dominant residue of how "postmodern feminists," and especially those influenced by deconstruction, understand the real — as what can never be touched or known in itself, an ever-receding horizon. We need to reconceptualize the real as forces, energies, events, impacts that preexist and function both before and beyond, as well as within, representation.

Doing so would open up a series of new questions and new objects for feminist interrogation, not just social systems but also natural systems; not just concrete relations between real things but relations between forces and fields; not just economic, linguistic, and cultural analysis but also biological, chemical, and physical analysis; not just relations between the past and present but also between the present and the future.

Tied in with these two points, feminist theory needs to affirm, rather than the subject and what it knows, feels, and believes, and the cultural which constitutes, defines, and limits this subject, what is *inhuman* in all its rich resonances. We have tended to oppose culture to nature, to see culture as variable and nature as invariable, culture as open to history and nature as closed to history, and this is the third aspect of feminist thinking that I would question. Feminist theory needs to place the problematic of sexual difference, the most fundamental concern of feminist thought at its most general, in the context of both animal becomings and the becomings microscopic and imperceptible that regulate matter itself. Sexual difference — the bifurcation of life into (at least) two morphological types, two different types of body, two relations to reproduction, two relations to sexuality and pleasure, two relations to being and to knowing — is not only our culture's way of regulating subjects, it is also the way in which the dynamic natural world has generated a mechanism for the production of endless variation and endless difference. Sexual difference is an invention of life itself which the human inherits from its prehuman past and its animal connections here and now (a subject that I discuss in later chapters). We have devoted much effort to the social, cultural, representational, historical, and national variations in human relations. We now need to develop a more complex and sophisticated understanding of the ways in which natural forces, both living and nonliving, frame, enrich, and complicate our understanding of the subject, its interior, and what the subject can know. In other words, feminism needs to direct itself to questions of complexity, emergence, and difference that the study of subjectivity shares in common with the study of chemical and biological phenomena. We need to understand in more explicit terms how newness, change, the unpredictable, are generated, and what mechanisms are available, perhaps below or above the level of the social, to explain the very unpredictability of social and political change. These are no longer the exclusive concerns of cosmologists and physicists; they also belong to those committed to social and political change.

I dream of a future feminist theory in which we no longer look inward to

affirm our own positions, experiences, and beliefs, but outward, to the world and to what we don't control or understand in order to expand, not confirm, what we know, what we are, what we feel. Feminist theory can become the provocation to think otherwise, to become otherwise. It can be a process of humbling the pretensions of consciousness to knowledge and mastery and a spur to stimulate a process of opening oneself up to the otherness that is the world itself. At its best, feminist theory has the potential to make us become other than ourselves, to make us unrecognizable.

SIX Differences Disturbing Identity

DELEUZE AND FEMINISM

In this chapter I would like to address, one more time, the question of difference, and especially sexual difference and how it may be more adequately thought through and represented than in the terms which are structured by any aspiration to universality or a broad humanity. Here I would like to explore, in more detail than in the previous chapter, how we might more positively conceptualize the vast range of differences that help constitute the category of "woman" and the terms by which we might think about difference. Instead of affirming the absolute specificity of our sexual and social identity, its unique particularity, through a concept of "diversity" — that is to say, through the ways in which recognizable and mappable characteristics are distributed through a population to render its members comparable and thus ultimately analyzable — I am more concerned with destabilizing identity, and addressing social and political problems. I intend to do so not with the (poor) resources of the past and present — the very resources patriarchy, racism, colonialism, religious zealotry, and class privilege have elaborated and maintained for their privileged subjects — but with the most underdeveloped and immanent concepts, concepts addressing the future and presenting a new horizon in which to dissolve identity into difference. If the problem of identity is, as I have just argued, one of the current limits of feminist thought, how might we think of some of the qualities that identity has explained up to now in other terms? How might we

talk about shared qualities and the differentiation and variation of features that make up social and natural categories, such as the category of woman?

Power

The ways in which identity and its relations to overlapping structures, social categories, and forms of social oppression are conceived through concepts like structure, location, positionality, and intersectionality *could* be developed in other, more promising directions. A more interesting and far-reaching question than, "How can we include the most marginalized social groups and categories in policies that are directed to easing their social marginalization?" is "How can we transform the ways in which identity is conceived so that identities do *not* emerge and function only through the suppression and subordination of other social identities?" If social and political identities, identities that are understood either essentially or in terms of historically and socially specific constructions, are only possible to the extent that they are defined in opposition to others, those defined as different from oneself, then perhaps the very concept of identity, and the search for personal and collective identity, a hybrid or "intersectional" identity, may be problematic and could be displaced by other concepts that more adequately convey both the cohesion and the open-endedness of acts that have been defined through the consistency of subject-agents.

I have already argued, along with many other feminists, that we need to overcome, somehow, the overwhelming dominance of identity politics, by which I mean the overriding concern with questions of who the subject is and how its categorical inclusion in various types of oppression is conceived. We must affirm, with Iris Young,[1] that such specification of identity in terms of race-class-gender–sexual orientation-and-ethnicity, must ultimately lead to individuality alone, to unique subject positions which then lose any connections they may share with other women in necessarily different positions. But if subjectivity, or rather the reduction of subjectivity to identity, is to be overcome in feminist thought, then we need other terms by which to understand these categories of oppression, terms other than those which converge on and find their unity through the subject.

Difference and Identity

The concepts of diversity and intersectionality were developed quite early in second-wave feminism through the interventions of black feminists, women of color, and other women who are also members of ethnic, national, and religious minorities. The critique of the invisible whiteness and the implicitly middle-class orientation of many early feminist texts and positions is by now quite well known. It can be traced from the early 1970s through the writings of feminists like bell hooks and Hortense Spillers and the texts of Gloria Anzaldúa and Chicana feminists to the more theoretical texts of feminist theorists like Elizabeth V. Spelman, Kimberle Crenshaw, Iris Young, and Patricia Hill Collins from the late 1980s and early 1990s, and on to contemporary concerns regarding women in the European Union or women and fundamentalist religions, as explored in the works of Saba Mahmood and others.[2] Nevertheless, the concept of difference — of pure difference, of a difference without or preceding preexisting terms, a difference without identity that resists concepts like diversity, plurality, and comparison, which imply a relation between two given entities, things, or identities — has a much larger though more neglected and less understood philosophical genealogy. Difference is what underlies identity. Perhaps identity is the misunderstood concatenation and congealing of the unstable play of differences *without* positive identity.

The concept of difference is elaborated most explicitly in the early semiological texts of Ferdinand de Saussure, who used it to explain the mechanisms by which language or materiality is able to signify, to represent what is other than and different from itself. For Saussure difference is the only positivity in language, which relates neither words nor things to each other, but functions only with the differences between words and the differences between things. Difference is what enables signs to function, and things to become (provisionally, momentarily) identical with themselves. It is the relations between different sounds and different concepts, signifers and signifieds, none of which ever exist as a unit or entity of pure sound or pure conceptuality that enables us to give a provisional meaning to any sign or to designate or refer to any thing.

As is well known by now, Saussurian semiology, coupled with Freudian psychoanalysis, enabled Lacan to understand the subject's identity as a kind of illusion of the ego, one of the psychical agencies which mistakes itself for the whole of the subject. This alliance of psychoanalysis with semiology

leads indirectly to the work of Derrida and his return to the notion of pure difference, now transformed outside of semiology and beyond psychoanalysis into the very methodology of the world itself as *différance*, the irreducible movement of self-transformation that defies identity, confinement, definition, or control; the endless possibilities of the world writing itself. *Différance* is the unrecognizable movement by which different things differ, but it cannot be identified with these different things insofar as it is both the condition of their appearance and also their dissolution as things. Derrida understands, beyond the centrality of language and signification which Saussure elaborated, that difference is the very mechanism of the world itself, the way in which all things, all entities, subjects, and objects, are both constituted and undone. Saussurianism, psychoanalytic theory, and deconstruction have provided some of the most powerful structural and poststructural tools and questions for feminist thought, from Luce Irigaray's and Julia Kristeva's subversions of psychoanalysis through the concept of difference, to Eve Sedgwick's, Gayatri Spivak's, Judith Butler's, and Drucilla Cornell's readings and transformations of deconstructive difference and its relations to colonial, antiracist, queer, and feminist political struggles.

But rather than Saussurian difference and the deconstructive strategies to which it gives rise, where difference functions primarily as a force of psychic or material representation, a leveling of the real through the symbolic, I am interested now in addressing how difference problematizes rather than undergirds identity. And for this purpose, we perhaps need a different genealogy, a non- or even anti-structuralist genealogy, a genealogy that runs from the work of that original genealogist, Nietzsche himself, to his most avid and dedicated readers in the twentieth century, Michel Foucault and Gilles Deleuze.

What I am interested in is an understanding of difference as the generative force of the world, the force that enacts materiality (and not just its representation), the movement of difference that marks the very energies of existence before and beyond any lived or imputed identity. It is the inhuman work of difference — rather than its embodiment in human "identity," "subjectivity," or "consciousness," rather than its reflection in and through identity — that interests me now, the ways in which difference stretches, transforms, and opens up any identity to its provisional vicissitudes, its shimmering self-variations that enable it to become other than what it is. I am more interested now in those differences that make us *more than we are*,

recognizable perhaps for a moment in our path of becoming and self-overcoming but never fixed in terms of how we can be read (by others) or how we classify ourselves, never the basis of an identity or a position, even a fractured identity and multiple positions.

In short, one of the problems of feminist theory is its reliance on images of social relations conceived in terms of identities, even if those identities are rendered more complex through intersectionality, that is, through imagining a kind of series of interlocking oppressions, whether these are understood in terms of various metaphors of overlapping axes or crossing structures or intertwined systems of separate orders of oppression. This merging and multiplication of forms of oppression is always understood as the accretion, accumulation, and complication of readily definable and separable processes of oppression. There is no question for theorists of intersectionality that patriarchy is a system that is different from the system or order that constitutes racism, class, or postcolonialism, whether their relations are assumed to be additive (even in spite of the critique of the "ampersand," the additive connection of sex and race),[3] cumulative, or mutually transformative. Each oppression, while perhaps sometimes invisible to some, is ultimately assumed to be determinable, recognizable, and separable from the other forms of oppression with which it engages, and each has its specific effects on those subjects who occupy overlapping categories, or are members of numerous oppressed groups, constituting a matrix of domination, a hierarchy of misery.

Pure Difference

Deleuze has many representations of difference in his various writings, beginning with his reading of Bergson, the master theorist of difference, elaborating itself through his readings of Spinoza and Nietzsche, and culminating in his most philosophical text, *Difference and Repetition*. Here Deleuze outlines how the concept of difference is aligned, repressed, and evaded in the history of Western thought, but also the ways in which nevertheless a monstrous, impossible, unconstrained difference is implicated in all concepts of identity, resemblance, and opposition by which difference is commonly understood and to which it is usually reduced. Deleuze wants to think difference *in itself*, difference as a process which produces itself. Difference is not a vagueness or indetermination, an imprecision or failure of identity, but is precisely "the state in which one can

speak of determination as such."[4] Difference is determination, specificity, particularity. Difference in itself must be considered primordial, a non-reciprocal emergence, that which underlies and makes possible distinct-ness, things, oppositions: "Instead of something distinguished from some-thing else, imagine something which distinguishes itself—and yet that from which it distinguishes itself does not distinguish itself from it. Light-ning, for example, distinguishes itself from the black sky but must also trail it behind, as though it were distinguishing itself from that which doesn't distinguish itself from it."[5]

Difference is internal determination. Difference is the point at which determination, the lightning, meets the undetermined, the black sky. This difference in itself is continually subjected to mediation, restructuring, or reorganization—to a neutralization—through being identified with en-tities, things. Whatever identity there may be—lightning has the most provisional and temporary form of identity, an identity that is fleeting and intangible—difference is that movement of self-differentiation, that move-ment of internal differentiation that separates itself from the difference that surrounds and infuses it. Difference produces its own differentiations from the undifferentiated.

Deleuze identifies four philosophical techniques which reduce differ-ence to representation: identity, analogy, opposition, and resemblance. These are the four primary means by which difference is converted, trans-formed from an active principle to a passive residue. Difference is diverted through identity, analogy, opposition, and resemblance insofar as these are the means by which determination is attributed to the undetermined, in other words, insofar as difference is subjected to representation. Difference is always reduced to, as well as mediated, constrained, and translated by, the identical, the similar, the analogous, or the opposite: "Difference becomes an object of representation always in relation to a conceived identity, a judged analogy, an imagined object or a perceived similitude." This pure difference in itself, this process of self-differentiation that has no self before it begins its becoming, is the undermining of all identities, unities, cohe-sions, under the differing movement that both distances and decenters all identity. This difference is both ontological and moral, both the ground and the destination of thought.[6]

Unlike the Derridean concept of pure difference, a difference con-strained to the functioning of representation, a difference that resides in and infiltrates from the sign or text, Deleuze claims that representation is the

limit of difference rather than its privileged milieu or its mode of expression. Difference abounds everywhere *but* in and through the sign. It lives in and as events — the event of subjectivity, the event as political movement, the event as open-ended emergence. The sign and signification, more generally, are the means by which difference is dissipated and rendered tame. Difference is the generative force of the universe itself, the impersonal, inhuman destiny and milieu of the human, that from which life, including the human, comes and that to which life in all its becomings directs itself.

Thus difference is not, as the intersectional model implies, the union of the two sexes or the overcoming of race and other differences through the creation or production of a universal term by which they can be equalized or neutralized, a term that provides compensation for the wrongs done to social minorities according to their degrees of injury, even through the hybrid generation of intersectionality. Indeed, in spite of its claims to proliferate and acknowledge differences, such intersectionality actually attempts to generate forms of sameness, similar modes of access to social resources, through the compensation for socially specific modes of marginalization (for migrants, access to translation services; for battered wives, access to shelters, and so on). For Deleuze, in contrast, difference cannot be equalized, and social marginalization cannot be adjusted directly except through the generation of ever-more variation, differentiation, and difference. Difference generates further difference because difference inheres the force of duration in all things, in all acts of differentiation, and in all things and terms thus differentiated.

Difference is the name we can give to any identity — minoritarian, majoritarian, pure, or hybrid — for it is the force that underlies all temporary cohesions as well as the possibility of their dispersion. Difference is the acknowledgement that there are incomplete forces at work within all entities and events that can never be definitely identified, certainly not in advance, nor be made the center of any political struggle because they are inherently open-ended and incapable of specification in advance. Although they may appear to be static categories and are of course capable of conceptually freezing themselves through various definitions for various purposes, race, class, gender, and sexuality are precisely those differences that cannot be determined in advance. What sex, gender, and sexuality mean for, say, a poverty-stricken woman in Sri Lanka, or a working-class lesbian in Japan, or a single mother in Nigeria is in the process of being determined, and it is

wishful thinking on the part of the analyst or activist to believe that these differences can be represented by first-person voices, or measured by any "objective" schemas. (No voice ever represents a group, category, or people without dissent; and no categories are so clear-cut and unambiguous that they can be applied willy-nilly, without respect for the specific objects of their investigation.) What difference means and how it is lived remains an open question, to be negotiated by each generation and geography in its own, unpredictable terms.

Feminism and Difference

If we wish to affirm difference as central in our political theories and struggles regarding social change, then it is crucial to address two different concerns. The first involves the practical questions of social amelioration, which compensate socially marginalized groups — whether ethnic or religious minorities, indigenous peoples, migrants, queers, single mothers, the disabled, the sick, or the homeless — for their marginalization by attempting to provide conditions under which they can function more ably within prevailing social and economic networks. This project has occupied the work of many feminist activists, policy-makers, and social scientists. As our second concern, we must also address a more intangible, less measurable conception, a more philosophical and less practical concern, of difference as potential, virtuality, or the possibility of being otherwise. This dimension of social struggle is often deemed utopian, but it does not seem to be about addressing ideal conditions, conditions of perfection, which is the traditional and common concern of utopian theorists. Rather, it is about the future to be made and not the past and the present in idealized form; it is about ensuring that the future is different from the past and the present, that those subjects and social categories privileged or subordinated in the past or present have a future in which that social status has no guarantees. There is nothing idealistic about this concern. It is the question, the most central question, of all political struggles. How to bring about change, how to transform the present, not just reproduce its privileges which are now distributed to those previously subordinated? It is the task of the philosopher to address and welcome the question, the call, of the future, just as it is the task of the historian to address the pull of the past, and of the social scientist to address the forces of the present. But without this

call to the future that philosophy, along with the arts, offers, difference inevitably becomes bound up with difference between things which already are, rather than the generation of difference to come.

There are a number of implications of using this indeterminable concept of difference, difference as incalculable force, to address some of the central questions of identity, location, and value that currently concern feminism. First among these is that by focusing on difference rather than identity, on constitutive rather than comparative differences, feminist theory in its alignments with the struggles of peoples of color, ethnic and cultural minorities, and movements of postcolonialism and antiracism, can bring new questions to bear on social and policy questions. Instead of asking how to equalize differences, supplementing the least privileged through compensations sought from the most privileged, so that all subjects have access to the rights of the most privileged, we need to address the question of whether a plurality of subject positions can be adequately accommodated by the ideals represented by the able-bodied, white, middle-class, Eurocentric, male heterosexual subject. That peoples of color seek the rights of whites, and gays seek the rights of heterosexuals is, it seems, a highly contestable claim.

The concept of difference entails that there cannot be a unified subject-position, no matter how specified and hyphenated it may be; that is, there can be no speaking as a Latina or Asian lesbian, as if this label or position itself isn't an abstraction of the differences within this constituency. Difference means that there cannot be one aim, goal, or ideal for all sexes, races, classes, or constituencies, no common goal, interest, terrain of negotiation. Only liberalism gives us the pretense of unity through its assumption of a rational, self-identical subject who knows its own already existing interests and can thus adequately represent all others in the same broad position.

The concept of difference, ironically, does link together various categories of subject, various types of identity, humanity itself, not through the elaboration of a shared identity, but through the common variation or difference that the human, in all its modalities, asserts from the inhuman, both the subhuman (material, organic, and living forces) and the superhuman (the cultural, the collective, the cosmic, and the supernatural). The second implications of using the indeterminable concept of difference is that this perspective, which inserts cultural and political life in the interstices between two orders of the inhuman — the pre-individual and the impersonal — provides a new framework and connection, a new kind of liberation

for the subject, who understands that culture and history have an outside, are framed and given position, only through the orders of difference that structure the material world. This is the work currently explored by Deleuzians in relation to social networks or assemblages.[7] This notion of difference, Deleuze makes clear, is not an imprecision in our understandings of space, time, and materiality but the very means of their operation. Becoming, and dispersion, spatial and temporal elaboration, are part of the "nature" of any thing, entity, or event. Becoming means that nothing is the same as itself over time, and dispersion means that nothing is contained in the same space in this becoming. And so a third implication of this concept of difference, is that difference is the undoing of all stabilities, the inherent and immanent condition for the failure of identity, or the pressure to develop a new understanding of identity that is concerned not with coinciding the subject with its past so much as opening the subject up to its becoming-more and becoming-other. Difference means that the constraints of coherence and consistency in subjects, and in the identity of things or events, is less significant than the capacity or potential for change, for being other.

A final implication is that the very notion of separate forms or types of oppression, or the notion that various forms of oppression are recognizable, systematic, and distinct (if overlapping) structures, perhaps needs to be reconsidered. Perhaps these structural conceptions of power need to be transformed. I certainly do not want to suggest that there is no such thing as oppression, but we could reconsider the terms by which it is commonly understood. Oppression is made up of a myriad of acts, large and small, individual and collective, private and public: *patriarchy*, *racism*, *classism*, and *ethnocentrism* are all various names we give to characterize a pattern among these acts, or to lend them a discernable form. I am not suggesting that patriarchy or racism don't exist or have mutually inducing effects on all individuals. I am simply suggesting that they are *not* structures, *not* systems, but immanent *patterns*, models we impose on this plethora of acts to create some order. What exists, what is real, are these teeming acts—the acts of families, of sexual couples, and of institutions and the very particular relations institutions establish between experts and their objects of investigation; the acts of teachers and students, of doctors and patients, of migrants and those whose roots in a nation run deep. Patriarchy, racism, and classism are the labels we attach, for the sake of convenience, a form of shorthand, to describe this myriad of acts that we believe are somehow systematically connected.

There is thus no self-contained system of patriarchy that is capable of being connected to a self-contained system that is racism to form an intersectional oppression. There is only the multiplicity of acts, big and small, significant and insignificant, that make up racist and patriarchal networks; regimes of acts, including those acts which constitute knowledges as well as those acts which make up institutional practices. Patriarchy, racism, heteronormativity, and other forms of oppression consist in these various acts.

If we understand that this multiplicity configures in unique ways for each individual yet enables shared patterns to be discerned for those who share certain social positions, then we will not confuse these acts for a latent order or, worse, for a coercive system. Instead, we will be able to see, not just how socially marginalized groups are discriminated against, but also the agency and inventiveness, the positive productivity, that even the most socially marginalized subjects develop or invent through the movements they utilize and the techniques that marginalization enables them to develop. The acts that constitute oppressions also form the conditions under which other kinds of inventions, other kinds of acts, become possible. Perhaps there are only differences, incalculable and interminable differences, for us to address—no systems, no identities, no intersections, just the multiplying force of difference itself. It may be that these acts, and the immanent patterns they form and the bodily alignments they create, are as close to identity as we can get. In this case, identity cannot be understood as what we are, the multiple, overlapping categories that make us into subjects; rather, we are what we do and what we make, we are what we generate, which may give us an identity, but always an identity that is directed to our next act, our next activity, rather than to the accretion of the categories that may serve to describe us.

Irigaray and the Ontology
of Sexual Difference

I am . . . a political militant of the impossible, which is not to say a utopian. Rather, I
want what is yet to be as the only possibility of a future.
— LUCE IRIGARAY, *I Love to You*

It is not only feminist theory but also the very discipline of philosophy that
owes a debt of acknowledgement and recognition to the writings of Luce
Irigaray. Although she has been long recognized as a leading figure in
"difference feminism," it is only very rarely that she has been acknowledged
as a philosopher of great originality, a major thinker whose primary contri-
butions may best be understood, not in terms of a theory of the subject, a
field already established through phenomenology and psychoanalysis, but
rather in terms of her contributions to and transformations of ontology.
She has been commonly accepted as a philosopher of ethics or of politics, a
reader of key texts in the history of philosophy, and even a contributor to
epistemology and, at a stretch, to aesthetics, but it is only rarely accepted
that, with perhaps Deleuze alone, she is responsible for a return to those
questions that could never in fact be avoided even though they succeeded in
being translated into other terms for nearly a century. I refer to the terms by
which we understand our existence as beings in a world larger than our-
selves, a world not entirely of our making, whose limits and constraints
provide the very limits and constraints of thought itself. Irigaray enables

us to rethink the real along with the processes involved in rethinking subjectivity beyond its universalizing human norm.

There have been a few feminist theorists who have seen Irigaray's writings as "ontological" in its broadest sense (for example, Margaret Whitford and Ellen Mortensen), but they generally have been reluctant to describe them as metaphysical. However, I believe that as much as a theory of the subject, or a theory of political and civic order, it is precisely a new metaphysics, a new account of the forces of the real and the irreducibility of a real that is fundamentally dynamic, that Irigaray proposes in her writings. If she elaborates a theory of the subject, which is the concern of her earliest psychoanalytically inflected writings, it is the first step in a broader, more ontological, and less psychological direction, where the bulk of her writings lie. And if her most recent work has been directed to rethinking the function of the couple in personal, social, cultural, and political life, this attention is rendered necessary because being is divided into (at least) two irreducibly different types, and social and political life has at least as part of its aim the constitution of an order that will enable these two to coexist. As Irigaray writes, "A revolution in thought and ethics is needed if the work of sexual difference is to take place. We need to reinterpret everything concerning the relations between the subject and discourse, the subject and the world, the subject and the cosmic, the microcosmic and the macrocosmic."[1]

Irigaray's project is nothing short of the elaboration of a new understanding of the real, a new conception of the dynamic forces of the universe itself, half of which have been hidden and covered over by the other half. Hers is not simply the project of restoring female subjectivity or femininity to where it should belong, in the position of an adequate and respected partner of man the subject. Rather, her project is much broader, for it aims at destabilizing the ways in which we understand the world, and a reformulation of the real that brings with it a transformation of the ways in which we understanding epistemology, ethics, and politics. It is Irigaray's ontological and metaphysical orientation that distinguishes her writings from those of the majority of feminist theorists, whose concerns we may understand as primarily about transformations in empirical reality. Unfortunately, this orientation is also responsible for many misunderstandings regarding her work and for some of the most strident criticisms — namely, the charges of homophobia, racism, xenophobia, and Eurocentrism that have been directed at her work by other (usually white and usually hetero-

sexual) feminists. In outlining her ontological position, I will show that many of these criticisms are either misdirected or manifestly unfair.

Irigaray makes it clear that the future of sexual difference — with whatever openness it entails, with whatever inability to predict that this openness implies — is nevertheless irreducible, necessary, unavoidable to the extent that life is embodied, terrestrial, linked (by evolutionary elaboration, a hypothesis I will address in the next two chapters) to both the past and its overcoming. I want to use Irigaray's work to discuss the inevitable, if inevitably open, force of sexual difference, not only in the present but in the future — the irresistible future of sexual difference. Sexual difference is the difference which "is not one"; it is a mysterious force of creativity, indeed the very measure of creativity itself. She affirms: "I think that man and woman is the most mysterious and creative couple. That isn't to say that other couples may not also have a lot in them, but man and woman is the most mysterious and creative. Do you understand what I'm saying: people who are sexually different and who create a different relation to the world."[2]

This notion is the center both of her unique ontological claims and of the criticisms which commonly have been directed to her work, from her earliest writings to the present. But her claims here and elsewhere need to be carefully unpacked. Without sexual difference, there could be no life as we know it, no living bodies, no terrestrial movement, no differentiation of species, no differentiation of humans from each other into races and classes — only sameness, monosexuality, hermaphroditism, the endless structured (bacterial or microbial) reproduction of the same. Sexual difference is the very machinery, the engine, of living difference, the mechanism of variation, the generator of the new. Sexual difference ensures that each generation and each individual is unique, irreplaceable, new, historically specific, different from all others, and able to be marked in relation to others. Without sexual difference there may be life, life of the bacterial kind, life that reproduces itself as the same except for contingency or random accident, except for transcription errors at the genetic level, but there can be no newness, no inherent direction to the future and the unknown.

Life and creation would be separated, invention would be a rare accomplishment instead of the very breath and milieu of all living beings. Reproduction of the same would be a strategy rather than a given, difference being understood here as the force of invention, creativity, newness. The forgetting of sexual difference is the "dereliction in our time" (to borrow a

phrase from Irigaray), the forgetting of the conditions of life itself, and thus a kind of (atomic) imperiling of life from within, an inherent self-destructiveness in a life that does not admit its own complexity and entwinement with otherness. According to Irigaray, "The fundamental dereliction in our time may be interpreted as our failure to remember or prize the element that is indispensable to life in all its manifestations: from the lowliest plant and animal forms to the highest. Science and technology are reminding men of their careless neglect by forcing them to consider the most frightening question possible, the question of a radical polemic: the destruction of the universe and of the human race through the splitting of the atom and its exploitation to achieve goals that are beyond our capacity as mortals."[3]

Irigaray's works can be divided, not without some arbitrariness, into three broad phases or orientations. The first, more psychoanalytically oriented phase directs itself to the unearthing of a sexual difference and a specificity of the female from the maleness of the neutral or the universal. The second, more philosophically directed phase focuses on key texts in the history of Western philosophy, from the Greeks through to phenomenology and beyond. The third, current phase (developed since the publication of *I Love to You* [1992]), is directed more to an elaboration of the social, cultural, civic, and epistemic conditions for the engagement and productive encounter between the two sexes, now adequately acknowledged and recognized as radically different from each other; a sociopolitical, ethical, and civic analysis of the functioning of the couple. I want to focus on a key concept in this second phase that I believe draws together the strands elaborated — with remarkable consistency — in both early and late works from a philosophical career that spans more than forty years.

That sexual difference, the concept that remains consistent in all of her writings, from beginning to end, is an ontological and not just an empirical concept, a mode of being rather than a found or discovered object in the world, is the basis of my argument here. Sexual difference is, for her, not just one among many possible characteristics defining subjects; it is the universal, both natural and social condition (the natural and the social are undecidably indivisible), not only of subjects but of the human in general and of a living and dynamic nature in its totality.

Sexual difference *cannot* be overcome, it *cannot* be superseded, though of course its significance and social value is never self-identical and can never be assumed to be the same. It cannot be tied simply to its biological form

(which is itself inherently open to all uses and to all possible futures) or ascertained in advance. Sexual difference is ineliminable, the condition of all other living differences without itself having a fixed identity. Sexual difference is the principle of radical difference, the failure of identity, destination, or finality. It is the eruption of the new, the condition of emergence, evolution, or overcoming.

Difference is, arguably, the greatest philosophical concept of the twentieth century, the twentieth century's production of a new ontology, a new metaphysics whose implications ripple through all other forms of philosophy and through other modes of thought. Irigaray's particular contribution to metaphysics is her insistence that difference, if it *is* at all — and it is not clear that difference has a being, if that means an identity or stability — is primarily, or in the first instance, sexual difference, the difference that manifests itself in bodily morphology and in the logics of knowledge that follow from the privileging of one type of bodily morphology over another, or one type of dominance, mode of action, or type of thought over all possible others. If difference is the engine of the world itself — as Derrida and Deleuze seem to argue — then sexual difference is the engine of life, of nature, of all that lives.

SEXUAL DIFFERENCE IS THE QUESTION OF OUR AGE: if we had to reduce philosophy to a single question, a question that would shake ontology and bring a striking transformation of epistemology, ethics, aesthetics, and politics, it would be the question of sexual difference, the first philosophy, the philosophy that founds all others, founds all knowledges. This is why this question has the power and force to transform not only subjects (individuals and groups) but also cultures, knowledges, and practices that are not directly reducible to sexual difference but are flavored by its operations.

Sexual difference is the question or issue of our age because it is that which is not adequately represented in knowledges, practices, or values, in social or psychical life. It is the question of our age to the extent that the questions of difference it raises — questions that have dominated twentieth-century philosophy — can only be adequately addressed to the extent that sexual difference is their paradigm, the way in which difference cannot be reduced or explained away. The elision of sexual difference is the way in which all other (human) differences are also elided or repressed, covered over, and represented through singular norms. While Irigaray does not

herself refer to the writings of Darwin — the object of my speculative analysis in chapter 9 — she does confirm with him the inevitable and brilliant eruption into the world that the "discovery" or advent of sexual difference brings with it: endless newness, the adventures of life forever incapable of being predicted, forever open to the vagaries of chance, history, temporality in ways that cannot be controlled or understood in advance.

Her work is not alien to a Darwinian understanding of natural and sexual selection and is actively confirmed by his claims more than perhaps those of any other theorist of the nineteenth and twentieth centuries, as I argue in the following chapters, where I try to connect their respective projects. Darwin insists that sexual bifurcation, the division of species into (at least) two sexes, is an evolutionary invention of remarkable tenacity and value, for it multiplies difference *ad infinitum*. Irigaray's conception of nature as the differentiating and differentiated condition of subjectivity which living subjects forget or elide only at their own peril remains consistent with Darwin's conception of sexual selection — the division of species into two sexes, two different morphologies, and with it the advent of sexuality and sexual reproduction, and the generation of ever-new (genetic and morphological) characteristics and qualities, ever more morphological or bodily differences. Irigaray's conception of a sexually differentiated nature is not in dramatic opposition to a Darwinian account, though I believe her concepts cannot be directly absorbed into an eco-feminist position (in which nature takes on the maternal function, the function of making whole, of totalizing instead of operating as the site for the elaboration of difference). For Irigaray, nature itself is sexed, made up of (at least) two types of being, two forms of incarnation, two types of sexuality and morphology, two types of activity and interpretation:

> Before the question of the need to surpass nature arises, it has to be made apparent that it is two. This two inscribes finitude in the natural itself. No one nature can claim to correspond to the whole of the natural. There is no "Nature" as a singular entity. In this sense, a kind of negative does exist in the natural. . . .
>
> The natural, aside from the diversity of its incarnations or ways of appearing, is at least two: male and female. This division is not secondary nor unique to humankind. It cuts across all realms of the living which, without it, would not exist. Without sexual difference, there would be no life on earth. It is the manifestation of and the condition for the

production and reproduction of life. Air and sexual difference may be the two dimensions vital for/to life. Not taking them into account would be deadly business.[4]

Nature itself takes on the form of the two, of beings radically incommensurable with each other (each requiring their own bodily forms, reproductive organs, and modes of knowledge and forms of action) which nevertheless are capable of coming together, not only for sexual and reproductive purposes but perhaps precisely because of the appeal that difference or otherness holds in its proximity to the living being. According to Darwin, the emergence of sexual reproduction was such a momentous discovery that it soon marked the vast bulk of life on earth. As Irigaray argues, the mechanism of bodily variation is sexual difference. I will discuss later whether this argument in fact heterosexualizes Irigaray's work (an objection commonly leveled at it), placing her in the position of an apologist for normative heterosexuality, who reduces all other cultural and social differences to sexual difference. This is probably the most common anxiety expressed about Irigaray's work, whether from the angle of racial, religious, ethnic, or cultural differences. For the moment, however, I want to make it clear that Irigaray's writings, especially during her middle period, insist on the necessity and universality of sexual difference, the way it accompanies, even if it does not preclude or explain, all other differences.

Sexual difference, which Darwin acknowledges operates in the whole of nature (at least from the bacterial level upward), is the condition for the emergence of all other differences, even if these other differences (phenotypic or morphological) are not ultimately reducible to sexual differences. And this is the case, for Irigaray, because sexual differences have an ontological status, or rather, perhaps more interestingly, because ontology itself has always been sexualized, although the kind of sexual position and identity it has possessed has been covered over under the guise of the objective, the one, the neutral, the human. Irigaray claims that sexual difference *is* ontological difference, the condition for the independent emergence of all other living differences; sexual difference is the impetus for the eruption of all other human variations:

> Without doubt, the most appropriate content for the universal is sexual difference. . . . Sexual difference is an immediate natural given and it is a real and irreducible component of the universal. The whole of humankind is composed of women and men and of nothing else. The problem

of race is, in fact, a secondary problem—except from a geographical point of view . . . and the same goes for other cultural diversities—religious, economic, and political ones.

Sexual difference probably represents the most universal question we can address. Our era is faced with the task of dealing with this issue, because, across the whole world, there are, there are only, men and women.[5]

This is perhaps one of the most contentious claims that Irigaray makes in a lifetime of intellectual provocation. She argues that sexual difference is the universal condition for all other differences for two reasons. First, sexual relations, relations of reproduction, are the very relations that generate the morphologies of race, geography, and ethnicity, which are all social, contingent categories based on sociopolitical and historical reworkings of morphology and bodily variations. Race, ethnicity, and, to a much lesser extent, class and religion, are a function of the sexual and reproductive relations of the preceding, parental generation, contingencies of desire and power—random evolutionary effects, in Darwin's understanding. They are among the sociological implications and effects of ontological forces. Race, class, and religion are divisions imposed by cultures on sexed bodies, bodies which are differentiated from each other and in each generation through the implications of sexual reproduction. The second reason Irigaray finds that sexual difference is the universal condition is that, whatever other differences are generated, whether they are linked to the valuation of various social categories (classes, religions, ethnicities) or to mobile, transformable biological relations, they are always accompanied by sexual difference. To take the most contentious example: while heterosexuality is clearly governed by an oppositional understanding of masculine and feminine positions, theorists like Judith Butler, Drucilla Cornell, Gail Weiss, Tina Chanter, Ewa Ziarek, and Penelope Deutscher argue that perhaps homosexual relations, or better still, queer relations, altogether bypass this oppositional structure. Queer, ethnic, and race relations, for them, problematize Irigaray's ontological understanding of sexual difference.

As Butler suggests in her shared interview with Cornell, "A certain heterosexual notion of ethical exchange emerged in *An Ethics of Sexual Difference*. Clearly there is a presumptive heterosexuality in all that reading, which . . . actually made heterosexuality into the privileged locus of ethics. As if heterosexual relations, because they putatively crossed this alterity,

which is the alterity of sexual difference, were somehow more ethical, more other-directed, less narcissistic than anything else. . . . Here is the thing: do we want to say that sexual difference understood as masculine/feminine is the paradigmatic interval of difference? I would say no."[6]

For Cornell, as for Deutscher, Chanter, and Ziarek,[7] Irigaray's conceptions of woman, the feminine, or sexual difference cannot accommodate the other categories, particularly race and ethnicity, by which woman is also identified. In this objection, Cornell echoes the earliest critiques of Irigaray, developed by Monique Plaza and other Marxist feminists,[8] that contend Irigaray ignores class and class differences between women. More recently, with the demise of Marxist conceptions of politics, it seems that race comes to function as class once did. While Irigaray may mention race and other cultural differences, she largely ignores the racial and cultural differences between women. Cornell charges that "Irigaray simply cannot grapple with someone who is a woman whose 'feminine difference' is inseparable from imposed personas that she has to live with in a racist society like our own, one in which Spanish culture and society has been evacuated of cultural significance. . . . [O]ur categories of traditional gender-understanding simply cannot grapple with the kinds of oppression and alliances that are mandated by a sense of 'being a woman.' And that for me has become the limits, particularly of the later Irigaray."[9]

In brief, for Butler, Irigaray's account of sexual difference reduces sexuality to a version of heterosexuality, and for Cornell, it reduces ethnic and presumably class identity to an expression of a sexual or gender identity where it might not be appropriate. In other words, both accuse her of privileging sexual difference over all other types of difference. But are these claims accurate or fair? While I certainly agree that sexual difference is universal, an ontological condition of life on earth rather than a performatively produced artifact as Butler's work claims, it also seems fair to suggest — as Butler and Cornell do — that it may not be directly relevant to or the most significant thing about other forms of oppression (sexual, religious, racial, ethnic, class, and so on).

But Irigaray never claimed that in addressing other forms of oppression we should consider sexual difference the most important, only that we should consider our oppression where it affects each of us the most directly, where it touches each of us in our specificity. This means that in many contexts, the question of sexual difference need not be the most central, the most relevant and revealing. Even in her earliest writings, Irigaray makes it

clear that women's struggles need to be directed to where they are most acutely lived, which cannot be adjudicated by someone else. She maintains that one needs to act according to one's own interests, which are highly specific: "I think the most important aim is to make visible the exploitation common to all women and to discover the struggles which every woman should engage in, wherever she is: i.e., depending on her country, her occupation, her class, and her sexual estate — i.e., the most immediately unbearable of her modes of oppression."[10]

Irigaray suggests that although women may have common struggles, independent of the issues of race, class, and sexuality (and this, after all, is feminism's basic contention), this does not mean that all women must commit themselves to the same struggles! For many if not most women, race and class may be where they experience and express their oppression most acutely. We must, all of us, struggle where our oppression is the "most immediately unbearable," where we experience it the most directly, and where we can act on it with the most effect.

One must question Irigaray's critics seriously to discover, within sexual relations (and particularly queer sexual relations, for Butler) and relations of ethnicity and globalization (for Cornell, Weiss, and Chanter), whether sexual difference is indeed really as insignificant as they suggest. I cannot see how an understanding of sexuality, sexual pleasure, desire, and identity can be developed which doesn't discern, as part of its very operations, the relative values of and attraction to the particularities of male and female bodies, organs, and activities. The body of the lover in any sexual relation is never a matter of indifference, and even in the case of intersexed bodies, as relatively rare as they are — that is, in the case of bodies that are not clearly classifiable as male or female — the form, nature, and capacities of the body are crucial elements of sexual attraction.

Butler talks of nontraditional families, for example, but that the family, as well as the right to marry and to have or adopt children, is itself an object of struggle within queer politics is only because heterosexuality *has* formed the template, even if it is a challenged template, for the creation of the family, especially nontraditional families, which express patriarchy as readily as the traditional family. Somebody takes on the role of mommy or daddy, although it is no longer clear that the mommy is a woman and the daddy is a man. To the extent that the roles of mommy and daddy are perpetrated even within gay families is the extent to which sexual difference and the ideal of the couple generated through sexual difference remain

pervasive in our structuring of domestic relations. This is even truer in the case of butch-femme relations, however parodic they may be.

And in the case of Cornell's objection that other differences than sexual difference — particularly ethnic, racial, and cultural differences — may be as significant as sexual difference and may serve to problematize its centrality, it is certainly true that one may experience one's oppression much more acutely as a member of an ethnic minority, a particular class, or persecuted religion (Irigaray in no way denies this), but it is also true that how one experiences one's race, class, ethnicity, or religion is sexually differentiated. Ethnicities, religions, and forms of social stratification function and are expressed differently according to whether one is a boy or girl, man or woman. Race, ethnicity, and religion are no more homogenous or cohesive than sexual difference and are inflected by sexual difference as sexual difference operates through race and class. It can be argued, as Irigaray does, that all forms of Western (and probably Eastern) religion still affirm the hierarchical relations between man and woman, husband and wife, and part of the explanation for their resurgence in the late twentieth century is a backlash against the coming of sexual difference. The construction of a category like "Latina" is only possible or even desirable to the extent that feminism has made it clear that "Latino" is not a category that adequately and unambiguously includes women. In other words, ethnic, religious, postcolonial, and antiglobalization struggles are enriched rather than impoverished by an understanding of sexual difference which does not operate at the expense of these other categories but only ever in conjunction with them. If class, race, and gender are not intersecting categories or structures, as I have argued in the last chapter, then they are lived through sexed bodies and the forms of categorization to which living sexed bodies succumb; the practices of these living bodies are structured through the historical and cultural meanings of race, class, ethnicity, and other forms of identity. One lives one's identities, whatever they may be, however complex their intricacies, within a sexed body.

Irigaray argues that whatever else one might be — whatever race, class, sexuality, nationality, ethnicity, and religion one might be assigned to — one is assigned only as male, or as female, or in the mode of some identification with male or female. She questions, not homosexuality, nor ethnic identification, but only the disavowal of one's own morphological specificity. However queer, transgendered, and ethnically identified one might be, one comes from a man and a woman, and one remains a man or a woman, even in the case of gender-reassignment or the chemical and surgical transforma-

tion of one sex into the appearance of another. Sexual difference is still in play even to the extent that one identifies with or actively seeks the sexual organs and apparatus of the "opposite" sex: at most one can change the appearance and social meaning of the body, but the sexually specific body that is altered remains a sexually specific, if altered, body. Sexual difference has no one location, no one organ or condition. This is why surgical or hormonal alterations do not actually give one the body of the other sex, instead providing an alteration of only some of the key social markers of gender. Irigaray directly addresses this issue:

> Between man and woman, there really is otherness: biological, mor-phological, relational. To be able to have a child constitutes a difference, but also being born a girl or a boy of a woman, who is of the same or the other gender as oneself, as well as to be or to appear corporeally with differing properties and qualities. Some of our prosperous or naive contemporaries, women and men, would like to wipe out this difference by resorting to monosexuality, to the unisex and to what is called identi-fication: even if I am bodily a man or woman, I can identify with, and so be, the other sex. This new opium of the people annihilates the other in the illusion of a reduction to identity, equality and sameness, especially between man and woman, the ultimate anchorage of real alterity. The dream of dissolving material, corporeal or social identity leads to a whole set of delusions, to endless and unresolvable conflicts, to a war of images or reflections and to powers being accredited to somebody or other more for imaginary or narcissistic reasons than for their actual abilities.[11]

Whatever other features may characterize subjectivity — whether race, class, and sexuality, or class, caste, and religion — for Irigaray sexual differ-ence is a necessary accompaniment, a necessary differentiation and mode of inflection of each of the other social categories. And this is primarily be-cause, for Irigaray, sexual difference is of a different ontological order than other relevant social differences, for in addition to being one of the most significant social characteristics, it is also that around which the transition from nature to culture and from culture back to nature is affected. Irigaray says:

> To succeed in this revolutionary move from affirmation of self as other to the recognition of man as other is a gesture that also allows us to pro-mote the recognition of all forms of others without hierarchy, privilege

or authority over them: whether it be differences in race, age, culture, religion.

Replacing the one by the two of sexual difference thus constitutes a decisive philosophical and political gesture, one which gives up a singular or plural being [l'être un ou pluriel] in order to become a dual being [l'être deux]. This is the necessary foundation for a new ontology, a new ethics, and a new politics, in which the other is recognized as other and not as the same: bigger or smaller than I, or at best, my equal.[12]

It is not that all other differences are not significant — on the contrary, they are the very marks of a particular historical and geographical moment and of particular social struggles and concrete power relations — they simply function in a different manner. Each has a history, a specific temporality, concrete social and political conditions under which it operates and beyond which it collapses. Classes rise and fall, and their functioning is utterly transformed through upheavals in production. Sexuality, too, as we have learned from Foucault and many others, is remarkably volatile and flexible, able to alter and adapt, reconstruct its constituent parts, alter its social and intimate bonds; the same is true for religious, ethnic, and national differences. Each functions, is altered, and perhaps even is eliminated according to historical exigencies. But through each of these historical upheavals and readjustments, sexual difference — which of course also functions according to social conventions — nevertheless insists on intervening and is the very mechanism for the transmission from one generation to the next of all other living differences.[13]

Whatever historical circumstances are conceivable, there is no overcoming of sexual difference. Each culture is impelled in its own ways to mark, accommodate, and perhaps erase sexual difference as it does with no other difference. That is why the future, whatever unpredictability it might entail, will always contain and express sexual difference, to which it is inevitably drawn. While there is no given form or static force behind sexual difference, and while its forms of expression and representation are potentially infinite in number, it is clear that no social upheaval is going to be thoroughgoing enough to eliminate or even overcome sexual difference. (At best, it will simulate sexual difference, simply reproducing it in another form, as in the case of artificial insemination or fertilization.) Irigaray has understood, as no other thinker has before her, that the immeasurable and unrepresentable difference between the sexes, a difference that is not calculable or represent-

able in any fixed frame, is an ontological force, a force larger than and lived through individuals that infects all other differences and ensures that they too are lived in sexually specific ways. She has understood that this is not to be lamented or overcome, but to be more adequately celebrated and enjoyed. The opening up of humanity through sexual difference is an opening up as well of class, race, ethnic, and sexual relations to difference, to variation, to multiplicity, to change, to new futures.

animals, sex, and art

Darwin and the Split between Natural and Sexual Selection

The relations between feminism and Darwinism have always been complicated, ambivalent, and multistranded. From the very outset, feminists have resisted many of the assumptions, methods, and questions Darwinian thought has developed. Shortly after the publication of Darwin's *The Descent of Man, and Selection in Relation to Sex* in 1871, Antoinette Brown Blackwell published *The Sexes throughout Nature* (1875), and Eliza Gamble published *The Evolution of Woman: An Inquiry into the Dogma of Her Inferiority to Man* (1893). Both were concerned, not with Darwin's understanding of the relations between the production and inheritance of variation and the operations of natural selection, that is, with his broad understanding of evolution, with which they concurred, but rather with his understanding of sexual selection. They were alarmed by what they perceived to be Darwin's privileging of the male position and its concomitant values. This suspicion has marked the development of Darwinian thought since its inception.

Feminists have had reason to be extremely wary of the eruption of new Darwinian projects that seemed to emerge at precisely the same time as the resurgence of feminist thought in the late 1960s and 1970s (For example, E. O. Wilson's *Sociobiology: The New Synthesis* was first published in 1975). Many have quite justifiably distanced themselves as much as possible from the essentialist and reductionist assumptions that proliferated with the eruption of sociobiology and the merging of natural with sexual selection, and the reduction of culture to nature that was effected through it. Socio-

biology and its contemporary heir, evolutionary psychology, have, through their reduction of maleness and femaleness to their reproductive capacities and activities alone, become the objects of considerable debate among contemporary feminist theorists working in both the sciences and the humanities. While it is clear that there is immense resistance to sociobiological thought from many feminist scientists, it is also clear that there is a growing body of feminists, many working within evolutionary biology and psychology, who believe that it can provide some answers to feminist questions about the tenacity of patriarchal power relations and the effectiveness of social policies addressing evolutionary effects.[1] I believe that some of the most serious problems facing feminist thought (outlined in chapter 5) — problems about the preeminence of identity, as well as problems about the replacement of ontological with epistemic questions, the consequent indifference to the real and a privileging of representation, and the privileging of the human at the expense of the inhuman, as if the human were the only space of culture and change — may be more directly addressed if we take seriously Darwin's writings, writings that are not adequately understood without philosophical as well as biological concepts, as openings to a feminism of difference.

Sociobiologists have performed a number of philosophical reductions — the reduction of the living body and its associated questions of embryology and development to its selfish genes (for the body is but the temporary vehicle for the immortal gene); the reduction of sexual selection to natural selection; the reduction of maleness and femaleness to the size of gametes; and the reduction of the continuity of life to algorithmic steps.[2] It is only a theoretical or philosophical rereading of Darwin's own texts that can restore the image of life as a whole, in all its elements, to our understanding of the life of species and to man *and* woman as participants in the same evolutionary schema. It is in the spirit of philosophy's — especially feminist philosophy's — capacity to think through the implications of scientific theses in ways that perhaps scientists cannot that I want to develop an analysis of the relations between natural and sexual selection in Darwin's own writings, for it is there that we find resistances to the contemporary impulse to reductionism, as well as resources for the construction of a more dynamic, open-ended, and ontologically complex account of sexual divergence, a primary concern of contemporary feminist thought.

If Darwin's works are carefully addressed, a new and quite different

understanding of sexual selection than that which dominates sociobiology emerges, one more consonant with a feminism of sexual difference, a feminism beyond the constraints of identity. Darwin's own writings outstrip those of his later interpreters: his meticulous attention to the accumulation of vast and detailed examples, as well as his focus on a larger philosophical picture of the lived world, is missing in the writings of many, perhaps most, of his followers. If sociobiology represents one position regarding how to understand life and its bifurcations, then perhaps feminist struggles (and their alliances with antiracist and postcolonial movements) represent another position that must be addressed and complicated, as they too are issues of direct relevance in Darwin's own texts. Darwin's writings may give us the resources to develop a counterforce to the prevailing scientism that dominates much of evolutionary thought and to the prevailing humanism that pervades much of feminist thought. I am not developing a critique of science or scientific method — Darwin's work itself is, after all, precisely the birth of a new kind of science, a new scientific attention to the question of history and the movement of time, that is, a major reconfiguration of how the sciences of life must work — but I am trying to ascertain what the limits of scientific relevance may be, the points beyond which some more general or theoretical reflections are necessary. And I believe that these reflections, to be of value, need to address some of the real questions facing feminism in the present.

Most feminists who have worked on Darwinian projects, either theoretically or empirically, have brought to his works a rather naive egalitarian understanding of feminism, in which its goal is to produce an equality or sameness between the sexes. It is only to the extent that feminism is committed to the primacy of sexual difference that the value and significance of Darwin's conception of sexual selection can be appreciated and the reductive impulses of social Darwinism resisted. Sexual selection is perhaps another way of understanding sexual difference, a concept that has been bound up with notions of representation and textuality. However, sexual difference neither is a purely representational and cultural concept nor is it reducible to biology, or ultimately to genetics. As I argued in the previous chapter, sexual difference is a concept, a framework, or rather, an ontology, that encompasses and reconfigures both nature and culture, both body and mind, both reproduction and the nonreproductive, both animal and human. We may find unexpected confirmation of Irigaray's claim, as I have

argued in the previous chapter, that sexual difference is the source of all other differences in the philosophical research on life that Darwin initiated.

To the extent that it is implicated in egalitarianism, feminism tends to resist Darwin's understanding of sexual selection, which has privileged maleness and attributed activity to it while affirming the relatively passive position of femaleness. Yet even though Darwin develops a theory of the centrality of sexual dimorphism (or polymorphism!) to the production of ever greater variation, his work has been understood in largely essentialist, biologistic terms by the vast majority of feminists, who either affirm this essentialism, or in some way want to challenge it.[3]

Darwin's conception of sexual selection is irreducible to natural selection, and thus is relatively independent of the principles of fitness or survival that regulate natural selection. Sexual selection operates as a principle that both is contained broadly within and also seeps into, complicates, and compromises natural selection. It is a principle of excess in relation to survival. This energetic excess is the condition for the production of biological and cultural extravagance, the uncontainable production of intensification, not for the sake of the skills of survival but simply because of its force of bodily intensification, its capacity to arouse pleasure or "desire," its capacity to generate sensation.[4] Darwin understood, far better than his contemporaries and successors, the irreducibility of sexual selection to strategies of survival, whether linked to gene maximization or to the creation of ever-greater numbers of progeny.

Darwin's writings are the ongoing provocation not only for new and inventive modes of experimentation and empirical research but also for the development and refinement of more rigorous and elaborate forms of analysis and interpretation, for a new philosophical understanding of life and the kinds of intensities and excesses it produces. He offers us the possibility of thinking of subjectivity and life in different terms than those which have prevailed in philosophy since at least the Enlightenment. Instead of separating man from the world of nature and from animal species (a separation accomplished in Cartesianism), Darwin affirms the fundamental connection between man and his animal ancestors and contemporaries. Instead of distinguishing between mental and physical qualities, or between cultural and natural properties, the mental or the cultural being those which serve in some way to separate the human from the animal and explain man's dominion over nature, Darwin affirms, as discussed in the opening chapter, the fundamental continuity of reason, morality, affect, and all the defining

qualities of the human with the animal, and the movement, obtainable by degrees, from the animal to the human (and beyond).

Darwin decenters man from the pinnacle of creation, he renders the human a temporary species, he makes life itself, not a rational strategy for survival, not a form of adaptation, but the infinite elaboration of excess, the conversion of the excesses of bodies, of natural objects and forms, into both new forms of body and also new forms of culture, new modes of social organization, new arts, new species. Darwin emphasizes, in ways not commonly recognized in the writings of his successors, the nonadaptive, nonreductive, nonstrategic investment of (most) forms of life in sexual difference and thus sexual selection.

We must understand his account of sexual selection as a principle different from and at times opposed to natural selection, a view entirely contrary to the tradition of social Darwinism, which sees them as ultimately two versions of the same principle (the principle of survival). Darwin himself thus offers an alternative reading to that posed by the so-called grand synthesis of Darwinian evolutionary theory with genetics. While of course I have no objections to or problems with genetics, insofar as it is addressed primarily to questions linked to genes, I do have a problem with the tradition, initiated long ago in the work of August Weismann on the distinction between the germ plasm and the soma, and elaborated in the work of Richard Dawkins, that explains the organism in terms of its genetic structure, and evolution primarily in terms of the struggle between genes. Sexual selection can be understood, not from the gene's point of view, which has become the only perspective considered in sociobiology, but from the point of view of the more inclusive entity, life, which is Darwin's object of analysis. Life has no privileged moments: neither at conception, at sexual maturity, at the moment of reproduction, nor at death is life understood any more essentially than at any other point. While there is a gene's perspective, there is also not only the obvious perspective of the living entity, there is also, as Nietzsche made clear, a will-to-power, an interest, a perspective, for every organ and every cell of the body, not just those of the gametes. This is what life is, the continuous reframing of every internal perspective with another equally valid perspective. Instead of privileging any one of these internal perspectives — indeed, the body is nothing but a vast, teeming multiplicity of such perspectives, nothing but a vast series of cells, organs, and (micro-) organisms, a network of aligned and competing forces or perspectives — I will analyze natural and sexual selection not from

the perspective of any part, however small, concentrated, and information-rich, but from the largest of these forms, from the point of view of organisms and their groupings into species.

It is by now a commonplace that there are (at least) two major respects in which Darwin's primary texts today require revision: his ignorance of the unit of variation and inheritance, the gene, and his ignorance of sex-specific hormones and their effects in generating primary and secondary sexual characteristics. However, it seems to me that while this is no doubt true, Darwin's work was so descriptively accurate and philosophically astute[5] that it remains agnostic with respect to the emerging complexities and disputes within genetics and endocrinology, and stands independent of these disciplines even as they may feed into evolutionary theory.

Except for some rare assertions, Darwin's work is not in need of revision, updating, or scientific modification, although of course it is fully open to conflicting interpretations and antagonistic frameworks. Rather, it needs to be understood not as historical artifact or curiosity but as containing a philosophical world-view of considerable sophistication and explanatory power, at least to the extent that it avoids the common pitfalls of its successors, which contain a multitude of reductionisms.

Natural and Sexual Selection

Darwin devoted considerable thought to the various ways in which natural selection can be understood. He begins his discussion in *On the Origin of Species* very carefully, by addressing artificial selection, the selective breeding of plants and animals, not according to the effects of environment and the competition from other individuals and species (this is what Darwin calls natural selection), but according to criteria selected by man. His claim is that artificial selection — domestic breeding — is only possible to the extent that it conforms to the parameters of natural selection, which also operates on phenotypes to select from some larger number the more desirable or fit from the less desirable or fit. He introduces sexual selection only very briefly, when he carefully differentiates it from natural selection. If natural selection is primarily directed to survival, the struggle for existence, then sexual selection is primarily directed to the attainment of possible sexual partners, which *may* lead to reproductive success. He opens up a rift between the demands of survival and those of sexual success:

This form of [sexual] selection depends, not on a struggle for existence in relation to other organic beings or to external conditions, but on a struggle between individuals of one sex, generally the males, for the possession of the other sex. The result is not death to the unsuccessful competitor, but few or no offspring. Sexual selection is, therefore, less rigorous than natural selection. Generally, the most vigorous males, those which are best fitted for their place in nature, will leave the most progeny. But in many cases, victory depends not so much on general vigor, as on having special weapons, confined to the male sex. A hornless stag or spurless cock would have a poor chance of leaving numerous offspring. Sexual selection, by always allowing the victor to breed, might surely give indomitable courage, length to the spurred leg, and strength to the wing to strike in the spurred leg, in nearly the same manner as does the brutal cock-fighter by the careful selection of his best cocks.[6]

Sexual selection enhances and intensifies the differences between the sexes, and explains the sometimes strange, often superficial, and generally nonfunctional qualities, properties, and behavior that distinguish one sex from another. Sexual selection is a principle needed to explain why it is that members of the different sexes within the same species differentiate them-selves in their appearance, not through the acquisition of survival skills or capacities but through enhanced attractiveness. Sexual selection alone can explain the differences between the sexes regarding, not reproduction itself, but appearances that are only indirectly connected to reproduction. Sexual selection influences the sexual appeal of individuals of one sex for other individuals (whether of the same sex or, more commonly, the other sex), and this is also the kind of appeal that is passed on to same-sexed progeny. Darwin explains, "Thus it is, as I believe, that when the males and females of any animal have the same general habits of life, but differ in structure, colour, ornament, such differences have been mainly caused by sexual selec-tion; that is, by individual males having had, in successive generations, some slight advantage over other males, in their weapons, means of defence, or charms, which they have transmitted to their male offspring alone."[7]

 In this quotation, we find much of what caused the indignation of feminist theorists. If sexual selection is the growing differentiation of the sexes from each other, *not* in terms of their reproductive capacities (which are linked to natural selection), but in terms of their appearance and the behavior surrounding courtship and sex—already an understanding of sex-

ual selection very different from a sociobiological conception which links it only to reproduction—then sexual selection is a principle different from and sometimes incompatible with natural selection. For feminists, many of the problems arise because Darwin attributes sexual selection primarily to the activities of male members of various species, and understands sexual selection to differentiate the two sexes in terms of male competition for females, and female selection of successful males.[8] In fact Darwin is quite open to observational details and spends considerable time discussing not only male competitions for females and the effects of female discernment and selection, but also female competitions for males and male discernment and selection, which is more common in insects, birds, and some species of fish than it is in mammals (Darwin, *The Descent of Man*, 2:276). For him, the "activity" of males and the "passivity" of females is not a given but an emergent and potentially changeable phenomenon.[9] And to suggest male eagerness and female reluctance are aligned with activity and passivity, respectively, is to render binary a range of qualities and behaviors that run through a series of gradations not adequately represented by only negative and positive terms. (This may be why Darwin spends literally hundreds of pages addressing the very different forms of sexual difference observable in animal and plant species: they cannot be adequately addressed in terms of only two.)[10]

In *On the Origin of Species*, Darwin makes it clear that sexual selection is the mechanism by which colors and sounds that in themselves may have no particular survival value become intensified; rendered more vivid, ornate, and complex; and come to have value in terms of their appeal, their beauty, their erotic effects. Sexual selection renders plants and animals more appealing, enhancing and intensifying their colors, forms, sounds, and smells. In the case of plants, this may entail the production of some excessive intensity that appeals, not so much to other plants, but to the insects and birds that fertilize them by transferring pollen, resulting in an excess of colors, smells, or shapes that appeal to and attract insects and birds, creating a kind of ménage-à-trois rather than a coupling between two. In the case of many animal species, sexual selection entails the selection of more beautiful and appealing partners, whose beauty *may* be passed on to their offspring, but which, significantly, also may not. It is not clear that the most fertile creatures are the most attractive and so get to exercise their taste and choice. As Darwin explains,

I willingly admit that a great number of male animals, as all our most gorgeous birds, some fishes, reptiles, and mammals, and a host of magnificently coloured butterflies, have been rendered beautiful for beauty's sake; but this has been effected through sexual selection, that is, by the more beautiful males having been continually preferred by the females, and not for the delight of man. So it is with the music of birds. We may infer from all of this that a nearly similar taste for beautiful colours and for musical sounds runs through a large part of the animal kingdom. . . . How the sense of beauty in its simplest form — that is, the reception of a peculiar kind of pleasure from certain colours, forms, and sounds — was first developed in the mind of man and of the lower animals, is a very obscure subject.[11]

If Darwin spends only a brief time addressing sexual selection in *On the Origin of Species*, this is not because he considered it a minor form of selection, a subsidiary, like artificial selection, to the more significant force of natural selection. On the contrary, it is because he recognized, even in his notebooks dating from well before its publication, how significant sexual selection is in the evolution of life on earth and what wayward, perhaps even deranging effects sexual selection has on the operations of natural selection.[12] It is so significant to Darwin that he devotes an entire book to it, *The Descent of Man, and Selection in Relation to Sex*, a book commonly assumed to be Darwin's reflections on how the principles of individual variation and natural selection affect man; in fact, it is primarily directed to extending and explaining this second principle of life on earth, sexual selection. The discussion of the descent of man takes up about a third of the text: the rest is devoted to an extraordinarily detailed discussion of the various forms of sexual selection, and their surprising and inventive creations in the worlds of animals and plants.[13]

In *The Descent of Man*, Darwin claims that sexual selection must be carefully distinguished from natural selection. This distinction cannot be understood simply as the separation of reproduction from all other aspects of life. Reproduction is, for Darwin, a function of natural selection. Erotic attraction is, by contrast, a part of sexual selection. Ironically, all those functions and organs that are directly connected to reproduction — for example the existence of anisogamy, or the vastly differently sized ova and sperm that so fascinate sociobiologists — these raw materials for most forms of sexual reproduction are considered by Darwin to be the consequences

and effects of natural rather than sexual selection (*The Descent of Man*, 1:256). Natural selection regulates the operations of birth and death, while sexual selection regulates the operations of beauty, appeal, and attraction.

Darwin admits that it is "in most cases scarcely possible to distinguish between the effects of natural and sexual selection" (*The Descent of Man*, 1:256), for there is no clear-cut distinction between what is beneficial for life in this generation and the next (the domain of natural selection), and what is beneficial for sexual attractiveness. Nevertheless, sexual selection is that which privileges some males over other males (or, less commonly, some females over other females), not in the struggle for survival, but in gaining some advantages over other males in terms of sexual attractiveness and in the ability to transmit these advantages to their male, or male and female, offspring. As Darwin explains,

> When the two sexes follow exactly the same habits of life, and the male has more highly developed sense or locomotive organs than the female, it may be that these in their perfected state are indispensable to the male for finding the female; but in the vast majority of cases, they serve only to give one male an advantage over another, for the less well-endowed males, if time were allowed them, would succeed in pairing with the females; and they would in all respects, judging from the structure of the female, be equally well-adapted for their ordinary habits of life. In such cases, sexual selection must have come into action, for the males have acquired their present structure, not from being better fitted to survive in the struggle for existence, but from having transmitted this advantage over other males, and from having transmitted with advantage to their male offspring alone. It was the importance of this distinction which led me to designate this form of selection as sexual selection. (*The Descent of Man*, 1:256)

Darwin's point is that sexual selection privileges some members of one sex over other members, not in terms of any survival skills, not even clearly in terms of who leaves the most progeny, but in terms of having access to their primary objects of desire or attention, in gaining access to those they deem most attractive. He continues:

> There are many other structures and instincts which must have been developed through sexual selection — such as weapons of offence and the means of defence possessed by the males for fighting with and driving away their rivals — their courage and pugnacity — their ornaments of

many kinds — which organs for producing vocal or instrumental music — and their glands for emitting odours; most of these latter structures serving only to allure or excite the female. That these characters are the result of sexual and not of ordinary selection is clear, as unarmed, unornamented, or unattractive males would succeed equally well in the battle for life, and in leaving numerous progeny, if better endowed males were not presented. We may infer that this would be the case, for the females, which are unarmed and unornamented are able to survive and procreate their kind. Secondary sexual characteristics . . . depend on the *will*, *choice* and *rivalry* of the individuals of either sex. (*The Descent of Man*, 1:257–58; emphasis added)

Sexual selection is that which privileges the beautiful and the attractive, sometimes counterbalancing survival skills with the skills of spectacular performance, including the performance of the (competing) body under those conditions which maximize its physical and muscular skills, as well as the performance of those activities which maximize its appeal to others. Sexual selection marks out the strongest, the fastest, the most adept, the most intricately or brightly ornamented, the most beautiful and attractive from their rivals, enhancing their appeal independent of their survival skills.

Sexual selection consists in the struggles between members of the same species to attract sexual partners, a struggle which may lead to conflict but rarely to death; natural selection, by contrast, is the struggle for survival. Each of these struggles is no doubt crucial to individuals of most species, but each functions very differently: "Sexual selection acts in a less rigorous manner than natural selection. The latter produces its effects by the life or death at all ages of the more or less successful individuals. Death, indeed, not rarely ensues from the conflicts of rival males. But generally the less successful male merely fails to obtain a female, or obtains later in the season a retarded and less vigorous female, or, if polygamous, obtains fewer females; so that they leave fewer, or less vigorous, or no offspring" (*The Descent of Man*, 1:278).

Even those beings less successful in the struggle for survival may be successful in attaining sexual partners and in leaving behind more progeny than those more successful in the struggles at the level of natural selection. Sexual selection is primarily the ability to attract or to choose one's most immediate and direct objects of attraction or desire, whether these objects are indeed the fittest, or the most appealing.

Competition and Choice

Sexual selection in the world of animals takes two forms, not alternatives but dual or bifurcated strategies that usually operate together with different degrees of emphasis, though they are each capable of operating alone. The first is rivalry or competition between males for the attention of and access to females (or more rarely, vice versa); and the second is female choice, the ability of females to discern and select those males that most please them (or vice versa). The widespread nature of male competitiveness — leaving aside for the moment the question of competition in the human — seems incontestable to Darwin.[14] Males compete through battle, performance, and constructions; through muscular prowess or experience; through beauty; and through a capacity to build, to catch, or to make. In doing so they not only create orders of dominance among themselves but also undertake acts to be viewed and judged by the females of their species. There are, on the one hand, forces that intensify male combat — antlers and horns, greater musculature or strength, the spurs on various birds and insects — and on the other hand, forces that intensify adornment and appearance, more and more beautiful and exotic feathers and patterns, colors, and sounds, rendering various species more and more spectacular. The first is a function of the ongoing intensification of male combat; the second is an effect of the increasing investment in female choice and taste.

In Darwin's characterization, it is female choice that accounts for much of the noisy colorfulness of living things — their artistic excessiveness, their increasingly enhanced attractiveness — while it is male combat that accounts for the intensification of sporting and war-like activities. Female preferences may have led to the privileging of attractiveness over fitness (a concept that is self-contradictory for sociobiology) and thus the increasing cost of ever more visible and spectacular animals. Darwin tells us,

> In a multitude of cases the males which conquer other males, do not obtain possession of the females, independently of choice on the part of the latter. The courtship of animals is by no means so simple and short an affair as might be thought. The females are most excited by, or prefer pairing with, the more ornamented males, or those which are the best songsters, or play the best antics; but it is obviously probable, as has been actually observed in some cases, that they would at the same time prefer the more vigorous and lively males. Thus the more vigorous

females, which are the first to breed, will have the choice of many males; and though they may not always select the strongest or best armed, they will select those which are vigorous and well armed, and in other respects the most attractive (*The Descent of Man*, 1:262).[15]

Do the most successful males competing against other males always become the males who most attract females and thus leave behind the most progeny? Is there an alignment or a potential disconnection between the two forces that operate to regulate sexual selection, male competition, and female choice? Do fierce competitiveness and the attainment of adornments and charms attractive to the other sex ensure greater numbers of offspring? According to Darwin, "Our difficulty in regard to sexual selection lies in understanding how it is that the males which conquer other males, or those which prove the most attractive to the females, leave a greater number of offspring to inherit their superiority than the beaten and less attractive males. Unless this result followed, the characters which gave to certain males an advantage over others, could not be perfected and augmented through sexual selection" (*The Descent of Man*, 1:260–61).

The question of female choice is more contentious than that of male combat, but it is just as necessary an assumption. It is female choice, more than male competitiveness — which may, after all, serve an indirect function of selecting natural fitness — that is a kind of unhinging of the scientificity of Darwin's claims, for, unlike many of his sociobiological and evolutionary psychology heirs, he links female choice to an indefinable form of taste and to the appeal of beauty that are incapable of generalization and are absolutely species-specific or relative. According to him, sexual selection is not linked to some implicit or unconscious discernment of fitness, as some recent analyses of beauty imply (relating beauty or appeal to symmetry and symmetry to health and physical vigor).[16] During Darwin's time as in our own, there was strong resistance to the conception of female taste in the appearance of males (and the consequent downgrading of male discernment's significance). Darwin devotes considerable effort to making it clear that female discernment and taste, even in the most humble species, is a warranted and confirmable claim: "Sexual selection depends on the success of certain individuals over others of the same sex in relation to the propagation of the species; whilst natural selection depends on the success of both sexes, at all ages, in relation to the general conditions of life. The sexual struggle is of two kinds; in the one it is between the individuals of the same

sex, generally the male sex, in order to drive away or kill their rivals, the females remaining passive; whilst in the other, the struggle is likewise between the individuals of the same sex, in order to excite or charm those of the opposite sex, generally the females, which no longer remain passive, but select the more agreeable partners" (*The Descent of Man*, 2:398).

Even at the most elementary animal levels, females have distinct preferences for one or more among many available and usually eager males. In the case of the peahen, after males compete with each other by parading and shaking their tails in front of a number of admiring peahens in an impressive display of beauty, commonly all the peahens will mate with a single peacock, the one that they all find most attractive. They may refuse to mate at all if this peacock is removed. It is not altogether clear whether the peahens each find the same peacock attractive or whether they are concerned with the interests of their peer group and thus driven to the most "popular" male by the interest of the other peahens. Generally, the more adorned one sex is, the more discerning the other seems to be, otherwise there hardly seems to be any reason for the continuity in and intensification of male ornamentation over time.

Not only are animal forms selected or rejected by the forces of natural selection according to various changeable and environmentally specific criteria (remembering that natural selection does not cause individual variation but at best selects from variations already given), but they are above all given their variability, their remarkable forms, and amazing degrees of individual variation primarily from differences produced by sexual reproduction, which is itself the indirect consequence of sexual selection. Sexual selection is, in the vast majority of species, responsible for many of the bodily characteristics that mark each species and especially those that characterize its most attractive members in their sexually specific ways.

Sexual reproduction is part of natural selection, but the processes that lead to reproduction, as well as those activities that may not lead to reproduction, those activities which intensify the bodies and organs of living things, which excite and enervate the body for the sake of pleasure, display, and performance, are the consequences of the largely irrational, nonfunctional, nonadaptive operations of sexual selection. It is important to distinguish sexual appeal from any reproductive orientation, as many theorists in the sociobiological tradition do not, for not doing so risks not only a reduction of sexuality to reproduction but also the assumption that all

sexual encounters are either fundamentally heterosexual or in some sense preparations for, substitutes of, and addenda to heterosexual copulation.[17]

In approximately the last decade, there has been a vast wave of discussions of "queer" animals, or gay animals, animals that make same-sexed pairings and many cases where such pairings "adopt" or raise young. While sexual selection may primarily lead to the mating and opposite-sexed individuals and the possibilities for reproduction this may entail, it does also quite commonly—or so it has been noted in recent work such as Joan Roughgarden's—lead to all sorts of improbable pairings (a swan "in love with" a boat painted to look like a swan, for example), from forms of heterosexuality which lack all discernment, even the awareness of the absence of the female, to clear homosexual attachments. Given this recent fascination with commonly neglected forms of animal homosexuality—over 450 species have been identified thus far where homosexual activity has been observed—it seems clear that the standard arguments about sexual selection being linked to gene maximization, or the selfish gene's interest in its own perpetuation through reproduction, are problematized. On the models of sexuality which link it primarily to gene proliferation, to the maximization of progeny, homosexuality must be regarded either as a kind of rehearsal and compensation for the absence of heterosexuality or as a kind of mal-adaptation that has persevered only to the extent that it facilitates the gene maximization in others, close kin. Either it functions as a socially useful form of altruism (!), or it is the genetic or hormonal confusion of male and female. E. O. Wilson, for example, can only understand human homosexuality on the model of (male) companionship and friendship (the gay as the friendly helper of the straight), rather than on the model of variation and diversity. He must desexualize homosexuality in order for it to fit his model: "The homosexual members of primitive societies may have functioned as helpers, either while hunting in company with other men or in more domestic occupations at the dwelling sites. . . . They could have operated with special efficiency in assisting close relatives. Genes favoring homosexuality could then be sustained at a high equilibrium level by kin selection alone."[18] Even Dawkins admits that the existence of a "gay gene" or the ongoing historical reproduction of homosexually directed beings born from heterosexual parents is a problem for evolutionary accounts.[19]

This is a problem for Darwin's theory only if natural selection fully incorporates sexual selection. But if they are indeed two separate forces, a

separation itself produced by natural selection which represents the advantages of sexual over asexual reproduction, then nonfunctional, that is, nonreproductive encounters of all kinds that mark much, probably most, of sexual attraction are the consequence of sexual selection. The function of sexual selection is to maximize difference or variation, and it succeeds in doing this by maximizing sexual interests as much as bodily types or forms. Homosexuality and all the other possible encounters enabled by sexual attractions of various kinds are part of the production of variation for its own sake. And even if homosexuality does not reproduce itself sexually (which is not entirely clear, for there are some reproductive relations, especially if female as well as male homosexuality is considered — something that is extraordinarily rare in evolutionary studies), it is a continuous and regular product or consequence of heterosexual encounters. Evolutionary scientists are rarely interested in what they consider unproductive sexual encounters — those that do not result in reproduction — for this is the absence of an object of study. This means that those sexual encounters which cannot lead to reproduction are not regarded as genuine sexual encounters, because there is no measurable object of scientific investigation without reproductive success.

Homosexuality and other queer variants of animal sexuality cannot be reduced to maladaptive developments. The regularity of homosexual pairings in the animal world makes it clear that nature itself has no problem with the elaboration of all sorts of sexual activity that may have little to do with reproduction, for reproduction is in any case never or rarely the goal of copulation, only its frequent accompaniment. Likewise, we should reject the notion that homosexuality results from the undue influence of prenatal sex hormones that have somehow been misdirected to the "wrong" sex. Sexual selection is itself the bizarre and incalculable appeal of objects, whether other members of the same species, other members of the same sex, members of different species, or inanimate objects, that induce pleasure rather than progeny.[20] Sexuality is not about the production of a norm but about the eruption of taste. Animals themselves do not engage in copulation in order to reproduce; rather they engage in copulation because it in some way pleases or provides something of benefit for them. Reproduction is the side effect or by-product of sexuality, not its purpose, aim, or goal. This may be why sexual activity is pleasurable, rewarding in itself, done for nothing more than its own activities and intensities, its own internal qualities.

Male and female homosexuality are created generation after generation

with such regularity and in so many wide-ranging and disparate species that it would have been weeded out of species and populations except to the extent that it remains indifferent or neutral rather than negative or dangerous (to individuals or populations) with respect to natural selection. While it remains unclear what if any reproductive benefits a species' homosexual members bring it — this is the preeminent question of sociobiology — Darwin's understanding of natural selection does not entail the elimination of the unreproductive but only the elimination of the less fit under conditions of competition or stress. To the extent that homosexuality is no disadvantage in terms of natural survival, there is no reason to assume its eventual elimination; but more than this, homosexuality is itself a testament to the production of variation or difference in all its resonances that sexual selection brings to the life and forms of species. Homosexuality, like racial diversity or difference, as we shall see, is one of the many excesses that sexual selection introduces to life, like music, art, and language, excesses that make life more enjoyable, more intense, more noticeable and pleasurable than it would otherwise be.

If natural selection functions, in the terms provided by Georges Bataille, according to a restricted economy, according to determinable rules and procedures, then sexual selection functions according to a general economy, without order, without striations or organization. The laws of sexual selection are the principles of aesthetics, not the strategies of game theory; the functioning of appeal rather than the operations of rational agents who act according to their self-interests; the order of taste rather than forms of miniature calculation. Sexual selection is not the ability to choose the best genes for the following generation, but is rather the activity of spontaneous beings who operate according to their (sometimes) irrational desires and tastes to make bodily connections and encounters, sometimes but not always leading to orgasm or copulation, and even less frequently to reproduction. The forces of sexual selection exert a powerful effect on the development and unpredictable future of sexual beings, not only favoring the reproduction of certain privileged (more beautiful, forceful, or cooperative) beings, but also favoring certain privileged qualities, forms, or capacities, independent of their survival value. If sexual selection imperils natural selection, if it has a cost, produces a risk, this is because it also adds to natural selection the vagaries of individual (and species-specific) taste, an irreducible dimension of singularity.

Sexual Selection, Excess, Creativity

Sexual selection is above all creative. Darwin has suggested that sexual selection provides the artistic raw materials for song, dance, painting, sculpture, and architecture, or at least for the animal preconditions of these human arts, as we shall see in the following chapters. It is sexual selection that is responsible for the abundance of colors, sounds, shapes, forms, raw materials that can function to enhance the animal body and its surroundings. It is sexual selection that provides the energy, impetus, and interest in the production of excessive qualities, qualities over and above those that accomplish mere survival of the individual. Sexual selection may be understood as the queering of natural selection, that is, the rendering of any biological norms, ideals of fitness, strange, incalculable, excessive.

Sexual selection, as an alternative principle to natural selection, expands the world of the living into the nonfunctional, the redundant, the artistic. It enables matter to become more than it is, it enables the body to extend beyond itself into objects that entice, appeal, and function as sexual prostheses, as do twigs and leaves for birds. Sexuality and the imperatives of sexual selection render nature artistic; they enable a leaf, functional appurtenance of a tree, also to operate as an enticing opening for a nest or a speckled-patterned platform for the outpouring of song: they enhance the artisticness of birds, enabling birds to attract other birds through being bound up with something in no way contained in the leaf already. The leaf becomes a connective to the bird's erotic life and is no longer bound up with the tree and its capacity for survival. Sexual selection enables the leaf to have another "life," but also it enables the accidental colors, feathers, and features of birds to continue a life in the species that may not be warranted in terms of natural selection.

Sexual selection unhinges the rationality of fitness that governs natural selection (and this may be why the concept is so resisted and tamed in scientific attempts to measure and render predictable its operations). It does so, not by selecting the least fit or the less fit, but by selecting according to terms other than those related to fitness — beauty, appeal or attractiveness. (This is the case in spite of the attempt on the part of sociobiologists to demonstrate that the most sexually attractive individuals are the fittest, or that their sexual appeal is in some way an index of their health, vigor, or vitality.) Sexual selection unveils the operations of aesthetics, not as a mode of reception, but as a mode of enhancement.

It erupts massive variation and difference into the world of the living; it is a difference machine that ensures that all progeny vary from their parents, and that all individuals differ from each other (with the exception of identical twins). It is also a procedure which gives broad value even to the nonreproductive, explaining not only the enriched capacity for the production of life as difference, but also the generation of differences that may not be inherited insofar as they do not lead to reproduction but only to sexual activity.

Darwin attributes two of the most monumental evolutionary breakthroughs in human history to the operations of sexual rather than natural selection: first, the operations of language, which are part of a trajectory opened up by the possibilities of articulation and musicality that were first selected for their charm or appeal; and second, the diversification of the human into different races. This subject, mentioned in the opening chapter, is one to which I will now turn.

Music and Art

Articulation, the ability to produce sounds and make them harmoniously resonate — the most elementary form of music — is the direct result of sexual selection in Darwin's own understanding. Although contemporary sociobiology has insisted on the primarily functional advent of language or vocal communication, its adaptive or survival value, Darwin himself and some of the most recent theorists of the evolution of language have argued that both the growth of the brain and the development of linguistic and musical skills are the result of erotic intensification, that is, sexual selection, rather than natural selection.[21]

For Darwin, in opposition to Herbert Spencer and the tradition of social Darwinism that has followed from him, language is a consequence and outgrowth of musicality; it is the rendering functional of what initially emerged as sexual. It is because music, or the resonance of sound, appeals, entices, and eroticizes that vocalization or articulation is initially selected and preserved. Once so selected, this capacity can be utilized in different ways, and language may be the indirect result of the impact of such articulation: rather than language and functionality coming first, and music being the residual effect of language, it is language that is epiphenomenal, reliant on the primacy of the powerful erotic and emotional forces that music is capable of arousing.[22] Articulated sound functions not so much as warning

or communication of danger as a lure or enticement. This is because, as Darwin understands it, there is a pleasurable resonance that charms and signals to others that the stage for sexual activity has been set.

Darwin suggests that music and song are among the most primordial characteristics that humans share with other primates, and also with all the lower vertebrates. He claims that the generally male capacity to articulate or vocalize (the "musical powers possessed by the males" [*The Descent of Man*, 2:27]) is clearly capable of stirring or charming females, from the insect world up. Darwin seems to imply that either males gain combative bodily weapons to compete with their male rivals, or they are imbued with the power to charm, which results in bright, beautiful coloring, erotic ornaments, or the capacity to entice and allure through vocal means.

He evinces a number of arguments to affirm the claim that music is an achievement of sexual selection and that language is the derivative of the rhythmical elaboration of musical cadences. He claims that, first, there is a "great difference" between the length of vocal cords in males and females, among all the primates including man.[23] Second, castration or emasculation arrests vocal development so that a man's voice resembles that of a boy or a woman. Third, vocalization or articulation, especially among vertebrates, dramatically increases during breeding seasons and is sometimes never heard except during courtship ("The male alone of the tortoise utters a noise, and this only during the season of love" [*The Descent of Man*, 2:331]). Fourth, even in cases where females or both sexes vocalize, the amount, rate, or volume of vocalization dramatically increases during periods of courtship, led either by females or males. Fifth, it is likely that rhythmical repetition, resonance, has a pleasurable effect on all living things, possessing as it does the ability to move, to stir, to rally.

Shifting the argument to the functioning of rhythm, music, and song in man, Darwin elaborates this final claim. The appreciation of music is universal in man (though different groups clearly have different tastes), and is so primitive an impulse that it comes well before the division of the human into the different races, and is in fact one of the earliest connections between man and his animal predecessors.[24] Man is soothed or moved by music (and by the arts more generally), and it orients him away from the practical concerns of daily life to provide an immersion in sensation, which prepares and promotes sexuality and erotic intensification.

Music precedes the development of language and communication systems because it exerts such a powerful affective force on all living beings: it

clearly stirs emotions, and functions to rally intensity, calm, soothe, or excite. This is why music functions as an accompaniment to sadness but also stirs and readies social groups in the march to war, it accompanies mourning, or it intensifies affect at times of great sadness. Music resonates in ways that commonly appeal to the forces of living bodies.

These arguments make it clear that in Darwin's conception, the creation of music and art, visual display, and the joy of immersion in sonorous or visual qualities, are a primordial resource of sexual selection and not simply the by-product of the preparation and rehearsal for hunting, gathering, or communication. Darwin's assumption is that animals, even at the most primitive levels, have the power of discernment or taste, which enables them to appreciate and respond to musical and artistic enhancements of the body in members of their own species. And even simple animals can not only elicit such responses from their appearance, behavior, or activities but can regulate them so as to be enticing precisely during mating rituals and forms of courtship. The power to surprise and excite and the power to discern and appreciate are entailed in these sexually charged relations:

> Although we have some positive evidence that birds appreciate bright and beautiful objects, as with the Bower-birds of Australia, and although they certainly appreciate the power of song, yet I fully admit that it is an astonishing fact that the females of many birds and some mammals should be endowed with sufficient taste for what has apparently been effected through sexual selection; and this is even more astonishing in the case of reptiles, fish, and insects. But we really know very little about the minds of the lower animals. It cannot be supposed that male Birds of Paradise or Peacocks, for instance, should take so much pains in erecting, spreading, and vibrating their beautiful plumes before the females for no purpose. (*The Descent of Man*, 2:400)

Animals are artistic only to the extent that they function sexually, that is, are di- or polymorphic, have different bodily forms and characteristics that are attractive and enhance the appeal of the body. Music, painting, dance, and the other arts are only possible because the power to appeal and enhance seems to reside in regular ways in the use of colors, sounds, and shapes for the purposes of resonance and intensification. Art is the formal structuring or framing of these intensified bodily organs and processes which stimulate the receptive organs of observers and coparticipants. The sonorous and visual arts are possible only because the body finds intensities of sound,

color, and form pleasing and alluring. It may be, Darwin suggests, that this most elementary form of discernment or taste is the evolutionary origin not only of all art, but of language use and intelligence more generally. Only those living beings that have "sufficient mental capacity" (*The Descent of Man*, 1:99) to experience distinguishable pleasure from the observation of other processes or activities can undertake the labor of sexual selection and can begin the productive spiral that generates and provokes intelligence as its consequence. From taste to reason, from affect to order, from appeal to organization, Darwin suggests that the forces involved in sexual selection may be more powerful than those regulating natural selection in dynamizing and reorienting species not only to survival but to their own inner states, to their processes of perception and reception, their possibilities of intelligence, communication, and collective living. In doing so, he implies that these human-like qualities are not necessarily the accomplishment of intensified stakes in natural selection but are the surprising products of the forces of sexual selection:

> He who admits the principle of sexual selection will be led to the remarkable conclusion that the cerebral system not only regulates most of the existing functions of the body, but has indirectly influenced the progressive development of various bodily structures and of certain mental qualities. Courage, pugnacity, perseverance, strength and size of body, weapons of all kinds, musical organs, both vocal and instrumental, bright colours, stripes and marks, and ornamental appendages, have all been indirectly gained by the one sex or the other, through the influence of love and jealousy, through the appreciation of the beautiful in sound, colour or form, and through the exertion of a choice; and these powers of the mind manifestly depend on the development of the cerebral system. (*The Descent of Man*, 2:402)

Sexual Selection, Race, and Beauty

The question of beauty and taste so central to Darwin's understanding of the powers of sexual selection in the animal is also crucial in his rather innovative and surprisingly open account of the development of racial differences within the human. Although it is a commonplace to align much of Darwinism with racism, and not without good historical reason, seeing how certain versions of Darwinism have served to justify many practices of

extreme racism, it is important for us not to dismiss Darwin's work on human racial differences, remembering that *race* is an overloaded term and one that referred to the nonhuman as well as human, and sometimes even human as opposed to animal relations. Not only is his work far superior to virtually all that has followed regarding the question of race, but also he provides us with a way of understanding race not merely as social construct but as lived phenotype, as human variation or human difference. There has been considerable debate on the role of Darwin's work in both furthering and problematizing the labor of empire-building. What is clear, however, is that he consciously disavows the most obvious and worrisome forms of racism — that which, for example, announces a hierarchy between different races, linking the "lowest" forms to primates and the highest to European civilization, and the related claim that races are at different levels of development in an underlying movement of the progress of civilization. Instead he insisted that human beings all form a single species and that what largely and most significantly distinguishes the races from each other are customs and habits rather than any given or fixed biological characteristics.[25]

Racial differences — which he takes to be visible differences regarding skin, facial features, hair, and body types, as well as historically and economically different modes of social and cultural organization — are those differences produced, not by the direct effects of the environment (as sociobiology suggests), but through the operations of ideals of beauty and taste. Aesthetics more than any other factor once served to distinguish different types of human body from each other and enables these differences over vast numbers of generations to form systematic typologies of resemblance and difference that we call "race" today. It is taste that has served to differentiate into categories and types the systematic features that entice and appeal.

Darwin's argument, in this conceptual minefield of racist and colonialist fantasies regarding the order of human beings and their place in a divine and human hierarchy — undoubtedly the most contentious and politically problematic of all possible uses of evolutionary theory, the one most related to a history of eugenics, or the artificial selection of human subjects — is refreshingly straightforward. Not only was he vehemently opposed to slavery, a commitment made by his entire family, but his travels on the *Beagle* brought him into contact with a wide variety of different races and cultures and he saw the humanity in all.[26] Races cannot be understood in hierarchical terms, in terms of progress, in terms of gradations between the human and the animal, or in terms of the direct effects of the environment,[27]

though these are all caricatures of Darwin's own thought that have enabled it to be used to justify a variety of outrageous and shameful social practices, as was the tendency in nineteenth- and twentieth-century thought. Instead, races must be understood as ad hoc groups which share certain features, which form a broad consistency of recognizable characteristics only as a result of taste or preference.

Darwin's claim, in brief, is that slight variations in skin color, facial features, or other bodily or psychical characteristics that were once simply individual variations have proved to be pleasing and attractive, resulting in sexual selection. The proclivity to be attracted to these features is as heritable as are these features themselves. When repeated over many generations, these characteristics may help constitute a recognizable group, or subgroup, within a given population. This phenomenon coupled with the possibilities of geographical separation or dispersion and thus long-term isolation are the necessary conditions for the constitution of a subcategory or for incipient new races being created. Darwin explains,

> It is certainly not true that there is in the mind of man any universal standard of beauty with respect to the human body. It is, however, possible that certain tastes may in the course of time become inherited, though I know of no evidence in favour of this belief; and if so, each race would possess its own innate ideal standard of beauty. . . . The men of each race prefer what they are accustomed to behold; they cannot endure any great change; but they like variety, and admire each characteristic point carried to a moderate extreme. Men accustomed to a nearly oval face, to straight and regular features, and to bright colours, admire, as we Europeans know, these points when strongly developed. On the other hand, men accustomed to a broad face, with high cheek-bones, a depressed nose, and a black skin, admire these points strongly developed. No doubt characters of all kinds may easily be too much developed for beauty. Hence a perfect beauty, which implies many characters modified in a particular manner, will in every race be a prodigy. (*The Descent of Man*, 2:353–54)

Darwin argues that in the case of man, it seems certain that various characteristics — among them, the beard and men's general hairiness, men's deeper voices, and men's relative tallness to women — are the result of women's choosiness. Equally, women's greater relative beauty may be the consequence of male selectivity (*The Descent of Man*, 2:373–74). These

characteristics are the raw materials for what may later be characterized as racial differences. Darwin claims that the loss of hair in the transition from primate to man's progenitors may itself have been an effect of sexual selection. The increasing loss of hair from various parts of the body, he surmises, may not be the result of a preference for bare skin and the increasing vulnerability this entails, but rather a consequence of a desire to see the color of the skin, a desire to observe and be pleased by skin color, the most primary and obvious marker of race in our culture.

For Darwin, the differences between human races are a later emergence than the eruption of recognizably human progenitors. Racial differences are not steps or gradations of movement from the animal to the human, as much racist literature implies; rather, racial differences are all equally modifications or variations of a newly emergent, protohuman form.[28] The races, while they may be classified as subspecies, are in fact systematic variations of a broad, common humanity: "[Since man] attained to the rank of manhood, he has diverged into distinct races, or as they may be more appropriately called sub-species. . . . [A]ll the races agree in so many unimportant details of structure and in so many mental peculiarities, that these can be accounted for only through inheritance from a common progenitor; and a progenitor thus characterised would probably have deserved to rank as man" (*The Descent of Man*, 2:388).

Darwin's claim, which seemed preposterous to smug, bourgeois Europe, was that races, understood as distinct, physically similar groupings of human subjects, are the consequence of the particular appeal of certain racially associated characteristics and features that, repeated over generations, led to the formation of more or less coherent and visibly connected groupings of subjects. The form that races have today is a consequence primarily of the sexual attractions and forms of reproduction that ensued over many generations. It is primarily sexual and not natural selection that is capable of explaining the nonfunctional, excessive appeal of the preservation of racially particular characteristics. As Darwin states,

> We have thus far been baffled in all our attempts to account for the differences between the races of man; but there remains one important agency, namely Sexual Selection, which appears to have acted powerfully on man, as on many other animals. I do not intend to assert that sexual selection will account for all the differences between the races. An unexplained residuum is left. . . . Nor do I pretend that the effects of

sexual selection can be indicated with scientific precision; but it can be shewn that it would be an inexplicable fact if man had not been modified by this agency, which has acted so powerfully on innumerable animals, both high and low in the scale. It can further be shewn that the differences between the races of man, as in colour, hairyness, form of features, &c., are of the nature which it might have been expected would have been acted on by sexual selection. (*The Descent of Man*, 2:249–50)

While Darwin clearly maintains that many socially particular and racially distinct behaviors are learned, being the effects of culture and habit, he nevertheless insists that the bodily differences between races, which have a certain broad homogeneity (though certainly no identity and no transhistorical features), are largely the consequence of sexual selection, the attraction not exactly of like to like, but of those who recognize their shared characteristics. In his words, "Each race would possess its own innate ideal standard of beauty" (*The Descent of Man*, 2:353–54).

Darwin is rarely explicit about the linkage between sexual selection and the development of racial differences, but his strongest hint is tied to this claim about culturally specific standards of beauty. Different groups of men and women find different characteristics beautiful or attractive, and these tastes may be inherited. If this is the case, then sexual selection may work upon the manifest or visible elements that distinguish one race from another, such as skin color. Although there is no direct proof of this, Darwin hypothesizes that it is these variable standards of beauty and of taste that are responsible for the increasing divergences of races from each other: "The best kind of evidence that the colour of the skin has been modified through sexual selection is wanting in the case of mankind; for the sexes do not differ in this respect, or only slightly or doubtfully. On the other hand, we know from many facts already that the colour of the skin is regarded by the men of all races as a highly important element in their beauty; so that it is a character which would be likely to be modified through selection. . . . It seems at first sight a monstrous supposition that the jet blackness of the negro has been gained through sexual selection; but this view is supported by various analogies, and we know that negroes admire their own blackness" (*The Descent of Man*, 2:381–82).

Darwin and Sexual Difference

Sexual selection insists on a dimension of taste, on the recognition of beauty, and on the assertion of preferences based on the perception of appeal that complicate the relentless operations of natural selection. Sexual selection is not another, more complicated form of natural selection that directs itself to the survival not of the individual but of progeny, as much contemporary sociobiology asserts, because it does not harmonize with or further the aims of natural selection. The appeal of beauty is not simply another more complicated and indirect test of fitness. Rather, taste, appeal, and aesthetics are fundamentally irrational and unpredictable forces within individuals and species, though they conform to certain parameters and are able to be delimited and analyzed in terms of their effects. Sexual appeal is not simply some nuanced and indirect advancement of fitness, an awareness of one's partner's capacity to yield fit or attractive offspring and to invest in childraising, or a method for social and biological betterment — though of course it can be all these things — but something much less distinctive and goal-oriented than the pursuit of fitness. Sexual appeal is the place, not of the selfish gene, which always hides underneath all apparent forms of altruism and spontaneity, subverting them with its own self-interest, but of the living being whose pleasures, sensations, and intensities regulate at least some of its activities.

Sexual selection introduces a new kind of bifurcation in life, between male and female (or variations thereof), which can never be restored to unity, and with it, the vagaries of taste, desire, appeal, and intensification that make up sexuality. Sexuality leads to reproduction but that is not its purpose; sexuality attenuates life by making it beautiful, intensifies the everyday by making it spectacular, exciting, intense, stimulating, not a preparation for something else but the experience for its own sake, for the sake of what it does to the body and the subject. Sexual selection, in introducing sexual difference into the universe, forever orients life in two different incalculable directions, two directions not governed by the size and number of gametes but by the unpredictabilities of desire.

Sexual selection is Darwin's unique and singular contribution to biology (as natural selection was an assumption, in various forms, of a number of his predecessors and colleagues). His insistence on the separation of sexual selection from natural selection is arguably his greatest insight, for he acknowledges that the rich variety of life on earth, and particularly, its percep-

tible beauty and charm, resides in this incalculable force of sexual appeal that was ignored by virtually all other theorists of evolution. In developing his understanding of the entwined relations between sexual and natural selection, he made it clear that as the engine for the biological creation of variation or difference, sexual difference, the irreducible existence of at least two types of sexual morphology, is central to explaining life on earth. This makes him, perhaps unbeknownst to himself, the first feminist of difference.

I CONTINUE TO EXPLORE Darwin's relevance to contemporary feminist thought in the next chapter by examining the relation between his concepts and those elaborated by Irigaray.

Sexual Difference as Sexual Selection

IRIGARAYAN REFLECTIONS ON DARWIN

I have suggested throughout this text, without adequately exploring the idea, that perhaps the works of Luce Irigaray on the question of sexual difference—the most central concept defining her position—could find strange and unexpected support from the work of Darwin. Irigaray's concept is, perhaps, just what Darwin elaborated in *The Descent of Man, and Selection in Relation to Sex*. It may be, ironically, in view of the feminist resistance to biological frameworks and modes of explanation, that Irigaray finds the greatest philosophical confirmation of her claims regarding sexual difference in Darwin's understanding of the power and force of sexual selection. Darwin's work, with equal irony, in view of the belief of evolutionary biologists, psychologists, and others that they are the true heirs of his insights into the origins and evolution of life, may be best interpreted not only as a wide-ranging and systematic account of the forces that compose and transform natural existence but also as the first theoretical framework that makes the amorphous forces of sexual attraction and sexual differentiation productive of all of the richness and complexity of life.

If Irigaray sees sexual difference as the engine of cultural life, Darwin sees it as the motor of natural existence. Can Irigaray's concept, which she clearly wrote with women's social, cultural, and conceptual subordination in mind, find resonance in biological theory? Can biology, through the transformation wrought by Darwin's revolution, provide feminist thought with resources by which to understand sexual difference? Is sexual differ-

ence not only one of the regulating questions of social and cultural life but one of the questions that biology itself must address, one of the natural provocations for complexifying and proliferating life itself? Is sexual difference the universal question that life, in all its various human and nonhuman forms, attempts to address? Or is sexual difference one among many cultural differences, like race, class, ethnicity, or religion, that constitute the richness and conflict that characterizes only human social and cultural life? What is the ontological status of sexual difference — a concept that many feminists have affirmed as fundamentally cultural and variable, rather than essential — if it is rooted in and elaborated through biology? Can Irigaray and Darwin be used to illuminate the most radical insights of each other?

Irigaray and the Concept of Sexual Difference

Irigaray's understanding of the concept of sexual difference is by now quite well known, even if, nearly forty years or more after its elaboration in her earlier works, it is still not very well understood. This concept is the most central concept of contemporary feminist theory, the concept that elaborates both an entire research paradigm that can affect all forms of knowledge, and a politico-ethical project that involves major transformations in social, cultural, and interpersonal life. It is a concept that has the potential to change how life is understood and lived, a concept that can affect how we understand both nature and culture, both ourselves and the world.

Irigaray has argued that sexual difference is the threshold concept of our age, the singular philosophical issue that defines the present. It is not only the concept of most interest to women as a category, or to feminists involved in women's struggles. Rather, her claim is stronger — that sexual difference is the most significant *philosophical* concept, the most significant thought, issue, idea, of our age, the concept that defines the social, political, and intellectual preoccupations of our era. By its careful articulation, through its entwinement with all the other concepts it is bound up with and affects — all those concepts related to every category or type of lived difference, among them, differences in sexual orientation, race or ethnicity, religion, economic status, geography, and politics, that is, differences generally inassimilable within the forms of democracy that we currently recognize — sexual difference marks the threshold of a new way of understanding ourselves, the world, and conceptuality itself.

It is the pivotal concept for understanding the entwinement of all other

social, political, and individual differences and the bonds that may serve to unite subjects across and in recognition of these differences. This is why it is not just one concept among many others, but a defining concept, a concept that opens up conceptuality itself, a *philosophical* concept par excellence, which makes it also a concept that affects life, that affects the social and all its products, that affects also what is larger than life, a collective order as well as the natural and the divine. For Irigaray, sexual difference, as that which has been repressed or unacknowledged by patriarchal cultures, is the concept whose elaboration has the potential to transform our relations to ourselves, to our world, and to our future. Along with the concept of difference itself, sexual difference is the engine of virtually all living difference, the concept whose elaboration has helped to specify the research paradigms and forms of conceptuality that mark the present. Whether sexual difference is an elaboration and specification of pure difference (following the contrary works of Saussure, Derrida, or Deleuze), or whether pure difference is itself the consequence of sexual difference, as Irigaray implies, is a question that I cannot directly address here, but one that has marked the sometimes terse relations between Irigaray's work and that of contemporary (male) philosophy.[1]

I will develop Irigaray's account of sexual difference only in outline form, recapitulating many of her central claims regarding the concept, claims that have been elaborated in considerable detail in the primary texts of Irigaray, through her most astute readers (Margaret Whitford, Karen Burke, Ellen Mortensen, and Naomi Schor), and in preceding chapters of this book. Her central claims regarding sexual difference are as follows:

1. Sexual difference is the most basic, irreducible, nonreciprocal difference between the sexes; it is the incapacity of one sex to step into the body, role, and position of the other sex.[2]

2. Sexual difference is morphological difference, the difference in the significance and meaning of the body, and in the perceptual and qualitative immersion in the world that is developed through the body. Where many feminists have interpreted this bodily difference as anatomical and thus as given, Irigaray insists that bodily difference is lived, is never a raw nature but always mediated by cultural and psychical significance. The bodies of men and women are not lived merely anatomically, but are constructed through the constitution of their organs as functional only through various forms of attaining psycho-social value and meaning. Sexual difference is the

concept that differentiates bodies, not in terms of their nature but in terms of their value and use.[3]

3. Sexual difference is not only irreducible, it is also immeasurable, incalculable, a relation between terms that have no outside measure, no third term, no object to provide a metric by which to judge this relation or its constituents.[4]

4. Sexual difference is not a comparative relation between two entities, two sexes, that are independently given. It is not a comparison or contrast of two autonomous entities but is constitutive of the two sexes, which do not preexist their differentiation.

5. Sexual difference does not exist in its own terms, or in terms adequate to its conceptual and political expression. Given that recorded history is the history of various types of patriarchy, sexual difference has been reduced to forms of opposition, in which man and his associated masculinized qualities are regarded as positive and woman and her associated feminized qualities are regarded as the negation of those positive terms. Alternatively, woman is reduced to a position of sexual complementarity, in which the feminine is only ever regarded as that which complements the masculine rather than that which itself requires complementing; or to a position of sexual equality, in which women and the feminine are regarded as versions of, or formally the same as, men and masculinity.

6. Sexual difference is not based on existing characteristics of the two sexes, which at best reflect the social constraints patriarchy has imposed on one sex for the interests of the other, but is indeterminable, does not yet exist, though it nevertheless has the right to exist and elaborate itself. Sexual difference is indeterminable difference, the difference between two beings who do not yet exist, who are in the process of becoming. It is a difference that is always in the process of differentiating itself.

7. Sexual difference is both a mode of differentiation of that which must differentiate itself and also a form of sexuality, a mode of erotic encounter that links different bodies in specific if open-ended modes of intensity that may result in reproduction but are not directed to it. Sexual difference, as bodily difference, is not reducible to genital differences but does include such differences and the practices they enable.[5]

8. Sexual difference is a universal. It is that which marks all of natural

as well as cultural life; moreover, it marks two modes of transition in the movement from nature to culture. It is a lived universal that is the condition for the emergence of other natural and cultural differences.[6]

9. While sexual difference characterizes the potential as well as the actual relations between the two sexes, it cannot be reduced to reproduction, which is its indirect product but never its *telos*. Sexual difference enables the existence of two radically different beings to create a third being, irreducible to either but the product of both. This third cannot be identified with the child, who is one of these two. This third is the creation of something new in the relation between the two, an object, quality, or relation that can mediate between the two, can confirm the relation between the two.[7]

10. Sexual difference is not only contained within the sexual identities of male and female; its implications are far ranging and touch on the real itself. Sexual difference is not simply the existence of two different types of subject, but includes at least two different perspectives, frameworks, experiences, modes of conceptualization, forms of knowledge, and techniques of existence, or at least two ways of undertaking *any* activity. The ontology of sexual difference entails sexually different epistemologies and forms of pragmatics — that is, different relations to subjects, objects, and the world itself.

11. Sexual difference is the condition for the existence of multiple worlds, not just a single shared world. Sexual difference entails not only that each subject occupies its own morphological, perceptual, and associative relation to the world but that it can indirectly access other morphological, perceptual, and associative relations through its capacity to engage with and co-occupy a shared world, a world other than the one immediately available to the subject, through its relation to the other. The one who is sexually other than me is the one who offers me a world other than the one I occupy, who opens up new worlds to me.[8]

12. Sexual difference is the force involved in the production of all other differences, and thus has an ontological status that is radically different from that of racial, ethnic, religious, class, and other differences, for sexual difference is both the universal accompaniment of all other lived differences and is one of the means for their transmission and propagation. None of these other differences has the same

relation to the transition from nature to culture — they are all social and cultural — and none of these other forms of social discrimination can propagate itself without the cooperation of sexual difference.[9] This claim is arguably Irigaray's most contentious.

While this outline has reduced Irigaray's conception to its most elementary formulation, this exercise in outlining the various facets of this dazzling concept may help to explain Irigaray's hostility to those egalitarian projects that have marked much of feminist theory and practice. Any egalitarian project, whether directed to the equalization of relations between the sexes, or between races, classes, or ethnicities, is, for Irigaray, antagonistic to the project of the specification of differences. Egalitarianism entails a neutral measure for the attainment of equality, a measure that invariably reflects the value of the dominant position. Egalitarianism entails becoming equal to a given term, ideal, or value. Irigaray's work on sexual difference, along with the writings of other feminists and antiracists focused on the work of specifying irreducible differences, problematizes any given norm by which sexes or races can be measured independent of the sexes and races thus measured. Equality in its most far-reaching sense involves the creation of multiple norms and the recognition of multiple positions and not the acceptance of a norm or value based on the dominant position, as most forms of egalitarianism entail. It is her anti-egalitarianism, her anti-essentialism and her refusal to privilege the present and the actual over the future and the virtual that mark Irigaray's unique and ongoing contribution to philosophy, and that are key elements of her understanding of sexual difference.[10]

Nature and Culture

Sexual difference is what characterizes the natural world, the multiple forms of culture, and the varieties of transition from nature to culture. This is why, for Irigaray, sexual difference is given, not constructed. Yet even as it is given, it must also be lived, created, invented. Nature need not be seen as static or fixed in order to understand that sexual difference characterizes nature and is one of the most striking features of the natural world. Sexual difference is a problem that each culture has no choice but to address, as it must also address the problem of mortality and the problem of cultural inheritance, of how to transmit ways of living from one generation to the next. These are biological contingencies that become cultural necessities.

Irigaray understands that nature itself provides no limit to the social and cultural possibilities of women. For her, the problem is not biology but the ways in which biology has been dominated by masculinist thought: "What has served to exploit women is a biology interpreted in terms more masculine than feminine."[11]

If we are both natural and cultural beings, if culture is not the supersession and overcoming of nature but instead a coexistence, a mode of mutual engagement and elaboration — the cultural a mode of addressing the natural, and the natural a condition for cultural emergence — then we need other ways to understand nature than as that which we abandon or move beyond. We need a new, dynamized conception of nature that acknowledges that nature itself is continually changing, and thus never static or fixed, and is also a mode of production of change (and thus produces nothing fixed, nothing static or unchanging: nature is itself historical rather than antihistorical). This new conception must also recognize that nature is itself always sexed — that sexual difference marks the world of living things, plant, animal, and human — or that nature itself is at least two. Irigaray explains,

> The natural is at least two: male and female. All the speculation about overcoming the natural in the universal forgets that nature is not *one*. In order to go beyond — assuming this is necessary — we should make reality the point of departure; it is *two* (a *two* containing in turn secondary differences: smaller/larger, younger/older, for instance). The universal has been thought as one, thought on the basis of *one*. But this *one* does not exist.
>
> If this *one* does not exist, limit is therefore inscribed in nature itself. Before the question of the need to surpass nature arises, it has to be made apparent that it is *two*. This *two* inscribes finitude in the natural itself. No one nature can claim to correspond to the whole of the natural. There is no "Nature" as a singular entity.[12]

Irigaray develops a new conception of nature, one very different from that found in the history of Western philosophy: instead of seeking a point of origin or departure for the social, she sees in nature the site of productivity. If nature is never one but always at least two, and if it is a mode of becoming rather than a form of being, a mode of temporal change rather than a form of fixity, it may provide a new mode of conceptuality itself.

Irigaray provides us with precisely a philosophy that, while addressing

the question of sexual difference, never loses sight of what is beyond subjectivity and identity and opens us to the larger world, the worlds of nature and culture together. Hers is the beginning of precisely the feminist philosophy of the real, of matter and life, which may help revitalize contemporary feminist thought, although her philosophical trajectory has been a veritable road map of the intellectual and political challenges facing feminist intellectual inventiveness.

Through Irigaray, we are returned to a dynamic and open-ended nature, a nature that, while universal and providing universal questions for culture to address, produces no answers, only modes of elaboration and development. Irigaray elaborates a new understanding of nature as creation, and in the process, she develops new concepts of the movement from nature to culture than those violent forces of mastery, containment, and control posed by masculinist sciences, technologies, and economies. She declares, "Thus it is from the natural that we should start over in order to refound reason. . . . The natural, aside from the diversity of its incarnations or ways of appearing, is at least *two*: male and female. This division is not secondary nor unique to human kind. It cuts across all realms of the living which, without it, would not exist. Without sexual difference, there would be no life on earth. It is the manifestation of the condition for the production and reproduction of life."[13]

For Irigaray, the political and cultural task of sexual difference is to become what one is, to socially and conceptually cultivate the being that is given naturally, to create a way of living that opens up and develops that nature that one is and can become (for nature is never fixity but endless resource). Culture is not the overcoming or rewriting of nature but its cultivation, its enhancement and expansion. Culture can be, must be, more than nature's reduction to (deadly) commodity. Through a more adequate recognition of sexual difference, culture is the opening up rather than the containment and control of nature, although of course it contains the homicidal impulses that have thus far characterized a masculine relation to nature. Irigaray explains, "My project is regulated on the basis of my natural identity. The intention is to assure its cultivation so that I may become who I am. Equally, it is to spiritualize my nature in order to create with the other."[14]

A new kind of relation between the sexes is only possible if the natural is reconceived in terms other than those which have reduced it to a frozen set of archetypes. The relations constituting the social order—interpersonal

relations, relations of production and creation — are themselves founded on a misrecognized nature, a nature whose openness has been misunderstood. A new series of social relations that more adequately recognize sexual difference involves a new understanding of nature and of the foundational relation between nature and culture: "The difficulties women have in gaining recognition for their social and political rights are rooted in this insufficiently thought out relation between biology and culture. At present, to deny all explanations of a biological kind—because biology has paradoxically been used to exploit women—is to deny the key to interpreting this exploitation."[15]

Irigaray recognizes that we need to return to a different concept of nature, not one that reduces nature to human resource or useful commodity, but one that recognizes our connection with and our cultural duty to the natural. Nature offers, for Irigaray, not just a story of origins, the place from which the human begins, a place of prehistory, but a source of renewal and transformation of the cultural. Nature as the other of culture must itself be respected as the place and time by which culture and its human products renew and transform themselves: "Nature is a place of rebirth. Nature is a second mother, but it's also a sexed universe. Nature offers an alternative place for life and sharing in relation to the human world, the manufactured world. Rather than exploit it or forget it, I try to praise it, sing it."[16]

The Transition from the One to the Other

Irigaray affirms a positive conception of nature that in no way threatens or undermines the force and power of culture; unlike the vast majority of contemporary feminist work, the anxiety about essentialism or naturalism regarding nature does not appear in her writings. Instead, nature is valorized as a site of renewal and regeneration, as the source of culture and its transformation. The transition from nature to culture interests her much more than the life of sexual difference within nature itself. In this regard, Irigaray remains invested, in spite of her other criticisms of the tradition, in Hegel's understanding of the transition from nature to culture, which has so influenced Marxism, structuralism, and post-Hegelian phenomenology and existentialism. Indeed, modern philosophy itself seems deeply invested in understanding culture as a kind of second-order birth, a second-order nature that rewrites and transforms the first order, the place where the

natural bonds between mother and child are replaced by the loyalties to father, law, and the nation.

In Irigaray's case, this means that sexual difference, as naturally given, must be affirmed and cultivated in culture for it to serve as the basis for a new social order and new modes of democracy. For her, it is clear that Western culture, and patriarchal capitalism in particular (whose rise Hegel chronicles), sees in nature only resources to be conquered, material to be converted into property, used, and used up. Men's labor is directed to the transformation of nature into commodities, and in this process, a natural relation of debt to materiality, to nature, and to the maternal body—all unspoken conditions for the patriarchal subject—is left unrepresented and covered over by conquest. Irigaray explains, "Because of its blindness to the significance of its patriarchal foundations, mankind no longer sees that the privilege of wealth originally concerns men alone. . . . Wealth, understood as the accumulation of property through the exploitation of others, is already the result of the subjugation of one sex to the other. Capitalization is even the organizing force behind patriarchal power *per se*, through the mechanization of our sexually differentiated bodies and the injustice of dominating them."[17]

This hostility to nature and to materiality expresses itself in both the desire for the domination over the material world and in the control of men over women. If men "care little about living matter," converting matter into property, creating nature as that which must be dominated, controlled, mined, extended indefinitely, even to "the most distant stars," this helps justify their refusal to recognize woman as other than, separate from, and irreducible to man, to justify their reduction of women as well to commodity form.[18] Here Hegel is significant, for he recognizes that the failure to adequately uplift and transform our relation to nature inevitably affects the forms our cultural productions take. Hegel recognizes that the failure to spiritualize nature, to effect an ethical relation to nature, as Antigone's story testifies, wrenches the entire social order. Irigaray writes, "Men's society is built upon ownership of property. Life itself is treated like a commodity, productive capital, and possessed as a tool of labour, but not as the basis of an identity to be cultivated. Patriarchy cares little about spiritualizing sexually differentiated nature. This perverts its relationship to matter and its cultural organization. Hegel was particularly aware of this shortcoming of an ethics of our relationship with the natural world as it concerns the genders and their ancestries; Antigone is sacrificed because she pays her

respects to the blood and gods of her mother by honouring her dead brother. Hegel wrote that this sacrifice hobbles the whole rest of the becoming of the spirit."[19]

Hegel addresses the processes by which nature is sublated into spirit, and animal life, the life of plants and animals, the life that also characterizes sexual difference, is sacrificed, surpassed, and uplifted. The intense immediacy of sexual and family life must give way to the forces of the nation and the processes of sacrifice, death, and mourning that enable the natural family to accede to the universal of spirit through war, through the wrenching of man from a private family order into civic life. But for Hegel, this universal, attainable only when man leaves the family, is produced by cutting man off from his sexual specificity and from his relation to the other sex, rendering him neutral in the process of becoming universal.[20] It is, ironically, man's neutralization into citizen, subject, soldier, or philosopher that effects both the illusion of his disembodiment and the need for woman to be restricted to her (bodily or natural) function as nurturer, mother, carer for his body and those of his offspring. Spirit is attainable only at the cost of the sexed specificity of the body and a direct relation to the natural order: spirit is the overcoming of the natural, its transformation into the universal. Irigaray's task is to restore the sexed specificity of the body to not only nature but the processes of culture or spiritualization that transform natural need into social law. As she explains, "Life can only be thought about, guaranteed, protected if we give consideration to *gender* as one constituent of the human race, not only in reproduction but also in culture, spirit."[21]

Instead of the neutralization of sexual and generational specificity that Hegel's account of the family as hinge between nature and culture entails, Irigaray seeks to recognize the sexed forms of nature and to provide a model of culture that builds on rather than neutralizes this specificity. Irigaray seeks a universal that reflects the dual forms of nature itself.[22]

She seeks a continuity between the natural and the cultural, the private and the public, the family and the social order, not the split and antagonism that Hegel, and all of phenomenology that follows from him, creates between private life and civic identity, between the interests of sexuality and of social order, between the world of women (mothers) and the world of men. Cultivation of the natural rather than its neutralization and universalization is the task of the social and especially its agent, the family. As the point of transition between the natural and the cultural, the family is not the

site of the abstraction and formalization of the subject-citizen, no matter how strong its task of producing citizens who take on the labor of the creation of spirit. Only if the family in its sexual and natural specificity remains connected to its origins can we have a spiritual or social and civic order that is embodied, sexed, that recognizes at least two sexes instead of a single neutral universal.[23]

Another Nature

Irigaray tends to understand nature through this Hegelian lens, as concrete materiality that requires refinement and abstraction to serve as the content for social and civic relations. There is no evidence that Irigaray is interested in or has read Darwin's works, especially in the context of her conception of sexual difference.[24] But it may be that Darwin's work can provide her with a richer and more resonant concept of the place of sexual difference in the universal than that provided by the phenomenological and structuralist traditions. Darwin affirms the continuity of the human with the animal and the vegetal, and the continuity between the natural and the cultural. For him, there is no movement from nature to culture, for culture is regulated by the same broad principles as nature. Nature already contains many different forms of culture. In addition, he asserts the centrality of sexual difference — or more accurately, sexual selection, which I will argue is a form of sexual difference — in the life of species. It is only with the publications of Darwin's provocative picture of the web of life adapted through natural and sexual selection that the human's place in nature has finally achieved a kind of scientific and philosophical recognition that affirms man's place in nature as much as in culture. Darwin's understanding of nature supersedes Hegel's, and indeed entirely reorients the trajectory of German nature philosophy.[25] According to Darwin, the human's two forms are given in nature but cultivated through culture. Culture is not the completion of nature but rather the experimentation with nature's open possibilities, which include its possibilities for both oppression and liberation.

Irigaray's understanding of sexual difference as a striking characteristic of both nature and culture may be elaborated and developed through Darwin's work on species. A nonreductionist understanding of sexual difference as biological force finds its greatest support in Darwin's writings, and Darwin provides biology with its most open philosophical framework. To the extent that Irigaray's conception of sexual difference may be sharpened and further

elaborated through Darwin's account of sexual selection, I will also claim that Darwin's work is further expanded and made relevant to feminist and other contemporary political concerns through itself being interpreted, not through feminist egalitarianism, which Darwin himself sometimes addresses in both respectful and sarcastic terms, but through a feminism of sexual difference. That is to say, instead of a philosophical framework in which the formal or abstract identities of male and female subjects are treated as if they are or could be the same, a recognition of the irreducible differences between the sexes — and the consequent necessary failure of any but the most abstract forms of equality — would also help to clarify the relevance of Darwin's work for feminist thought. Darwin provides perhaps the most systematic and elaborate explanation for the genesis and near-ubiquity of sexual difference, and thus his work finds an unexpected support in Irigaray's understanding of sexual difference, which may help explain at least some of the unrecognized radicality of Darwin's writings.

Though Irigaray never refers to Darwin's work or to a conception of nature that is dynamized and fully compatible with and inseparable from culture (at least in the case of social animals), she approximates many of his concepts. For example, she distinguishes between something like natural and sexual selection, natural necessities for life and sexual requirements: "Two natural necessities dominate societies. One of them may appear to be neuter, unmarked by the sexual: we all have to breathe, feed, clothe and house ourselves. Our societies are controlled by this need, which, rightful as it is, accords money a power that is totally disproportionate. . . . In addition to need, there is another dimension in the person, that of desire, which is linked to energy, particularly sexual energy. This dimension of the person as sexed is important for social production and reproduction: without it, there is no society. Yet the dignity and necessity of sexual difference goes unrecognized."[26]

Her distinction between two natural necessities is the distinction between natural selection and sexual selection, between the struggle for existence against natural elements and chance itself and the struggle to attract sexual partners that characterizes sexual selection. These two forces, Irigaray recognizes, are what nature bequeaths to all forms of social organization — the necessity to provide for conditions which sustain life and the necessity of addressing sexual energy and attraction. Cultures may vary immensely in how they address these two necessities, but each must find some way in which these are adequately addressed. Patriarchy is one such

attempt, but by no means the only one possible. Feminism is another. Darwin may provide another concept of nature than the Hegelian framework through which Irigaray understands the transition from nature to culture. And Irigaray may provide a framework for understanding the differences between male and female that will help clarify Darwin's understanding of sexual selection and open it up to new feminist understandings of evolution and biology.

Darwin and Feminism

A philosophical exploration of the concept of sexual selection in Darwin's writings, directed by a commitment to a feminism of irreducible difference, would enable a new nonreductionist understanding of sexual selection as a principle both vital for and irreducible to natural selection. Feminists who are committed to the concept of the irreducible difference between the sexes may find in Darwin's writings surprising confirmation of their claims, as well as a deeper understanding of the relation between nature and culture.

Darwin's own relation to feminism and to women's struggles is quite complex. He is clearly sympathetic to programs of social equalization, especially educational programs, for breaching the social gap between men and women. Along with his friend and correspondent John Stuart Mill, he believed that the index of a culture's openness is the way in which men treat women. Slavery and the denigration of women are, for him, twin evils that exist in both barbarous and developed cultures: "The great sin of Slavery has been almost universal, and slaves have often been treated in an infamous manner. As barbarians do not regard the opinion of their women, wives are commonly treated like slaves. Most savages are utterly indifferent to the sufferings of strangers, or even delight in witnessing them"[27]

He recognizes that patriarchal power keeps woman in the state of servitude that she shares with man's animals: "Man is more powerful in body and mind than woman, and in the savage state he keeps her in a far more abject state of bondage than does the male of any other animal; therefore it is not surprising that he should have gained the power of selection."[28] Darwin also believes that although man is more educated than woman, with the benefit of an intense and rigorous training in both mind and body, woman can, in addition to her skills of procreation and nurturance, become as educated, as civilized, and developed as man.[29] This egalitarianism, his clear hostility to the rampant racism of his time, and his commitment to

questions of class — and indeed his warm if guarded relations to Karl Marx and Friedrich Engels — were also fervent political commitments of his family. It is hardly surprising that Marxists warmly greeted his account of evolution through natural selection. After the publication of *On the Origin of Species* in 1859, Marx wrote to Engels: "Although it is developed in the crude English style, this is the book which contains the basis in natural history for our view."[30] Indeed, Marx clearly felt a very great affinity with Darwin's work on the struggle for existence. He inscribed in Darwin's copy of volume 1 of *Capital*, "Mr. Charles Darwin, on the part of his sincere admirer, Karl Marx, London, 16 June 1873" and offered to dedicate volume 2 to him — an offer Darwin politely declined!

Darwin's own politics was directed to an impulse to consider the sexes, all races, and all classes as fundamentally equal, as governed by degrees rather than by any insurmountable gap. But this may be because a politics of difference had yet to be thought as such. Egalitarianism represented, in his time, the highest aspirations of a culture concerned for the well-being of all its members. Yet the concept of fundamental difference, a difference in bodies, and thus in interests, perspectives, and values, was already emerging in his understanding of animal existence, and would provide the conceptual and historical preconditions for Irigaray's understanding of sexual difference and the proliferation of politics of racial, class, and other differences, and would itself benefit from being interpreted and understood from such a perspective.

Sexual Selection

I have already briefly elaborated Darwin's understanding of sexual selection. While natural selection has privileged sexual reproduction over the forms of asexual reproduction that still characterize some forms of life (bacterial, viral, protozoan), sexual selection is irreducible to natural selection. Natural selection is always ultimately directed by the struggle for existence, the struggle to survive; sexual selection, by contrast, is directed to the struggle to attain sexual partners, and thus the stakes are much less severe and dire. While it is in some sense subordinated to the forces of natural selection, which remain the final arbiter in the assessment of the value of any characteristics, sexual selection is a principle separate from and not reducible to natural selection. Sexual selection is not only a separate principle from natural selection (for it could have never been deduced from

a knowledge of natural selection), it also attenuates and problematizes the criteria by which natural selection operates and substitutes its own, sometimes contrary, principles of taste, attractiveness, or desire. Sexual selection not only complicates natural selection, it has the potential to imperil life, to render various activities or qualities more noticeable, more obvious, and as liable to attract predators as potential sexual partners. As I discussed in the previous chapter, sexual selection regulates many of the perceptible differences between the sexes, but it paradoxically does not direct itself to those sexual differences that lead directly to reproduction, which are regulated by natural selection. All other sexual characteristics, those not directly related to the production and care of the young but rather to attracting sexual partners, are forms of sexual selection, even if these may also serve in some way as forms of advantage in the struggle for existence.[31]

Natural selection privileges some individuals and species over others in the struggle for existence. Sexual selection privileges some members of one sex within a species over others in the struggle to attain desirable sexual partners. Sexual selection tends to differentiate the sexes more and more from each other in appearance. That these are forms of sexual selection rather than natural selection is clear from the fact that both male and females survive equally well though they look and act in increasingly divergent ways over the passage of time. And the less attractive members of either sex would continue to reproduce in lieu of the presence of more attractive members. Sexual selection produces characteristics and activities that are linked to appeal and attraction and to spectacle and display.

As previously mentioned, sexual selection takes two forms. First, it consists in various forms of competition between members of the same sex, usually males (or more rarely, females) for the right to select the sexual partner who appeals most to them. Second, sexual selection also entails forms of (usually) female discernment, in which females select from a number of possible partners those which most appeal to them. This distinction between active male competition and passive female discernment has, not surprisingly, been the object of much (egalitarian) feminist criticism, for it seems to reproduce precisely the most stereotyped images of male and female as oppositional in active (or positive) and passive (or negative) terms. In fact, however, Darwin devotes considerable detail to the analysis of female competition and male discernment, which seems more common in insects, fish, and some species of birds than in higher mammals.[32] In any case, for those patriarchs contemporary with Darwin, the very idea of

female discernment was disturbing, for it assumes a degree of intelligence, preference, and choice that is at odds with the assumption that it is males who are the primary force of sexual encounters and that female preferences are of little consequence. (Similar arguments inform the current forms of sociobiological justification of rape as an evolutionary tool, which assume that the only sexual forces are active forces and that these are male.)

Darwin makes a strong argument in favor of female selection. Only female discernment can explain the increasingly different bodily forms of males relative to females; the heritable advantages to particular males granted by their attractiveness to females can intensify and exaggerate these qualities in successive generations. Only female discernment or taste can explain the ongoing existence of extravagant, sometimes even endangering, ornament: "Does the male parade his charms with so much pomp and rivalry for no purpose? Are we not justified in believing that the female exerts a choice, and that she receives the addresses of the male who pleases her most? It is not probable that she consciously deliberates; but she is most excited or attracted by the most beautiful, or melodious, or gallant males."[33] Females are generally both less eager and more discerning in their sexual encounters than males of the same species. The females tend to consider sexual encounters rather than to immediately enact them. Darwin argues that if male competition intensifies the physical capacities, strength, energy, agility, and war-like activities of males, it is female discernment that intensifies male appearance, the production and extension of ornaments, forms of charm, and beauty. Female discernment intensifies male beauty and attractiveness, sometimes even at the cost of male survival.[34]

Darwin develops a number of arguments for the distinctness of sexual selection from natural selection. According to him, the attributes produced as a result of sexual selection generally have five qualities.[35] First, they are much more marked in adults than in the young; in particular, the qualities of adult maleness are often attenuated or difficult to observe in the young and only emerge after sexual maturity. Second, they tend to be inherited by offspring of the same sex: males tend to inherit those characteristics that mark their male progenitors; females, the same with their female progenitors. Although Darwin was unaware of genes and their role in the inheritance of characteristics, he was acutely aware of the inheritance of phenotypic forms. Without characteristics' tendency to be inherited, sexual selection would not accumulate characteristics but would function only for the current generation. Third, the attributes resulting from sexual selection

are increasingly intensified as time progresses; that is, the sexes are less and less alike with the passage of time. Fourth, sexual selection characterizes not only many perceptible qualities of the body, but also character traits, forms of personality, and modes of activity, meaning it functions with both the products of body and those of mind. And finally, sexual selection functions primarily through subjective qualities — taste, appeal, and what is attractive and alluring for its own sake. This may coincide with a discernment of fitness but it may not. Sexual selection elevates the artistic, the gratuitous, the ornamental, for its own sake, for the sake of pleasure or beauty, even to the point of imperiling the more beautiful and noticeable individuals over their less beautiful competitors. Sexual selection both augments and problematizes natural selection.

It is because the concept of sexual selection in Darwin's writings is so closely linked to taste, the discernment of beauty, and the appeal of the ornamental, the secondary, and the frivolous that there has been an enormous investment in contemporary evolutionary theory to explain sexual selection as a form of unconscious or indirect natural selection. But, as I argued in the previous chapter, Darwin is right to keep separate from the discussion the (relative) usefulness of those attributes acquired through natural selection, for they function according to contrary principles and have very different effects. Sexual selection is primarily creative. It enhances, elaborates, and exaggerates individual differences to make them as enticing and appealing as possible. It complicates and intensifies attractive individual differences. Natural selection, by contrast, is primarily negative. It tests and eliminates the less fit rather than privileging the more fit. Sexual selection relies on altogether different criteria than those regulating natural selection — not the impersonal criteria of random chance, but the highly individually variable criteria of attractiveness. Darwin suggests that it is sexual selection that maximizes difference, that generates individual variation, and that guarantees that offspring will be different from their parents, even as they share certain of their qualities. Sexual selection is the engine for the creation of those differences that natural selection evaluates.

Barnacles and the Origin of Sexual Selection

While the origin of sexual selection only occupies a few pages of *The Descent of Man* (1:207–11), it is a question that clearly fascinated Darwin. In spite of his reserving a detailed discussion of sexual selection until the publication

of that work in 1871, sexual selection was in fact one of Darwin's earliest hypotheses — the one that served to distinguish him most clearly from the many other naturalists also working at roughly the same time on the mutability of the species. Already in his travels on the HMS *Beagle*, he was fascinated with those organs, appendages, and activities that seem to have no direct bearing on an individual's capacity to survive but are linked to sexual attraction. In his third and fourth notebooks, he addresses the question of the origin of sexual dimorphism. And in his joint publication with A. R. Wallace, *Evolution by Natural Selection*, where he first publicly presents his research on natural selection (while Wallace makes no mention of sexual selection), Darwin "devotes a disproportionately large section to it,"[36] which implies that he wanted both to emphasize its importance as well as to mark out in advance his differences from Wallace's position.

As is well known, he held off publication of both *On the Origin of Species* and *The Descent of Man* for a number of years, fearing both the reception of these works and the need to demonstrate his empirical and observational credentials before presenting his quite wild and philosophically oriented understanding of the historically aimless movement of evolution. What is perhaps less well known is that after he had drafted an early version of *On the Origin of Species* but before he published it, and well before the publication of *The Descent of Man*, he devoted an immense amount of time — eight years — to an analysis of a lowly creature, the barnacle. One might see this work as a distraction from the anxieties surrounding the publication of what Darwin understood would be profoundly contentious claims about the transmutation of species. However, it should be noted that his work on barnacles, which admittedly took a good deal longer than he had expected, was in part directed to major revisions in the taxonomy and categorization of barnacles, but was largely directed to an analysis of the origins of sexual selection and the very peculiar forms of sexuality that were revealed by his laborious observation, dissection, and analysis of the vast range of living and fossil barnacles. In this process, he became the world authority on barnacles, and his four monographs on the topic remain even today an "indispensable reference" for those interested in the topic.[37]

Darwin does discuss the possible origins of sexual bifurcation briefly in *The Descent of Man*, where he speculates on the origin of certain vestigial or rudimentary organs of the one sex being found in the other sex. This phenomenon is quite striking in the case of the embryos of many species, but there are also clearly traces of the other sex, such as nipples in males, that

occur in mature individuals.[38] The existence of such organs attests to "some extremely remote progenitor of the whole vertebrate kingdom [that] appears to have been hermaphrodite or androgynous."[39] The earliest ancestors of sexually bifurcated species, he speculates, may have included the reproductive organs of both sexes within a single form. Mammalian life may have descended from earlier forms that were organically bisexual. The sexes divided before mammals as a category were distinguished from their progenitors,[40] Darwin suggests, and each sex still carries the rudiments of its preceding premammalian androgynous state. It is perhaps his fascination with this question, raised so briefly in *The Descent of Man*, that directed him to the laborious investigation, by no means a detour, into the evolutionary history of the barnacle.

Barnacles have many peculiarities—their anatomy and morphology, and their variety and scope—which were largely unknown when Darwin began his researches. One question that fascinated him was the genealogical relation between barnacles and other crustaceans. Barnacles were insensibly differentiated from crustaceans over a vast period of time, and Darwin hypothesized that their capacity to secrete a glue-like substance and to permanently cement themselves onto various surfaces, one of their characteristic but not universal features in the present, may have derived from a sticky substance, present in crustaceans, that lines the female barnacle's tract. Darwin suggests that the contemporary barnacle is descended from an ancestral barnacle that was hermaphroditic and was itself the indirect offspring of crustaceans, which may explain how barnacles acquired their cementing capacities but would not explain how male barnacles can attach themselves either to objects, as do the females, or, most importantly, to females in order to engender reproduction. Darwin wanted to know how male barnacles had acquired some of the characteristics of female crustaceans. Much of Darwin's detailed work provides intermediate examples, drawn from fossilized barnacles, that could explain the sequences of anatomical transmutation that transformed hermaphroditic ancestors into the two sexes. What Darwin discovered was that many of the barnacle fossils, especially the oldest, exhibit an hermaphroditic anatomy, but, more peculiarly and surprisingly, some quite rare contemporary forms of barnacle still appear to be hermaphrodites, though with male organs that are "microscopically small" and in the process of atrophying. In addition, these largely female contemporary hermaphrodites had various small parasites attached to them, which turned out, on closer inspection, to be dwarf males, males in

the processes of emerging as a separate sex but which were still largely primitive modes of insemination, little more than sacks of sperm.[41] In one and the same species, then, there are hermaphrodites, which are largely female with atrophying male organs, and there are female barnacles and tiny parasitic males without well developed organs, males in the process of developing.

Although hermaphrodites (both in the plant kingdom and among various sea creatures) have the possibility of self-fertilization, Darwin has argued that this rarely occurs. Hermaphrodites generally cross-fertilize. Sessile or immovable animals, such as the barnacle (or Darwin's other favorite, coral), grow their shells directly onto a fixed place and, after this attachment, are not able to move. Thus barnacles can only exchange sperm with their nearest neighbors. If their nearest neighbor is one of two sexes, then there is only a 50 percent chance that a male and female will be in proximity to each other. With two hermaphroditic individuals, the possibilities for cross-fertilization are greatly enhanced for any two individuals in proximity. And the emergence of complemental males, males which attach themselves to the female or hermaphrodite to live parasitically, also increases the likelihood of cross-fertilization from what exists for two separate and autonomous sexes. In addition, the male barnacle, even when of dwarf stature, is known to have an extraordinarily long penis (the largest penis size to body ratio of any animal[42]), which maximizes the chances of fertilization. Having both types of morphologies only further enhances the likelihood of reproduction. This indeed may explain the remarkable evolutionary stability of barnacles, which have well over 1,200 species, which differ widely in their anatomical structure and in their reproductive relations.

As primitive sea creatures, barnacles are very much like the earliest forms of life to appear after the emergence of animals from plants (and their bisexual structure attests to this). Yet barnacles are also pervasive, to be found along every coastline and tidal location across the globe. Some barnacle fossils are as old as 500 million years, while many have stable forms that can be dated back 20 million years. Darwin hypothesizes a genealogy of contemporary barnacle forms from an originally hermaphroditic barnacle ancestor, an ancestor that emerged by slow degrees of change from the crustaceans as distinctively and uniquely hermaphroditic. The question was: how and why did this hermaphroditic creature become a sexually differentiated one?

In his exploration of the stalked barnacle *Ibla*, common in the Philip-

pines, Darwin discovered only females in all of his dissections. It was only when he turned his attention to the tiny parasites on the body of the *Ibla* that he understood that these parasites were tiny males — very primitive creatures with no mouth and no digestive system, little more than living insemination tubes — attached to or burrowed into the female's body. Yet when he dissected an Australian *Ibla*, he discovered, along with females, some hermaphroditic specimens. Both females and hermaphrodites had complemental males burrowed into their bodies, which in no way resembled either female or hermaphroditic morphologies. They resembled no other animal forms, though they did resemble species "in the Vegetable Kingdom."[43]

The *Ibla* provided a concrete illustration of the sequence of evolutionary elaboration. First came the ancient progenitors of today's vast range of barnacles and barnacle forms, hermaphroditic barnacles, which are still quite prevalent even today. Then emerged barnacles like the *Ibla*, which represent a transitional stage. Hermaphrodites incorporate male organs in the process of atrophy, as well as robust female organs, for their function can now be assured with the emergence of these complemental or parasitic males. Eventually these hermaphroditic male organs will either disappear or become vestigial (much like the atrophied stamen and pistils of hermaphroditic plants). Through gradual, imperceptible changes come separately sexed barnacles, the females resulting from the hermaphroditic forms, and the males emerging as complemental to the female (a kind of reverse patriarchy!). These complemental males are not truly autonomous, for they usually have no modes of sustenance, ingestion, or digestion. They are neither entirely autonomous nor entirely submerged in and part of the female or hermaphroditic body. They remain parasitic.[44] These species are currently in the slow process of transforming from hermaphroditic to bisexual and then to two separate sexes, which have emerged with stalked barnacles.[45]

What emerges from Darwin's analysis of barnacles is the story of the half-emergence of maleness, not femaleness, whose reproductive capacity must be marked somewhere in the living being. The significant question is less how do living beings (plants and animals) reproduce themselves, for in order for life to emerge at all, the (female) capacity for generation must be assumed; the question is really, why is there a second force of generation? Why is there maleness? What advantages does the emergence of a separate form of maleness create? Why, in other words, does sexual selection erupt?

What advantage does sexual selection bring such that it generates more than one body type, more than one form of inheritance?

For Darwin, the answer is clear. Sexual bifurcation, the eruption of more than one (by default, female) sex, is a strategy to maximize the potential for variation, to maximize the forms of living beings, to maximize difference itself. Natural selection selected the strategy of dividing the sexes into (at least) two bodies rather than a single morphological type—not for all forms of life, especially those invested in evolutionarily stable environments, but for those involved in changing situations. Sexual selection is the most reliable reproductive strategy in a large number of contexts, for plants and animals, because it provides the conditions under which the greatest variety of living beings can be produced from which the fittest, or the most contextually embedded, can be selected to produce the next generation in greater numbers than their less fit or embedded counterparts. Sexual bifurcation is privileged by natural selection as a means for maximizing the survival of some if not all the members of a particular species; that is, as a mode of differentiation that guarantees the maximization of differences between individuals. And in turn, sexual selection functions to deflect natural selection through its extravagant and excessive pleasures, its inventions and intensifications of new relations, new forms of attraction, and new modes of artfulness. Sexual selection is arguably the greatest invention of natural selection.

Darwin claims that it is responsible, not only for the vast range of variations of life on earth, but also for the creation of a kind of arms war that intensifies the value of certain qualities, those that are sexually alluring and attractive, and gives them a disproportionate value over other qualities, which may not be warranted in terms of natural selection alone. It is responsible for the intensification of beauty over generations and for the proliferation of colors, sounds, and forms that are pleasing to members of one's own species. Darwin even suggests that sexual selection has played a powerful role in the creation of the human, whose present form is not only a result of biological survival strategies but even more the consequence of forms of appeal and pleasure that account for many of the perceptible features we still find appealing today: those linked to racial differences, to degrees of hairiness, to the timbre of the voice, to height, strength, grace, and other tangible qualities.

Sexual Difference as Sexual Selection

So is Darwin in fact the first theorist, the first feminist, of sexual difference? Although clearly for him sexual difference is not irreducible insofar as it is derived in a slow, even imperceptible movement from anterior forms of existence, nevertheless sexual difference, di- or polymorphism, once it erupts as a random invention of life, comes to characterize most of life in increasingly marked terms. Once hermaphroditic or female forms elaborate the possibility of other morphologies of the same species as their forms of variation, sexual difference is increasingly marked, emphasized, and each sex is sent on its own specific trajectory, never to be reconciled in a single entity again. Sexual difference is the random development that alters the course of life as we know it, deflecting all other forms of evaluation and selection through the inexplicable, incalculable vagaries of taste, desire, appeal.

Sexual bifurcation establishes a problem for all forms of life: how to engender life, given that life is no longer self-perpetuating; that life, whether natural or social, now requires at least two? How to engender sexual attraction, sexual selection, and the production, with variation, of new generations? Darwin addressed these questions very carefully, slowly, and with immense detail, because it is not only in the world of animal existence that they are relevant. These are of course also the most basic questions for human life. His reluctance to address human sexual selection in any but the briefest terms, articulating only the broadest descriptive differences between the sexes, is by now well known. This was much less his terrain of expertise than the activities and physiologies of plants and animals, even though some of his other work — his notes on the early development of his own children, his detailed observation of his daughter Annie's prolonged illness, and his writings on the expression of emotions (*The Expression of the Emotions* [1872]) — evinces his astute powers of observation and reflection in the field of human affairs as well. He largely refrains from much speculation on human sexual relations and human forms of attraction (though these forms of attraction do provide a detailed explanation of racial differences).

Irigaray of course has no such hesitation. The domain of human relations and especially the relations between the sexes are the objects of her intense analysis. Although she does occasionally mention animal and plant relations, she only addresses them in passing and in relation to how they illuminate the position of woman in phallocentric cultures.[46] There can be no direct reconciliation between Irigaray and Darwin to the extent that

each is implicated in quite different projects—Irigaray in philosophy and addressing only the human, Darwin in biology and addressing the animal. Yet it may be that by a kind of cross-fertilization, the work of each can be sharpened, made more conceptually incisive, more broadly relevant.

If Darwin's work can be understood, not in the context of the egalitarianism that defined the horizon of radical thought in the sexually and class-stratified society of his time, but through Irigaray's understanding of sexual difference, then it will be broadened and made relevant for contemporary political accounts of difference. Read in opposition to the idea of a neutral norm by which both sexes can be socially assessed, Darwin's work can be understood as an analysis of the proliferation of nothing but differences: differences without any hierarchical order, without fixed identities or biological archetypes; differences generated for their own sake and evaluated only through social and natural contingency; differences without norm, without inherent value. These are different experiments in living that are broadly evaluated through their survival capacities. Darwin's understanding of the production of variation is fundamentally embedded in his understanding of sexual selection. Sexual selection proliferates differences as asexual reproduction cannot. Sexual selection must be understood as the creation of differences without clear models, without pregiven boundaries, differences that have value in themselves for the range of variations they bring to natural (and artificial) selection as possibilities to select from.

If Irigaray's work can be understood not only in sociocultural and linguistic terms but also in terms of the biology of lived bodies, then she would not need to account for a transition between nature and culture, which figures so centrally in her more recent writings, or to use the dialectical movement beyond nature in order to explain how social and cultural life are possible. Culture is not the movement away from nature, its overcoming, supersession, or transformation, but the complication of nature, the functioning of the same broad principles to regulate social and cultural relations that structure natural relations. Irigaray's account of sexual difference as that which has been elided by patriarchal cultures but is nevertheless their unacknowledged condition and which must have its day is only confirmed and strengthened through Darwin's understanding of the pervasive and productive role of sexual selection in the proliferation of differences in nature. It is the force of the natural that insists on sexual difference, and that is a kind of assurance of its return in culture in spite of any forces directed to its repression (the promise of feminism itself).

Irigaray's work has been painstakingly defended as cultural and political rather than natural or anatomical in its analysis. But if a more complex and nuanced account of nature — such as Darwin himself provides — is acknowledged, then concepts of nature need not be tied to essentialism or naturalism. Nature itself is dynamized, historical, and subject to dramatic change. Sexual difference remains the most creative and powerful means by which this transformation is brought about. It is the means by which the natural cultivates culture, rather than culture cultivating nature. We do not leave nature behind, we do not surround ourselves with culture in order to protect ourselves against nature, for culture, cultures in their multiplicity, are complex forms of variation of natural forces, both human and animal.

If Irigaray's work is interpreted through the work of Darwin rather than Hegel, and if Darwin's work is interpreted through the work Irigaray rather than John Stuart Mill, Harriet Taylor, and British egalitarianism, then each is modified through the influence of the other. Each is able to displace the concepts that limit or inadequately frame the implications of their respective positions. Darwin's work is opened to a nonreductive politics of (racial, sexual, ethnic, class) difference, and made relevant to a political analysis of cultural relations. Irigaray's work is strengthened, fortified through the incontestable place of sexual difference as a natural force that is culturally registered, which makes it clear that sexual difference is not just one social difference among many but that form of difference that makes all other lived differences possible, the engine of all lived differences.

Sexual difference is ineliminable, the force that proliferates all social and natural relations. Sexual selection refers to the possible erotic relations and encounters of sexes (whether within one sex, between two, or across a number of sexes), and these sexes themselves are separated by difference. Sexual difference is made more visible and perceptible over time as the sexes diverge further from each other. Sexual selection is how sexual difference transforms itself, intensifies itself, and selects the most attractive, noticeable forms, new ideals, and new types of body, qualities, and activities. Sexual selection enhances sexual difference and sexual difference proliferates and varies itself through sexual selection. While different, they operate hand in hand to complexify social and natural life and to divide and increasingly differentiate populations. Irigaray and Darwin have each come to a point of commonness in which different bodies, divided along the lines of sex, become the means for new natural and cultural relations, the road to new forms of politics and new forms of life.

Art and the Animal

The artist: the first person to set out a boundary stone, or to make a mark. Property, collective or individual, is derived from that, even when it is in the service of war and oppression. Property is fundamentally artistic because art is fundamentally *poster, placard*.

In truth, there are only inhumanities, humans are made exclusively of inhumanities, but very different ones, of very different natures and speeds.

— GILLES DELEUZE AND FÉLIX GUATTARI, *A Thousand Plateaus*

I have outlined in considerable detail the intimate internal connections between man and the animal preconditions of man. Darwinism has opened up a way to engage with animal forces as those with which our own forces participate, and which direct us to a humanity that is always in the process of overcoming and transforming itself. It is the animal forces in us that direct us to what is regarded as most human about us — our ability to represent, to signify, to imagine, to wish for and make ideals, goals, aims. It is the animal in us that, ironically, directs us to art, to the altruistic, to ethics, and to politics. It is animals' modes of coexistence, their modes of difference, their direct encounters with nonliving forces and materialities that guide our own. Rather than explaining human creativity and productivity through the rise of intelligence, reason, and the attainment of higher, more ennobling goals, as philosophies from the Enlightenment suggested, Darwin enabled

us to see a direct filiation between what is most noble and admirable about the human and the animal ancestors from which these admirably human qualities derive. In this chapter I want to explore the animal preconditions of art, the animal-becomings that inform and direct human art production. How are our conceptions of human accomplishments — whether in art, architecture, science, and philosophy, or in governance and in social and political relations — transformed when, following Darwin's suggestions, we place the human within the animal? How and why does the animal imperil human uniqueness and dignity? What do we gain in restoring the human to the animal from which it has come? In chapter 1, I asked about a humanities beyond the human. I now want to turn to thinking about art beyond the human, about the inhuman and its place in the constitution of art.

These are the broadest speculations that may help us to rethink the role of the animal, both in human self-understanding and, perhaps more importantly, in the evolutionary movement in which the human is in the process of self-overcoming, that is, in the process of becoming inhuman. The animal becomes not that against which we define ourselves but that through which we come to our limits. We are animals of a particular sort which, like all of life, are in the process of becoming something else.

Eight Theses about Art and the Animal

I want to begin purely speculatively with some broad hypotheses about the animal preconditions of art which I cannot prove here but which are the background to my claims in this chapter. The following overview more or less summarizes some of the recent work I have undertaken on art and the animal.[1]

1. All of the arts, from architecture to music, poetry, painting, sculpture, and dance, are the indirect effects of Darwin's concept of sexual selection. If natural selection can help explain the remarkable variety and adaptation of life to its specific environments, then only sexual selection can explain the extravagant, often useless, sometimes imperiling qualities that have no survival value but nevertheless continue in abundance.

2. Sexual selection can be more explicitly linked to the arts than natural selection to the extent that it functions to highlight, to intensify, the bodies of both the living beings exciting through and the living

beings excited by various forms of bodily display — such as in the courtship songs and dancing of competing birds, the dazzling displays of colors in sticklebacks and other erotically attuned fish, and the loud and colorful encounters of various mammals in competition with members of the same sex over sexual partners (which may also be of the same sex, or not). Sexual selection unhinges, deranges, and complicates survival for the sake of intensification.

3. Art, like technology or like science, links living bodies to the earth, not wholesale but through the connections it makes between specific qualities — the attractiveness of leaves to various showy birds, the shininess of objects that appeal to bower birds — and specific bodies and body parts. But unlike technology or science, which aim to extract useful principles, principles which can be used to attain specific aims or goals — regularity, predictability, order, and organization — the arts redirect these forces of practical regularity through intensification to produce something no longer regular, ordered, or predictable, but an intensity, a force, a sensation, which actively alters the very forces of the body itself, something appealing, irregular, unpredictable.

4. This emphasis on sexual selection rather than natural selection entails that wherever art is in play — that is, wherever qualities, properties, features, and forms have the capacity to brace and intensify the body — we must recognize that sexual selection is the underside of sexual difference (a claim made in the preceding chapter). Sexual selection, the sexual appeal and attraction of members of the same species, is always at least two-fold, resulting both in the development of at least two different kinds of morphology or bodily type, male and female, and in at least two different kinds of criteria for attractiveness.

5. Art, especially the first and most primordial of the arts, architecture, is thus a particular linkage between living bodies and the forces of the earth, formed above all through rhythm. Architecture is the first art, the art that is the condition for the emergence of all the other arts, for without some cordoning off of territory from a more generically conceived earth, no qualities or properties can be extracted, or can resonate, intensify, effect, and transform bodies. It is only to the extent that both the body and the earth are partially tamed through the creation of a provisional territory that protects the living creature and creates a temporary "home" that art as such can emerge.

6. Art is the sexualization of survival; equally, sexuality is the rendering artistic of nature, the making of nature into more than it is, the making of a leaf into a sexual adornment rather than just a residual shedding, photosynthesizing characteristic of a tree.[2] Art is that ability to take a property or quality and make it resonate with bodies to the extent that this quality takes bodies away from their real immersion in a particular habitat and orients them to a virtual world of attraction and seduction, a world promised or possible but never given in the real. This is why the first art is architecture: for qualities to be extractable, a territory, a framed and delimited space, must first exist—a space of safety, competition, courtship, and flight. Only within such a provisional space, a space always threatened with deterritorialization, can there be the pure joy of qualities, the immersion of the living in intensities. Architecture is the bridge between life and art, the condition under which life complicates itself and finds transportable, transformable qualities for this complication.[3]

7. If art is rooted in the ways in which sexual selection deviates from natural selection, making properties, qualities, organs, and muscles function not only usefully but also intensively, art is the capacity of materiality to function in ways other than what is given. Art is the exploration of qualities and properties, not for their own sake, not for their use value or exchange value, but only insofar as these qualities and properties do something, have some effect, on living beings. Art is the means by which nature deviates itself from givenness, comes to function in other terms than the useful or the manageable. It is thus the space in which the natural and the material are the most attenuated, rendered the most visible and tangible for living beings.

8. These qualities and properties, attractive to various forms of life, become art only to the extent that they can be moved, transferred outside of where they are found, sent on a deterritorializing movement, able to function elsewhere than where they originate or are found. While the conditions and raw materials for art are located within territory, as part of the earth, they become art, architecture, dance only to the extent they become transportable elsewhere; that they intensify bodies that circulate, move, change; that they too become subject to evolutionary transformation and spatial and temporal movement.

These broad Darwinian claims about art can perhaps help frame a more specific discussion of animal worlds through some of the work of the Estonian biologist Jakob von Uexküll, whose writings on the worlds of animals and men have been influential on a wide variety of disparate philosophical positions, including those not only of Deleuze and Guattari, but also of Ernst Cassirer, Maurice Merleau-Ponty, Jacques Lacan, Martin Heidegger, and Giorgio Agamben. They are also foundational within the burgeoning field of zoo- and biosemiotics, as acknowledged in the work of the semiotician Thomas Sebeok.[4] In some ways, Uexküll, along with Henri Bergson, serves as a mediator between the Darwinian hypotheses I address in this book about the animal condition of the human and Deleuze's involution of Darwinism into a human becoming-animal. Uexküll enables a rare access to thinking not only about animals but, above all, about the worlds that animals inhabit, worlds they sometimes share with us, worlds waiting to be invented, worlds that may inform our understanding of our own inhabited worlds.

Uexküll is unique in the fields of biology and ethology primarily because he is interested in understanding the worlds in which animals live from the perspective of those living beings themselves, rather than from any external or behavioral framework. He may be understood as the first animal phenomenologist, with all the irony this entails. His work fits into the lineage of vitalist or biocentric works that runs from Schelling to Hans Dreisch, Paul Berg, Hans Spemann, and D'Arcy Wentworth Thomson, to Kurt Goldstein, Georges Canguilhem, and Oliver Sacks. It is really Deleuze who hijacks him from this lineage to place him within a context he shares with others concerned with the elaboration of technology and materials — among them, Gilbert Simondon and Raymond Ruyer.

What is perhaps most significant here about Uexküll's claims is his understanding that the most basic problem of biology is fundamentally a problem of design, the design of organisms. This is the problem not of a designer but of all life forms insofar as they find themselves within a particular context where their bodily forms, their organs and capacities, must find a way of organizing and coordinating themselves to utilize what they need from this context to survive and thrive. The problem of life is the problem of design; or, put another way, life is artistic in the biological forms it induces, in the variations in patterns of living it generates, and, above all, in the forces of sexual intensification, as highly variable as these are, it proliferates.

Animal and Umwelt

Darwin deflects art through sexual selection and through the animal. Deleuze too links art to the relation between an animal and its territory. Coming between them, Uexküll develops an account of the centrality of the notion of milieu in understanding the ways in which particular species experience and coevolve with their life-worlds. Uexküll discusses what he understands as the "musical laws of nature [*Weltgesetz*],"[5] which bind together the evolution of the spider and the fly, the tick and the mammal, the wasp and the orchid, the leaves of an oak tree and drops of rain, each serving as a motif or counterpoint for the other. Nature itself is musical, composed of material notes which each play their own melody, a melody complicated, augmented, syncopated, and transformed through the melodies of the other living and nonliving things with which it engages. For Uexküll, music is not just a useful metaphor for understanding relations between living elements within given milieus, it is a profound model by which nature can be understood as dynamic polyphony, a playing out of the vibratory structure of life and its worlds, always playing at least two tunes which produce resonance and dissonance such that changing, dynamic, interacting forms result. The snapdragon and the bumblebee evolve together, form a becoming, and enhance and transform each other so that each can only be understood in relation to its counterpoints with the other. These are no longer autonomous entities, self-sustaining organisms, but operative pairs, a duet, two entwined melodies, which may function without the other, but which open up and resonate only together.[6] Mutual adaptation, or rather, the fundamentally harmonic coordination of the properties of two living things — bees and flowers, for example — produces the intensification of the dynamic interactive qualities of both. The intensification of fragrance and color in flowers and the intensification of bees' capacity to access and utilize nectar and pollen from plants leads to a creative spiral of properties for both plants and the insects that fertilize them.[7]

Uexküll argues that an animal is not immersed in its entirety in a given milieu, but discerns only certain features which are significant to it, those which are in counterpoint with its own organs. Each organism is surrounded by its *Umwelt*, an "island of the senses," the schematized world in which it acts.[8] The Umwelt, the "soap-bubble" in which each living being is housed, is the world provided to it by its receptor organs, its sense or perceptual organs, and through its organs of action, effector organs, double

pincers through which the living being engages with and forms part of the natural world. The Umwelt is the particular world, a subsection or partial framing of the more abstract material universe, to which living things, including the human, have only limited access; it is a sliver or fragment of a world which is fully accessible to no living being.[9]

Each of its perceptual senses bathes the living being in a world, extending its world beyond the reach of the body's own limits through its senses, which generate a particular mode of access to the world of things that affects a particular part of its body.[10] The lived or phenomenal world of the organism, its Umwelt, is precisely as complex as its organs. An organism's Umwelt is the unique world in which each species lives, the world as its body represents it, the world formed by the very form of the organism, whose morphology is the long-term result of evolutionary pressures, of the living engagement with a particular territory and its particular modes of object. The Umwelt is the world in which each creature, animal and human, lives, a particular angle on the world which highlights for the creature what it needs and its organs can perceive and act upon but leaves everything else in obscurity, unperceived. As Uexküll explains, "Everything that falls under the spell of an Umwelt is altered and reshaped until it has become a useful meaning-carrier; otherwise it is totally neglected."[11]

For Uexküll objects are not cohesive sets of qualities but opportunities for engagement, for action, that offer themselves in particular ways to particular organs and otherwise remain indiscernible. Objects are pragmatically accessible;[12] thus living beings, animals, cannot be construed, as they have been in modern philosophy since the seventeenth century, as complex machines or automata. Organisms are sense-bubbles, isolated worlds, monads composed of fragments of milieus and organs, musical counterpoints creating a melody. The Umwelt is the sensory world of space, time, objects, and qualities that form perceptual signs for living creatures, the world that enables them to effect actions, to exercise their organs, to act. Uexküll calls it a "circular island," a "wall of the senses."[13] It is a bubble-world, much like a creature enclosed in an invisible snow globe, which always positions the subject within the center of a movable horizon.

There are no stable objects, equally and always perceived in the same way for all living things; no one sun, moon, or stars, just as there is no single space or field, time or rhythm, no universal within which we can locate all living things. One and the same object on entering different Umwelten becomes different. Each species perceives what it needs and can use from its

world, a process exactly as complicated as its sense organs (receptor and effector) allow. Each living thing lives in precisely the world which accords with its bodily needs. The lived reality of each living thing already includes, mirrored inside the organism, the forces that impinge on it from the outside.[14] The objects in the world of an animal are precisely as numerous and rich as the animal can distinguish, which are equal to the number of functions the animal can enact. Its world is richer or poorer in external terms only according to the animal's capacity to discern and utilize objects and their qualities. Every animal is precisely as complex as its context enables it to be. As any animal learns and develops, the range and number of its performances, or actions, grows and so does the number of objects that populate its world.[15] Uexküll argues that we can understand this apparently perfect adaptation of bodily form, not in terms of the Darwinian explanation of natural selection (for natural selection only eliminates the less fit rather than privileging any form as more fit), but in terms of the "musical" or harmonic "laws of life": "It is thus musical and not mechanical laws that we need to study if we want to find out about the laws of Life."[16]

If music becomes the model by which life can be understood, then this music is composed, not of vocal or instrumental notes, but of various tones, frequencies, forms of organic resonance. Each living creature is a series of "tonal" responses to various "melodies" played by its Umwelt, through various performances it undertakes. The world is composed not so much of objects but of tunes with which a creature can resonate through its own ego- or I-tone or quality [Ich-Ton], the specific muscular contractions and neurological reactions that characterize the specific body of each creature. These tones make particular objects in its world drinkable, edible, walkable, sittable, and so on, and animals classify things into such categories associated with specific activities. Their worlds are defined in terms of what they can do with objects and their qualities, what those objects and qualities enable them to accomplish — to eat, drink, sit on, and so on. Objects are nothing more than these perceptual occasions for possible action.

How can we come to understand animal worlds through this conception of Umwelt? And how do they help us, if they do, to understand our worlds? How can they help us to understand the animal in us, the animal from which we have come, and the animal that still dwells within us? Uexküll believes that we can understand the animal's world, its lived experience, its phenomenology, not directly or in terms that exactly represent the

animal's unmediated experience of its own world, but through our own perceptual organs, through the lens of our own Umwelt.

Two things are crucial if we are to understand the animal as living organism rather than functional automaton. First, Uexküll claims that we must understand animal physiology or psychophysiology, just as to understand ourselves we need to understand our morphological organization. And second, he claims that we need to understand the other terms, whether objects, environments, or other living beings, with which the animal co-evolves. That is, we need to understand that the units of evolution are neither individuals nor species; rather the living creature, individual and species, is fully immersed in an Umwelt. It is this particular tune, which the living creature plays and which its Umwelt composes, that survives or becomes extinct, that is the object of natural selection. "The tune is complete master of the individual musician."[17]

Space

To understand the animal it is not adequate to decompose it into its parts, to understand the functions of each organ in isolation from the others. Neither is it adequate to compare and contrast individuals or species with others, to classify them in terms of relations of resemblance or degrees of affiliation, as Darwin did. Uexküll provides us with a way of discussing associations between unlike species, rather than resemblances or genealogies within transmuting species. While he does not dispute the concept of reflex or instinct, Uexküll claims that even reflex actions, apparently mechanical actions that involve minimal conceptual activity, nevertheless do involve the recognition and reception of signs which act as triggers, signs that begin the reflex movement. Animals live only to the extent that they interpret, make sense of the things, that are capable of being of use to them; that is, that they are immersed in the world composed of signs, traces, indices, or significations.[18] Animals are not complex machines but living forms, whose bodies are not randomly produced but are specifically "tuned" to coordinate with their milieu, with the melody with which they must coordinate or harmonize. Instead of breaking the body down into cells, tissues, organs, each with their own operations and their own object of knowledge, we can instead understand the living animal in terms of how it moves, with what it functions, what it makes and does, what connections it makes, what relations it establishes.

For Uexküll, the living body, a species-specific body, functions as an instrument in a larger orchestra: it is not the body that produces harmony, it is the "harmony of the performance that determines that of the body."[19] Every species has a characteristic, even if changing, melody, which distinguishes it from all other species. Each species, as it were, sings its own song, according to its own rhythms and harmonies, using its body as its instrument and its particular bodily activities — moving, acting, sitting, sleeping, eating, and so on — as notes or tones that are available for its musical performance, the enactment of its tasks and activities. It is the role of the theorist, whether ethologist or philosopher, to discern with what I-tones, what particular bodily responses, what activities and passions, what sensations and actions an animal experiences — that is, the processes by which the melody is carried when an individual or species responds to the qualities of objects in its Umwelt.

For Uexküll, the living organism is a bodily being whose physiology, itself the dynamic product of feedback relations with an environment, has in a sense already synthesized its environment or Umwelt into the organization and use of its organs according to the form of a plan (*Bauplan*), that is, as a creative response to the cues its Umwelt emits. We can understand our particular organization of space and time, for example, as the consequences of the body's particular makeup, the particular form its senses take. Uexküll argues that we can only live, move, and act in a three dimensional space to the extent that our own direction-signs, our modes of orientation to the world and to objects, our own bodily form, are structured to the tune of such a space, precisely the same kind of space in which the objects we need also find themselves. Our bodily senses attune us to precisely the space and the objects we need and through which we operate to act in the world. We perform the tune our milieu has composed for us, with whatever variations and improvisations the melody will tolerate.

We humans function and live within three directional planes linked directly to three different kinds of order, which unfold for us very simply when we are infants learning to move. These planes are the orientations of back and forth, up and down, and left and right, and are linked perpendicularly to each other to produce the system of three dimensional coordinates. In other words, we are capable of dividing and locating objects according to these three dimensional direction-signs.[20] These direction-signs are the ways in which a particular physiology incorporates within its form the very designs that "nature" has drawn for it. These direction-signs

that orient us to act in our world are directed to the possibilities entailed by our bodily form and come to us from within.[21] Uexküll argues that the three-dimensional character of our lived space is to be attributed to the form of the semicircular canals in the middle ear, whose three directions approximate the three dimensions of operational space and orient us by their three directions.[22] This hypothesis suggests that those living beings with semicircular canals — including fish, for example — share the same broadly characterized space and thus live according to the same broad orientations or directions as we do, even as they clearly address different objects with differently structured organs.

This operational space is structured only by the kinds of movements and actions a body is capable of undertaking. This is the space of orientation within which action and movement take place in the broad biological frame within which bodies can become more oriented to objects, to details, to discernment. Space is also characterized not only through planes or orientations but through our attraction to loci, specific places, regions, that are given to us directly through our bodily familiarity, that is, through tactility. (As Uexküll tells us, "Rats and cats remain quite unhampered in their motions even if they have lost their vision, so long as they have their tactile hairs. All nocturnal animals and all cave dwellers live primarily in tactile space, which represents a blending of places with orientational units."[23]) Tactile space, the space felt by the body at its limits — whether through tentacles, whiskers, or arms and legs — augments and complicates the spaces of orientation which more or less defines the body at its core, in the torso and head.

Vision, and the space that unfolds because of vision, the visual field, adds to and complicates the space of orientation and tactility, which are not two separate spaces, but spaces augmented by and nested within each other. Vision adds peculiarly visual characteristics, such as the framing of the visual field and the sensation of objects growing smaller and larger according to distance, a sense counteracted by tactility, for which objects do not change their size. It is only visual space that brings with it a horizon, which Uexküll calls "the farthest plane."[24] Vision places the farthest plane well beyond the body itself. This farthest plane is the limit-horizon, beyond which all objects appear on the same plane, as sun, moon, and stars appear to the untrained human eye equally far away from us, all located in a single field.

The farthest plane is the limit of the animal world, the outer wall of the soap-bubble which surrounds all living things, from the level of the cell up. Animals live in a complex space in which the organs of sense and of move-

ment, the receptor and effector organs, elaborate and open up the only space in which the being can live and act, a space that perhaps it can share with other species and beings but never reciprocally. Space is built up, sense by sense, perceptual organs upon organ forming the soap bubble, its limits, its contents. The living being lives somewhere within the smallest discernable space, the space that its body cannot distinguish from other spaces, the space where two points, felt or seen, begin to blur for it. The point at which a human back can discern two different impingements, or points, from each other hovers around two centimeters. The farthest plane, the limit-horizon, which for humans, Uexküll claims, is around six kilometers, is for a fly maybe half a meter.[25]

Territory

What is it that distinguishes territory from environment, niche, or context? All living beings live in an environment, a spatial field, a particular geography subjected to temporal transformations, which they share with other living beings. What defines territory, if territory is the most irreducibly oriented spatial terrain for many, though not all, animals? It is true that many insects do not have territory. We are all familiar with flies, mosquitoes, fireflies, gnats, and other insect irritants. Although they seem ubiquitous at certain times of the year, it is significant that, like pigeons, they have no territory. They fly back and forth but they don't have a home, which is the necessary condition for territory.[26] While the fly has no territory and thus no real limit to where it may roam, the spider is firmly located in territory, the immediate vicinity which surrounds its web.

In building a home, the spider, like moles with their holes and bats with their caves, termites with their mounds, and many (but not all) forms of bird and their nests, defines both a home and the space surrounding it as territory.[27] The web defines the space of the home for the spider, and the surrounding region — the trees or branches between which its strands are threaded — its territory. Yet the spider and the fly are still commonly bound together in a kind of musical duet in which the operations of each harmonize with the other without the slightest conscious planning or coordination. Uexküll discusses the production of the spider's web as a kind of spatial counterpoint to the movements of the fly. The web is not entirely comprehensible and its form is not adequately explained unless we understand its relation to the fly. The threads of the web must be strong enough

to capture the spider's prey yet invisible enough for the prey to be unable to see them. There are, for example, two kinds of thread in every web: smooth, radial threads that the spider is able to stand on and spin from, and sticky threads that function to catch flies. The size of the net, its holes, and gridding are a quite exact measure of the size of the fly or other specific forms of prey for the spider. The fly is contrapuntal to the web: or equally, the fly, the web, and the spider form a unique coupling, a milieu qualitatively selected for specific pairings, specific productions. The "properties of lifeless things" like the web intervene "contrapuntally in the design of living things."[28] The fly is already mapped, signaled, its place accommodated in, for example, its inability to see the smooth and unmoving threads of the web. Likewise the spider's bodily behavior is specified before any particular spider has encountered any particular fly.[29] As Uexküll puts it, the web is already a counterpoint to the fly, its features already mapped (in this case as invisible) in the fly's world.

Or take the case of the honeybee. It too lives in a simplified world, a world of limited sights and smells. It is profoundly limited in hearing. It is unable to discriminate between sounds except through tactile vibrations which are in its immediate vicinity.[30] In the case of vision, the honeybee, one of the many species of social bees, can only discern two kinds of visible shapes: solids or "broken" patterns,[31] the cues for opened and closed forms (which will enable it to distinguish flowering from closed buds). It also has the cues for only four basic colors — ultraviolet, blue, green, and yellow — whereas humans have cues for at least sixty. Significantly, as Karl von Frisch was to learn in his elaborate studies, honeybees seem unable to distinguish red from black. Bees' eyes are attuned not to all colors but only to those that may give them access to pollen. This may explain why, like most other insects except butterflies, bees are red-blind — there are very few red-blooming flowers that are bee-blossoms rather than bird-blossoms.[32] The honeybee lives in a world overwhelmed by many different kinds of aroma, and it has a nuanced and complex sense of smell that enables it to distinguish many different types of bloom and to have distinct preferences. Uexküll argues that if we can adequately understand the theme of its Umwelt, we can understand the nature and form of an animal's perceptual cues and its active selection of those milieu-elements that signify for it. The melody the honeybee performs is that of its flowers, the flower's life-cycle, of which it is an active part: "The theme of the music for the honeybee is the collection of nectar and pollen. To find them the path that leads to them has to be marked

with perceptual cues. This explains the choice of properties of flowers that become form, color, smell, and taste perceptions to the bees. A honeybee meadow is something very different from a human meadow. It is a honeybee composition made up of bee notes."[33]

Each living thing is a melodic line of development, a movement of counterpoint, in a symphony composed of larger and more complex movements provided by its objects, the qualities that its world illuminates or sounds off for it. The organism and its Umwelt taken together are the units of survival. Each organism is a musician completely taken over by its tune, an instrument, ironically, of a larger performance in which it is only one role, one voice or melody. Its milieu is an ongoing provocation to the organism to utilize its capacities, to act, to make. The organism itself is a provisional response to that provocation: it has generated as many senses, organs, actions as it is capable of using to extract what its body needs and can harness.

Uexküll claims that if we could explore any tract of land, however small, in adequate detail, we would discover a series of distinct territories, sometimes not even overlapping or co-occupied, because they are occupied by living beings functioning on vastly different scales. These territories, like the ever-shifting map of nations, and of struggling groups within nations, represent a political map of the activities undertaken within them, territories divided and mapped by dogs through scent, by birds through the songs and dances that emanate from their nests, by spiders with their webs, and wasps, bees, and ants in movements in and around their hives or nests.[34]

Space as life lives it is immersed in and invaded by memories, events, instinctive triggers, that are, as it were, experienced rather than determined objectively. The space that accommodates animals is infused with the (virtual) objects and actions they can contain, and these actions and passions are as variable as living creatures. Yet these are not simply subjective impressions, for they operate according to a plan of nature, an ongoing structured and improvised melody that involves the techniques of point and counterpoint to generate form and harmony between the interior or lived world of an animal and the external forces that impinge on it and which it must harness internally if it is to survive those forces that are mediated and communicate with each other through the morphology of each species and each individual.

The body of an animal is an inverted map of its world. Equally, its world, the bubble-world it extracts from a larger, blurring indeterminacy in which

to live, is a projection of its bodily capacities. Similarly, the objects made, produced, by animals—nests, hives, and webs, but also love objects, small toys, and objects of play—have their counterpart somewhere in the body of these animals. These animal-objects, objects constructed and invested with animal desire, are both the contrapuntal impression of materiality, of material forms—trees, branches, sticks, stones—used in animal construction, and also contrapuntal responses to the specificity of the animal body.[35]

Home

The industriousness of constructive animals, such as beavers, squirrels, birds, ants, bees, termites, moles, and wasps, has provided a model of human construction since at least the time of the ancient Greeks. It is significant that from the Middle Ages, Freemasons, builders of churches and cathedrals, have taken the beehive as their "hieroglyphic emblem." Masonic lodges are designated as "hives" and meetings are described as "swarms." (Mormons are also very attached to bees: Utah is the "beehive state.") Masonry and building aspire to the precision, accuracy, parsimony, selflessness, and dedication of bees.[36] In the case of collective hives, not a scrap of extra material—wax, propolis or bee glue, pollen, or nectar—is wasted. Efficient and functional, the form of the six-sided honeycomb makes the maximum use of space with the minimum amount of wax in providing housing for newly laid larvae, hatchlings, and young bees and in storing honey.[37] The six-sided cells that make up the honeycomb function with impressive geometrical regularity in both natural and human-made hives.[38] Like the structured hive which separates different functions—hatching eggs, feeding pupae, storing food—in separate locations, it is also clear from excavated ants' nests that there is a complex organizing structure that inflects the design of the nest.[39]

Even Darwin himself explains bees' diligent activity in terms of works of human masonry. For him, their hive-building ability is "the most wonderful of all known instincts," a testimony of the honing power of natural selection to select the most efficient, economical, and sturdy instincts and activities that most intimately engage life forms with their environments for preservation.[40] Bees, ants, termites, wasps, and other communal or social insects show a remarkable self-organizing capacity, working together under instinctive instructions that are clearly distributed according to bodily morphology, coordinating tasks of construction for a collective home with no

specific instruction, communication, or planning. Because there is, for Uex-küll, a "plan of nature," in the coordination of vast numbers of collectively behaving animals — swarms, flocks, herds of sheep, and schools of insects or fish, moving collectively as one massive, disaggregated body according to simple, noncognitive rules — there can be agreement in the activity of group members (for example, the various categories of insect) on a single task which is performed with amazing skill and speed, without leaders, without any overviewing position, meetings, or consensus.

Some ant species have devised ingenious intertwined "melodies" — duets — with other living species, particularly fungi, with whom they co-evolve. There are, for example, fungus growing and cultivating leaf cutter ants, which carefully tend to quite large "gardens" of fungus mixed with leaves which are indigestible to the ants. Only when the fungus breaks down the cellulose in the leaves can the ants consume them. The more the ants care for the fungus, the more effectively the fungus breaks down the cellulose and the more well-fed are the ants.[41]

Members of the same colony recognize each other from occupying the same home, and, over the life of a colony or hive, they come to recognize their colony's near neighbors and to avoid encounters and thus any possible conflict with them as much as is possible through foraging in other areas, avoiding trails where their neighbors have been seen before, or decreasing their amount of foraging activity. It is significant that, in at least the case of ants, they seem to prefer to avoid their neighbors even more than strangers.[42] Their territory is in part structured by the needs of the nest or hive itself, but it is also in part a function of the political division of territory that occurs between competing colonies, which mercilessly destroy newly mated queens to prevent them starting new colonies. Territory becomes habitually marked, familiar paths traversed frequently and new paths explored less and less frequently the older (and more successful) a colony becomes, though its outlines are never absolute or able to be maintained year after year. Territory, unlike property, has no fixed boundaries and is maintained only through regular use, otherwise reverting back to the unbounded earth. The older a nest becomes, the less aggressive and the more insular the colony grows, and the more it is rooted to the territory it knows rather than seeking expansion of the nest.[43]

The location of the nest, hive, or tunnel defines the home which the surrounding territory protects and enhances. The nest is at the center of an

insect's or animal's territory. Territory is what radiates irregularly around the home; a terrain marked intermittently by signs significant to that species, signs emitted by members of that species and by elements of its milieu, whether they are tracks or the scent of other species, the existence of other members of the same species, or the particularities of geography.[44] Territory surrounds the home, space of rest, feeding, and nurturance. Territory is the space of courtship, rivalry, competition, and resources. Without territory surrounding the home, both protecting it and infusing it with a certain set of resources, there can be no stable or ongoing home, as is the case for the vast majority of animals. And without the space and safety of the home, there can be no elaborate courtship dances and songs, no acts of spectacular rivalry, no arts of performance and enhancement — that is, no territory, no milieu, no art, no seduction, only the weighty reality of the phenomenal world, the Umwelt. This is not to say that there is no sexuality, no seduction, no sexual selection for the homeless or the nomadic of the animal world, only that such animals have no access to the resources for the artistic transformations of their own bodies or their milieu such as territory enables.

The architecture of the home defines the space of territory, which is the condition for the eruption of qualities, rhythms, sounds, colors, all capable of being extracted from objects to be deterritorialized, transported else-where. Whether the ingenious elaboration in stucco of the neatly organized oval nests of termites, the beautiful ordered regularity of the honeycomb, or the nests of the mason bee, which take over snail shells and block them with pebbles, hiding them under straw and twigs, the architecture of the home is the condition under which art is unleashed on the world. Without the bees' attraction to the perfume of flowers and plants, there would be no art of smell for humans. Without the bird's capacity to make melodious tones to charm and amuse us or to strut about fluffing up its most dazzling and colorful feathers in acts of courtship, we would be blunted to the allure of sounds, melodies, color, texture, and shape. These animal arts are the con-ditions under which the resources of nature, plucked or dragged away from their given context, become the raw materials of the human arts. The feathers the bird uses to appeal to other birds are those used by milliners in their designs of hats. The scents that are alluring to bees become the base scents for various manmade perfumes. The colors that fish and birds use to attract each other are the same ones we use to intensify our sensations and our actions. Art is the human capitalization on these inhuman, animal

qualities, the submission of these materials to other requirements than the instinctive. Art is the human transportation of these qualities, through framing, to any place whatsoever.

The human arts are thus as inhuman as the human itself is: both are the transformation, the reworking, the overcoming of our animal prehistory and the beginning of our inhuman trajectory beyond the human. Art is that which most directly returns us to the animal lineage to the extent that art's qualities are not purely bound up with the concepts, meanings, and values art represents but instead primarily reside in its capacity to affect and transform life — that is, in what it does more than what it means. The animal reminds us of this movement in which we are bound, this movement beyond ourselves that our art best represents. The animal is that from which qualities emanate and territories proliferate, and through which life is architecturally framed by more than need. The animal is that from which the all-too-human comes and that through which the human moves beyond itself.

Living Art and the Art of Life

WOMEN'S PAINTING FROM THE WESTERN DESERT

In the preceding chapter, I looked at how the animal prepares and enables the world of human art to fill itself with qualities: the qualities of materiality, nature, and the real; the qualities and effects of imperceptible forces, forces that come to resonate and affect living bodies through their impacts on the body and the affects and sensations they generate. But the animal arts of seduction, those arts that enable an animal to attract others of interest to it, those comprising sexual selection, are in themselves not art but the liberation of qualities from any given context and from any particular use. They are the matter of art without yet being art. Art requires something else. It requires framing, decontextualization, a transport elsewhere, a movement that Deleuze and Guattari describe as deterritorialization. Animals compose, they bring together raw materials, but they neither frame nor deterritorialize. It is not their transport of qualities that enables these qualities to acquire an autonomy from their use. It is the positioning of these qualities *elsewhere* that enables them to generate sensations, enliven and transform bodies, and add new dimensions to objects. In this chapter, I explore in the most elementary way how this deterritorialization of qualities enables the eruption of a new kind of art, an art less than half a century old that has had a powerful effect both on the world of art and in the emergence of a new kind of politics and a new kind of political survival that show art's place in the production of new futures.

World Art

Indigenous Australian art has produced a radical transformation in world art. Art no longer represents — if it ever did — a particular story, a particular Dreamtime, people, land, and events: it now represents art itself, a new kind of art, a new way of doing art and thinking about art. This is an art that, forty years after its eruption into the art world, has become the most vibrant, dynamic, and living art of the present, an art that has had an indelible effect on Western art more generally. Other forms of painting look weak by comparison. This is an art that speaks to world art, affects the way that art will be made in the future, and has literally traveled the globe in various shows alongside the most powerful forms of contemporary Western and non-Western art.

Such art is a new mode of connection to life. Art not only represents life as it has been and is; above all, it summons up life to come, even as it also represents a particular life, a particular place, a particular Dreamtime. Indigenous Australian art resonates with particular responsibilities, a particular history, and particular forms of living. Yet it also opens up art itself to new becomings, new elaborations, new pathways.

Such art explodes with colors, forms, narratives, both public and secret, but also and above all, with affects, with forces that affect and are affected, with sensations — color-sensations, texture-sensations, form-sensations — that touch the living with inhuman powers that are beyond our control or understanding. With the art of the Western Desert, we, its sometimes far-flung spectators, are led to feel the forces of the universe, to see how we are embroiled in them, and we become, through the sensations such art induces, part of something bigger, which we can only intimate or dream about but not really comprehend or compute.

Universal forces — gravity, light, heat; the forces of wind, sun, rain, moon, and planets; geographical and ancestral forces, that is, the forces of the past, of history, not only of one's people but of all of life on earth — touch us unmistakably, not through predictive understanding that is required in the sciences or in forms of rational belief, but only through bodies, our living bodies. Art touches living bodies and induces transformations in those bodies which affect and move them and change art in the process.

If living bodies make art, it is also true that bodies are transformed by art. No longer reflective or contemplative bodies, far from the action, surveying

at a distance the events that don't touch one but are available for one's observations, bodies are now touched directly by the same forces that the art object invokes. Bodies, living bodies, the bodies of objects, bodies of land and of water, become the objects of art, what art depicts and transforms. Art affects bodies, bringing them into touch with the forces of the past and future, with the forces of the universe, with the force of other animals with which one shares a history and geography, and with the force of one's ancestors, which enable us to exist as we currently do and yet to differ from them. Art is an agent of change in life, a force that harnesses potentially all the other forces of the earth, not to make sense of them, not to be useful, but to generate affects and to be affected, to affect subjects, but also objects and matter itself. Art is the excess of matter that is extracted from it to resonate for living beings.

No other art is as alive to a constituency — not to an audience, but to a people — as indigenous Australian art. Such art does not *represent* a people, for a people can be represented in infinite different ways, politically and semiotically. It enables new prospects and possibilities for a people, not just the artist, but the constituency of the artwork itself, those it transforms, those who hear or see it as well as those who do not. It is not representative (representation always fails what it represents). It is expression, extending out.

Art denaturalizes life. It erupts from within a natural order, whether animal or human, but it also radically transforms and disrupts life, it detours life through intensity, force, pleasure, and pain as no natural or given forces can. Art is created, always made, never found, even if it is made from what is found. This is its transformative effect — as it is made, so it makes. As art is a detour of nature, so nature is transformed through art into culture, into history, into context, into memory, into narratives which give us, the living, a new kind of nature, one in which we can recognize or find ourselves, one in which we can live, survive, and flourish. This is what contemporary Aboriginal art announces.

Desert Art

In the last forty years, art has come to have a new life, for it became unchained from the representation of us, subjects, and our petty interests and fantasies to become invested with the forces of the world, the universe. This history effects precisely a transformation of perspective from the subject to the world. These forces are not reducible to life, for they preexist life

and make it possible. But life must address these forces one way or another, through the knowledges, practices, and events in which they are materialized, made real, have effects.

In the work of Aboriginal artists, art becomes ontology. It comes to resonate with the real, not to represent it at a distance, but to vibrate with the very same forces that make the real, to join with the real. No longer simply religious, ritualized, or historical, yet never entirely severed from these connections, art becomes musical and music artistic. Colors function like notes, singing a world into existence, vibrating with new forms of resonance and dissonance so that new kinds of particles, new kinds of nature, new melodies, and above all new kinds of future can be possible.

Art induces the real to reveal itself, to make itself more than itself, to discover economies of action, forces, effects that make as they change or unmake. It functions, not in opposition to science, however one may understand this term, but as its underside, as its intuitive complement. It doesn't grasp or comprehend the real. It intimates it, it feels, enacts, or performs the real.

This art has had a powerful impact on contemporary art as it gained recognition. What has been recognized, though, are not the particular regions, Dreamtimes, animals, plants, and events that such art represents. Rather, what is of influence is that a new kind of art has come into being. Neither figurative nor entirely abstract, this art is *both* figurative and abstract, *both* representational and anti-representational, *both* religious and secular, *both* functional and utopian. Like no other either traditional or contemporary art, it resonates; it makes clear that art has to touch one as well as be observable. Art has to be affective to be effective. It must have impact, to have a force of its own, derived from and partaking in the universal forces it expresses.

Such art expresses many things at once; a past, a people, and a future. It also expresses what all other arts also express — a world. It presents the teaching of, and prepares for the opening up to, new worlds, worlds linked to our own, to the past, but soaring from them, singing new tunes, beating out new rhythms.

Western Desert art teaches us of the forces that will overrun us, that made us and will unmake us. It teaches us how to live with imponderable and unmasterable forces and to make them the sources of affirmation, of new possibilities.

Art makes something eternal. It makes sensations, which operate some-

where *between* a living being and a material world. Sensations do not appear and disappear, for they are only ever created. They do not require an audience. They are the very stuff of art; they accompany art's transformation of matter. They are what art adds to materiality, to the substance of the world, to stones, plants, air, and water, to make the world more than it is, to add becoming and qualities to the world that in itself is only what it is. Art expands the world by expressing in sensation the imperceptible forces of the world, and especially those that herald the inevitability of change, movement, transformation.

Art adds intensity, intension, and investment to the neutral indifference of the real. It makes a world inhabitable, hopeful, by marking it with the excess in it or drawn out from it that makes the world palatable to life. Art is what enables a desert to bloom, rocks to be filled with mystical forces, natural elements such as the weather, the distribution of water, and flora and fauna to resonate, not only in themselves and through their own actions, but for the artists who capture these forces in their creations, or for the spectators, far and wide, who come to feel these forces and elements now long removed from their original location. Art makes these living and nonliving things eternal. Even if they are as momentary and provisional as sand paintings that disperse with the wind.

It is the capacity of art to intensify the world and particularly the various living and nonliving co-occupants of a territory, and to add to them another dimension, a virtuality, a promise, that makes Indigenous art come alive. It is living art, an art related to living and sharing resources for survival and more in a land, a territory, or terrain that is both indifferent and unmasterable but marked by the history of life it has sustained.

Art is how one lives at one's best with others through creating something eternal, something that creates affects, that impacts the bodies of others, especially those in the future, that summons up a future, sings or paints it into existence from the sources of the past and present. Art is a virtual leap into new worlds to come, it is the way that the present most directly welcomes the future.

That is why Western Desert painting and other arts (print-making, batik, sculpture) are profoundly political without usually explicitly articulating a politics. They are the summoning up of the past, its events, and the narratives they generate—events that were not always life-affirming and were commonly, since the white invasion of Australia, genocidal—as a welcome to a new future, to future generations, to their children and ours, a welcome

that enjoins the remembrance of the events of the past that brought about these future generations, different from us in the present. These arts are both history and incantation, both geographical and historical, both cultural and political, both aesthetic and pragmatic.

Art is thus both what is added to the material forces of the world to give them a new kind of resonance and also what is extracted from material forces and made to function in a different way. Natural materials, such as ochers, clay, wood, sand, sticks, and reeds, and now also artificial materials, like boards, acrylic paints, and linens, become the resources for an incantation of the future beyond the history of annihilation that successive governments have accomplished, whether intentionally or not. Yet something resists, and more than resists. It creates boundless new forms, provocative and arresting colors, vibrating forces that tell of a new way of seeing and living in the world. This art is the lifeblood of many Aboriginal peoples, their possibilities for a future that overcomes some of the shameful present.

As hostile and genocidal as the forces of white governance have been for over two centuries in white Australia (as no doubt it has been elsewhere under colonization across the globe), and as systematic as the attempt has been to wipe out Aboriginal culture through exclusion or assimilation, nevertheless, there have always been forces of resistance, strategies and techniques for survival, that have ensured the inassimilable continuation of Indigenous culture. Through the intervention of art-making activities, some bright and utterly unexpected possibilities emerged for the future of otherwise decimated Aboriginal peoples. This is a future developed through the staggering talent of their artistic practices, a talent that is nearly universal, which runs through clans, families, skin groups, and that is taught and refined from one generation, group, or community to the next. Children learn from their parents — sons from fathers, daughters from mothers — the stories for which they are the custodians, the myths and sacred rituals that explain the universal for a nomadic people. Art, music, and dance are deeply embedded in the historical narratives and religious rituals required to keep nomadic peoples safe in an unpredictable environment.

These are not merely forms of survival, however. They are the creative production of processes to mark history, identifications, both animal and human, and knowledge, and to transmit them from one generation to the next. Not simply history, science, and nutritional lessons, these ways of conveying knowledge are forms of allegiance and identification with a

territory, and with its living flora and animals. They are forms of affect, of intensification of one's membership in a group, a clan, and a people.

Art has emerged as one of the major ways to ensure that Aboriginal people can earn money on their own terms, without too much of a compromise with their values, as well as the only condition under which they may face a cultural future in which their work is valued and recognized by the rest of the world. Art is a way of remaining true to the stories that constitute Indigenous culture, while not too directly revealing the secret and sacred meanings of various representations (indeed, it may be that art hides rather than reveals meaning, that it complexifies and intensifies meaning rather than explaining it). Nevertheless, for its makers, this art produces adherences, identifications, patterns that explain one's own existence and that of one's group.

Doreen Reid Nakamarra

I want to discuss two examples of work by women artists. The first belongs to Doreen Reid Nakamarra, an extraordinary artist who only began to paint in 1996, and whose works are now powerful, striking expressions of the land she lives on and travels around. (One of these works is presented as the frontispiece here.) The second is a gorgeous, collectively generated artwork by Martu women, mothers and daughters, who have created a vast, intricate, breathtaking painting of *Ngayarta Kujarra* (Lake Dora). (This is represented on the front cover.) Taken as in some ways representative of newly emerging directions in women's Indigenous art, these two sets of work show the strength, resilience, and open creativity of a new generation of Indigenous art that now focuses on works made by women, representing women's lives and stories, a new and unexpected eruption of sexual difference. These works demonstrate two quite different trajectories or directions in Indigenous women's arts. One is a tendency toward ever finer and more nuanced abstraction, focusing on the line and the movements generated by and represented through linearity. The other is directed more to the concrete expression of women's bodies, experiences, and narratives, and is more focused on forms—female forms, shapes, and symbols of the female body undertaking women's activities.

Doreen Reid Nakamarra was born in the late 1950s in Mummine, near Warburton in Western Australia. She grew up living a traditional nomadic

life with her family. In the 1960s, they walked many hundreds of kilometers to a government settlement at Ikuntji (Haasts Bluff), in Warlpiri country. Collecting together diverse Indigenous populations in settlements was part of the federal government's policy of assimilating Aboriginal traditions, languages, and cultures into the values of white Christian Australia. Moved to the desolate camps of Papunya and Haasts Bluff from the 1940s to the 1960s, many different Aboriginal language and skin groups were put together in appalling and degrading conditions, conditions consciously aimed at the annihilation of Aboriginal culture. Paradoxically, it was out of these very wretched communities that art was to erupt with unexpected force and ferocious creativity decades later.

Doreen's family moved from Haasts Bluff to Papunya, where she attended school, and from Papunya, which was to become the epicenter of the eruption of contemporary Indigenous art in the 1970s, her family moved to Areyonga, a community between Hermmansberg and Alice Springs, and later to the community at Kaltukatjara, also known as Docker River, southwest of Alice Springs.

In the 1980s, she traveled to Kintore, where she met her husband, George Tjampu Tjapaltjarri, one of the more subtle of the Papunya Tula artists. Together they settled in Pintupi country, in Kiwirrkura, where George's people live. They collaborated on his artworks together, producing a number of rich, flowing works in traditional ochers, with detailed and intricate fine-line work, of the countryside and its Dreamings. It seems as if she was brought into the world of modern art, trained in a kind of apprenticeship in painting, as were many Indigenous women, through collaborative work with her husband. This cooperative work was one among many influences on her emerging artistic skills. Upon his death in 2005, she returned to her homeland, in Warakurna, but shortly after returned to Kiwirrkura to live and to paint with other women. (Kiwirrkura is an outstation around seven hundred kilometers from Alice Springs, where a group of Pintupi set up a permanent community in 1983.) There she elaborated a style that was, while linked to the techniques she learned with George, a new opening, a new direction, a new linearity.

She claimed that her husband had enjoined her "to stay here and paint the country around Kiwirrkura," perhaps as a way of ensuring her integration into her adopted community. She aimed to paint, in part at least, she said, "for white fellas to see that country like I do."[1] Her work transmits a

terrain or territory as it feels, as it functions haptically, as it is experienced as one walks through it rather than as one observes it. Like other major Indigenous artists, her work presents an aerial view, the perspective of a bird, a fish, a being immersed in the land it traverses, a living being crossing territory, moving through time and space inside the work more readily than outside it.

With the death of her husband, Doreen began working with some of the other women painters in the Kiwirrkura community to paint various women's ceremonial sites and stories. She claims that many of her works have to do with her husband's land, and with the women's sites and stories she has had access to in his country. Each painting is the elaboration of a particular site and region, a visual and tactile exploration of various women's Dreamings. In conversation with me,[2] she also claimed that her works represent women's strengths, the fortitude of women in their activities, their capacity to survive and thrive. Her work is perhaps a way of celebrating and remembering the terrain in which her husband lived, where these many activities, not only men's ceremonies and stories, which he painted, but also women's ceremonies, locations, and activities, occurred.

In Australian Indigenous communities, painting was primarily the activity of men from the 1970s to the 1980s. It was only later that many Indigenous women began to produce works of their own (primarily acrylics), representing their own Dreamtime. By 1996, women from both the Kintore and Kiwirrkura communities began to paint for the Papunya Tula and the Martumili Artists companies. These women artists emerged primarily from the mid-1990s on, when Pintupi women began acrylic painting with the same feverish creativity as two decades before the men had, both groups coming alive through their artwork at Papunyu. According to Luke Scholes, who has written with consideration and care about these groups, many of these women began their artistic careers as assistants for their (commonly aging) husbands.[3] This apprenticeship through collaborative work no doubt produced a kind of training for many women in the development of their artistic skills, the laying down of the groundwork for the production of their own Dreamtime stories, their own rituals, practices, and perspectives. It provided a kind of formal training in technique that then opened up and out when these women elaborated their own stories and hid their own secrets within their art. A new kind of art about different places, animals, and events than those that mark the art of the men was

created; an art by and for women, not so much about women themselves as about the places and events that mark their specific migrations across territory. A new kind of art expressing sexual difference itself emerged.

Because of unusual heavy flooding between 2000 and Cyclone Abigail in 2001 (March 3–5), Kiwirrkura's small population of 170 was evacuated to Kintore (around 150 kilometers east of Kiwirrkura), then to Alice Springs, and then to Morapoi station, more than 2,000 kilometers away. It was only by late 2002 that the community came home to Kiwirrkura. They returned with strong images of Kiwirrkura under water, and watery images emerged in the women's art, though this region is usually extremely dry. Also, through their recent contact with other Aboriginal communities and their art practices, many Kiwirrkura women, both young and old, were drawn with a new vigor to both previous art practices and the creation of new art as the way forward for their people, a mode of pride and learning for the younger generation and a mode of teaching, self-generation, and sustenance for the older. Art became a living line of connection from the past to the future, a lineage marking the continuous movement of peoples from the long distant past into the present and future, traveling vast terrains only through the help of the narratives art elaborates.

Doreen Reid Nakamarra's works are now recognized as major contributions to contemporary Australian indigenous art. She won the General Painting Award at the Twenty-fifth National Aboriginal and Torres Strait Islander Art Awards in 2008 (she was also runner-up in 2009), and her works are now in the collections of the National Gallery of Australia and numerous state galleries. They have also been exhibited at dozens of shows, including the Sydney Biennale in 2008, the Moscow Biennale in 2009, and the Adelaide Biennial in 2010, as well as in the "We Are Here Sharing Our Dreaming" show at the Grey Gallery at New York University in September 2009.

It is clear that in many ways her vibrant works represent sand dunes, hills, the movement of wetness and dryness, of waves — waves of force-fields, waves of air, and watery waves, as well as the traces of waves in sand and dunes, perhaps waves that open up the desert to its various forms of blooming. She captures waves in visual form, though waves are vibratory and tactile: her fine lines and zigzags capture the flowing movement of sand, the movement of wind through dryness. She adopted a kind of minimalism that traces these fluid forces through the lines of indirect movement, movement that fans out, that ripples. She has claimed (in conversation with me) that all

of her current works are representations, of maps of Marrapinti, the usually dried-out creek, and the small soakages and water holes and sandhills around her adopted home. They all represent aspects of the journey that women take, stopping at various sites, undertaking initiation ceremonies (such as the piercing of the nasal septum for girls in their early teen years), and other activities — eating, sleeping, encountering animals. These works express the sites traversed and the women's activities that take place in them. Each work is viscerally tied to the land, to the movements and changes that occur to the land, to the forces that transform the land.

Her paintings all resonate. They represent a field of forces, colored, calibrated, measured not in dots by which much of men's art is known but in fine lines, etching the motion of wind over sand, the ways in which sand is transformed into patterns. Her works, through the use of colors that are difficult to work with — the acrylic forms of yellows, ochers, oranges, the palette of sands — nevertheless generate a kind of synaesthetic effect. They are like sound waves, like pure resonance itself, the intimation of a hidden source or emanation, the following of a resonance trail, the opening up of a terrain to the elements and effects which are enacted on it. It is the wind and the elaborate patterns it generates from its changing orientations that are depicted, for her work evokes the feeling, the haptic forces, of the elements rather than their look. They dazzle, they induce throbbing sensations, they make visible the forces of these unseeable impulses. These forces, the forces of gravity, of wind and air, of generation and regeneration, are at work continuously but only made visible through painting, sculpture, and other visual arts.[4]

The Martu Women's Painting Collective

Like the powerful, resonating beauty of Doreen Reid Nakamarra's work, the Martu women's collective's extraordinary painting has generated much interest. Many of the women who make up the Martu collective gained their training in art practices through working on art with their husbands, as did Doreen, though many of the Martu women's husbands were already dead when they started painting. According to Gabrielle Sullivan, manager of Martumili Artists' Cooperative,

> The majority of Martu artists painting are female, there are only two senior men painting at Punmu (neither painted the Lake Dora canvas,

[although] Minyowe Miller, Nancy Chapman's husband, spent a few hours each day watching the painting progress, [and] it is quite possible that his presence influenced the creation of the painting in some unspoken way which will probably remain unspoken). I think it is true that the memory of many of the artists' husbands inspired the creation of the painting; artist Rosie Williams (she took the lead in the creation of the painting from inception to completion) spoke sentimentally about her husband's role and responsibility in the establishment of Punmu Community 27 years ago. Rosie expressed that the creation of the painting acknowledged the hard work her husband and the other artists' husbands undertook to establish Punmu Community in their traditional desert home.[5]

Like Doreen Reid Nakamarra's dazzling work, their work is directed to territory, to the living and natural resources that make up their country.

This collective work may now come to represent the art of communities as much as individual artists. The art of these women, and of many others who work in remote regions of the great desert of Western Australia and the Northern Territory, highlights the eruption of a younger generation of women artists whose work, while linked to and in some cases created in conjunction with family members (husbands, brothers, mothers), brings a new direction to art. These artists have matured to develop their own styles and techniques, enabling them to present an art based on women's ceremonies, stories, and Dreamtimes; on the activities, practices, plants, animals, and geographies for which they function as guardians; and on the body-representations and art forms that specify women's particular bodies and cultural activities, experiences and activities that are women's alone. They express in acrylic paint what were once forms of body painting, transferring and transforming traditional designs onto large, open, vibrant canvases that are strikingly contemporary in their colors, forms, and patterns. These images contain less linear and more organic, more traditionally feminine symbols, curves, U-shapes, and round forms, which are significantly different than the forms that make up Doreen's work.

Twelve Martu women artists living at Punmu (a community about 1,300 kilometers northeast of Perth and 640 kilometers from Port Hedland, the nearest town), decided in November 2008 to undertake a vast (3 × 5 meter) collective artwork.[6] They decided to create this painting as a way to provide some funds for the financially constrained Punmu community. But

as this activity was considered and worked through, and the resources—canvas, paints, brushes, and other materials—were carted in, the project became both an act of self-elaboration and an intricate and complex teaching and learning experience for all members of the community. For months before its execution, there were detailed discussions about what the painting was to be. As soon as the materials arrived, there was an immediate buzz of activity, and following the first brush stroke by Rosie Williams, the women began to paint with awesome intensity, even in the scorching 48 degrees Celsius [118 degrees Fahrenheit] heat. The women painted feverishly for ten hours that first day. For seven days, both older and younger women painted intensely, while telling stories and singing songs. They were watched by children, most other community members, and various dogs while they produced this extraordinary, path-breaking work. Mothers and grandmothers taught their daughters and granddaughters not only artistic techniques but the stories they represented. It was the first time that most of the artists were involved in collective painting, and yet the work is remarkably cohesive, a giant map of the significant sites and stories from where they live. And it is significant that in the middle of that intense week of painting, the women went down to the sites to rewalk them and to sing the stories of these places. The sites themselves spoke and this was what became embodied in the work.

Their collective work is a painting of the saltwater lake that has sustained all of them, Ngayarta Kujarra, or Lake Dora, a big white lake left glittering with salt crystals as it dries out after a rare rainfall. The Punmu community lives on the eastern finger of the lake, which is connected to a number of water holes, whose locations marked the nomadic pathways of their ancestors. This collective painting represents the movement from water hole to water hole, and the events and significant sites along the way. It depicts the movement from one site to another, the path of nomadic movement that marks space by activities, natural resources, and living things. It represents the stories of this territory, the songs, dances, animals, plants, natural phenomena, and events that occurred in it, that are historically and currently embedded in the land yet unperceived by those without access to this history. The land comes alive with what happens in it. It is the repository of life, but only if one understands its message, only if one can properly hear what it tells us. This can only occur through a certain attunement to its particularities, to its prehistory as well as its history.

The painting is not composed of the stories of these women and in no

way reflects what we might understand as individual narratives, autobiographies. Rather, the collective narratives are embedded in the earth and function as part of its surface, the surface on which humans live along with plants and animals. The painting maps out, not these narratives, but the sensations, intensities, and affects they generate. The artists do not tell a story: they depict its affects. The painting brings together several Dreamings, several narratives, collected into a single dynamic map. This is not a topographical map but a historical one, a map of things and happenings, a map of movement rather than, as usual, stasis, a map of lines of becoming rather than of inert and unchanging objects or points. This is a vibrant map of happenings, alive with color, with reds, pinks, greens, and an overpowering whiteness, the whiteness of salt in the desert, a whiteness that also shimmers on a surface that hides great depths. This is a painting of the great whiteness of the lake, of the whiteness that still generates living greens and pinks, the pathways traversed by people and the acts the terrain around the lake sustains.

As guardians of this history, each sex, group, and individual must repeat but also watch over and thus at times withhold both the Dreamings and the land that they explain and organize. The Dreamings are the key to understanding and belonging to the land. In withholding them, or only circulating these Dreamings among those in one's own group, the integrity and the function of each Dreaming is preserved. Each Dreaming, in its multinarrational and non-narrative elaborations in music, dance, storytelling, and art, has an obligation to both include and exclude, to open up the Dreamtime to all of humanity as a way of directing the human in the ways of the earth while still protecting the Dreaming from those forces that are hostile to the Indigenous cultures it protects. As one of the Martu artists explains, "We were taken away from Punmu to Jigalong mission and then we worked on stations. But we came back and now we are living in our country again: that's what this painting shows. It's a painting of Punmu for Punmu. We want to sell this painting and give something back to our community to help it."[7]

This extraordinary work is one in which we are lost as spectators. Like when before huge natural wonders, we are perceptually dwarfed. It draws us in as participants. We come to see the lake and its surrounding plants, animals, and people as if we were ourselves walkers, not observers. Our eyes become nomadic. They take us bodily through a terrain rather than providing a vista or a panorama for us to access from afar. We become the living

inhabitants of this country to the extent that we can perceive the painting. We cannot perceive it from far enough away. Instead we must draw close, be immersed, transported into the painting, into its terrain, for us to perceive it at all.

When the painting was finished it was taken to the lake, and placed on the dried white lake bed. There were many songs and dances elaborated, and the painting was admired by everyone in the community. It had become marked not only in the labors of its creators but also by the force fields of the lake itself. The painting expresses the lake and its waterholes, animals, and plants and has become part of the lake. It expresses the Martu people and the stories and land that they must look after and keep safe. The painting itself summons up a new kind of life, a life beyond flesh, a life in paint and canvas that also tells stories, sings, and dances without words or actions.

These works of Doreen Reid Nakamarra and the Martu women's collective, among the many luminous, shimmering works produced by Indigenous artists over the last four decades, represent new trajectories, new possibilities for women artists. They represent a new recognition that women's stories, sites, and experiences provide as much energy and inspiration for art activities as men's and that perhaps the ways in which women undertake these projects may prove different to and separate from those of men. They express a new vigor and energy, new forces of self-representation and self-production through the artistic production of new images, new techniques, new objects of representation, and in the process, they create new generations of artists to bring into existence more hopeful futures. This is an art that brings new forces into existence by elaborating natural and social forces themselves. It is an art thus directed to the future, an art beyond identity, an art directed to the forces of the real, to making a new kind of real.

notes

ONE. *The Inhuman in the Humanities*

1. Derrida's *The Animal That Therefore I Am* provides a moving testament to the intimate connectedness of man (this man at any rate) and the various and multiple worlds of animals. Derrida makes it apparent how much has been conceptually invested in ensuring that we, the all-too-human, are not cast into this animal world as one among many, but only as the one who rules, the one who need not know, and does what he can not to know, what the animal shares with all that is living — what it feels, acts, suffers: "The question is not to know whether the animal can think, reason, or speak, etc., something we still pretend to be asking ourselves (from Aristotle to Descartes, from Descartes, especially, to Heidegger, Levinas, and Lacan, and this question determines so many others concerning *power* or *capability* [*pouvoirs*] and *attributes* [*avoirs*]; being able, having the power or capability to give, to die, to bury one's dead, to dress, to work, to invent a technique, etc., a power that consists in having such and such a faculty, such and such a capability, as an essential attribute. . . . The *first* and *decisive* question would rather be to know whether animals *can suffer*" (27).

2. Freud well understood the affront to the primacy of consciousness that science offered, seeing his own revelation of the unconscious as the third and most decisive blow to human self-conception:

> In the course of centuries the *naïve* self-love of men has had to submit to two major blows at the hands of science. The first was when they learnt that our earth was not the centre of the universe but only a tiny fragment of a cosmic system of scarcely imaginable vastness. This is associated in

our minds with the name of Copernicus, though something similar had already been asserted by Alexandrian science. The second blow fell when biological research destroyed man's supposedly privileged place in creation and proved his descent from the animal kingdom and his ineradicable animal nature. This revaluation has been accomplished in our own days by Darwin, Wallace, and their predecessors, though not without the most violent contemporary opposition. But human megalomania will have suffered its third and most wounding blow from the psychological research of the present time which seeks to prove to the ego that it is not even master in its own house, but must content itself with scanty information of what is going on unconsciously in its mind. (Freud, "Fixation to Traumas," 284–85)

Freud understood that the first blow is a cosmological blow that displaced man and the earth from the centre of the universe, the second is a biological wound to human narcissism, and the third is a psychological injury that human narcissism sustains in the advances that science makes in spite of the wishes of consciousness itself. (He further elaborates these three blows in "A Difficulty in the Path of Psychoanalysis," 140–41.)

It is significant that for Derrida it is no longer the first or third traumas with which philosophy must now deal but only the second, in whose wake we live today. In discussing "this whole anthropocentric restitution of the superiority of the human order over the animal order, of the law over the living, etc.," he writes, "Whenever such a subtle form of phallologocentrism seems, in its way to testify to the panic Freud spoke of: the wounded reaction not to humanity's first trauma, the Copernican (the earth revolves around the sun), nor its *third* trauma, the Freudian (the decentering of consciousness under the gaze of the unconscious), but rather to its *second* trauma, the Darwinian." Derrida, *The Animal That Therefore I Am*, 136.

3. I have spent considerable time elsewhere distinguishing my position from the sociobiological tradition which has tended to dominate both the biological sciences and the philosophies of life that reflect on and accompany them. See, in particular, my critique of Daniel Dennett, who is among the more philosophically astute representatives of this tradition, in *The Nick of Time*.

4. Linguistics relies on a pragmatics, for language is itself diagrammatic, it enacts rather than represents: "If the external pragmatics of nonlinguistic factors must be taken into consideration, it is because linguistics itself is inseparable from an internal pragmatics involving its own factors." Deleuze and Guattari, *A Thousand Plateaus*, 91.

5. Darwin, *The Descent of Man*, 1:191. Additional citations of this source appear parenthetically in the text.

6. Derrida, *The Animal That Therefore I Am*, 32.

7. Derrida writes, "[Humans] have given themselves the word in order to corral a large number of living beings within a single concept: 'The Animal,' they say. And they have given it to themselves, this word at the same time according to themselves, reserving for them, for humans, the right to the word, the naming noun (*nom*), the verb, the attribute, to a language of words, in short to the very thing that the others in question would be deprived of, those that are corralled within the grand territory of the beasts: 'The Animal.'" Derrida, *The Animal That Therefore I Am*, 32.

8. Derrida is highly critical of Lacan's attempts to distinguish between human language, based as it is on the signifying chain and the internal and potentially infinite relation of signifiers, and animal coding, which Lacan considers to be a fixed relation between a sign and reality, a feature he attributes to the dancing language of bees that Karl von Frisch discerned.

 For Lacan, "We can say that [a code such as that of the dancing bee] is distinguished from language precisely by the fixed correlation between its signs and the reality they signify. For in a language, signs take on their value from their relations to each other in the lexical distribution of semantemes as much as in the positional, or even flectional use of morphemes—in sharp contrast to the fixity of coding used by bees. The diversity of human language takes on its full value viewed in this light." Lacan, "The Function and Field of Speech and Language in Psychoanalysis," 245–46.

 Derrida problematizes the distinction between a language and a code that Lacan uses to distinguish the "language" of animals from that of human languages by affirming that all codes, like languages, "take on their value from their relations to each other," implying that there is no logical gulf between the self-sustaining signifying chain Lacan affirms as truly language and those systems of code that animals use to communicate. Derrida, *The Animal That Therefore I Am*, 124. I further explore the elaborate language of bees and other insects in chapter 10.

9. Darwin remains skeptical that there is any unbridgeable gap between man and other animal species. First he claims that all the qualities that are to be uniquely attributed to man are also there in a less developed form in other species; and second, he claims that there is so little agreement among men themselves about what uniquely characterizes the human, that it seems the gap is not as impermeable as it first appears:

 > Many authors have insisted that man is separated through his mental faculties by an impassable barrier from all of the lower animals. I formerly made a collection of above a score of such aphorisms, but they are

not worth giving, as their wide difference and number prove the difficulty, if not impossibility, of the attempt. It has been asserted that man alone is capable of progressive improvement; that he alone makes use of tools or fire, domesticates other animals, possesses property, or employs language; that no other animal is self-conscious, comprehends itself, has the power of abstraction, or possesses general ideas; that man alone has a sense of beauty, is liable to caprice, has the feeling of gratitude, mystery, etc.; believes in God, or is endowed with a conscience. (*The Descent of Man*, 1:49)

10. Darwin has convincingly argued that the origins of species and of languages are remarkably similar and that the criteria by which competing languages are assessed accords with the criteria that regulate natural selection:

> The formation of different languages and of distinct species, and the proofs that both have been developed through a gradual process, are curiously the same. . . . We find in distinct languages striking homologies due to community of descent and analogies due to a similar process of formation. The manner in which certain letters or sounds change when others change is very like correlated growth. We have in both cases the reduplication of parts, the effects of long-continued use, and so forth. The frequent presence of rudiments, both in languages and in species, is still more remarkable. . . . Languages, like organic beings, can be classed either naturally according to descent, or artificially by other characters. Dominant languages and dialects spread widely and lead to the gradual extinction of other tongues. A language, like a species, when once extinct, never . . . reappears. The same language never has two birthplaces. Distinct languages may be crossed or blended together. (*The Descent of Man*, 1: 59–60)

11. "Although the sounds emitted by animals of all kinds serve many purposes, a strong argument can be made out, that the vocal organs were primarily used and perfected in relation to the propagation of the species. Insects and some few spiders are the lowest animals which voluntarily produce any sounds; this is generally effected by the aid of beautifully constructed stridulating organs, which are often confined to the males alone. The sounds thus produced consist, I believe in all cases, of the same note, repeated rhythmically; and this is sometimes pleasing even to the ears of man. Their chief, and in some cases exclusive use appears to be either to call or to charm the opposite sex." (*The Descent of Man*, 2:330–31)

12. I will further explore Bergson's elaboration of Darwin, and Deleuze's elaboration of Bergson, in the following chapters.

13. Darwin argues that it is only quite recently that dogs have learned to articulate

and to do so in remarkably expressive and distinctive ways: "The dog, since being domesticated, has learned to bark in at least four or five distinct tones. Although barking is a new art, no doubt the wild species, the parents of the dog, expressed their feelings by cries of various kinds. With the domestication of dogs we have the bark of eagerness, as in the chase: that of anger; the yelping or howling bark of despair, as when shut up; that of joy, as when starting on a walk with his master; and the very distinct one of demand or supplication, as when wishing for a door or window to be opened." Darwin, *The Descent of Man*, 2:54.

14. Messiaen makes birds themselves appear in musical form in the string quartet, *Quartet for the End of Time* (first performed in 1941), as well as in his only opera, *Saint-François d'Assise* (first performed in 1981); his solo piano of bird-song melodies, *Catalogue d'oiseaux* (composed between 1956 and 1958), is also of relevance here. His *L'Oiseau-lyre et la Ville-Fiancée*, for example, aims to capture the vocal and behavioral movements of the lyre bird.

15. Frisch's observations are used by Lacan as a form of proof that human language is of a fundamentally different order, regulated by its own signifying chain rather than through a fixed code which correlates only with real objects in the world (Lacan distinguishes the internal structure of signification from the external structure of reference). See Lacan, "The Function and Field of Speech and Language in Psychoanalysis."

16. Frisch describes in considerable detail in a number of central texts how the language of bees consists primarily of forms of communication transmitted through forms of dancing (Lacan talks of a "dancité," the kind of density or force of the dance) that are more forms of rhythmic contamination than unambiguous messages:

> The foraging bee, having got rid of her load [of honey], begins to perform a kind of "round dance." On the part of the comb where she is sitting she starts whirling around in a narrow circle, constantly changing her direction, turning now right, now left, dancing clockwise and anti-clockwise in quick succession. . . . What makes [this dance] so particularly striking and attractive is the way it infects surrounding bees: those sitting next to the dancer start tripping after her, always trying to keep their outstretched feelers in close contact with the tip of her abdomen. They take part in each of her manoeuvrings so that the dancer herself, in her madly wheeling movements, appears to carry behind her a perpetual comet's tail of bees. . . . What is the meaning of this round dance? One thing is obvious: it causes enormous excitement among the inmates of the hive sitting nearest to the dancers. (*The Dancing Bees*, 101–3; see also *Bees*, 56–58)

For Lacan's concept, see "The Subversion of the Subject and the Dialectic of Desire."

TWO. *Deleuze, Bergson, and Life*

1. Alain Badiou, *Deleuze*, 39.

2. The traditions of the ethological and the geological, the machinic phylum, and the biosemiological are referred to throughout Deleuze's works, including those initiated through Raymond Ruyer (*Néo-finalisme*) and Jakob von Uexküll (*Theoretical Biology*; see also his paper "A Stroll through the Worlds of Animals and Men" [1957]). The latter's work is discussed in further detail in the following chapters. Later in this essay, I examine Gilbert Simondon's work on individuation or disparation and its place in Deleuze's understanding of life. See Simondon, *L'individu et sa genèse psycho-biologique*; all quotes here are from the partial English translation "The Genesis of the Individual."

3. Deleuze devotes three texts specifically to Bergson: his book *Bergsonism*, and two short papers originally published in 1956, "Bergson, 1859–1941" and "Bergson's Conception of Difference" (both reprinted in *Desert Islands and Other Texts*).

4. See, for example, Lacey, *Bergson*; Mullarkey, *Bergson and Philosophy*; Pearson, *Philosophy and the Adventure of the Virtual*; and Grosz, *The Nick of Time*, chapters 7–9.

5. "The repetitions of the inorganic world constitute rhythm in the life of conscious beings and measure their duration." Bergson, *The Creative Mind*, 109.

6. "There will be novelty in our acts thanks only to the repetition we have found in things. Our normal faculty of knowledge is then essentially a power of extracting what stability and regularity there is in the flow of reality." Bergson, *The Creative Mind*, 111.

7. See Bergson, *Creative Evolution*, 29–30.

8. "Concrete space has been extracted from things. They are not in it; it is space which is in them. Only, as soon as our thought reasons about reality, it makes space a receptacle." Ibid., 113.

9. Bergson, *Creative Evolution*, 2–3. On the tendency of all life toward consciousness, Bergson writes, "Theoretically . . . everything living might be conscious. *In principle*, consciousness is co-extensive with life." Bergson, *Mind-Energy*, 8.

10. "[A living being is] a certain power to act, determined in quantity and quality: it is this virtual action which extracts from matter our real perceptions, information it needs for its own guidance, condensations within an instant of our duration of thousands, millions, trillions of events taking place in the enormously less drawn out duration of things. This difference in tension exactly measures the interval between physical determination and human liberty." Bergson, *The Creative Mind*, 69.

11. "Matter thus resolves itself into numberless vibrations, all linked together in uninterrupted continuity, all bound up with each other, and traveling in every

direction like shivers through an immense body." Bergson, *Creative Evolution*, 208.

12. Ibid., 54.

13. "Life would be an impossibility were the determination of matter so absolute as to admit no relaxation. Suppose, however, that at particular moments and at particular points matter shows a certain elasticity, then and there will be the opportunity for consciousness to install itself." Bergson, *Mind-Energy*, 13.

14. "The impetus which causes a living being to grow larger, to develop and to age, is the same that has caused it to pass through the phases of the embryonic life. The development of the embryo is a perpetual change of form. . . . Life does but prolong this prenatal evolution." Bergson, *Creative Evolution*, 99.

15. Ibid., 42–43.

16. See Kauffman, *The Origins of Order*, especially chapter 7. Kauffman's work is linked to accounts of emergence and order on the edge of chaos developed at the Sante Fe Institute through the work of Christopher Langton and others working on self-organization.

17. Bergson writes:

> "The truth is that life is possible wherever energy descends the incline indicated by Carnot's law and where a cause of inverse direction can retard the descent — that is to say, probably, in all the worlds suspended from all the stars. We go further: it is not even necessary that life should be concentrated and determined in organisms properly so called, that is, in definite bodies presenting to the flow of energy ready-made through elastic canals. It can be conceived (although it can hardly be imagined) that energy might be saved up, and then expended on varying lines running across a matter not yet solidified. Every essential of life would still be there since there would be slow accumulation of energy and sudden release. . . . Such may have been the condition of life in our nebula before the condensation of matter was complete." (Bergson, *Creative Evolution*, 256–57)

18. Ibid., 248.

19. For the notion of the real as "an undivided flux, " see ibid., 249. See also Deleuze and Guattari, *Anti-Oedipus*, 95–96.

20. On the subject of a singularity without identity, Deleuze writes, "Very small children all resemble one another and have hardly any individuality, but they have singularities: a smile, a gesture, a funny face — not subjective qualities." Deleuze, *Pure Immanence*, 30.

21. Simondon, "The Genesis of the Individual," 301.

22. See ibid., 304–5; Deleuze elaborates many of the central tenets of Simondon's work in his brief paper "Gilbert Simondon," *Desert Islands and Other Texts*, 86–89.

1. This process of emergence of life from materiality was largely the project of my book *The Nick of Time*.

2. See, for example, Hardt, *Gilles Deleuze*. See also Bogue, *Deleuze and Guattari*; Boundas, "Deleuze-Bergson"; and Colebrook, *Understanding Deleuze*.

3. For Deleuze's reflections on the nature of philosophy, see *Difference and Repetition* and (with Guattari) *What is Philosophy?*; on cinema and the arts, see *Cinema 1* and *Cinema 2*, *The Logic of Sense*, and his study of Proust in *Proust and Signs*; and on science, see *A Thousand Plateaus* and *What is Philosophy?* (both with Guattari).

4. As Deleuze says, "The notion of difference promises to throw light on the philosophy of Bergson and inversely, Bergsonism promises to make an inestimable contribution to a philosophy of difference." Deleuze, *Desert Islands and Other Texts*, 32.

5. Deleuze explains, "What science risks losing, unless it is infiltrated by philosophy, is less the thing itself than the difference of the thing, that which makes its being, that which makes it this rather than that, this rather than something else." Deleuze, *Desert Islands and Other Texts*, 24.

6. This concept of the living totality, a totality not made up of parts but analyzable into parts, underlies Bergson's understanding of both life and the material universe and binds them in a belonging together: "The material universe itself, defined as the totality of images, is a kind of consciousness, a consciousness in which everything compensates and neutralizes everything else, a consciousness of which all the potential parts, balancing each other by a reaction which is always equal to the action, reciprocally hinder each other from standing out." Bergson, *Creative Evolution*, 235.

7. As Deleuze makes clear, making or invention involves both the given and the undoing of the givenness of the given, from which the new extracts something of its resources: "What does . . . reality signify? Simultaneously that the given presupposes a movement that invents it or creates it, and that this movement must not be conceived in the image of the given." Deleuze, *Desert Islands and Other Texts*, 30.

8. They are the two short papers, originally published in 1956 and gathered together in *Desert Islands and Other Texts* ("Bergson, 1859–1941" and "Bergson's Conception of Difference"), and his full-length study *Bergsonism* (first published in 1966).

9. I have in mind here not only Derrida and Lyotard but also Luce Irigaray and Julia Kristeva, whose conceptions of difference, including sexual difference, must be closely allied with Derrideanism and the critique of binary structures.

I will explore Irigaray's understanding of sexual difference in considerably more detail in chapters 7 and 9.

10. As Deleuze affirms of Bergson: "A great philosopher creates new concepts: these concepts simultaneously surpass the dualities of ordinary thought and give things a new truth, a new distribution, a new way of dividing up the world." Deleuze, *Desert Islands and Other Texts*, 22.

11. "*Essentially, Bergson criticizes his predecessors for not having seen true differences of nature.* . . . If philosophy has a positive and direct relation to things, it is only insofar as philosophy claims to grasp the thing itself, according to what it is, in its difference from everything it is not, in other words, in its *internal difference*. . . . If differences of nature do exist between individuals of the same kind, we must then recognize that difference itself is not simply spatio-temporal, that it is not generic or specific—in a word, difference is not exterior or superior to the thing. . . . Without prejudging the nature of difference as internal difference, we already know that internal difference exists, *given that there exist differences in nature between things of the same genus.*" Ibid., 32–33; emphasis added.

12. As Bergson argues, "It is not 'states,' simple snapshots we have taken once along the course of change, that are real. This change is indivisible, it is even substantial. If our intelligence insists on judging it to be insubstantial, to give it some vague kind of support, it is because it has replaced this change by a series of adjacent states; but this multiplicity is artificial as is also the unity one endows it with. What we have here is merely an uninterrupted thrust of change—of a change always adhering to itself in a duration which extends it indefinitely." Bergson, *The Creative Mind*, 16.

13. As Deleuze explains:

> Matter and duration are never distinguished as two things, but as two movements, two tendencies, like relaxation and contraction. But we must go further: if the theme and the idea of purity have a great importance in the philosophy of Bergson, it is because in every case the two tendencies are not pure, or are not equally pure. Only one of the two is pure, or *simple*, the other playing, on the contrary, the role of an impurity that comes to compromise or to disturb it. In the division of the composite there is always a right half; it is that which leads us back to duration. . . . For if there is a privileged half in the division, it must be that this half contains in itself the secret of the other. . . . From a still dualistic perspective, duration and matter were opposed as that which differs in nature and that which has only degrees; but more profoundly there are degrees of difference itself; matter is the lowest, the very point where precisely difference is *no longer anything but* a difference of degree. (Deleuze, *Desert Islands and Other Texts*, 26–27)

14. Deleuze writes, "Duration is only one of two tendencies, one of two halves. So, if we accept that it differs from itself in all its being, does it not contain the secret of the other half? How could it still leave external to itself *that from which* it differs, namely the other tendency? If duration differs from itself, that from which it differs is still duration in a certain sense." Ibid., 39. He further elaborates: "That which differs in nature is in the end that which differs in nature *from itself*; consequently, that from which it differs is only its lowest *degree*; this is duration, defined as difference of nature itself. When the difference of nature between two things has become one of the two things, the other of the two is only the *last* degree of the first." Ibid., 50.

15. Bergson speculates: "If one . . . seeks to give 'resemblance' its exact meaning through a comparison with 'identity,' it will be found, I believe, that identity is something *geometrical* and resemblance is something *vital*. The first has to do with measure, the other belongs rather to the domain of art: it is often a purely aesthetic feeling which prompts the evolutionary biologist to suppose related forms between which he is the first to see a resemblance: the very design he gives these forms reveals at times the hand and especially the eye of the artist." Bergson, *The Creative Mind*, 67.

16. See Deleuze, *Desert Islands and Other Texts*, 46–47. "The word 'difference' at once designates *the particular that is* and *the new that is coming about*." Ibid., 45.

17. Bergson, *The Creative Mind*, 129, 132.

18. See Kuhn's *The Structure of Scientific Revolutions*. Bergson suggests, somewhat perversely, that an intuition, perhaps only a single one, is what a philosopher can hope to accomplish in a lifetime, given the vast structure of knowledge in the field, and the force of prevailing concepts, and given the amount of support, argument, and analysis required to sustain and communicate intuition. He writes, "A philosopher worthy of the name has never said more than a single thing: and even then it is something he has tried to say, rather than actually said. And he has said only one thing because he has seen only one point: and at that it was not so much a vision as a contact: this contact furnished an impulse, this impulse a movement, and if this movement, which is as it were a kind of swirling dust taking a particular form, becomes visible to our eyes only through what it has collected along its way, it is no less true that other bits of dust might as well have been raised and that it would still have been the same whirlwind." Bergson, *The Creative Mind*, 132.

19. In "An Introduction to Metaphysics," Bergson claims, "A true empiricism is the one which purposes to keep as close to the original itself as possible, to probe more deeply into its life, and by a kind of spiritual *auscultation*, to feel its soul palpitate; and this true empiricism is the real metaphysics. The work is one of extreme difficulty, because not one of the ready-made conceptions that

thought uses for its daily operations can be of any use here. . . . It cuts for the object a concept appropriate to that object alone, a concept that can barely say it is still a concept, since it applies only to that one thing." Bergson, *The Creative Mind*, 206–7.

20. Ibid., 147.

21. Deleuze too understands this dual movement from one side as a double foundation, and from the other, as a founding repetition:

> The first characteristic of intuition is that in it and through it something is presented, is given in person, instead of being inferred from something else and concluded . . . in science, in technical activity, intelligence, everyday language, social life, practical need, and, most importantly, in space — the many forms and relations that separate us from things and from their interiority.
>
> But intuition has a second characteristic: understood in this way, it presents itself as a return, because the philosophical relationship, which puts us in things instead of leaving us outside, is restored rather than established by philosophy, rediscovered rather than invented. We are separated from things; the immediate given is therefore not immediately given. But we cannot be separated by a simple accident, by a mediation that would come from us, that would concern only us. The movement that changes the nature of things must be found in things themselves; things must begin by losing themselves in order for us to end up losing them; being must have a fundamental lapse of memory. Matter is precisely that in being which prepares and accompanies space, intelligence and science. . . . [T]here will not be in Bergson's work anything like a distinction between two worlds, one sensible and the other intelligible, but only two movements, or even just two directions of one and the same movement. . . . In philosophy the first time is already the second; such is the notion of foundation. . . . In distinguishing the two worlds, Bergson replaced them by the distinction of two movements, two directions of one and the same movement, spirit and matter, two times in the same duration, the past and the present, which he knew how to conceive as coexistent precisely because they were in the same duration, the one *beneath* the other, and not the one *after* the other. (Deleuze, *Desert Islands and Other Texts*, 23–24)

22. For exceptions, see Prigogine and Stengers, *Order out of Chaos*; and Prigogine, *The End of Certainty*; as well as Thomas Kuhn, *The Structure of Scientific Revolutions*.

23. Bergson, *The Creative Mind*, 18–19.

24. "Life is tendency, and the essence of a tendency is to develop in the form of a

sheaf, creating, by its very growth, divergent directions along which its impetus is divided." Bergson, *Creative Evolution*, 99.

25. See Deleuze, *Desert Islands and Other Texts*, 26–27.

26. According to Bergson, "Matter this resolves itself into numberless vibrations, all linked together in uninterrupted continuity, all bound up with each other, and traveling in every direction like shivers through an immense body." Bergson, *Matter and Memory*, 208.

27. Bergson, *The Creative Mind*, 173.

28. Deleuze and Guattari, *A Thousand Plateaus*, 176. In that work, the authors claim that "a becoming is not a correspondence between relations. But neither is it a resemblance, an imitation, or, at the limit, an identification. The whole structuralist critique of the series seems irrefutable. To become is not to progress or regress along a series. Above all, becoming does not occur in imagination, even when the imagination reaches the highest cosmic or dynamic level ... Becoming produces nothing other than itself ... a becoming lacks a subject distinct from itself; but also ... it has no term, since its term in turn exists only as taken up in another becoming of which it is the subject, and which coexists, forms a block, with the first. This is the principle according to which there is a reality specific to becoming" (237).

29. Ibid., 238.

30. See *Negotiations*, 55.

31. "Each [species] simultaneously corresponds to a certain degree of the whole and differs in nature from the others, such that the whole itself is presented at the same time as the difference of nature in reality, and as the coexistence of degrees in the mind." Deleuze, *Desert Islands and Other Texts*, 29.

32. Ibid., 42.

FOUR. *Feminism, Materialism, and Freedom*

1. It is perfectly obvious that a freedom to create, to make, to produce, is a luxury that can be attained only with a certain absence of constraint. However, even in the most extreme cases of slavery, or in situations of political or natural catastrophe of the kinds globally experienced in recent years, there is always a small space for innovation, and not simply reaction. What remains remarkable about genocidal struggles, the horrors of long-term incarceration, concentration camps, prisoner-of-war camps, and the prospects of long-term social coexistence in situations of natural and social catastrophe is the inventiveness of the activities of the constrained, the flourishing of minor and hidden arts and literature, technologies and instruments, and networks of communication and the transmission of information. What is most striking about the extreme

situations of constraint, those which require a "freedom from," is that they do not eliminate a "freedom to," only complicate it.

2. See *The Nick of Time* (2004), as well as *Volatile Bodies* (1994).

3. There have been only a few feminist texts on Bergson. See in particular, Olkowski, "The End of Phenomenology"; and Hill, "Interval, Sexual Difference."

4. Irigaray articulates her objections to and her differences from the feminist egalitarian project in "Equal to Whom?."

5. At their base, Bergson argues, both the libertarian and the determinist are committed to a tautology, in fact to complementary tautologies: "The argument of the determinists assumes this puerile form: 'The act, once performed, is performed,' and . . . their opponents reply: 'The act, before being performed, was not yet performed.' In other words, the question of freedom remains after this discussion exactly where it was to begin with; nor must we be surprised at it, since freedom must be sought in a certain shade or quality of the action itself and not in the relation of this act to what it is not or to what it might have been." Bergson, *Time and Free Will*, 182. Additional citations of this source appear parenthetically in the text.

6. Bergson writes: "For it is by no means the case that all conscious states blend with one another as raindrops with the water of a lake. The self, in so far as it has to do with a homogeneous space, develops on a kind of surface, and on this surface independent growths may form and float. Thus a suggestion received in the hypnotic state is not incorporated in the mass of conscious states, but, endowed with a life of its own, it will usurp the whole personality when its time comes. A violent anger roused by some accidental circumstance, an hereditary vice suddenly emerged from the obscure depths of the organism to the surface of consciousness, will act almost like a hypnotic suggestion." Ibid., 166.

7. As Bergson explains: "The causes here, unique in their kind, are part of the effect, have come into existence with it and determined by it as much as they determine it." Bergson, *Creative Evolution*, 164.

8. Bergson claims: "In proportion as we dig below the surface and get to the real self, do its states of consciousness cease to stand in juxtaposition and begin to permeate and melt into one another, and each to be tinged with the colouring of the others. Thus each of us has his own way of loving and hating; and this love or hatred reflects his whole personality." Bergson, *Time and Free Will*, 164.

9. See "The Possible and the Real" in Bergson, *The Creative Mind*.

10. Bergson suggests: "As reality is created as something unforeseeable and new, its image is reflected behind into the indefinite past; thus it finds that it has from all time been possible, but it is at this precise moment that it begins to

have been always possible, and that is why I said that it's possible, but it is at this precise moment that it begins to have been always possible, and that is why I said that its possibility, which does not precede its reality, will have preceded it once the reality has appeared. The possible is therefore the mirage of the present in the past." Bergson, *The Creative Mind*, 119.

11. Bergson claims: "It is the whole soul, in fact, which gives rise to the free decision: and the act will be so much the freer the more dynamic series with which it is connected tends to be the fundamental self. Thus understood, free acts are exceptional, even on the part of those who are most given to controlling and reasoning out what they do." Bergson, *Time and Free Will*, 167.

12. He argues: "It is to these acts, which are very numerous but for the most part insignificant, that the associationist theory is applicable. They are, taken all together, the substratum of our free activity, and with respect to this activity they play the same part as our organic functions in relation to the whole of our conscious life. Moreover we will grant to determinism that we often resign our freedom in more serious circumstances, and that, by sluggishness or indolence, we allow this same local process to run its course when our whole personality ought, so to speak, to vibrate." Ibid., 168–69.

13. Most notably in *Matter and Memory*, *The Creative Mind*, *Mind-Energy*, and *Creative Evolution*.

14. As Bergson claims: "Theoretically, then, everything living must be conscious. *In principle*, consciousness is co-extensive with life." Bergson, *Mind-Energy*, 8.

15. His claim is that in the case of the plant, movement is dormant or latent: "Even in the vegetable world, where the organism is generally fixed to the soil, the faculty of movement is dormant rather than absent: it awakens when it can be of use. . . . It appears to me therefore extremely likely that consciousness, originally immanent in all that lives, is dormant where there is no longer spontaneous movement." Ibid., 10–11.

16. For Bergson, even the most simple organism exhibits freedom: "The amoeba . . . when in the presence of a substance which can be made food, pushes out towards it filaments able to seize and enfold foreign bodies. These pseudopodia are real organs and therefore mechanisms; but they are only temporary organs created for the particular purpose, and it seems they still show the rudiments of a choice. From top to bottom, therefore, of the scale of animal life we see being exercised, though the form is ever vaguer as we descend, the faculty of choice, that is, the responding to a definite stimulus of movements more or less unforeseen." Ibid., 9–10.

17. See, in particular, Uexküll, *Theoretical Biology* and "A Stroll through the Worlds of Animals and Men"; Ruyer, *Néo-finalisme*; and Simondon, "The Genesis of the Individual" and *L'individu et sa genèse psycho-biologique*.

18. Bergson, *Matter and Memory*, 31.

19. Life is the indetermination of matter extended and stretched into new forms: "Matter is inertia, geometry, necessity. But with life there appears free, predictable, movement. The living being chooses or tends to choose. Its role is to create. In a world where everything else is determined, a zone of indetermination surrounds it. To create the future requires preparatory action in the present, to prepare what will be is to utilize what has been; life therefore is employed from its start in conserving the past and anticipating the future in a duration in which past, present and future tread one on another, forming an indivisible continuity. Such memory, such anticipation, are consciousness itself. This is why, in right if not in fact, consciousness is coextensive with life." Bergson, *Mind-Energy*, 13.

20. Bergson, *Matter and Memory*, 114.

21. Ibid., 126.

22. Ibid., 127.

23. Bergson, *Creative Evolution*, 264.

24. Bergson's understanding of freedom is remarkably evolutionary. For him, freedom is the growing exploitation of the indeterminacy of matter: "This is precisely what life is, freedom inserting itself into necessity, turning it to its profit. Life would be an impossibility were the determinism of matter so absolute as to admit no relaxation. Suppose, however, that at particular points matter shows a certain elasticity, then and there will be opportunity for consciousness to install itself. It will have to humble itself at first; yet, once installed, it will dilate, it will spread from its point of entry and not rest till it has conquered the whole, for time is at its disposal and the slightest quantity of indetermination, by continually adding to itself, will make up as much freedom as you like." Bergson, *Time and Free Will*, 13–14.

25. It is primarily Irigaray's earlier works — *Speculum of the Other Woman*, *This Sex Which Is Not One*, *Marine Lover of Friedrich Nietzsche*, and *An Ethics of Sexual Difference* — that outline her understanding of autonomy and identity and a project of becoming, a project of the future that overcomes the sexual indifference of the past and present.

26. On the relevance of the sexed body for knowledge production, see Irigaray, "Is the Subject of Science Sexed?"

FIVE. *The Future of Feminist Theory*

1. See Simondon, *L'individu et sa genèse psycho-biologique*.

2. Deleuze and Guattari, *What is Philosophy?*, 16. Additional citations of this source appear parenthetically in the text.

3. "We are constantly trapped between alternative propositions and do not see that the concept has already passed into the excluded middle." Ibid., 22.

4. Deleuze and Guattari elaborate a new concept of the concept as the accompaniment, the host, of the event: "The concept of the contour, the configuration, the constellation of an event to come. Concepts in this sense belong to philosophy by right because it is philosophy that creates them and never stops creating them. The concept is obviously knowledge — but knowledge of itself, and what it knows is the pure event, which must not be confused with the states of affairs in which it is embodied. The task of philosophy when it creates concepts, entities, is always to extract an event from things and beings, to set up the new event from things and beings, always to give them a new event: space, time, matter, thought, the possible as events." Ibid., 32–33.

5. Deleuze's understanding of the concept as immediate self-survey is indebted to the work of Raymond Ruyer on consciousness as a mode of immediate access to objects that does not require any external viewpoint. See Ruyer's *Néo-finalisme*, as well as Ronald Bogue's "Deleuze and Ruyer."

6. Concepts are occasioned by events: "Concepts are centers of vibration, each in itself and every one in relation to all the others. This is why they all resonate rather than cohere or correspond with each other. There is no reason why concepts should cohere. As fragmentary totalities, concepts are not even the pieces of a puzzle, for their irregular contours do not correspond to each other." Deleuze and Guattari, *What is Philosophy?*, 23.

7. As Deleuze and Guattari claim: "The concept is the contour, the configuration, the constellation of an event to come. . . . The concept is obviously knowledge — but knowledge of itself, and what it knows is the pure event, which must not be confused with the state of affairs in which it is embodied. The task of philosophy when it creates concepts, entities, is always to extract an event from things and beings, to set up the new event from things and beings, always to give them a new event: space, time, matter, thought, the possible as events." Ibid., 133.

8. Deleuze is often taken as a pure and simple materialist, but it is clear from his writings that he believes that the very purpose and value of the concept is to introduce another layer, a new kind of interior, to the real, the force of events, beyond that which an elaboration of material forces would see and acknowledge. Philosophy brings the immaterial, the nonhistorical, the incorporeal, and the immanent to bear on the dragging, exhausting weight of reality: "The concept is an incorporeal, even though it is incarnated or effectuated in bodies. . . . The concept speaks the event, not the essence of the thing — pure Event, a hecceity, an entity." Ibid., 21.

9. This argument was even Hegel's way out of the impasse of the ruses of recognition that result in a life and death struggle between subjects who seek recogni-

tion of their value through each other. For Hegel, it is only the slave who develops an identity, eventually, without self-delusion, because it is only through labor, through making, that one also makes oneself. See *The Phenomenology of Spirit*.

SIX. *Differences Disturbing Identity*

1. Young, "Gender as Seriality."
2. On these writers, see, for example, Anzaldúa, *La Frontera / Borderland*; Spelman, *Inessential Woman*; Crenshaw, "Demarginalizing the Intersection of Race and Sex" and "Mapping the Margins"; Young, "Gender as Seriality"; Collins, *Black Feminist Thought* and "It's All in the Family"; and Mahmood, *The Politics of Piety*.
3. See Spelman, *Inessential Woman*.
4. Deleuze, *Difference and Repetition*, 28.
5. Ibid.
6. Ibid., 138, 56.
7. See de Landa, *A New Philosophy of Society*.

SEVEN. *Irigaray and Sexual Difference*

1. Irigaray, *An Ethics of Sexual Difference*, 6.
2. Irigaray, "An Interview with Luce Irigaray," 199.
3. Irigaray, *An Ethics of Sexual Difference*, 128.
4. Irigaray, *I Love to You*, 35–37.
5. Ibid., 47.
6. Butler and Cornell, "The Future of Sexual Difference," 27–28.
7. These critiques of Irigaray's apparent race-blindness are in *Rewriting Difference: Luce Irigaray and the Greeks*, edited by Elena Tzelepis and Athena Athanasiou. See also Ziarek, *An Ethics of Dissensus*, 178–80; and Deutscher, "*Between East and West* and the Politics of Cultural Ingénuité," 69.
8. See Plaza, "'Phallomorphic Power' and the Psychology of 'Woman.'"
9. Drucilla Cornell, quoted in Butler and Cornell, "The Future of Sexual Difference," 40–41. On the absence of racial and cultural differences between women in Irigaray's work, see Ziarek, *An Ethics of Dissensus*, 179.
10. Irigaray, "Women's Exile," 69.
11. Irigaray, *I Love to You*, 61–62.
12. Irigaray, "The Question of the Other," 19. Brackets in the original.
13. Irigaray writes: "It's not as Simone de Beauvoir said: one is not born, but rather becomes, a woman (through culture), but rather: I am born a woman,

but I must still become this woman that I am by nature." Irigaray, *I Love to You*,
107.

EIGHT. *Darwin and Natural and Sexual Selection*

1. For feminist resistance to sociobiological thought, see discussions by Anne
 Fausto-Sterling, Victoria L Sork, and Zuleyma Tang-Martinez in Gowaty,
 Feminism and Evolutionary Biology; Kay Harel, "When Darwin Flopped"; and
 Joan Roughgarden, *Evolution's Rainbow*. On those using sociobiology to seek
 answers to feminist questions, see discussions by Patricia Adair Gowaty, Mar-
 lene Zuk, and Margo Wilson, in Gowaty, *Feminism and Evolutionary Biology*; as
 well as Greit Vandermassen, *Who's Afraid of Charles Darwin?*; and Helena
 Cronin, "Getting Human Nature Right."

2. The concept of the selfish gene is most closely associated with Richard Daw-
 kins's book *The Selfish Gene*, but it is now a pervasive assumption within
 evolutionary thought. See also Dennett, *Darwin's Dangerous Idea*; and Wilson,
 Sociobiology. On the significance of the size of gametes: Dawkins claims the
 animal can be reduced to its sex cells and its sex cells can be largely, indeed
 solely, explained in terms of the size and quantity of gametes. He writes,
 "There is one fundamental feature of the sexes which can be used to label males
 as males, and females as females, throughout animals and plants. This is that
 the sex cells or 'gametes' of males are much smaller and more numerous than
 the gametes of females. . . . [I]t is possible to interpret all the other differences
 between the sexes as stemming from this one basic difference." Dawkins, *The
 Selfish Gene*, 141. On the algorithmic reduction of evolution: Dennett makes
 this reduction to a step-by-step process explicit when he asserts, "Here, then, is
 Darwin's dangerous idea: the algorithmic level *is* the level that best accounts
 for the speed of the antelope, the wing of the eagle, the shape of the orchid, the
 diversity of species, and the other occasions for wonder in the world of nature.
 No matter how impressive the products of an algorithm, the underlying pro-
 cess always consists in nothing but a set of individually mindless steps succeed-
 ing each other without the help of intelligent supervision." Dennett, *Darwin's
 Dangerous Idea*, 59.

3. Helena Cronin asserts that biology provides or should provide an account of
 human nature, one that is of relevance in the work of policy- and lawmakers
 who address this given nature in a variety of forms in an effort to transform
 behavior enacted on its basis: "All policy-making should incorporate an under-
 standing of human nature, and that means both female and male nature."
 Cronin, "Getting Human Nature Right," 61. For an example of a challenge to
 this essentialism, see the writings of Anne Fausto-Sterling, who expresses a

more postmodern understanding of the problem of essentialism; see "Feminism and Behavioral Evolution," 47.

4. Sensation is understood as muscular and bodily: "Sensation is the ordering contraction . . . in fibres united with nervous filament." Darwin, "Old and Useless Notes, #9," quoted in Gruber, *Darwin on Man*, 215.

5. This claim is confirmed in the writings of Michael T. Ghiselin, especially in *The Triumph of the Darwinian Method*, who makes clear the methodological and philosophical sophistication of even Darwin's earliest texts, as compared to not only those of his contemporaries but even the most advanced contemporary epistemologies.

6. Darwin, *On the Origin of Species*, 117–18.

7. Ibid., 118.

8. Darwin, *The Descent of Man*, 2:272–73. Additional citations of this source appear parenthetically in the text. That sexual selection differentiates between the two sexes of course only applies in cases where there are only two: for the vast bulk of insects, for example, there are more than two.

9. This is also a phenomenon to which there are a number of exceptions. For Darwin, it is quite clear that there can be female competition and male choice: this is an empirical question. He explains,

> In various classes of animals a few exceptional cases occur, in which the female instead of the male has acquired well pronounced secondary sexual characters, such as brighter colours, greater size, strength, or pugnacity. With birds, as we shall hereafter see, there has sometimes been a complete transposition of the ordinary characters proper to each sex; the females having become the more eager in courtship, the males remaining comparatively passive, but apparently selecting, as we may infer from the results, the more attractive females. Certain female birds have thus been rendered more highly coloured or otherwise ornamented, as well as more powerful and pugnacious than the males, these characters being transmitted to the female offspring alone. (Darwin, *The Descent of Man*, 1:276)

10. My assessment here concurs to some extent with Joan Roughgarden's in *Evolution's Rainbow*: Darwin does not endorse only binarized forms but also opens up our conceptions of biological life to other variations.

11. Darwin, *On the Origin of Species*, 254–55.

12. As early as 1838, in Notebook N, Darwin mentions in telegraphic form the strange beauty that attracts various animals: "What an animal like taste of, like smell of, . . . Hyaena likes smell of that fatty substance it scrapes off its bottom. It is a relic of same thing that makes one dog smell posterior of another. Why do bulls & horses, animals of different orders turn up their nostrils when

excited by love? Stallion licking udders of mare strictly analogous to men's affect for women's breasts. . . . Dr. Darwin's theory probably wrong, otherwise horses would have idea of beautiful forms." Darwin, Notebook N, quoted in Gruber, *Darwin on Man*, 278.

13. This is certainly Ghiselin's claim: "The subject is not man, but sex. . . . In *The Descent of Man* the major theme is *sexual selection*, a topic Darwin could only develop in bare outline in *The Origin of Species*." Ghiselin, *The Triumph of the Darwinian Method*, 214.

14. He argues that male competitiveness often occurs well before females even appear and functions to provide some kind of self-selection, some form of selection regulated by the establishment of male hierarchies, or orders of dominance. According to Darwin, "It is certain that with almost all animals there is a struggle between the males for the possession of the female. This fact is so notorious that it would be superfluous to give instances. Hence the females, supposing that their mental capacity sufficed for the exertion of a choice, could select one out of several males. But in numerous cases it appears as if it had been specially arranged that there should be a struggle between many males. Thus with migratory birds, the males generally arrive before the females at their place of breeding, so that many males are ready to contend for each female." Darwin, *The Descent of Man*, 2:259.

15. As if to confirm his attempted egalitarianism, after this cited passage, Darwin refers specifically to cases where males select females: "In the converse and much rarer case of the males selecting particular females, it is plain that those which were the most vigorous and had conquered others would have the freest choice; and it is almost certain that they would select vigorous as well as attractive females. Such pairs would have an advantage in rearing offspring, more especially if the male had the power to defend the female during the pairing-season, as occurs with some of the higher animals, or aided in providing for the young. The same principles would apply if both sexes mutually preferred and selected certain individuals of the opposite sex; supposing that they selected not only the more attractive, but likewise the more vigorous individuals." Darwin, *The Descent of Man*, 2:263.

16. The reduction of sexual to natural selection seems to make up the content of the debate in contemporary evolutionary psychology about the peacock's tail, or the female's attraction to various forms of ornament and what it reflects about the ongoing survival of species. It can be broken down into the so-called "sexy-son" theory versus the "healthy-offspring" theory: "The [R. A.] Fisher (sexy-son, good-taste) advocates are those who insist that the reason peahens prefer beautiful males is that they seek heritable beauty itself to pass on to their sons, so that those sons may in turn attract females. The good-geners (healthy-offspring, good-sense) are those who believe that peahens prefer beautiful

males because beauty is a sign of good genetic qualities — disease resistance, vigor, strength — and that the females seek to pass these qualities on to their offspring." Ridley, *The Red Queen*, 142. However, it seems that both sides are equally problematic insofar as they each seek to explain the appeal of beauty in terms of some anthropomorphic concept of usefulness, thereby once again reducing sexual selection to natural selection, or seeing qualities in terms of adaptive effects and consequences rather than in terms of appeal or taste.

17. The only theorist I know to have addressed the place of homosexuality and forms of sexual encounter that cannot result in reproduction (cross-species sexual acts, sexual acts with inanimate objects, sexual acts with members of the same sex, and so on) is Joan Roughgarden, yet of all the theorists working on evolutionary thought she is the one most adamantly opposed to any account of sexual selection, which she identifies with the forces of heteronormativity and with those forces aimed at minimizing variation or difference. At least to the extent that sexual selection is identified with reproductive selection, her criticisms are justified. But it is less clear to me that the concept of sexual selection is to blame for the reduction of sexual activities to reproductive activities: this is more the consequence of how sexuality is reduced to reproduction according to the principles of natural selection. Roughgarden's claim is that sexual selection is a concept that needs to be jettisoned:

> I am far from the first to call for a thorough overhaul of sexual selection theory. I join a tradition initiated in the courageous studies by Sarah Hrdy of female choice in Indian monkeys and continues today in the writings of Patricia Gowaty. I am, I confess, more extreme than they in calling for the outright abandonment of sexual selection theory.
>
> Darwin's sexual selection is evolutionary biology's first universal theory of gender. Darwin claimed, based on his empirical studies, that males and females obey nearly universal templates. . . . Darwin offered sexual selection as an explanation for why males and females should obey these universal templates. . . . [He] imagined that males come to be the way they universally are because these males are what females universally want, and the species is better off as a result. (Roughgarden, *Evolution's Rainbow*, 164–65)

This seems to me a caricature of Darwin's position: he is at pains to discuss the vast variety of relations of sexual selection in the animal world, and there is nothing universal about the models he proffers. Roughgarden's commitment to diversity and variation, to what she calls "the rainbow" of types of living things, is based on a privileging of natural selection rather than a recognition of the inventive, extravagant excesses of sexual selection, a concept one would imagine she would want to open up rather than eliminate.

18. Wilson, *Sociobiology*, 555. Note too that Wilson only considers male homosexuality, with no mention of female homosexuality, whose structure and relations to possible reproduction are more complex.

19. In a series of responses to questions in a British newspaper, one directed to a Darwinian explanation of homosexuality, Dawkins claims: "If a homosexuality gene lowers its own probability of being reproduced today, and yet still abounds in the population, that is a problem for commonsense as much as for Darwin's theory of evolution. And, intriguing as several of these theories may be [such as the 'mother's brother' effect, the 'sterile worker' effect, and the 'surplus bachelor' theories], I have to conclude that it remains a problem." Dawkins, "Could a Gay Gene Really Survive?"

20. Darwin cites the ardent indiscretions of various frogs as a kind of overcoming of natural selection by sexual selection. Instead of conforming to the principles of survival, their sexual activity may imperil survival directly: "It is surprising that frogs and toads should not have acquired more strongly-marked sexual differences; for though cold-blooded, their passions are strong. Dr. Günther informs me that he has several times found an unfortunate female toad dead and smothered from having been so closely embraced by three or four males." Darwin, *The Descent of Man*, 2:26.

21. To take just one example, Geoffrey Miller argues that encephalization, the rapid growth of the neocortex which makes the human head and especially the brain so large relative to other species and which is the condition for vocal communication, is, like the magnificent plumage of the peacock, the result of sexual selection. He writes, "I suggest that the neocortex is not primarily or exclusively a device for toolmaking, bipedal walking, fire-using, warfare, hunting, gathering or avoiding savanna predators. None of these postulated functions alone can explain its explosive development in our lineage and not in other closely related species. . . . The neocortex is largely a courtship device to attract and retain sexual mates: Its specific evolutionary function is to stimulate and entertain other people, and to assess the stimulations of others." Miller, quoted in Ridley, *The Red Queen*, 338.

22. Darwin claims that music comes first and language use may follow, rather than, as Spencer claims, that language is developed first and music and poetry are derived from its operations: "Mr. Spencer comes to an exactly opposite conclusion to that at which I have arrived. He concludes that the cadences used in emotional speech afford the foundation from which music has developed; whilst I conclude that musical notes and rhythms were first acquired by the male or female progenitors of mankind for the sake of charming the opposite sex. Thus musical notes became firmly associated with some of the strongest passions an animal is capable of feeling, and are consequently used

instinctively, or through association, when strong emotions are expressed in speech." Darwin, *The Descent of Man*, 2:336n.

23. Darwin, *The Descent of Man*, 2:330. Men's vocal cords are commonly one third longer than those of women or boys.

24. Music connects man to his most recent vertebrate ancestors:

> With man song is generally admitted to be the basis or origin of instrumental music. . . . [Songs] are present, though in a very rude and as it appears almost latent condition, in men of all races, even the most savage; but so different is the taste of the different races, that our music gives not the least pleasure to savages, and their music is to us hideous and unmeaning. . . . Whether or not the half-human progenitors of man possessed, like the before-mentioned gibbon, the capacity of producing, and no doubt of appreciating, musical notes, we have every reason to believe that man possessed these faculties at a very remote period, for singing and music are extremely ancient arts. Poetry, which may be considered as the offspring of song, is likewise so ancient that many persons have felt astonishment that it should have arisen during the earliest ages of which we have any record. (Darwin, *The Descent of Man*, 2:333–34)

Darwin writes in the *Beagle Diary* (July 3, 1832) of some of the black men, both former slaves and free men, that he met in Brazil: "I cannot help believing they will ultimately be the rulers. I judge of it from their numbers, from their fine athletic figures (especially contrasted with the Brazilians) proving they are in a congenial climate, & from clearly seeing their intellects have been much underrated; they are the efficient workmen in all the necessary trades." Quoted in Gruber, *Darwin on Man*, 77.

And in *The Descent of Man*, Darwin recalls the three Fuegians he had known aboard the *Beagle*, who were being returned home to Tierra del Fuego after a year in England, where they had learned some English, grown accustomed to wearing clothes, and developed European manners. Having remarked some years earlier on their rude and most primitive state—without clothes, unwelcoming to strangers, displaying absolutely savage behavior—he was no doubt surprised by the transformation that occurred after only a year away: "The American aborigines, Negroes and Europeans differ as much from each other in mind as any three races that can be named; yet I was incessantly struck, whilst living on the 'Beagle,' with the many little traits of character, shewing how similar their minds were to ours; and so it was with a full-blooded negro with whom I happened once to be intimate." Darwin, *The Descent of Man*, 2:232.

26. Not only were both his paternal grandfather, Erasmus Darwin, and his mater-

nal grandfather, the famous potter Josiah Wedgwood, vehemently opposed to slavery, but Wedgwood even "manufactured hundreds of copies of a cameo showing a black slave in chains with the words 'Am I not a man and a brother.' . . . On slavery, Charles never wavered . . . 'It makes one's blood boil, yet heart tremble, to think that we Englishmen and our American descendants, with their boastful cry of liberty, have been and are so guilty.'" Quoted in Gruber, *Darwin on Man*, 66–67.

27. Darwin is firm in his claim that racial variations in man are not simply the result of natural selection or the direct effects of the environment: "If . . . we look to the races of man, as distributed over the world, we must infer that their characteristic differences cannot be accounted for by the direct action of different conditions of life, even after exposure to them for an enormous period of time." Darwin, *The Descent of Man*, 2:246.

28. Race and racial characteristics are highly appealing and thus are sexually sought out characteristics: "As the newly-born infants of the most distinct races do not differ nearly as much in colour as do the adults, although their bodies are completely destitute of hair, we have some slight indication that the tints of the different races were acquired subsequent to the removal of the hair, which . . . must have occurred at a very early period." Darwin, *The Descent of Man*, 2:382.

NINE. *Sexual Difference as Sexual Selection*

1. Irigaray has always been suspicious of the attempts, primarily in the work of Derrida and Deleuze (and Guattari), to elaborate a politics of "becoming woman," in which sexual difference, while being abstractly recognized, is nonetheless continually undermined by men's attempts to "become woman" without the adequate recognition that such a becoming woman is at best a fantasy while it functions through the everyday operations of a male morphology. She urges men to cease becoming women and to begin becoming a new kind of man:

> As far as I am concerned, "becoming woman" or "becoming a woman" correspond to [a cultivation of] my own identity, the identity which is mine by birth. For Deleuze, it amounts to becoming what he is not by birth. If I appeal to a return to nature, to the body — that is, to values that our Western culture has scorned — Deleuze acts in the opposite way: according to him it would be possible and suitable to become someone or something which is without relation to my original and material belonging. How could this be possible above all from the part of a man with respect to becoming woman? Putting on the stereotypes concerning

femininity? Deleuze would want to become the woman who Simone de Beauvoir did not want to become? (Irigaray, *Conversations*, 79)

2. Sexual difference is the most elementary division of the human: "Whether through collective psychosis or cynicism, sexual difference, which constitutes the most basic human reality, is treated like an almost non-existent problem." Irigaray, *Thinking the Difference*, ix.

3. Biology plays a major role in the transmission and lived experience of the sexed body, but biology isn't the most significant determinant. It is the way that biology is lived, its meaning, that is more important for Irigaray: "Obviously I do not agree with the expression used by Freud in reference to the feminine condition, 'Anatomy is destiny.' The use made of it is at once authoritarian, final and devalorizing for woman." Irigaray, *Conversations*, 5.

4. All current scientific research, for example, which seeks out a measure of sexuality, desire, or pleasure of the two sexes in relation to each other, has been unable to understand the position of both sexes: "Despite the stir it provokes, the question of sexual difference has not yet satisfactorily been treated at the scientific level. When research is done on the distinctive traits of each sex, or each gender, it gives rise to comparisons, oppositions, or measurements. There has as yet been no questioning of difference itself, or of the way it determines the attraction between woman and man." Irigaray, *Key Writings*, 77.

5. Bodily differences between the two sexes, biologically given but psychically elaborated, for Irigarary mean that there is always a sexual and erotic division or interval between the sexes: "Woman engenders *in herself*, makes love *in herself*. *Man* engenders and makes love *outside of himself*. This means that their relationship to themselves and their relationship to the other are far from being similar, favoring either the inside *or* the outside, either refuge in oneself *or* respect for the other outside of oneself." Irigaray, "The Time of Difference," 96.

6. For Irigaray, sexual difference facilitates the transition from nature to culture as no other difference can: "Sexuate difference is the most basic and the most universal difference. It is also the difference which operates, or ought to operate, each time, the connection between nature and culture for everyone. This connection is specific to girl and woman in comparison with boy and man." Irigaray, *Conversations*, 77.

7. All of Irigaray's works over the last two decades or more have addressed the ways in which culture is the ultimate achievement of sexual difference: "Engendering in difference is not limited to procreation: culture, community, the word are also engendered by two. This presupposes an elevating of sexual difference to the level of a sexuate subjectivity and not to let it remain as a simple biological corporeal reality." Irigaray, *Key Writings*, 157.

8. It is through the other that we come to occupy a collective world: "From birth, men and women belong to different worlds, biologically and relationally, which they'll cultivate in their own ways if they stay faithful to their gender and avoid assuming a neutral identity." Irigaray, "The Time of Difference," 96.

9. Sexual difference is the point of transmission of all other differences, which, while not reducible to reproduction, nevertheless rely on it. All political differences, whether they involve class, race, ethnic, and religious considerations, entail and are the consequence of sexual difference:

> A nature that was not respected as such, but subjected to male instincts and passions [is a] nature that man persists in wanting to control, and despise, beyond the wife and the child, in the other race, the other ethnic community and all that reminds him of a natural belonging. As long as the other is not recognized and respected as a bridge between nature and culture, a bridge that gender at first is, every attempt to establish a democratic globalization will remain a moral imperative without concrete fulfillment. As long as the universal is not considered as being two, and humanity as being a place of fruitful coexistence between two irreducibly different genders, a culture will never stop imposing its colour and values upon another, including through its morality and religion. (Irigaray, *Sharing the World*, 134)

While sexual difference does not cause or explain all other social differences, it provides a necessary mode of engagement which has profound implications for how all social minorities are understood and treated: "In the entire world, there exists only men and women. To succeed in treating democratically this universal reality is a way to accomplish the task that the development of civilizations constrains us to carry out. It is interesting to note, related to this, that certain differences between cultures come from more or less hierarchical treatments of the relations between the genders, at the horizontal or genealogical level. Abolishing the rights and privileges of one gender over another signifies therefore working for the possibility of a world culture." Irigaray, *Conversations*, 18.

10. Irigaray recognizes that sexual difference has been relegated to the precultural, to the natural and the animal. As the point of transition from nature to culture, it is nevertheless the condition for all social and cultural forms, however much these have failed to consider sexual difference:

> Even today, any questioning about the cultural status of the difference between the sexes comes up against the stumbling block of it being considered purely natural, and thus as the purview of biology. Or of sociology, insofar as sociology deals with group relations more or less linked to nature: family gregariousness, power, etc.

Sexual difference is thus relegated to the status of a biological destiny, or to relations of domination-exploitation related to it. It is obvious that the fight for gender equality is not sufficient to overcome this state of affairs. All the more so since what we understand by "equality" is not so clear. To whom or what should women become equal in order to free themselves from their age-old subjugation? . . . In reality, equality between the sexes or genders tends to deny the existence of difference, rather than solve the problems difference poses. Even in terms of rights, it makes more sense to speak of equivalence rather than equality. Egalitarianism — like the reduction of sexual difference to a biological or sociological given — forgets that sexual difference represents an important dimension in subjectivity that is crucial for relational life. What are humans, if not a species capable of relationships that are not subject to instinct? (Irigaray, *Key Writings*, 77–78)

Irigaray's critique of egalitarianism is wide-ranging and long-term. Her claim, in brief, is that equality is at best a formal aim but is impossible to attain insofar as it must abstract from the real conditions of bodily life. In her words, "To become equal is to be unfaithful to the task of incarnating our happiness as living women and men. Equality neutralizes that dimension of the negative which opens up an access to the alliance between the genders." Irigaray, *I Love to You*, 15.

11. Irigaray, *Conversations*, 5.
12. Irigaray, *I Love to You*, 35.
13. Ibid., 37.
14. Ibid., 39.
15. Irigaray, *Je, Tu, Nous*, 46.
16. Irigaray, *Why Different?*, 118–19.
17. Irigaray, *Sexes and Genealogies*, 16.
18. Ibid., 16, 5.
19. Ibid., 16.
20. As Irigaray says, "Woman must leave her family, her home, her name, to take those of her husband. Even the child of her flesh will bear the name of her husband's genealogy. Abducted from her ancestors, particularly her mother, she is consigned to the natural immediacy of reproduction. Motherhood, in turn, is valued only if it is the bearing of *sons*, not daughters. Thus the family falls back in various ways into nonspiritualized nature. . . . Citizens as a gender are cut off from their roots in the body, even as they remain bound, as bodies, to their mother-nature. Unable to resolve this issue, they let it determine their relations with women, whom they restrict to the role of the mothers." Ibid., 136.

21. Ibid., 132. Karen Burke provides a succinct characterization of Irigaray's broad claim: "[Irigaray] calls for sexed rights to replace the neuter rights we have now. Developing civil identities as both masculine and feminine instead of a neuter citizenship, developing masculine and feminine universals instead of relegating the feminine and the body to the private realm, would mean, claims Luce Irigaray, that women would begin to develop a public subjectivity honest to their natural inclinations without reducing them to a naturality, to the naked capacity for bearing children." Burke, "Masculine and Feminine Approaches to Nature," 197.

22. Irigaray, *I Love to You*, 50–51.

23. For Irigaray:

> This absence of any dialogue within the couple, this failure of sexual dialectic (on condition of rethinking the senses of the method), perverts the spirit of the individual, of the family, of the race. The concrete, which Hegel seeks in the individual, has its sexual dimension cut away. The individual is already *abstract*. This abstractness forces us to think of the family as an undifferentiated substance and not as the place of individualization, of a spiritual differentiation that can occur only if there is some polemic between the sexes. The suppression of this miniwar between living beings operates by reducing woman as woman to silence, by equating women as mothers with nature, and by obliging them to sit on their hands rather than act as citizens with an active, open and responsible role to play in building the city. The passage to the race has been perverted, falsified, in its relation to life. (Irigaray, *Sexes and Genealogies*, 137)

24. I asked her directly in 2008 whether the work of Darwin interested her philosophically, and Irigaray looked at me as if I had asked if she worshipped the devil! It seems clear that it hadn't!

25. This is, in part, the object of investigation of Timothy Lenoir's book, *The Strategy of Life*.

26. Irigaray, *I Love to You*, 50.

27. Darwin, *The Descent of Man*, 1:94.

28. Ibid., 2:366–67. It must also be noted that, in spite of a well-intentioned commitment to a broad egalitarianism, his understanding of the relations between men and women is in fact quite ambivalent. He affirms in certain places that women are less intellectual, less detached, and more sympathetic and warm than men. At times he affirms women's social qualities as if they were biological qualities. However, at other times he seems to acknowledge that social pressures exert a considerable force in transforming character traits and personal abilities. He claims:

Woman seems to differ from man in mental disposition, chiefly in her greater tenderness and less selfishness; and this holds good even with savages, as shewn by a well-known passage in Mungo Park's *Travels*, and by statements made by many other travellers. Woman, owing to her maternal instincts, displays these qualities towards her infants in an eminent degree; therefore it is likely that she should often extend them towards her fellow-creatures. Man is the rival of other men; he delights in competition, and this leads to ambition which passes too easily into selfishness. These latter qualities seem to be his natural and unfortunate birthright. It is generally admitted that with woman the powers of intuition, of rapid perception, and perhaps of imitation, are more strongly marked than in man; but some, at least, of these faculties are characteristic of the lower races, and therefore of a past and lower state of civilisation.

The chief distinction in the intellectual powers of the two sexes is shewn by man attaining to a higher eminence, in whatever he takes up, than woman can attain — whether requiring deep thought, reason, or imagination, or merely the use of the senses and hands. If two lists were made of the most eminent men and women in poetry, painting, sculpture, music, — comprising composition and performance, history, science, and philosophy, with half-a-dozen names under each subject, the two lists would not bear comparison. We may also infer, from the law of the deviation of averages, so well illustrated by Mr. Galton, in his work on "Hereditary Genius," that if men are capable of decided eminence over women in many subjects, the average standard of mental power in man must be above that of woman. (Darwin, *The Descent of Man*, 2: 326–27)

29. Darwin argues that it is the social treatment of women that requires transformation if women are to attain the preeminence of some men:

In order that woman should reach the same standard as man, she ought, when nearly adult, to be trained to energy and perseverance, and to have her reason and imagination exercised to the highest point; and then she would probably transmit these qualities chiefly to her adult daughters. The whole body of women, however, could not be thus raised, unless during many generations the women who excelled in the above robust virtues were married, and produced offspring in larger numbers than other women. As before remarked with respect to bodily strength, although men do not now fight for the sake of obtaining wives, and this form of selection has passed away, yet they generally have to undergo, during manhood, a severe struggle in order to maintain themselves and

their families; and this will tend to keep up or even increase their mental powers, and, as a consequence, the present inequality between the sexes. (Darwin, *The Descent of Man*, 2:329)

30. Marx, quoted in Gruber, *Darwin on Man*, 71.

31. In some cases, the position or placement of sexual and reproductive organs may influence both sexual and natural selection — natural selection may take advantage of what is produced by sexual selection:

> The female often differs from the male in having organs for the nourishment or protection of her young, as the mammary glands of mammals, and the abdominal sacks of the marsupials. The male, also, in some few cases differs from the female in possessing analogous organs, as the receptacles for the ova possessed by the males of certain fishes, and those temporarily developed in certain male frogs. Female bees have a special apparatus for collecting and carrying pollen, and their ovipositor is modified into a sting for the defence of their larvæ and the community. In the females of many insects the ovipositor is modified in the most complex manner for the safe placing of the eggs. . . . There are, however, other sexual differences quite disconnected with the primary organs with which we are more especially concerned — such as the greater size, strength, and pugnacity of the male, his weapons of offence or means of defence against rivals, his gaudy colouring and various ornaments, his power of song, and other such characters. (Darwin, *The Descent of Man*, 2:254)

32. Ibid., 2:272.

33. Ibid., 2:123.

34. Sexual selection as a form of display also involves a potential cost, that of being observed by others. As Darwin claims:

> It is certain that the females occasionally exhibit, from unknown causes, the strongest antipathies and preferences for particular males. When the sexes differ in colour or in other ornaments, the males with rare exceptions are the most highly decorated, either permanently or temporarily during the breeding-season. They sedulously display their various ornaments, exert their voices, and perform strange antics in the presence of the females. Even well-armed males, who, it might have been thought, would have altogether depended for success on the law of battle, are in most cases highly ornamented; and their ornaments have been acquired at the expense of some loss of power. In other cases ornaments have been acquired, at the cost of increased risk from birds and beasts of prey. (Ibid., 2:123)

35. For further details, see *The Descent of Man*, 2:316–26.

36. Ghiselin, *The Triumph of the Darwinian Method*, 219. See also Darwin and Wallace, *Evolution by Natural Selection*.

37. Ghiselin, *The Triumph of the Darwinian Method*, 104.

38. Darwin claims, "The mammary glands and nipples, as they exist in male mammals, can indeed hardly be called rudimentary; they are simply not fully developed and not functionally active. They are sympathetically affected under the influence of certain diseases, like the same organs in the female. At birth they often secrete a few drops of milk; and they have been known occasionally in man and other mammals to become well developed, and to yield a fair supply of milk." Darwin, *The Descent of Man*, 1:210–11.

39. Ibid., 1:207. He continues, "In the mammalian class the males possess in their vesiculæ prostraticæ rudiments of a uterus with the adjacent passage; they bear also rudiments of mammæ, and some male marsupials have rudiments of a marsupial sack" (1:208).

40. Ibid., 1:208.

41. In a letter to his friend Joseph Dalton Hooker, Darwin explains his discovery of the emergence of maleness in a particular barnacle species:

> I have lately got a bisexual cirripede, the male being microscopically small and parasitic within the sack of the female. I tell you of this to boast of my species theory, for the nearest closely allied genus to it is, as usual, hermaphrodite, but I had observed some minute parasites adhering to it, and these parasites I now can show are supplemental males, the male organs in the hermaphrodite being unusually small, though perfect and containing zoosperms: so we have almost a polygamous animal, simple females alone being wanting. I never should have made this out, had not my species theory convinced me, that an hermaphrodite species must pass into a bisexual species by insensibly small stages; and here we have it, for the male organs in the hermaphrodite are beginning to fail, and independent males ready formed. (Darwin, quoted in Ghiselin, *The Triumph of the Darwinian Method*, 115)

42. See Stott, *Darwin and the Barnacle*, 85.

43. Darwin, quoted in ibid., 100.

44. As Darwin affirms: "The whole [male] animal is reduced to an envelope . . . containing the testes, vesicula, & penis. In male *Ibla*, we have hardly any cirri or thorax; in some male Scalpellums no mouth. . . . I believe that males occur on every female; in one case I found 12 males & two pupae on point of metamorphosis permanently attached by cement to one female!" Darwin, letter to Hancock, quoted in ibid., 213.

In the case of his most fascinating object of study, the *Arthrobalanus*,

Darwin explains: "The probosciform penis is wonderfully developed, so that in Cryptophialus, when fully extended, it must equal between eight and nine times the entire length of the animal! These males . . . consist of a mere bag, lined by a few muscles, enclosing an eye, and attached to the lower end by the pupal antennae. . . . [I]t has an orifice at its upper end, and within it there lies coiled up, like a great worm, the probosciformed penis. . . . [T]here is no mouth, no stomach, no thorax, no abdomen, and no appendages or limbs of any kind. . . . I know of no other animal in the animal kingdom with such an amount of abortion." Darwin, from *A Monograph of the Sub-Class Cirripedia*, quoted in ibid., 220.

45. As Darwin explains in a letter to John Stevens Henslow, "But here comes the odd fact, the male or sometimes two males, at the instant they cease being locomotive larvae become parasitic within the sack of the female, & thus fixed & half embedded in the flesh of their wives they pass their whole lives & can never move again. Is it not strange that nature should have made this one genus unisexual & yet have fixed the males on the outside of the females?" Letter quoted in ibid., 101.

46. See, for example, "Introducing: Love between Us" from *I Love to You*, where she discusses plants and flowers (34, 38), as well as *Animal Philosophies*.

TEN. *Art and the Animal*

1. See Grosz, *Chaos, Territory, Art*.
2. Of course the leaf itself is the result of its own processes of formation and the impingement of various forces to which its own form responds. Leaves are not simply random shapes but those random shapes which, through the eliminations of equally random but less useful shapes provided by natural selection, can provide the tree with maximal life, maximal utilization of competing and potentially scarce resources. As Jakob von Uexküll describes, the leaves of trees are in part the counterpoint of the tree and its various photosynthesizing requirements, but equally the leaf reflects and counterposes the forces of water and of rain, elemental forces which the tree must both withstand and utilize if it is to survive and proliferate:

> One of the meaning factors relevant to oak leaves is rain. Upon striking a leaf, falling raindrops follow the physical laws governing the behavior of liquids. In this case, according to Uexküll, the leaf is the "receiver of meaning," which is coupled with the meaning factor "rain" by a "meaning rule." The form of leaves is such that it accommodates the physical laws governing the behavior of liquids. The leaves work together by forming cascades in all directions to distribute rain water on the ground in optimal reach of the roots. . . .

Wherever there is a point, its corresponding counterpart can be found. The physical behavior of raindrops is the counterpoint corresponding to the point of the leaf's form. (Krampen, "No Plant—No Breath," 420)

3. Deleuze and Guattari make territory, and deterritorialization, the conditions for the emergence of art: "The territory is first of all the critical distance between two beings of the same species: Mark your distance. What is mine is first of all my distance: I possess only distances. Don't anybody touch me, I growl if anyone enters my territory." Deleuze and Guattari, *A Thousand Plateaus*, 319–20.

4. Some, such as Oliver A. I. Botar, have even suggested that Uexküll's writings have been directly influential on various major artists and architects in the twentieth century, such as the *de Stijl* artist Theo van Doesburg, who in turn quite profoundly influenced Mies van der Rohe and the International style. See Botar, "Notes towards a Study of Jakob von Uexküll's Reception," 596–97.

5. Uexküll, "The New Concept of Umwelt," 118.

6. As Uexküll suggests:

All living things, animal and plants, with few exceptions, appear in pairs; with a male and a female. Sometimes the male and the female organs are in the same individual, as in most plants, sometimes in different individuals, as we have seen them leave the ark of Noah in pairs. We see here the first comprehensive musical laws of Nature (*Weltgesetz*). All living beings have their origin in a duet. The male-female duet is a theme that is interwoven in a thousand variations into the orchestration of the living world. Often the duet is enlarged to a trio, when a third party is needed to bring about the male-female union. We know the role of insects in aiding the pollination of flowers. (Ibid., 118)

7. Karl von Frisch addresses this very issue: "Mutual adaptation between bees and flowers over millions of years has been largely responsible for the present advanced development of the fragrance of flowers and the splendor of their colors. For the greater the flowers' appeal to the senses of smell and vision, the easier it is for the insects to find them, and the better the chance for their pollination and propagation." Frisch, *Animal Architecture*, 66.

8. Uexküll, "An Introduction to Umwelt," 107.

9. Uexküll's commitment to Kantianism is quite well elaborated. This is one of the limits of Uexküll's position — the distinction between the phenomenal and the noumenal, and the conception of space and time as intuitions imposed on the world rather than extracted from it are difficult positions to maintain. But it is also, paradoxically, one of its strengths, at least to the extent that it opens his position up to a perspectivism that could well abandon the concept of the

noumenal altogether with no conceptual loss, which thus opens his claims to a less Kantian and more Nietzschean reading.

10. The senses frame our world, providing it with a living and moving horizon: "Around us is a protective wall of senses that gets denser and denser. Outward from the body, the senses of touch, smell, hearing and sight enfold man like four envelopes of an increasingly sheer garment. This island of the senses, that wraps every man like a garment, we call his Umwelt. It separates into distinct sensory spheres, that become manifest one after the other at the approach of an object." Uexküll, "An Introduction to Umwelt," 107.

11. Uexküll, "The Theory of Meaning," 31.

12. There has been considerable discussion of the possible relations between Uexküll's work and that of the American pragmatists, and especially Charles Sanders Peirce. See, for example, Sharov, "Umwelt-Theory and Pragmatism"; and Deely, "Semiotics and Jakob von Uexküll's Concept of Umwelt" and "Umwelt."

13. Uexküll, "An Introduction to Umwelt," 107.

14. He makes it clear that:

> No one, who has the least experience of the Umwelten of animals will ever harbour the idea that objects have an autonomous existence that makes them independent of the subjects. The variability of objects is the norm here. Every object becomes something completely different on entering a different Umwelt. A flower stem that in our Umwelt is a support for the flower, becomes a pipe full of liquid to build its foamy nest.
>
> The same flower stem becomes an upward path for the ant, connecting its nest with its hunting ground in the flower. For the grazing cow the flower stem becomes part of a tasty morsel of food for her to chew in her big mouth. (Ibid., 108)

15. This is explicit in examples of training animals to perform functions useful for humans:

> This may be observed especially in dogs, who learn to handle certain human implements by turning them into canine implements. Nevertheless, the number of dog objects remains considerably smaller than that of our objects. To illustrate this fact, let us imagine a room in terms of the functional tones connected with the objects in it, first by man, secondly by a dog, and thirdly, from a housefly. . . . In the world of man, the functional tones of the objects in a room can be represented by a sitting tone for a chair, a meal tone for the table, and by further adequate effector tones for plates and glasses (eating and drinking tones). The floor has a walking tone while the bookcase displays a reading tone and the desk a writing tone. The wall has an obstacle tone and the lamp a light tone.

If we represent the recurrent similar functional tones by identical colors in the dog's world, only feeding, sitting, running and light tones are left. Everything else is an obstacle tone. Owing to its smoothness, even a revolving piano stool does not have a sitting tone for a dog.

Finally, for the fly, everything assumes a single running tone, except for the lamp . . . and the crockery on the table. (Uexküll, "A Stroll through the Worlds of Animals and Men," 49–50)

See also his further discussions of dog-training, the transformation of dog-tones into human-tones:

We know from Sarris's experiments that a dog trained to the command "chair" learns to sit on a chair, and will be on the look-out for other seating-accommodations if the chair is removed; indeed, he searches for canine sitting-accommodations, which need in no way be suitable for human use.

The various sitting-accommodations all have the same "sitting-quality" (*Sitz-Ton*); they are meaning-carriers for sitting because they can be exchanged with each other at will, and the dog will make use of them indiscriminately upon hearing the command "chair." Therefore, if we make the dog a house-occupant, we will be able to establish that many things will have a "sitting-quality" for the dog. A great number of things will also exist that will have an "eating-quality" (*Fress-Ton*), or a "drinking-quality" (*Trink-Ton*) for the dog. The staircase certainly has a "climbing-quality" (*Kletter-Ton*). The majority of the furniture, however, only has an "obstacle-quality" (*Hindernis-Ton*) for the dog — especially the doors and cupboards, which may contain books or washing. All of the small household effects, such as spoons, forks, matches, etc. do not exist for the dog because they are not meaning-carriers. (Uexküll, "The Theory of Meaning," 29)

Given this explanation, training a dog involves accommodating human "tones" into the dog's melody, making objects that are otherwise insignificant take on dog qualities that resonate with the human's or making objects that are highly significant in dog-terms more subservient to human interests. Tuomo Jämsä expands on Uexküll's view:

When a dog is out walking with its master, kept on a leash by him, it examines the Umwelt where it currently is. Only those signs that have a meaning for it are paid attention to. This is an expression of *Bedeutungs-verwertung* such as Uexküll proposes in his model. The surroundings where the master and his dog are walking are mostly made for humans, not dogs. The signs and meanings to be used by the master are quite

different. The dog tries to have access to an Umwelt of its own. It is attracted — as is well-known — to signs of other dogs and the mere sight of a representative may cause uncontrollable excitement. The sign and meaning systems in a dog's and in a man's Umwelten are different. The value of each element depends on its place in the system of relations of other elements. The principal rules of the utilization of sign and meaning elements, the stream of the successive choices of them, don't differ in the dog's Umwelt from those in its master's Umwelt, although the Umwelten are internally distant from each other. Dogs don't write essays and humans don't sniff marks of smell. But the discourse they construct all the time is their lives. Life is composed of acts. In dogs, it comprises getting familiar with other dogs, the smells of them, the alternation of aggressive and friendly emotions. Intentionality concerns the largely inherent rules of each organism and has a determining role in the decisions of choosing the signs and meanings that will be used or ignored. (Jämsä, "Jakob von Uexküll's Theory of Sign and Meaning," 517–18)

16. Uexküll, "The New Concept of Umwelt," 117.

17. Ibid., 121. Uexküll utilizes the work of both Dreisch and Spemann regarding embryonic development to show that even in experiments where sea urchin blastocysts or embryos are cut in half, the "sea urchin tune," if we may call it that, continues to play independent of whatever material resources are left. The melody plays on whatever parts of the orchestra may be destroyed: the tune reins supreme:

> The dependence of the cellular musicians on the tune was already evident from the sea urchin experiments by Driesch. Cutting the embryo of the sea urchin in half reduced the number of cells to half but did not change the building tune. This was continued by the other half. This applies to all orchestras. When half the musicians leave, the other half of the orchestra goes on playing the same tune.
>
> Spemann reports an astonishing experiment. Inserting frog cells, that normally evolve into frog brain, into the mouth area of a triton larva, the insert obeys the mouth building tune of the triton larva. However, it does not become a triton mouth but the mouth of a tadpole, true to its origin. One could do a similar experiment with a string orchestra. When replacing the violins with horns in a certain movement, the orchestra can go on playing the same tune but with a very different tonal quality. (Ibid., 121)

18. All biological reactions require a mode of interpretation: "Even the simple blink-reflex, caused by the eye being approached by a foreign body, does not

consist of a mere sequence of physical causes and effects, but of a simplified functional circle, beginning with perception and ending with effect." Uexküll, "The Theory of Meaning," 34.

19. Uexküll, "The New Concept of Umwelt," 117.

20. Uexküll, *Theoretical Biology*, 7–8; and Uexküll, "A Stroll Through the Worlds of Animals and Men," 14–17.

21. Directionality is provided only by our bodily organs and their modes of coordination:

> By holding one's hand vertically, at right angles to the forehead, and moving it right and left with eyes closed, the boundary between the two becomes obvious. It coincides approximately with the median plane of the body. By holding one's hand horizontally and moving it up and down in front of the face, the boundary between above and below can easily be ascertained. For most people, this boundary is at eye level, though many people locate it at the height of the upper lip. The boundary between front and behind shows the greatest variation. It is found by holding up one's hand palm forward and moving it back and forth at the side of the head. Many people indicate that this plane near the ear opening . . . and by some it is even placed in front of the tip of the nose. Every normal person carries around within him a coordinate system composed of these three planes and firmly connected with his head, thus providing his operational space with a solid framework for his directional steps. (Uexküll, "A Stroll through the Worlds of Animals and Men," 15)

22. "This relationship is so clearly proven by numerous experiments that we can make the assertion: all animals possessing the three canals also have a three dimensional operational space." Ibid., 16; see also Uexküll, *Theoretical Biology*, 17–20.

23. Uexküll, "A Stroll through the Worlds of Animals and Men," 19.

24. Uexküll, *Theoretical Biology*, 2.

25. See Uexküll, *Theoretical Biology*, 2–3. He also discusses the plane of flies in other work: "It is hard to decide where the farthest plane begins in the *Umwelt* of an animal, for it is difficult to determine experimentally at what point an object approaching the subject in his environment becomes nearer as well as larger in his specific world. Attempts at catching flies show that the approaching human hand makes them fly away only when it is about half a meter from them. Accordingly, it would seem justifiable to suppose that their farthest plane is at this distance." Uexküll, "A Stroll through the Worlds of Animals and Men," 27.

26. Uexküll, "A Stroll through the Worlds of Animals and Men," 54–55. The fly is a

much underestimated creature, whose morphology has enabled it to survive and thrive in a wide range of terrains and geographies. It has itself a quite rich world, marked by a number of I-tones—a flying tone (never direct or in a straight line but in a zigzagged line), an eating tone, a walking tone. Flies are by no means driven by instinct alone; rather, their behavior is linked to the transformations of activity undertaken through the acquisition or transformation of meanings. A fly will continue to hit a glass window over and over until it switches from a flying-tone to a walking-tone: "The fly, which comes to the window-pane, hits it with its head several times, and then no longer treats it as though it were air, but walks about on it as if on the ground . . . through the coming in of an indication, a rearrangement of the action is undertaken." Uexküll, *Theoretical Biology*, 328.

27. Uexküll likens the spider to the mole: the network of underground caves and tunnels the mole has excavated for itself is, for him, "spread out underground like a cobweb. . . . In captivity it plots its tunnels so that they resemble a cobweb." Uexküll, "A Stroll through the Worlds of Animals and Men," 55.

28. Uexküll, "The New Concept of Umwelt," 122.

29. It does matter whether the codes instructing the spider are genetic or environmental or a mixture of both. There is much to suggest that even if the design of the web is genetically structured, it seems unlikely that the location of the web is genetically structured. According to Jesper Hoffmeyer, "Individual spiders repeatedly make webs in their environments, generation after generation, because they repeatedly inherit genes instructing them to do so. Subsequently, the consistent presence of a web in the spider's environment may, over many generations, feed back to become the source of a new selection pressure for a further phenotypic change in the spiders, such as the building by Cyclops of dummy spiders in their webs to divert the attention of avian predators. . . . In this case, although the bird predator may not be a direct part of the spider's Umwelt, this Umwelt has, nevertheless, accommodated itself so as to fit (though faking) into the bird's Umwelt." Hoffmeyer, "Seeing Virtuality in Nature," 390.

30. Frisch, *The Dancing Bees*, 29.

31. Frisch, *Bees*, 24.

32. Frisch affirms that:

> Bees are red-blind. That is very interesting. We understand why scarlet red bee-blossoms are so rarely found. There are very many red flowers in America, for instance, but only in bird-blossoms. Bird's eyes are very sensitive to red. In Europe there are some plants with red flowers, but their pollination is—with few exceptions—effected by certain butterflies. These butterflies are the only insects which are not red-blind. There

is an exception to the rule — the poppy, the flowers of which are visited by bees though they are scarlet red. But these flowers reflect many ultra-violet rays. Ultra-violet is a special colour for them, distinguishable from blue and all other colours. It is evident that the colours of flowers have been developed as an adaptation to the colour-sense of their visitors. (Ibid., 10)

33. Uexküll, "The New Concept of Umwelt," 120. "The number and nature of perceptual cues can to a certain extent be predicted as soon as one knows the theme of the music (*Lebensmusik*) that the Umwelt of the animal is playing." Ibid.

34. He says: "We shall probably find that countless animals defend their field of prey against members of their species, thereby making it their territory. Any tract of land, if the territories were drawn into it, would resemble a political map for each species, their borderlines determined by attack and defense. It would appear that there is no free land left, but that everywhere territory touches territory." Uexküll, "A Stroll through the Worlds of Animals and Men," 56.

35. Birds' nests attest to the form of treeness from which they are composed, but also each nest is a measure of both the form of the body of the bird whose nest it is and particularly of the eggs the birds lays in the nest. In taking over the activities of other insects should they succumb to some illness or death, some species of birds reveal a kind of hidden design, a plan, in nature that is not designed by any planner but nevertheless adds up to a mosaic of impulses, orders, designs: "In this way we get the impression of a comprehensive harmonic totality, because the properties of lifeless things also intervene contrapuntally in the design of living things." Uexküll, "The New Concept of Umwelt," 121.

36. Bee Wilson(!) claims that bees have provided particular inspiration for two very different types of architect in the nineteenth and twentieth century, influencing both Antonio Gaudi's free forms and parabolic arches, shaped like the natural arches of hives, and also the regimented, geometrical minimalism of Le Corbusier, who had been so strongly influenced by the writings of Frisch on the efficiency and cleanliness of bees. Wilson, *The Hive*, 51–54.

37. Ibid., 44.

38. Frisch has presented a very convincing argument, along the lines of Uexküll's claims, that the bees' capacity for building cells of remarkable regularity has to do with their attunement to gravity (natural combs, for example, are aligned north to south but even under human cultivation are always built vertically downward), which itself is a function of their capacity to use their head as a plummet to discern gravitational forces. Small, fine, tactile bristles on a bee's

head enable it to register the degree of movement away from the vertical. If these bristles are immobilized or coated with wax when bees are "in a building mood and . . . gathered in a building cluster," nothing will happen. They will, according to Frisch, act "like workmen whose tools had been confiscated." Frisch, *Animal Architecture*, 91.

39. For harvester ants, there is the creation of a vast cone-shaped chamber, which is itself surrounded by many other chambers that together constitute a rough cone shape that deepens, widens, and becomes more and more elaborate over the life of the nest. Different chambers store seed supplies, carefully sorted in neat piles with the largest seeds at the bottom and smaller ones above; others contain larvae laid out one by one on the floor, and others become chambers for shorting through refuse, or midden, including the bodies of dead ants, returned to their nest for burial. At least half the population of the nest works inside the nest or hive, tending to the queen, to food supplies, and to eggs, larvae, and pupae, ensuring the internal operations of the colony. These nest workers, like bees tending the hive, are younger and relatively inexperienced. As they emerge from the larval stages, young bees are able to care for those even younger as well as to direct themselves to the maintenance, care, and expansion of the nest from within. As the ants mature, some of them change their tasks and become patrollers and foragers, seeking out food sources and bringing food, usually seeds, back to the nest. See Deborah Gordon's illuminating book, *Ants at Work*.

40. Darwin, *On the Origin of Species*, 346, 349. To digress only briefly, it is significant too, as Darwin notes, that it is through the apparently paradoxical functionality of sterile or neuter subjects, commonly sterile females in insect communities, that many species of insect, like bees, can survive. Although not surprising, Darwin has no account of homosexuality, even in his elaboration of sexual selection, but his discussion of the productivity of sterility in insect communities provides some insight into what such an account might entail. Clearly sterility is not directly heritable — to the extent that a creature is sterile, there are no progeny to inherit any tendency. Nevertheless there seems to be an evolutionary advantage, if not to individuals then to communities, if some or even the majority of its members are devoted to activities other than sexuality and reproduction. If reproduction is contained to few or only one member of the community, then it may enable the community more success in continuing to enhance itself than if rivalrous reproductive activities were undertaken by all of its members. The "queerness" of insects, if it may be so understood, is their creation of two or even three different morphologies, bodily types, the existence of more than two sexes, and the self-evidence of the fact that such bodies are not necessarily or always complementary or harmo-

nious. In the production of three bodily types — male drones, sterile female workers, and the reproductive queen — reproduction takes place with drones and the queen (the drones dying or being cast out rapidly after copulation), leaving the workers to build the hive, seek food, and tend to the young. Darwin describes, "As with the varieties of the stock, so with social insects, selection has been applied to the family, and not to the individual, for the sake of gaining a serviceable end. Hence we may conclude that slight modifications of structure or of instinct, correlated with the sterile condition of certain members of the community, have proved advantageous: consequently the fertile males and females have flourished, and transmitted to their fertile off-spring a tendency to produce sterile members with the same modifications." Ibid., 354. This bodily specialization gives each member of the hive or nest its allocated roles, tasks, and capacities — to reproduce, to fertilize, to build, to nurture, and to feed. And it gives each member a different life span, different activities, and different rhythms.

41. "Such nests may reach down to a depth of five meters with their chambers and, in some cases, may have more than a million inhabitants. They are the descendants of one single queen who, when she founded her nest, took with her in a pocket of her mouth cavity a small piece of the fungus mat of the mother nest as her most precious possession. This fungus strain is passed on from generation to generation." Frisch, *Animal Architecture*, 119.

42. Gordon, *Ants at Work*, 72. In Deborah Gordon's understanding, ants learn a kind of regional politics that guides their interactions with other colonies. The older the colony becomes, the more it tends to seek peaceful, minimal interactions; it is only at their reproductive peak — three to four years old — that colonies tend to prefer fighting over avoiding each other. Gordon explains, "Relations between colonies are elaborate: ants recognize their neighbors, colonies adjust their trails around the trails of their neighbors, and colonies develop new diplomatic maneuvers as they grow older and larger. In the dialogue between colonies, the tone is set by the ages of the colonies in the neighborhood." Ibid., 73.

43. Gordon makes clear that only young colonies, those whose pupae far outnumber their mature members, have the motivation to discover new territories and food stock, and to fight aggressively with other colonies or different species to secure their own capacity to grow, to ensure the feeding of the next generation, and to sustain the nest and the colony.

44. For red harvester ants, patroller ants first leave the nest in order to find trails and food, which sets up the paths that forager ants will take that day. A mature colony, one over four or five years old, may take up to eight foraging directions, which Gordon suggests have been developed through repetition. Ibid.,

49. The space of ant territory is largely habitual, which is not to say that under extreme circumstances — drought, intense localized competition, regional catastrophes — ants do not expand their territories through the exploration of other areas and directions. But even if abundant food supplies are made available in new areas as close to the nest as other habitual loci, through, for example, human intervention, the older the ant colony, the less likely it is to seek, find, or be interested in the new food sources.

ELEVEN. *Living Art and the Art of Life*

My special thanks to Doreen Reid Nakamarra for discussing some central elements of her artwork; to Sarita Quinlivan and Luke Scholes, assistant managers for Papunya Tula Artists, for their generous and engaging discussions of Doreen's work; and to Gabrielle Sullivan, manager of Martumili Artists, for discussing in detail with me the background and history of Martu women's art production. I received invaluable feedback and corrections from both Sarita and Gabrielle.

1. Nakamarra in 2008, quoted in Scholes, "Kiwirrkura Women," 498.
2. In New York, September 2009. See endnote 4.
3. Scholes, "Kiwirrkura Women." 498–99.
4. I had the honor to meet Doreen Reid Nakamarra at a show that prominently included her work, along with that of other Indigenous artists: "We Are Here Sharing Our Dreaming," exhibited in New York in September 2009. There I spent some time talking with her about her work, and she was very pleased with the response her art has received around the world. It was with very great sorrow that I was to learn that shortly after this highly successful show, only a few weeks after her return to Australia, she became seriously ill with pneumonia, and after being taken to the hospital in Adelaide, where she appeared to improve, she unexpectedly passed away, leaving her family, her community, and the art world devastated. I would like to dedicate this chapter to her memory.
5. Gabrielle Sullivan, who was intimately involved in the gathering of materials and the conceptualization and circulation of the painting, in email correspondence with the author, September 27, 2009.
6. The twelve women are Jakayu Biljabu, Yikartu Bumba, Doreen Chapman, May Chapman, Nancy Chapman, Linda James, Donna Loxton, Mulyatingki Marney, Reena Rogers, Beatrice Simpson, Ronelle Simpson, and Rosie Williams.
7. From one of the individual artists, quoted in the Martumili Artists' statement accompanying the work. The statement is now at the National Gallery of Victoria in Melbourne, Victoria.

bibliography

Agamben, Giorgio. *The Open: Man and Animal*. Translated by Kevin Attell. Stanford, Calif.: Stanford University Press, 2004.

Ahmed, Sara. *The Cultural Politics of Emotion*. London: Routledge, 2004.

———. *Strange Encounters*. London: Routledge, 2000.

Alcoff, Linda. *Visible Identities: Race, Gender and the Self*. Oxford: Oxford University Press, 2005.

Anzaldúa, Gloria. *La Frontera / Borderland: The New Mestiza*. San Francisco: Aunt Lute, 1987.

Ayasse, Manfred, Florian P. Schiestl, Hannes F. Paulus, Fernando Ibarra, and Wittko Francke. "Pollinator Attraction in a Sexually Deceptive Orchid by Means of Unconventional Chemicals." *Proceedings of the Royal Society: B* 270, no. 1514 (2003): 517–22.

Badiou, Alain. *Deleuze: The Clamour of Being*. Translated by Louise Burchell. Minneapolis: University of Minnesota Press, 2000.

Bains, Paul. "Umwelten." *Semiotica* 134, no. 1–4 (2001): 137–67.

Bardon, Geoffrey. *Papunya Tula: Art of the Western Desert*. Ringwood, Australia: McPhee Gribble / Penguin, 1991.

Bardon, Geoffrey, and James Bardon. *Papunya: A Place Made after the Story; The Beginnings of the Western Desert Painting Movement*, Aldershott, UK: Lund Humphries, 2006.

Beauvoir, Simone de. *The Second Sex*. Translated by H. M. Parshley. Harmondsworth, UK: Penguin, 1953.

Bergson, Henri. *Creative Evolution*. Translated by Arthur Mitchell. New York: Dover, 1998.

———. *The Creative Mind: An Introduction to Metaphysics*. Translated by Mabelle L. Andison. New York: Philosophical Library, 1946.

———. *Matter and Memory*. Translated by N. M. Paul and W. S. Palmer. New York: Zone, 1988.

———. *Mind-Energy*. Translated by H. Wildon Carr. London: MacMillan, 1921.

———. *Time and Free Will: An Essay on the Immediate Data of Consciousness*. Translated by F. L. Pogson. London: George Allen and Unwin, 1959.

Blackwell, Antoinette Brown. *The Sexes throughout Nature*. 1875. New York: Hyperion, 1976.

Bogue, Ronald. *Deleuze and Guattari*. New York: Routledge, 1989.

———. "Deleuze and Ruyer." *Deleuze's Philosophical Lineage*, edited by G. Jones and J. Roffe, 300–320. Edinburgh: University of Edinburgh Press, 2009.

Botar, Oliver A. I. "Notes towards a Study of Jakob von Uexküll's Reception in Early Twentieth-Century Artistic and Architecture Circles." *Semiotica* 134, no. 1–4 (2001): 593–97.

Boundas, Constantin V. "Bergson-Deleuze: An Ontology of the Virtual." *Deleuze: A Critical Reader*, edited by P. Patton, 81–105. Oxford: Blackwell, 1996.

Braidotti, Rosi. *Metamorphoses: Towards a Materialist Theory of Becoming*. Cambridge: Polity, 2002.

———. *Nomadic Subjects*. London: Routledge, 1994.

———. *Patterns of Dissonance*. Cambridge: Polity, 1991.

Buchanan, Ian, and Claire Colebrook, eds. *Deleuze and Feminist Theory*. Edinburgh: University of Edinburgh Press, 2000.

Burke, Karen. "Masculine and Feminine Approaches to Nature." *Luce Irigaray: Teaching*, edited by Luce Irigaray and Mary Green, 189–200. London: Continuum, 2008.

Butler, Judith, and Drucilla Cornell. "The Future of Sexual Difference: An Interview." *Diacritics* 28, no. 1 (1998): 19–42.

Canguilhem, Georges. *The Normal and the Pathological*. Translated by Carolyn Fawcett. New York: Zone, 1991.

———. *A Vital Rationalist: Selected Writings*. Translated by Arthur Goldhammer. New York: Zone, 1994.

Chanter, Tina. *Ethics of Eros: Irigaray's Re-writing of the Philosophers*. New York: Routledge, 1994.

Cheah, Pheng, and Elizabeth Grosz. "Of Being-Two: Introduction." *Diacritics* 28, no. 1 (1998): 1–18.

Colebrook, Claire. *Deleuze: A Guide for the Perplexed*. London: Continuum, 2006.

———. *Understanding Deleuze*. Sydney: Allen and Unwin, 2002.

Collins, Patricia Hill. *Black Feminist Thought: Knowledge, Consciousness, and the Politics of Empowerment*. Boston: Unwin Hyman, 1990.

———. "It's All in the Family: Intersections of Gender, Race, and Nation." *Hypatia* 13: 3 (1998): 3, 62–82.

Crenshaw, Kimberle. "Demarginalizing the Intersection of Race and Sex: A Black Feminist Critique of Antidiscrimination Doctrine, Feminist Theory and Anti-Racist Politics." *University of Chicago Legal Forum* (1989): 139–67.

———. "Mapping the Margins: Intersectionality, Identity Politics, and Violence against Women of Color." *Stanford Law Review* 43 (1991): 1241–79.

Cronin, Helena. "Getting Human Nature Right." *Science at the Edge: Conversations with the Leading Scientific Thinkers of Today*, edited by John Brockman, 53–65. London: Weidenfeld and Nicholson, 2004.

Darwin, Charles. *The Descent of Man, and Selection in Relation to Sex*. 1871. Princeton, N.J.: Princeton University Press, 1981. (Original two volumes reprinted in one volume.)

———. *The Expression of the Emotions in Man and Animals*. London: John Murray, 1872.

———. *On the Origin of Species by Means of Transmutation, or Preservation of Favoured Races in the Struggle for Life*. 1859. New York: Modern Library, 1998.

Darwin, Charles, and A. R. Wallace. *Evolution by Natural Selection*. Cambridge: Cambridge University Press, 1958.

Dawkins, Richard. "Could a Gay Gene Really Survive?" *Daily Telegraph*, August 16, 1993.

———. *The Selfish Gene*. Oxford: Oxford University Press, 1989.

Deely, John. "Semiotics and Jakob von Uexküll's Concept of Umwelt." *Sign Systems Studies* 32, no. 1–2 (2004): 11–33.

———. "Umwelt." *Semiotica* 134, no. 1–4 (2001): 125–35.

De Landa, Manuel. *A New Philosophy of Society: Assemblage Theory and Social Complexity*. London: Continuum, 2006.

Deleuze, Gilles. *Bergsonism*. Translated by Hugh Tomlinson and Barbara Habberjam. New York: Zone, 1988.

———. *Cinema 1: The Movement-Image*. Translated by Hugh Tomlinson and Robert Galeta. Minneapolis: University of Minnesota Press, 1986.

———. *Cinema 2: The Time-Image*. Translated by Hugh Tomlinson and Robert Galeta. Minneapolis: University of Minnesota Press, 1989.

———. *Desert Islands and Other Texts, 1953–1974*. Translated by Sylvére Lotringer. Los Angeles: Semiotext(e), 2004.

———. *Difference and Repetition*. Translated by Paul Patton. New York: Columbia University Press, 1994.

———. *Empiricism and Subjectivity: An Essay on Hume's Theory of Human Nature*.

Translated by Constantin Boundas. New York: Columbia University Press, 1996.

———. *Essays Critical and Clinical*. Translated by Daniel W. Smith and Michael A. Greco. Minneapolis: University of Minnesota Press, 1997.

———. *Expressionism in Philosophy: Spinoza*. Translated by Martin Joughin. New York: Zone, 1990.

———. *Francis Bacon: The Logic of Sensation*. Translated by Daniel W. Smith. Minneapolis: University of Minnesota Press, 2003.

———. *Kant's Critical Philosophy: The Doctrine of the Faculties*. Translated by Hugh Tomlinson and Barbara Habberjam. London: Athlone, 1984.

———. *The Logic of Sense*. Translated by Mark Lester. New York: Columbia University Press, 1990.

———. *Masochism: Coldness and Cruelty*. Translated by Jean McNeil. New York: Zone, 1989.

———. *Negotiations*. Translated by Martin Joughin. New York: Columbia University Press, 1995.

———. *Nietzsche and Philosophy*. Translated by Hugh Tomlinson. London: Athlone, 1983.

———. *Proust and Signs*. Translated by Richard Howard. Minneapolis: University of Minnesota Press, 2000.

———. *Pure Immanence: Essays on a Life*. Translated by Anne Boyman. New York: Zone, 2001.

———. *Spinoza: Practical Philosophy*. Translated by Robert Hurley. San Francisco, City Lights, 1988.

Deleuze, Gilles, and Félix Guattari. *Anti-Oedipus: Capitalism and Schizophrenia*. Translated by Robert Hurley, Mark Seem and Helen R. Lane. Minneapolis: University of Minnesota Press, 1983.

———. *A Thousand Plateaus: Capitalism and Schizophhrenia*. Translated by Brian Massumi. Minneapolis: University of Minnesota Press, 1987.

———. *What Is Philosophy?* Translated by Hugh Tomlinson and Graham Burchell. New York: Columbia University Press, 1994.

Dennett, Daniel. *Darwin's Dangerous Idea: Evolution and the Meanings of Life*. New York: Touchstone, 1995.

Derrida, Jacques. *The Animal That Therefore I Am*. Translated by David Wills. New York: Fordham University Press, 2008.

Deutscher, Penelope. "*Between East and West* and the Politics of Cultural Ingénuité: Irigaray on Cultural Difference." *Theory, Culture, and Society* 20, no. 3 (2003): 65–75.

———. *The Politics of Impossible Difference: The Later Work of Luce Irigaray*. Ithaca, N.Y.: Cornell University Press, 2002.

Driesch, Hans. *The History and Theory of Vitalism*. Translated by C. K. Ogden. London: MacMillan, 1914.

———. *The Science and Philosophy of the Organism*. London: A&C Black, 1929.

Fausto-Sterling, Anne. "Feminism and Behavioral Evolution: A Taxonomy." *Feminism and Evolutionary Biology: Boundaries, Intersection, and Frontiers*, edited by Patricia Adair Gowaty, 42–60. New York: Chapman and Hall, 1997.

Freud, Sigmund. "A Difficulty in the Path of Psychoanalysis." *Standard Edition of Complete Psychological Works of Sigmund Freud*. Translated by James Strachey. Vol. 17., 135–44. London: The Hogarth Press, 1955.

———. "Fixation to Traumas—The Unconscious." *Standard Edition of Complete Psychological Works of Sigmund Freud*. Translated by James Strachey. Vol. 16, 273–85. London: The Hogarth Press, 1955.

Frisch, Karl von. *Animal Architecture*. Translated by Lisbeth Gombrich. New York: Harcourt Brace Jovanovich, 1974.

———. *Bees: Their Vision, Chemical Senses, and Language*. Translated by Dora Ilse. Ithaca, N.Y.: Cornell University Press, 1950.

———. *The Dancing Bees: An Account of the Life and Senses of the Honey Bee*. Translated by Dora Ilse. New York: Harcourt, Brace, and World, 1953.

Gamble, Eliza. *The Evolution of Woman: An Inquiry into the Dogma of Her Inferiority to Man*. New York: Putnam and Sons, 1893.

Ghiselin, Michael T. *The Triumph of the Darwinian Method*. Mineola, N.Y.: Dover, 2003.

Goldstein, Kurt. *Human Nature in the Light of Psychopathology*. Cambridge, Mass.: Harvard University Press, 1951.

———. *The Organism: A Holistic Approach to Biology Derived from the Pathological Data in Man*. New York: Zone, 1995.

Gordon, Deborah. *Ants at Work: How an Insect Society Is Organized*. New York: W. W. Norton, 1999.

Gowaty, Patricia Adair, ed. *Feminism and Evolutionary Biology: Boundaries, Intersection, and Frontiers*. New York: Chapman and Hall, 1997.

Grosz, Elizabeth. *Chaos, Territory, Art: Deleuze and the Framing of the Earth*. New York: Columbia University Press, 2008.

———. *The Nick of Time: Politics, Evolution, and the Untimely*. Durham, N.C.: Duke University Press, 2004.

———. *Volatile Bodies: Toward a Corporeal Feminism*. Sydney: Allen and Unwin, 1994.

Gruber, H. E. *Darwin on Man: A Psychological Study of Scientific Creativity together with Darwin's Early and Unpublished Notebooks*. Notebooks transcribed and annotated by P. H. Barrett. New York: Dutton, 1974.

Hardt, Michael. *Gilles Deleuze: An Apprenticeship in Philosophy*. Minneapolis: University of Minnesota Press, 1993.

Harel, Kay. "When Darwin Flopped." *Sexuality and Culture* 5, no. 4 (2001): 29–42.

Hegel, G. W. F. *The Phenomenology of Spirit*. Translated by A. V. Miller. Oxford: Oxford University Press, 1979.

Hill, Rebecca. 2008. "Interval, Sexual Difference." *Hypatia* 23, no. 1 (2008): 119–31.

Hoffmeyer, Jesper. "Seeing Virtuality in Nature." *Semiotica* 134, no. 1–4 (2001): 381–98.

hooks, bell. *Ain't I a Woman: Black Women and Feminism*. Boston: South End, 1981.

——. *Feminist Theory: From Margin to Center*. Boston: South End, 2000.

Irigaray, Luce. *Between East and West: From Singularity to Community*. Translated by Stephen Pluhaçek. New York: Columbia University Press, 2002.

——. *Conversations*. London: Continuum, 2008.

——. *Elemental Passions*. Translated by Joanne Collie and Judith Still. New York: Routledge, 1992.

——. "Equal to Whom?" *differences* 1, no. 2 (1989): 59–76.

——. *An Ethics of Sexual Difference*. Translated by Carolyn Burke and Gillian Gill. Ithaca, N.Y.: Cornell University Press, 1993.

——. *I Love to You: Sketch of a Possible Felicity in History*. Translated by Alison Martin. London: Routledge, 1996.

——. "An Interview with Luce Irigaray." *Hecate* 9, no. 1–2 (1983): 192–202.

——. "Is the Subject of Science Sexed?" *Cultural Critique* 2 (fall 1987): 65–87.

——. *Je, Tu, Nous: Towards a Culture of Difference*. Translated by Alison Martin. London: Routledge, 1993.

——. *Key Writings*. London: Continuum, 2004.

——. *Marine Lover of Friedrich Nietzsche*. Translated by Gillian Gill. New York: Columbia University Press, 1991.

——. "The Question of the Other." Translated by Noah Guynn. *Yale French Studies* 87 (1995): 7–19.

——. *Sexes and Genealogies*. Translated by Gillian Gill. New York: Columbia University Press, 1993.

——. *Sharing the World*. London: Continuum, 2008.

——. *Speculum of the Other Woman*. Translated by Gillian Gill. Ithaca, N.Y.: Cornell University Press, 1985.

——. *Thinking the Difference: For a Peaceful Revolution*. Translated by Karin Montin. New York: Routledge, 1994.

——. *This Sex Which Is Not One*. Translated by Catherine Porter. Ithaca, N.Y.: Cornell University Press, 1985.

——. "The Time of Difference." *Why Different? A Culture of Two Subjects*, translated by Camille Collins, 95–102. New York: Semiotext(e), 2000.

———. "Women's Exile." *Ideology and Consiousness* 1 (1977): 62–76.

Irigaray, Luce, Kiki Amsberg, and Aafke Steenhuis. "An Interview with Luce Irigaray." *Hecate* 9, no. 1–2 (1983): 192–202.

Irigaray, Luce, and Mary Green, eds. *Luce Irigaray: Teaching*. London: Continuum, 2008.

Jämsä, Tuomo. "Jakob von Uexküll's Theory of Sign and Meaning from a Philosophical, Semiotic, and Linguistic Point of View." *Semiotica* 134, no. 1–4 (2001): 481–551.

Jardine, Alice. *Gynesis: Configurations of Woman and Modernity*. Ithaca, N.Y.: Cornell University Press, 1985.

Johnson, Vivien. *Lives of the Papunya Tula Artists*. Alice Springs, Australia: IAD Press, 2008.

Jones, Graham, and Jon Roffe, eds. *Deleuze's Philosophical Lineage*. Edinburgh: University of Edinburgh Press, 2009.

Kauffman, Stuart A. *The Origins of Order: Self-Organization and Selection in Evolution*. New York: Oxford University Press, 1993.

Kirby, Vicki. *Telling Flesh: The Substance of the Corporeal*. New York: Routledge, 1997.

Knudsen, Susanne V. "Intersectionality: A Theoretical Inspiration in the Analysis of Minority Cultures and Identities in Textbooks." *Caught in the Web or Lost in the Textbook*, edited by Eric Bruillard, Mike Horsley, Susanne V. Knudsen, and Bente Aamotsbakken, 61–76. Paris: IUFM de Caen, 2006.

Krampen, Martin. "No Plant—No Breath." *Semiotica*, 134, no. 1–4 (2001): 415–21.

Kuhn, Thomas. *The Structure of Scientific Revolutions*. Chicago: University of Chicago Press, 1970.

Kull, Kalevi. "Jakob von Uexküll: An Introduction." *Semiotica* 134, no. 1–4 (2001): 1–59.

Lacan, Jacques. "The Function and Field of Speech and Language in Psychoanalysis." *Écrits*, translated by Bruce Fink, 197–267. New York: W. W. Norton, 2006.

———. "The Subversion of the Subject and the Dialectic of Desire." *Écrits*, translated by Bruce Fink, 671–701. New York: W. W. Norton, 2006.

Lacey, A. R. *Bergson*. London: Routledge, 1989.

Lenoir, Timothy. *The Strategy of Life: Teleology and Mechanics in Nineteenth-Century German Biology*. 1982. Chicago: University of Chicago Press, 2003.

LeVay, Simon. *Queer Science: The Use and Abuse of Research into Homosexuality*. Cambridge, Mass.: MIT Press, 1996.

Lewens, Tim. *Darwin*. Abingdon, UK: Routledge, 2007.

Lorraine, Tamsin. *Irigaray and Deleuze: Experiments in Visceral Philosophy*. Ithaca, N.Y.: Cornell University Press, 1999.

Lutzow, Thomas H. "The Structure of the Free Act in Bergson." *Process Studies* 2 (summer 1977): 73–89.

Mahmood, Saba. *The Politics of Piety: The Islamic Revival and the Feminist Subject*. Princeton, N.J.: Princeton University Press, 2004.

McCall, Leslie. "The Complexity of Intersectionality." *Signs* 30, no. 3 (2005): 1771–800.

Miller, Geoffrey. "Evolution of Human Music through Sexual Selection." *The Origins of Music*, edited by Nils B. Wallin, Björn Merker, and Steven Brown, 329–60. Cambridge, Mass.: MIT Press, 2002.

Mithen, Steven. *The Singing Neanderthals: The Origins of Music, Language, Mind and Body*. London: Weidenfeld and Nicolson, 2005.

Mortensen, Ellen, ed. *Sex, Breath, Force: Sexual Difference in a Postfeminist Era*. Lanham, Md.: Lexington, 2006.

———. *Touching Thought: Ontology and Sexual Difference*. Lanham, Md.: Lexington, 2003.

Mullarkey, John. *Bergson and Philosophy*. Notre Dame, Ind.: Notre Dame University Press, 1999.

Myers, Fred. *Pintupi Country, Pintupi Self*. Berkeley: University of California Press, 1986.

Nietzsche, Friedrich. *The Will to Power*. Translated by Walter Kauffman and R. J. Hollindale. New York: Vintage, 1968.

Olkowski, Dorothea. "The End of Phenomenology: Bergson's Interval in Irigaray." *Hypatia* 15, no. 3 (2000): 73–91.

———. *Gilles Deleuze and the Ruin of Representation*. Berkeley: University of California Press, 1999.

Pearson, Keith Ansell. *Germinal Life: The Difference and Repetition of Deleuze*. London: Routledge, 1999.

———. *Philosophy and the Adventure of the Virtual: Bergson and the Time of Life*. London: Routledge, 2002.

Plaza, Monique. " 'Phallomorphic Power' and the Psychology of 'Woman.' " *Ideology and Consciousness*, no. 4 (autumn 1978): 5–36.

Prigogine, Ilya. *The End of Certainty: Time, Chaos, and the New Laws of Nature*. New York: Free Press, 1997.

Prigogine, Ilya, and Isabelle Stengers. *Order out of Chaos: Man's New Dialogue with Nature*. London: HarperCollins, 1984.

Ridley, Matt. *The Red Queen: Sex and the Evolution of Human Nature*. New York: Penguin, 1993.

Roughgarden, Joan. *Evolution's Rainbow: Diversity, Gender, and Sexuality in Nature and People*. Berkeley: University of California Press, 2004.

Ruyer, Raymond. *Néo-finalisme*. Paris: Presses Universitaires de France, 1952.

Saussure, Ferdinand de. *The Course in General Linguistics*. Translated by Charles Balley and Albert Schecherhaye. New York: McGraw-Hill Humanities, 1965.

Scholes, Luke. "Kiwirrkura Women: The Shifting Shape of Western Desert Painting." *Art and Australia* 43, no. 3 (2009): 498–99.

Sharov, Alexei. "Umwelt-Theory and Pragmatism." *Semiotica* 134, no. 1–4 (2001): 211–28.

Simondon, Gilbert. "The Genesis of the Individual." *Incorporations*, edited by Jonathan Crary and Sanford Kwinter, 297–319. New York: Zone, 1993.

———. *L'individu et sa genèse psycho-biologique*. Paris: Presses Universitaires de France, 1964.

Spelman, Elizabeth V. *Inessential Woman: Problems of Exclusion in Feminist Thought*. Boston: Beacon, 1988.

Spivak, Gayatri Chakravorty. "Feminism, Criticism, and the Institution." *The Post-Colonial Critic: Interviews, Strategies, Dialogues*. New York: Routledge, 1990.

Stott, Rebecca. *Darwin and the Barnacle*. New York: W. W. Norton, 2003.

Thompson, D'Arcy Wentworth. *On Growth and Form*. New York: Dover, 1992.

Tzelepis, Elena, and Athena Athanasiou, eds. *Rewriting Difference: Luce Irigaray and the Greeks*. Albany: State University of New York Press, 2008.

Uexküll, Jakob von. "An Introduction to Umwelt." *Semiotica* 134, no. 1–4 (2001): 107–10.

———. "The New Concept of Umwelt: A Link between Science and the Humanities." *Semiotica* 134, no. 1–4 (2001): 111–23.

———. "A Stroll through the Worlds of Animals and Men: A Picture Book of Invisible Worlds." *Instinctive Behavior: The Development of a Modern Concept*, edited by Claire Schiller, 5–80. New York: International Universities, 1957.

———. *Theoretical Biology*. Translated by D. L. MacKinnon. London: Kegan Paul, Tench, Trubner, 1926.

———. "The Theory of Meaning." *Semiotica* 42, no. 1 (1982): 25–82.

Vandermassen, Griet. *Who's Afraid of Charles Darwin? Debating Feminism and Evolutionary Theory*. Lanham, Md.: Roman and Littlefield, 2005.

Weiss, Gail. *Body-Images: Embodiment as Intercorporeality*. New York: Routledge, 1999.

Whitford, Margaret. *Luce Irigaray: Philosophy in the Feminine*. London: Routledge, 1990.

Wilson, Bee. *The Hive: The Story of the Honeybee and Us*. New York: Thomas Dunne, 2004.

Wilson, Edward O. *Sociobiology: The New Synthesis*. Cambridge, Mass.: Harvard University Press, 1975.

Young, Iris Marion. "Gender as Seriality: Thinking about Women as a Social Collective." *Signs* 19, no. 3 (1994): 713–38.

Ziarek, Ewa Plonowska. *An Ethics of Dissensus: Postmodernity, Feminism, and the Politics of Radical Democracy*. Stanford, Calif.: Stanford University Press, 2001.

index

Badiou, Alain, 26, 50

barnacles, 160–66, 233n41, 233n44, 234n45

Bataille, Georges, 131

beauty. *See* aesthetics; art; taste

becomings, 1–7, 32, 37–47, 51–54, 65, 97, 149–51, 193–201, 214n28. *See also* difference; ontology; sexual difference; *specific thinkers*

bees, 20–22, 182–86, 207n16, 240n32, 242n40

being: Deleuze on, 41; disruption of, 3; hierarchies of, 4; individuation and, 36–37

Berg, Paul, 173

Bergson, Henri: becoming and, 3, 49, 51–54; *Creative Evolution*, 29, 62; *The Creative Mind*, 29; as Darwin's intellectual heir, 4, 19, 26, 28, 37, 40, 69; difference and, 26–27, 43–47; feminism and, 5, 60–61, 72; freedom and, 5, 62–68, 70–72, 215n5, 215n16, 217n24; influence of, on Deleuze, 11, 26, 29, 35–36, 40–47, 51–56, 92, 210n4, 211n10; intuition as philosophical method of, 47–51, 212n18; life's definition and, 27, 29, 31–32, 210n6; matter and materiality and, 4, 68–71, 214n26; *Matter and Memory*, 62; *Time and Free Will*, 62, 64, 67–68; vitalism and, 33–34. *See also* duration; intuition

biological sciences, 7, 141–44, 149, 167, 220n3

birdsong, 20, 207n14

Blackwell, Antoinette Brown, 115

bodies: art and, 188–89, 193–97; concepts and, 80–81; expressiveness of, 19–21, 28; freedom and, 72; morphologies of, 82, 104, 108, 110, 130,

137, 139–40, 145–46, 227n5; sexual selection and, 157–60; Uexküll on, 178–80. *See also* life; matter and materiality; sexual difference

Burke, Karen, 145

Butler, Judith, 91, 106–7

Canguilhem, Georges, 173

Capital (Marx), 157

Cassirer, Ernst, 173

chance, 77, 79, 83, 104, 148

change. *See* becomings

Chanter, Tina, 106–8

Chapman, Nancy, 198, 244n6

choice, 125–32, 138–40, 157–60, 220n12, 221n14

class, 5–6, 16, 59, 76, 87, 96–97, 106–11, 157

Collins, Patricia Hill, 90

colonialism, 61, 75, 83, 87, 91, 117, 192

competition, 125–32, 157–60, 220n12, 221n14

compression. *See* matter and materiality

concepts, 76–83, 144–45, 147, 218nn3–8. *See also* Deleuze, Gilles; philosophy

consciousness, 31–32, 34, 43, 50, 68–69, 208n9, 215n14

consistency, in truth production, 77–79

contingency, 77, 79, 83, 104, 148

contraction. *See* matter and materiality

Cornell, Drucilla, 91, 106–9

Creative Evolution (Bergson), 29, 62

The Creative Mind (Bergson), 29

Crenshaw, Kimberle, 90

Cronin, Helena, 220n3

culture, relation to nature, 148–57

Darwin, Charles: definitions of the human and, 21–23, 26, 205nn9; *The Descent of Man*, 16–17, 19, 22–23, 115, 122–28, 134–36, 138–40, 143, 160–66; difference and, 4, 8, 16–18; excess and, 7, 169; *The Expression of the Emotions*, 166; feminism and, 5, 7, 60–61, 115–16, 118, 155–60, 166–68, 230n28, 231n29; historical importance of, 13; the humanities and, 13–16, 169; intellectual heirs to, 2–4, 116–19, 154; Irigaray's thinking and, 7, 143–44, 166–67, 230n24; language and, 17–20, 133–36, 183, 206n10; natural selection and, 2, 116, 176; *On the Origin of Species*, 16, 18, 120, 122–23, 161; ontological thinking of, 4; politics and, 167–68; on race, 136–40, 156, 166, 225nn25–26, 226nn27–28; on sexual difference, 141–42; sexual selection and, 3, 6, 104, 116–20, 126–36, 157–74, 220n12, 221n14, 223n17. *See also* feminism; Irigaray, Luce; life; natural selection; sexual selection

Dawkins, Richard, 119, 129, 220n2, 224n19

deconstruction, 91

Deleuze, Gilles: becoming and, 3, 8; Bergson's influence on, 4, 20, 28–30, 35–36, 40–47, 51–56, 211nn10–11; *Desert Islands and Other Texts*, 26; difference and, 6, 27, 41–47, 90–95, 103, 145, 174, 210n4; *Difference and Repetition*, 92; *Essays Critical and Clinical*, 11; feminism and, 5, 61; identity's relative stability and, 52, 55, 213n21; intellectual genealogy of, 26, 35, 55, 91, 173; life and, 28–30, 53–54, 208n2; materiality and, 4,

53–54; project of, 35–36, 38–39, 49, 77–78; singularity and, 36, 38, 209n20; *A Thousand Plateaus*, 11, 169; *What Is Philosophy?*, 78–79. *See also* deterritorialization

Deleuze (Badiou), 50

Dennett, Daniel, 204n3, 220n2

Derrida, Jacques, 3, 11–18, 41–45, 80, 91–94, 103, 145, 203nn1–2, 205nn7–8, 210n9

Descartes, René, 12, 118

The Descent of Man (Darwin), 16–17, 19, 22–23, 115, 122–28, 134–36, 138–40, 143, 160–66

Desert Islands and Other Texts, 1943–1974 (Deleuze), 26

desire, 106, 108, 118, 125, 130, 139, 141, 160

determinism, 62–68, 215n5

deterritorialization, 50, 187, 235n3

Deutscher, Penelope, 106–7

différance, 91

difference: art and, 42, 96; Bergson's philosophy and, 43–47; definitions of, 93; definitions of the human and, 16; Deleuze on, 6, 35, 41–47, 90–95, 97, 103, 210n4; Derrida's theories of, 43–44, 91, 93–94, 103; internal, 5, 31, 45, 47, 55, 93; of kind and degree, 16–17, 31, 37, 40, 45–46, 50; language and, 90, 92–93; life as elaboration of, 3, 22–24, 32, 34, 119; potential place of, in feminist thought, 90–91, 95–98; as proliferative generator, 26, 54, 97, 103, 130, 133; pure, 90–95, 145; as relation-structuring, 1; sexual, 3, 6, 23–24, 87, 99–104, 111, 120–21; vital, 34, 212n15. *See also* art; class; race; sexual difference; sexual selection

Irigaray, Luce: academic foci of, 102; autonomy and subjectivity and, 62, 71; criticisms of, 106–9, 148, 168, 215n4, 219n7; Darwin's thinking and, 7, 144, 155, 166–67, 230n24; *An Ethics of Sexual Difference*, 106; Hegel as interlocutor of, 152–53, 168; *I Love to You*, 99, 102; on nature and the natural, 104–5; as ontologist, 99–101, 103, 105–6, 109–12, 117–18, 227n2; psychoanalytic theory and, 91, 106; sexual difference and, 3, 6, 8, 45, 143–46, 148–52, 155, 226n1, 228nn9–10. *See also* Darwin, Charles; feminism; sexual difference

Kant, Immanuel, 13
Kauffman, Stuart, 34, 209n16
Kiwirrkura community, 193–97
knowledge: art as one kind of, 192–93; concepts and, 81–83, 144; Darwin's influence on, 17; Derrida on, 18; feminist theory and, 6, 73, 144–47; humanities and, 15–16; multiplicities of, 23–24; power of, 76–77, 83, 103
Kristeva, Julia, 91, 210n9
Kuhn, Thomas, 48

Lacan, Jacques, 13, 90, 173, 205n8, 207n15
Lake Dora. See *Ngayarta Kujarra* (painting)
language: animality and, 14, 19–22, 206n10; Bergson's intuition and, 48; as contextualizer of the human, 5, 18–19; difference and, 90–91, 93–94; musicality of, 20, 133, 206nn10–11, 224n22; sexual selection and, 18,

133–36. *See also* music and musicality; sexual selection
Levinas, Emmanuel, 13, 41
liberalism, 5–6, 60–61, 72, 82, 96, 215n5
life: art and, 38–39; becoming and, 42, 52; Bergson's definition of, 27–30, 32; biologism and, 28; concepts and, 80–81; Darwin on, 3, 5, 27, 118; definitions of, 3, 28, 119, 217n19; Deleuze on, 35–36; design as primary biological problem of, 173–80; difference as engine of, 26–27, 68–71, 94, 101–2; dynamism of, 27–30; events and, 35, 39; as excess in matter, 28, 32, 35, 53, 65, 68, 119, 189–90; freedom and, 68–71; individuation and, 36–38; materiality and matter and, 2, 5, 27–36, 38, 40, 43, 52–54, 77, 152, 170; more and other and, 8, 52; sexual selection and, 2–3, 101, 144, 166–68; unity of, 33–35. *See also* Bergson, Henri; Darwin, Charles; evolution; matter and materiality; vitalism
Lorenz, Konrad, 7
Lyotard, Jean-François, 41, 44

Mahmood, Saba, 90
Martumili Artists' Cooperative, 195, 197–201
Martu women painters (collective), 8, 193–201
Marx, Karl, 157
Marxism, 6, 72, 74–77, 82, 107, 151, 157
matter and materiality: art and, 38–39, 188–89, 191, 193–201; Bergson on, 4, 29, 214n26; concepts and, 80–81; definitions of, 29, 34; Deleuze on, 4,

66, 220n8, 223n17; definitions of, 130–31, 157; language and, 17–19, 131, 133–36; morphological difference and, 24, 130, 233n38; operations of, 2, 121–23; performativity and, 125, 158–59, 170, 232n34; race and, 136–40; reductive understandings of, 116–17, 119–20, 128–31. *See also* art; Darwin, Charles

Simondon, Gilbert, 36–38, 78, 173, 208n2

singularity, 36, 38, 42, 131, 209n20

slavery, 156–57

sociobiology, 115–17, 131, 137, 159, 204n3, 220n1

Sociobiology (Wilson), 115

Sophocles, 152–53

spatiality, 28–30, 48–49, 65, 177–83

Spelman, Elizabeth V., 90

Spemann, Hans, 173, 238n17

Spencer, Herbert, 133

Spillers, Hortense, 90

Spinoza, Baruch, 11, 41–43, 55, 60, 92

spirit, 151–53

Spivak, Gayatri, 91

structuralism, 4, 6–7, 91, 151

subjects and subjectivity: bodies' morphologies and, 82, 110; feminism and, 59–61, 71–73, 84; freedom of, 6, 60–61, 64–68; identity and, 32, 214n28; Irigaray and, 62, 102, 152; oppression of, 6, 89; singularity and, 38; theoretical understandings of, 74–75, 100. *See also* Irigaray, Luce; Lacan, Jacques; sexual difference

Sullivan, Gabrielle, 197, 244n5

Sydney Biennale (2008), 196

taste, 127, 130–31, 136, 141–42, 159, 182, 220n12

Taylor, Harriet, 168

temporality: becomings and, 2–3; causality's complications and, 63–65, 67; Dreamtimes and, 188–201; forces and, 5, 52; life's relation to, 31–32, 53; the real and, 54. *See also* becomings; Deleuze, Gilles; duration; matter and materiality

tendencies, 15, 19–20, 23, 30, 35, 46–47, 50, 97, 213n24. *See also* Deleuze, Gilles; forces; temporality

territorialization, 50, 180–86, 241nn33–36, 244n49

terrorism, 74

theory, 76–77, 81–83, 99

Thomson, D'Arcy Wentworth, 173

A Thousand Plateaus (Deleuze and Guattari), 11, 169

Time and Free Will (Bergson), 62, 64, 67–68

transformation. *See* becomings

truth, criteria of, 76–77, 79, 81–83. *See also* epistemology; knowledge

the two, 149–51

Uexküll, Jakob von, 7, 173–86, 208n2, 234n2, 235n9, 236n12, 236n15, 238n17, 241nn33–35; on perception, 174–82, 191, 220n4, 236n10, 239n21, 239n25

Umwelt, 173–83, 236n15, 240nn27–29

variety. *See* difference; multiplicity; tendencies

the virtual: actualization and, 77; conceptuality and, 49, 78–80; Deleuze on, 20, 55; life and, 32, 35–36; matter and, 39, 51–52; as opposed to the possible, 66. *See also* Deleuze, Gilles; new; real

vitalism, 33–34

Elizabeth Grosz is a professor of women's studies and gender studies at Rutgers University. She is the author of several books, including *Chaos, Territory, Art: Deleuze and the Framing of the Earth*; *The Nick of Time: Politics, Evolution, and the Untimely*; and *Time Travels: Feminism, Nature, Power*.

Library of Congress Cataloging-in-Publication Data
Grosz, E. A. (Elizabeth A.)
Becoming undone : Darwinian reflections on life, politics, and art / Elizabeth Grosz.
p. cm.
Includes bibliographical references and index.
ISBN 978-0-8223-5053-8 (cloth : alk. paper)
ISBN 978-0-8223-5071-2 (pbk. : alk. paper)
1. Feminist theory. 2. Sex role. 3. Natural selection. I. Title.
HQ1190.G756 2011
305.4201 — dc23
2011021950